EARLY MODERNISM

EARLY MODERNISM

LITERATURE, MUSIC, AND PAINTING IN EUROPE, 1900–1916

CHRISTOPHER BUTLER

OXFORD
UNIVERSITY PRESS

OXFORD

UNIVERSITY PRESS

Great Clarendon Street, Oxford OX2 6DP

Oxford University Press is a department of the University of Oxford.
It furthers the University's objective of excellence in research, scholarship,
and education by publishing worldwide in

Oxford New York

Auckland Bangkok Buenos Aires Cape Town Chennai
Dar es Salaam Delhi Hong Kong Istanbul Karachi Kolkata
Kuala Lumpur Madrid Melbourne Mexico City Mumbai Nairobi
São Paulo Shanghai Taipei Tokyo Toronto

Oxford is a registered trade mark of Oxford University Press
in the UK and in certain other countries

Published in the United States
by Oxford University Press Inc., New York

First published 1994

British Library Cataloguing in Publication Data

Data available

Library of Congress Cataloging in Publication Data

Butler, Christopher.
Early modernism : literature music and painting in Europe,
1900-1916 / Christopher butler.
Includes index.
1. Modernism (Art)—Europe. 2. Arts, European.
3. Arts, Modern—20th century—Europe. I. Title.
NX542.B88 1994 700'.94'09041—dc20

ISBN 0-19-811746-9 (hbk.)
ISBN 0-19-818252-X (pbk.)

10 9 8 7 6

Printed in Great Britain on acid-free paper by
Ashford Colour Press Ltd., Gosport, Hants

PREFACE

This book is designed to help those who know something about one of the arts involved in the Modernist movement, and who would like to know more about the larger intellectual picture and the other two arts. Many of the thoughts expressed here have grown out of a course on 'The Modern Tradition' which I had the pleasure of giving for many years with Richard Ellmann; but the book's most basic intellectual debts go even further back, to the teaching of Isaiah Berlin, who first inspired me to ask how it is that general ideas move individual men and women.

Anyone who works on an interdisciplinary topic will accumulate numerous intellectual debts to others who are expert in their various fields; but my chief debt has been to those who believe that the kind of comparative activity I attempt here is worth while—and for this kind of invaluable and continuing encouragement I would like to thank in particular Malcolm Bradbury, Ihab Hassan, and Marjorie Perloff. I owe more specific debts to Kathleen Woodward and the Centre for Twentieth Century Studies at the University of Wisconsin-Milwaukee, whose conferences and resources for the study of German literature are alike inspiring, to Gerhard Hoffmann at the University of Würzburg, whose conferences on Postmodernism were always willing to contain some historical retrospection, and to the Governing Body of Christ Church, who with great generosity made it possible for me to have extra time for research. Many others have helped me, in conversation or by reading parts of an originally rambling typescript. I would particularly like to thank Walter Abish, Anne-Pascale Bruneau, Barrie Bullen, Gillian Butler, Nöel Carroll, Alison Denham, Alastair Fowler, Orlando Gledhill, John Griffiths, Bill Handley, Susan Haskins, Tim Hilton, David Luke, Karen Luscombe, Judith Mackrell, Allison Miller, Siva Narayanan, Francesca Orestano, Sowon Park, Simon Rattle, Elise Ross, Karen Shepherd, Richard Sheppard, Alistair Stead, Anthony Storr, Stella Tillyard, Charles Tung, and the readers employed by the Oxford University Press, whose patience must have been sorely tried by an earlier version of this book which tried to find a not very well-defined place for everything. I am particularly conscious of the fact that all those

acknowledged above could in various ways have saved me from error; nevertheless, the errors which remain are my own, and I alone am responsible for them.

At Oxford University Press, Kim Scott Walwyn has unfailingly managed to be encouraging and constructively critical, Andrew Lockett helpfully suggested many improvements; and Jason Freeman made the process of production exceptionally pleasurable.

Since academic life is not everything, and since great art can be life-enhancing for everyone, and as a small response to their love and enthusiasm, I dedicate this book to my daughters, who have always been able to persuade me of the truth of the first two propositions in this sentence.

C.B.

Christ Church
Oxford

CONTENTS

LIST OF ILLUSTRATIONS

BLACK AND WHITE ILLUSTRATIONS

INTRODUCTION

In what follows I attempt to give an account of some innovative work in music, painting, and literature, from the turn of the twentieth century to the period of the First World War, and to show how it can be seen as constructing an 'Early Modernism'. The heroic figures within this initial development—Matisse, Picasso, Stravinsky, Schoenberg, Marinetti, Pound, Eliot, Apollinaire—all developed radically new conventions for their respective arts. I will show how such changes in artistic technique were related to profound shifts in intellectual assumptions.

My characterization of this generation, whose major works first appear in the decade before the First World War, as 'Early Modernist', depends on the idea that they come *after* something differently characterizable; after Romanticism, after English Victorianism (or similarly repressive social formations in other countries, as the careers of Ibsen, Strindberg, Wedekind, and Gide could show), after 'bourgeois' Realism or Naturalism—and, most particularly, after the Decadence, Aestheticism, and Symbolism of the late nineteenth century.

This sense of contrast with what has gone before is essential to the characterization of any artistic period. It is also the symptom of profound changes in dominant states of mind and feeling. The ideas which the Modernists took from Nietzsche, Bergson, Marinetti, and others made a cultural revolution whose effects are still with us, because they helped inspire that tradition in art which weighs most heavily on the present.

I have written this book because I believe that the nature of this intellectual and artistic change can only be understood in a European context, and in relation to all the arts (though I only consider literature, music, and painting in what follows). Many accounts of Modernism have an excessively literary bias, and fail to take into account the exceptional interaction between the arts in this period, as mediated by new ideas and common ends. Such restricted accounts also tend to privilege the relationship between the Anglo-American tradition and France, and to underplay the German and Italian contribution within this period. It is still not sufficiently appreciated that many Modernist achievements,

and particularly those which have a significant afterlife in Postmod-
ernism—such as atonality and Expressionism and the internationalist
politics of Dada—were distinctively German in inspiration.

My account is nevertheless the product of countless omissions, many
forced upon me by the need for that critical simplification which helps
to make historical narrative more intelligible. I have attempted to treat
some of my central works in such a way as at least to suggest the diver-
sity of thought behind them, but many wholly culpable gaps will
remain. I move, for example, from masterpiece to masterpiece, and so
tend to ignore the relationship between major and minor work within
the canon I propose.

In tracing this history I have contracted an immense debt to the schol-
arly work of my predecessors; they have provided the detail to which I
attempt to give a conceptual structure. And yet there is still a good deal
to find out about this much studied period. All of my themes deserve a
far more resolute and expansive pursuit than I have been able to give
them within the confines of a single-volume study. The notes to each
chapter, along with references for citations, attempt to provide the
reader with suitable starting-points for further exploration, and I have
supplemented them with a Bibliographical Note for some of the more
generally focused chapters.

I have attempted to see the development of the central ideas of the
Modernist period from within the mental world of the artists and
thinkers I discuss. My focus is on the individual because it is only within
persons that the new ideas of a period present themselves as problems
and attract further thoughts and feelings which can lead to innovation
and discovery, in work which, unlike that of science or much of formal
philosophy, will always bear the clear marks of individual character and
temperament.

The ideas with which I shall be concerned, for example those of the
unconscious, of intuition, of the necessary evolution of art, of the
expression of thoughts which are not dependent upon linear progres-
sion, of the relationship of abstraction to the real world, and so on, all
made a profound difference to the artists I discuss: they very often lib-
erated them at the same time as perplexing them. Nor did they come
singly; what made the period of Modernism one of revolution was the
conceptual interrelationship between innovations in the different arts
and the ways in which these expressed highly complex and often quite
fully articulated forms of life or views of the world (for example in inves-
tigating the nature of experience in the city). They are part of a general

intellectual climate which helped to motivate men and women and to shape their actions and their feelings, particularly in making art, just as much as did the more obviously material factors involved in historical and political change.

I believe indeed that the most important of these ideas derive from recurrent philosophical concerns to be found in many periods and under different social conditions, that they often run the artists involved with them into contradiction, and that the problems they centre on are no more likely to be brought to a final solution than the artist is to produce a 'final' work of art from which no others can be derived or 'progress'. Many of the issues which the Modernists faced are still open to debate in epistemology and moral thought; and the continuity of their aesthetic concerns is shown by the fact that our interpretation of the relationship of Modernism to Postmodernism is still a matter of dispute and probably will long continue to be so.

My initial theme in Chapter 1 is the sceptical analysis of previously established conventions for the arts, and this leads on to an examination of the most basic elements of artistic languages, such as logic, harmony, and perspective. These become the focus for the innovations discussed in Chapter 2. I then attempt to show in Chapter 3 how this process interacted with thoughts about divisions within the self and resulted in a new construction of personal identity, in particular to a confrontation with the primitive. This leads me to discuss in Chapter 4 the ways in which the divided artist pursued Modernist aims within an environment—the metropolis—which expansion and technological development was in any case rendering particularly baffling. I then attempt in Chapter 5 to see what a narrative ordering of the theoretical assumptions behind the innovatory activity of a more marginal avant-garde in London would look like. This leads me in conclusion to some general reflections on the nature of the avant-garde in the period from Fauvism to the beginnings of Dada in Zurich—in particular, on the ways in which its dominant ideas were diffused, on its turn towards the irrational, and on its claims to be 'progressive'.

I stop there for two reasons. One is trivial—any more extended account would go far beyond the bounds of a single volume. The other is that the nature of Modernism changes after the First World War, when a traditionalist, allusive conservativism is countered in its turn by the irrationalist pretensions of Surrealism. Modernist assumptions about art had become dominant by 1918, and they seemed to many to need adaptation to more explicitly social and political ends than had been

essayed before the war. This is hardly surprising, after a European crisis so great that hardly anyone at the turn of the century could have anticipated it. But Early Modernism evolved in a very different context.

1 | THE DYNAMICS OF CHANGE

1. Scepticism and Confrontation

> What Modernism and Postmodernism share in common is a single adversary which is, to put it crudely, realism or naïve mimesis. Both are forms of post-Realism. They likewise share in common a practice based on avant-garde and movement tactics and a sense of modern culture as a field of anxious stylistic formation.

These remarks by Malcolm Bradbury raise some quite general questions about the underlying conditions for a period of artistic innovation—he notes here a reaction against the past (anti-Realism), a strategy for gaining attention (the avant-garde), and a sense of relationship to the general culture of the time (anxious).[1] In what immediately follows I develop this line of thought by outlining some of the influences upon the major early Modernists. These conditions for revolutionary change involved in particular a general atmosphere of scepticism, which prompted a basic examination of the languages of the arts. (For example, should the marks artists leave on canvas be seen as an attempt to imitate our perception of the object, as in Impressionism, or be the signs of a merely subjective *con*ception, one no longer trusted to provide us with the illusion of a direct acquaintance with things?)[2]

Such changes in attitudes to the arts are motivated by particular ideas. If Bradbury is right about the attack on Realism, then there must have been a motivating reason for it. In the early Modernist period, such an attack was part of the critical examination of artistic modes of discourse whose burden was to secure the recognition of shared social practices, which Naturalism had often criticized, and Impressionism equally frequently celebrated. The anxiety of the avant-garde which attempted to succeed these movements thus arose at least partly from a sceptical loss of confidence in such modes, brought about by influential voices within early twentieth-century European culture. Nietzsche, Ibsen, William James, and others contested the totalizing religious and

political frameworks of the nineteenth century, in favour of a growing pragmatism or pluralism, and many followed Nietzsche in believing that 'What is needed above all is an absolute scepticism toward all inherited concepts'.[3]

Those intellectuals who were affected by propaganda in favour of the 'Modern' tended to see themselves as critics, who were divorced from, and marginal to, the society in which they lived. Ibsen in particular was supposed to have laid bare bourgeois self-deceptions, and Freud, the founder of a science described by his biographer as 'the nemesis of concealment, hypocrisy, the polite evasions of bourgeois society', identified himself with the courageous Dr Stockmann in Ibsen's *An Enemy of the People* (1882).[4] A sometimes despairing sceptical distance from social norms (and from the reforming zeal of Naturalist writers) is central to the novel at the beginning of the century. Hence the evolution of Marcel's consciousness in *À la recherche du temps perdu*, from a naïve acceptance of class assumptions to a detached, subjectivist criticism of them, the aristocratic political scepticism of Conrad's later work, and Gide's and Heinrich Mann's and E. M. Forster's advocacy of very different kinds of dissentient morality, divorced from conventional political and religious constraints. The common interest of painters and poets in an urban Bohemia also reinforced a sense of critical marginality, and, although this was inherited from the nineteenth century, it developed in many cases (such as those of T. S. Eliot, Gottfried Benn, and Franz Kafka) into profound forms of psychological alienation.

These pressures towards withdrawal from social consensus (and the morality it implied) had long been identified as symptoms of modernity. Matthew Arnold thought in the 1860s that:

Modern times find themselves with an immense system of institutions, established facts, accredited dogmas, customs, rules, which have come to them from times not modern. In this system their life has to be carried forward, yet they have a sense that this system is not of their own creation, that it by no means corresponds exactly with the wants of their actual life, that for them, it is customary not rational. The awakening of this sense is the awakening of the modern spirit.[5]

Oscar Wilde restated Arnold's position in his significantly entitled dialogue, 'The Critic as Artist', a quarter of a century later: 'It is enough that our fathers believed. They have exhausted the faith-faculty of the species. Their legacy to us is the scepticism of which they were afraid.'[6] This legacy bore down heavily upon the youthful protagonists of many turn-of-the-century works, such as Gide's *Immoraliste* of 1902, the

schoolchildren in Wedekind's *Spring Awakening* (written in 1891 and staged in 1906), and Musil's military cadet, *Young Torless*, of 1906. Thomas Mann's *Tonio Kröger* (1903) believes that the 'curse' of a literary vocation 'begins by your feeling yourself set apart, in a curious sort of opposition to the nice, regular people; there is a gulf of ironic sensibility, of knowledge, scepticism, disagreement, between you and the others; it grows deeper and deeper, you realise that you are alone.'[7] And Joyce's *Stephen Hero* (1904–6) realizes 'that though he was nominally in amity with the order of society into which he had been born, he would not be able to continue so'. His sense of the modern follows Arnold's injunction to see the object as it really is:

The ancient method investigated law with the lantern of justice, morality with the lantern of revelation, art with the lantern of tradition. But all these lanterns have magical properties: they transform and disfigure. The modern method examines its territory by the light of day.

This is Stephen the dissident student, who has been told (by a priest admittedly) that his essay on 'Art and Life', devoted to Ibsen, 'represents the sum of modern unrest and modern freethinking'.[8] This critical scepticism also sustains a myth, that young people have to break free from parental certainties, which are seen as being not just more demanding, but also, paradoxically, as more complacent than their own. But the young still needed the inspiration of their elders to do so. When the Oedipal adherents of *Jung-Wien* rose up against the previous generation in the 1890s, they called upon the supporting authority of older men, in the persons of Nietzsche, Ibsen, Wedekind, Strindberg, and others.[9]

Early Modernist innovators met the challenge of this withdrawal from the assumptions of a previous generation in two distinct ways. First, they developed Symbolist notions of stylistic autonomy, so that their work could seem to depend upon aesthetic conventions which were independent of public norms. Secondly, they relied upon the idea that creativity (and art) had to be subjective, intuitive, and expressionist in character. Kandinsky, for example, echoes Yeats in judging that 'When religion, science and morality are shaken, the two last by the strong hand of Nietzsche, and when the outer supports threaten to fall, man turns his gaze from externals in on to himself.'[10] Nietzsche's influence is all pervasive in this period. His thoughts about nihilism after the 'Death of God', the *Übermensch*, the Will to Power, the multiplicity of the self, and art as the last form of metaphysics, were widely discussed, and

(given the aphoristic and metaphorical nature of Nietzsche's style) very diversely interpreted, in avant-garde circles. Even James Joyce was a 'Nietzschean' for a while.[11] But Kandinsky's remark points to an essential aspect of Nietzsche's influence: he turned many towards subjectivism in a world no longer sustained by the moral imperatives issuing from a God.[12]

As we shall see, this metaphysical tendency towards subjective self-reliance (and the growth of a considerable anxiety about it) is reinforced by the work of Bergson (whose *Essai sur les données immédiates de la conscience* was published in 1889). It also leads to a growing interest in divisions within the personality, of which the psychology of Freud turned out to be the most influential symptom. His *Traumdeutung* (*The Interpretation of Dreams*), published in 1900, is entirely typical of the Modernist withdrawal from consensus in its defiance of previous authority and its revolutionary dependence upon self-analysis. It begins with a motto from Virgil: 'Flectere si nequeo Superos, Acheronta movebo' ('If I cannot bend the higher powers, I will move the infernal regions', *Aeneid*, bk. vii), which can be interpreted as meaning that wishes rejected by the 'higher mental authorities' will resort to a subjective 'mental underworld' of the unconscious.[13] But the verse is also spoken by an infuriated Juno after the Olympians have frustrated her wishes, and Freud no doubt identified with her.

2. The Withdrawal from Consensual Languages

Twentieth-century verse makes very few technical changes which go far beyond those to be found in the French Symbolist poetry of the nineteenth century, which had already experimented with free verse, typographical rearrangement, and an irrationalist association of ideas. Modernist poets had to come to terms with this earlier tradition, and in particular with the crisis it provoked concerning the poetic use of language, given Rimbaud's and Mallarmé's encouragement of the belief that poetry should devise a language which goes beyond the conventions of everyday speech. Mallarmé is reported to have said of his own poetry:

Ce sont les mots mêmes que le Bourgeois lit tous les matins, les mêmes! Mais, voilà (et ici son sourire s'accentuait), s'il lui arrive de les retrouver en tel mien poème, il ne les comprend plus! C'est ce qu'ils ont été ré-écrits par un poète.[14]

They are the same words that the Bourgeois reads every morning—the very

same! But then (and here his smile broadened), if he finds them again in one of my poems he no longer understands them! That's because they have been rewritten by a poet.

This 'rewriting' depended to a large degree on Mallarmé's punning disruption of the word orders permitted by French syntax and, in *Un coup de dés jamais n'abolira le hasard* (*A throw of the dice will never abolish chance*) (1897), on his making a wide-spaced typographical distribution of the words of the poem, to secure 'une vision simultanée de la page' ('a simultaneous vision of the page').[15] We are challenged to read the poem on different spatial and conceptual levels, as if it were an orchestral score (Mallarmé's Preface describes it as 'une partition'). The central concepts of the text were thus given new values by being put into defamiliarizing juxtaposition, within ambiguously complicated networks of metaphoric association. The word became, for Mallarmé, a 'centre of vibratory suspense' and is to be understood

indépendamment de la suite ordinaire, projétés, en paroi de grotte, tant que dure leur mobilité ou principe, étant ce qui ne se dit pas du discours: prompts tous, avant extinction, à une réciprocité de feux distante ou présentée de biais comme contingence.[16]

independent of the ordinary sequence, projected, [as if on] the inner walls of a cave, for as long as their mobility or principle lasts, being that part of a discourse which is not (to be) spoken; all of them ready, before their extinction, to take part in a reciprocity of fires, either at a distance, or presented obliquely, as a contingency.

Under such conditions, the controlling, socially conformist voice of the poet 'disappears' in favour of his presentation of the discoveries he has made within the structure of the language. In the absence of his guiding commentary, the literary work seems to be a language-construct, within which the reader is invited to play at the game of interpretation.

Such tendencies helped to establish the work of art as somehow autonomous, in a world of its own—an idea which Symons helped to spread in England through his *Symbolist Movement in Literature*:

Mallarmé was concerned that nothing in the poem be the effect of mere chance, that the articulation of every part with every other part should be complete, each part implying every other part, and that the meaning of the poem should be inseparable from its formal structure.[17]

The work typically projects a mysteriously visionary or dream-derived world, subject to its own laws. The technique for achieving this largely

depended on making these laws language dependent, by a subtle inter-connection of symbol and metaphor. The text becomes more and more inexplicit and figural, and the reader is challenged to re-create the author's or speaker's associative processes in order to realize the nature of the whole, as in Mallarmé's *L'Après-midi d'un faune* of 1876, which is a *locus classicus* of the Symbolist poem for the twentieth century.[18] Mallarmé's most celebrated remarks concerning his aims are frequently attached to it:

Nommer un objet, c'est supprimer les trois quarts de la jouissance du poème qui est faite du bonheur de deviner peu à peu; le suggérer, voilà le rêve. C'est le parfait usage de ce mystère qui constitue le symbole: évoquer petit à petit un objet pour montrer un état d'âme.[19]

The naming of an object suppresses three-quarters of the pleasure of a poem, which consists in the happiness of guessing bit by bit; suggesting the object— that makes for the dream. It is the perfect practice of this mysterious process which constitutes the symbol; in the evocation little by little of an object, in order to make manifest a state of soul.

The ambiguous reflexivity of this connection, between the 'jouis-sance' ('pleasure' or 'coming') of the act of writing and that of sexual possession, is slyly intimated in the very first sentence of *L'Après-midi*, by the punning on 'perpétuer' in the priapic (but virgin) Faun's opening words:

Ces nymphes, je les veux perpétuer.

These nymphs, I desire to perpetuate.

His mythical origin is as sophisticated as the pastoral tradition which perpetuates *him*, but he is also to be seen here as 'primitive' in his sexual impulses. The 'incarnat leger' ('light rosy flesh') he observes and creates for us in the poem of this 'heure fauve' ('tawny hour') may be no more than a dream—('Aimai-je un rêve?'—'Did I love a dream?')—and this leads to a glancing admission of the wish-fulfilling function of the whole dream poem, as the Faun plays upon the bodily and the verbal aspects of the 'figure' and 'sens' that he expresses. He splits his identity: he is both priapic agent and poetic observer:

. ou si les femmes dont tu gloses
Figurent un souhait de tes sens fabuleux.

Or if the women of whom you tell
Represent the wish of your fabulous senses.

(Or, in an alternative interpretation, 'are the metaphor for the wish that arises from the fabulous senses in which your poem can be read'.)

As he contemplates the two nymphs (one chaste, one passionate), he spins out many such analogies, between dream, the music he plays, desire, sexual satisfaction (succeeded by a 'lasse pâmoison'—'lazy swoon'), art, and instinct. He moves from the 'crime' of attempted rape to the disappointment of finding himself 'encore ivre' ('still drunk'), as the nymphs slip out of his arms.[20] The breath by which the Faun plays his flute is the 'serein souffle artificiel | De l'inspiration' ('serene and artificial breath of inspiration'), and also the instrument of sexual exploration:

> Inerte, tout brûle dans l'heure fauve
> Sans marquer par quel art ensemble détala
> Trop d'hymen souhaité de qui cherche le *la*:
> Alors m'éveillerai-je à la ferveur première,
> Droit et seul . . .

Inert, everything burns in the tawny hour wihout indicating by what art there ran off together the excess of hymen wished for by him who seeks A natural: then I will awake, to the first fervour, upright and alone.

Although the Faun comes to identify his desire with the laws of (human?) nature, that desire can never be satisfied, as its object slips away from him:

> Tu sais, ma passion, que, pourpre et déjà mûre,
> Chaque grenade éclate et d'abeilles murmure;
> Et notre sang, épris de qui le va saisir,
> Coule pour tout l'essaim éternel du désir.

You know, my passion, that every pomegranate bursts and murmurs with bees; and our blood, taken by [enamoured of] that which will seize it, flows for all the eternal swarm of desire.

Mallarmé's poetry is immensely important for later developments in the treatment of metaphor. It may be Symbolist and regressive in its aestheticism, but it is also startlingly modern in the way in which its imagery suggests a division, not just between the primitive and the civilized, but also within the Faun's consciousness, so as to license a disreputably suggestive subtext: psychoanalytic ideas are being anticipated here.[21] The Symbolism of Mallarmé, Strindberg, Yeats, and many others was also driven by the yearning to discover a hidden (but, obviously, occult and non-consensual) universe of analogy, and this

is a symptom, as Yeats for one admitted, of a lingering need for quasi-theological explanations of existence in an increasingly sceptical age.[22]

A version of this late nineteenth-century poetic affects all the arts in the Modernist period, not least because it was the poets who had most forcefully developed a language for their art which put into question its conventional, everyday, 'Realist' types of justification. George Steiner points to this, in arguing that, before Hölderlin and Rimbaud and Mallarmé, both poetry and prose 'were in organic accord with language'. Poetry was thought of as extending rather than challenging the language of prose, so that 'Violent, idiosyncratic as it may be, the [poetic] statement is made from inside the transcendent generality of common speech. A classic literacy is defined by this "housedness" in language, by the assumption that, used with requisite penetration and suppleness, available words and grammar will do the job.'[23]

Quite different assumptions lie behind works like Rimbaud's *Une saison en enfer* (written in 1873 but not generally known until publication by Verlaine in 1891) and *Les Illuminations* (written by 1874, and published by Verlaine in 1886) in which this everyday rationality, with its carrying conventions of language and plot, is overthrown. This is most explicit perhaps in the section 'Délires II—alchimie du verbe' ('Ravings II—Alchemy of the Word') of *Une saison en enfer.*

La veillerie poétique avait une bonne part dans mon alchimie du verbe.

Je m'habituai à l'hallucination simple: je voyais très franchement une mosquée à la place d'une usine, une école de tambours faite par des anges, des calèches sur les routes du ciel, un salon au fond d'un lac; les monstres, les mystères; un titre de vaudeville dressait des épouvantes devant moi.

Puis j'expliquai mes sophismes magiques avec l'hallucination des mots!

Je finis par trouver sacré le désordre de mon esprit.[24]

The old rubbish/archaisms of poetry played a large part in my alchemy of the word. I habituated myself to pure hallucination: I saw quite clearly, a mosque instead of a factory, a school of drummers consisting of angels, open carriages on the roads of heaven, a drawing-room at the bottom of a lake; monsters, mysteries; a music-hall title could call up horrors before me. Then I explained my magical sophisms by means of the hallucination of words! I ended by finding the disorder of my mind sacred.

This equation, between the 'alchemy of the word' (or the brush stroke) and a revelatory disorder of the mind, has a long life in twentieth-century avant-garde art.[25] It helped to give rise to a 'new programme for language and for literature' whose 'subversions of linearity, of the logic

of time and of cause so far as they are mirrored in grammar . . . are far more than a poetic strategy. They embody a revolt of literature against language.'[26] When the language of literature abandons the continuative binding conventions of syntax and logic, it is the reader who is left to fill in the gaps it so artfully leaves, with a form of psychological divination. From *Une saison en enfer* to *The Waste Land* (1922) we are challenged to reconstruct a state of mind from fragmentary evidence.

This slippery, metaphorical characterization of language, and its equivocation between observation and wish-fulfilling dream, also put in doubt that grip of language on the external world which was presupposed by Naturalism and Realism. Nietzsche had anticipated such a development in his 'On truth and lying in an extra-moral sense' of 1873:

[The investigator's] procedure is to hold man up as the measure of all things, but his point of departure is the error of believing that he has these things before him as pure objects. He thus forgets that the original intuitive metaphors [sc. of the language he has inherited for use] *are* indeed metaphors and takes them for the things themselves.[27]

There was a growing conviction that *any* natural language may be inherently misleading, and the philosophical questioning of its role descends from Nietzsche to Fritz Mauthner's *Beitrage zu einer Kritik der Sprache* (1901–3). Mauthner defines philosophy as a theory of knowledge, which is to be seen as 'Sprachkritik'. But this 'critique of language' is a 'labour on behalf of the liberating thought, that men can never succeed in getting beyond a metaphorical description [bildliche Darstellung] of the world, by the use of every day or philosophical language'.[28] This notion of a language as a 'bildliche Darstellung' has its most rigorous philosophical analysis in Wittgenstein's *Tractatus Logico-Philosophicus* of 1922, but Mauthner's main contention, that language is merely conventional like a game, did not commend itself to Wittgenstein until he had rejected this earlier work.

This crisis concerning the role of language in representation has a classic expression by a literary person in Hugo von Hofmannsthal's 'Letter of Lord Chandos' of 1902, which expresses the feeling, through the persona of Francis Bacon, that language can fail the writer, so that words lose all coherence for him: 'Es ist mir völlig die Fähigkeit abhanden gekommen, über irgend etwas zusammenhängend zu denken oder zu sprechen' ('I have completely lost the ability to think or speak of anything coherently'). Abstract terms like 'Geist' and 'Körper' ('mind' and 'body') have lost their meaning for him—they crumble in

his mouth like 'modrige Pilze' ('muddy mushrooms'), as things fall apart: 'Es zerfiel mir alles in Teile, die Teile wieder in Teile, und nichts mehr ließ sich mit einem Begriff umspannen' ('Everything broke down into its parts, those parts into other parts, and nothing any longer allowed itself to be embraced by a single concept'). When the unifying idea fails, words lose themselves in a 'Vortex'. Chandos feels that he will have to rely in future on the 'Sprache, in welcher die stummen Dinge zu mir sprechen' ('the speech in which dumb things speak to me') and renounce the writing of any book, in English or Latin.[29] Of course Hofmannsthal's later career shows no such renunciation, and the attempt to turn to things in the world, as if they were not at least partly dependent on our linguistic discrimination of them, is impossible (much though it inspired poets in this period). But Hofmannsthal's 'case' shows once more that, when the artist's confidence in public language is shattered, the alternative may well be the subjective, epiphanic approach to the external object which we find in much Modernist writing.

This combination, of a generalized scepticism driven to an interest in psychological suggestivity, seems to have made many experimental writers follow poetry rather than prose and thus give up the attempt to articulate a causally coherent world. As they lose confidence in the power of ordinary syntax to articulate causal processes, they believe less and less in the project of representing the world through the narrative of historical development. The writer's language becomes more and more elliptical, and turns to juxtaposition and the alogical, to the simultaneous and the collaged.[30]

These technical developments, about which we shall have a great deal to say in what follows, are to be found in all the arts, and I think of the artist's acquisition of such a 'language' as a means towards the development and mastery of a style. This application of the concept of language to the non-verbal arts seems to be justified, in so far as the painter and musician also become competent in a style for their arts, very much as one may become competent in a natural language, in mastering the poetic or painterly or harmonic conventions of a particular past period or style. Many critics think of 'technique' as intersubstitutable with 'style'. But I prefer to speak of them as independent from one another, because the individual artist learns technique, whereas an already acceptable style may be 'found'. The mastery of any style presupposes the acquisition of *some* technique, even when the style is merely being imitated, and so I see technique as the ability to control the elements of

an artistic language, in the process of creating a style. This process of style creation, in the absence of previously accepted consensual languages, was felt to be as radical in music and painting as in poetry, as we can see if we look briefly at the technical innovations of two other Frenchmen whose influence on their arts was as great as Mallarmé's on his—Debussy and Cézanne.

In Debussy's *Prélude à l'après-midi d'un faune*, which evokes its hero's languid shifts of erotic mood, there is 'for the first time in music . . . no thematic development, no thread of a logical discourse, but instead a purely sensuous flow of harmony and a new elusive poetry of instrumental timbre, a continuous process of transformation, fragmentation and regeneration of harmonic and melodic particles'.[31] This assessment by Christopher Palmer points to just such technical changes as I indicated above—the renunciation of thematic development, and a purely sensuous flow of harmony, which made for a new, fragmentary, and unstable language for music. Like Mallarmé's poetry it sacrifices plot for mood, and lacks the (conventional) harmonic thread of logical discourse. All this, taken with the other elements Palmer mentions—the poetry of instrumental timbre, fragmentation, and regeneration— amount to a distinct 'Impressionist' style, which is peculiarly sensitive to minute shifts of feeling, and so part of an innovatory reaction against the ossified formal prescriptions of the past. Work like this by Debussy helped to recast the hierarchy of genres for the Modernist period, as he and his successors evolved mixed, impressionist forms, which broke down the by then merely 'academic' procedures of accepted art. Debussy thought that the kind of symphony which slavishly followed established conventions was, by 1901, simply ridiculous:

The first part consists of the usual presentation of the theme : the foundation on which the composer is going to build. Then comes the obligatory breakdown. The second part is rather a laboratory devoted to the study of vacuums. The third unwinds with characteristic Breton gaiety, interspersed with strongly sentimental sections. . . . the demolition continues, much to the delight of the connoisseurs, who visibly mop their brows while the public yells for the composer.[32]

His own *La Mer* (1905) is a twentieth-century symphony of a very different kind. So original indeed, that when Debussy performed the work in London in 1908 with the Queen's Hall Orchestra, the critic of the *The Times* was of the opinion that

A new form of analytic programme note will have to be written for this kind of music, in which the examples shall deal purely with the visual aspect of the

themes, for the illustrations in notes are likely to direct the attention from what is certainly the intention of the composer, in that the listener strains to identify this or that theme as he would in a classical symphony and as a result the rhythmic movement of the thing escapes him.[33]

Even Constant Lambert thought as late as 1930 that although Debussy had 'put an end to the somewhat mechanised eloquence into which the German Romantics had degenerated', the sounds in *La Mer* succeeded one another 'with the arbitrary caprice of nature itself', and without any definite continuity or contrast.[34]

Easily recognizable melody and its (classical) development seems thus to have been subtracted from the language of this work. Its audience had the familiar avant-gardist experience, of being robbed of a familiar discursive logic, and forced to look in its absence for no more than an emotional coherence: no wonder *La Mer* then seemed to be fragmentary, arbitrary, and hence hopelessly subjective (like the work of Debussy's mentor, Mallarmé). Such structural guiding elements nevertheless tend to 'reappear' once the lapse of time has helped us to adjust our perception, rather as we can now see the Impressionists as representing the world—at the right distance. *La Mer* now seems to us to be wonderfully melodious and coherent: there *was* a traditional value there all the time.

Cézanne similarly produced paintings at the turn of the century which enforced an awareness in the viewer of a new kind of interrelationship between their elements, an awareness indeed of the language of the work. If we look, for example, at one of a series of still-life paintings which show a flower-decorated pitcher and a curtain with leaves, the *Apples and Oranges* of *c*.1899, we can see that one of the dishes of fruit looks as though it is about to slip forward out of the frame, and the table slopes exaggeratedly to the left, so that the perspective of this side of the table is not 'true'. The viewpoint on the objects is simply not consistent; it is as if the artist had moved about. Contemporary appraisals of Cézanne's tipped-forward tables, twisted jugs, and flattened oranges led to the accusation that his vision was literally defective, or alternatively that he was technically incompetent. Huysmans wrote of him in 1889 as 'an artist with diseased retinas ['aux retines maladives'] who in the overwrought apperception of his eyesight discovered the foretokens of a new art'.[35]

Largely as a consequence of the development of a new aesthetic in the early Modernist period, we can now appreciate that Cézanne's distortion of detail is made for the sake of the overall design of the

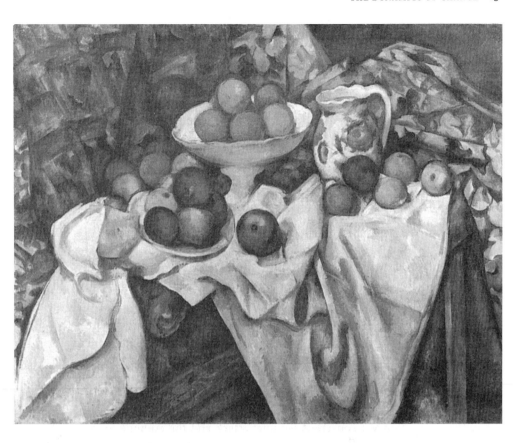

1. Paul Cézanne, *Apples and Oranges*, c.1899.

image. Émile Bernard had recognized, in 1904, this feature of his work, and how far it had taken him beyond Impressionism, in the

raising of form towards a decorative conception and of colour towards the most musical pitch. So that as the artist works on, the further he gets from objectivity, from the opacity of the model he started from, and the deeper he goes into sheer painting for its own sake; the more he abstracts his picture, the more broadly he simplifies it, after a narrow, conforming, hesitant commencement.[36]

This is prophetic of many later thoughts about abstraction, and also of the notion that work like this may be seen as a record of the different positions from which a given object could be studied (a realization which influenced the reception of Cubism, as we shall see). By the turn of the century there were critics who were 'at least aware that Cézanne's apples were more significant as analogues of a new mode of vision than as descriptions of botanical events', and so demanded an anti-illusionist concentration on the design of the canvas as a flat surface.[37]

This comparatively austere response was facilitated, once Cézanne's importance had been established, by the realization that his paintings may be appreciated in series (there are three other paintings of the pitcher and curtain), and hence, like much of the later work of Monet, as intriguing the spectator by displaying the development of their own method. Relativism is built into this practice, and it is another affront to realism, because we can see that no *one* version can claim to be adequate to the complexity of the objects it purports to represent. Such differences also make us aware of the expressive 'distortions' brought about by the painter's processes of composition. And yet each canvas has a valid claim to being 'true to the subject'. One of the lessons of Modernism is going to be that different aspects of a changing experience may have an equal claim on us, in perception and in art.

I shall show in the following chapters how the Modernists sustained this examination of what hitherto had seemed to be 'natural' conventions. Music will abandon what might have seemed the naturally consonant language of tonality, the Cubists will subvert the naturalist methods of Renaissance perspective, and the alogical free associations of Apollinaire, Cendrars, Benn, Hoddis, Stramm, and others will challenge the language of rational (and social) order.

3. Technique and Idea

When consensus is under attack and the authority of the individual artist is affirmed, the way is laid open for Protestant stylistic contortions, which express a subjectively validated vision. It is this emphasis on individual style which leads to a common feature in all the works which I see as canonical for Modernism—their experimentalism of technique. In concentrating on technical change as a guiding thread through this period, I do not imply that the Modernists were devoted to the production of an art primarily concerned with its own procedures. This formalist view of Modernism has been dominant for too long (particularly for painting), and it is the feature most often read into it from a Postmodern point of view, which attempts to define the Modernist strain by exclusive reference to one or other of those elements in the language of art which it subjected to examination. A notorious example of this is Clement Greenberg's promotion of 'flatness' as a defining characteristic of authentic Modernist (and hence of post-1945) painting. He argues that Modernism is to be identified with Kantian self-criticism, in that 'the essence of Modernism lies . . . in the use of the characteristic

methods of a discipline to criticise the discipline itself'. Whereas Realism dissembled art, Modernist art calls attention to itself—as did Cézanne in accommodating his drawing and design to the rectangular shape of the canvas:

> It was the stressing, however, of the ineluctable flatness of the support that remained most fundamental in the processes by which pictorial art criticised and defined itself under Modernism. Flatness alone was unique and exclusive to that art.[38]

Greenberg has grasped only half of the antithesis with which I am concerned. His emphasis on the language of art (and its reflexivity) is surely correct, but it leads to yet another account of Modernism, which makes it seem that its concerns were predominantly aesthetic ones.

I wish on the contrary to ask throughout how such changes in technique were motivated, and what they were *for*; how, to echo Schoenberg, 'style' is related to significant changes in 'idea'. Technique functions in my account not as the provider of aesthetic absolutes, but as the focus for stylistic metamorphoses, which are mediated by a new idea, a shift in an artist's conceptual scheme, that may be revolutionary. I believe that the artist is sustained in making formal discoveries by the expectation that they may be significant in relation to a particular content.

We can appreciate this point I think if we complete this brief review of some of the influences of the late nineteenth century upon Modernism by looking at free verse. We can see that its scansional differences (from the alexandrine and other previously dominant forms) display an extraordinary virtuosity. But Clive Scott, in analysing such procedures, shows that free verse was at the time thought to be able to 'express, organically, the uneven life of the poet's physiology and psyche, in a way that regular verse could not . . . If free verse is pervaded by temporal flow, by historicity, it is also subject to shifts in attitude and approach. Each verse line is a new lens for experience, the temporary installation of a new mentality.' This approach supported the defence of free verse as 'the direct rhythmic embodiment of the poet's deepest and most authentic self'.[39] As Marie Dauguet told Marinetti in 1909: 'Il est la forme même du moi intérieur emancipé' ('It is the very form of the emancipated inner self').[40] The preface to the anthology *Some Imagist Poets* proclaimed as late as 1915 that:

> We do not insist upon 'free verse' as the only method of writing poetry. We fight for it as a principle of liberty. We believe that the individuality of a poet may often

be better expressed in free verse than in conventional forms. In poetry, a new cadence means a new idea.[41]

It is this shift towards the defence of particular ideas about subjectivity that motivates artistic change. What makes a work of art Modernist is not just the loyalty of its maker to the aesthetic of an evolutionary or disruptive tradition (though that is very important) but its participation in the migration of innovatory techniques *and* their associated ideas. In this period, concepts like 'intuition' and 'expression', or 'subjectivity' and 'inner division', or 'harmony' and 'rhythm', are parts of a changing framework of ideas which inspired stylistic change in Modernist work in all the arts. Such developments arise as part of a conversation among artists (and the critics associated with them) which has a number of terms in common, and which modifies the conventions by which they address, conspire with, or provoke their audiences.[42] An abstract painting, an atonal piano study, or a Dada object like Duchamp's *Urinal*, which is aimed at subverting the institutions through which art itself is displayed, bewilder their audiences, because their innovations have left behind those modes of discourse that were previously common to the consumer and the work. For the result of the challenging discovery is often enough a change in the function of the work of art, and this often brings the artist (and his critic-supporters) into an adversarial relationship to an audience. Innovatory techniques can even call into question the viewer's, hearer's, or reader's very sense of their own identity, and that is another reason why I shall also relate technical innovations to changing concepts of the self in the early Modernist period.

Two brief examples may help to clarify some of the considerations raised above, and introduce some of the themes of later chapters. If we consider a work like Gustave Moreau's *Salomé* (1876) we find that it carries the burden of an interpretative 'idea' which has to be mediated to its audience by literature. This, to say the least, supplements the biblical account (Mark 6: 21–9). From it we can learn that Salome carries a lotus flower, symbolizing sensual pleasure, and wears a bracelet with the magical ligat, the representation of an eye. The black panther opposite her symbolizes lust, as does the peacock feather fan held by Herodias. Above Herod we can see a statue of the many-breasted Diana of Ephesus, symbolizing fecundity, and on either side a statue of Ahriman, Persian god of Evil. On the far left there is a picture of a sphinx with a male victim in its claws.[43] All these props serve to give Salome a

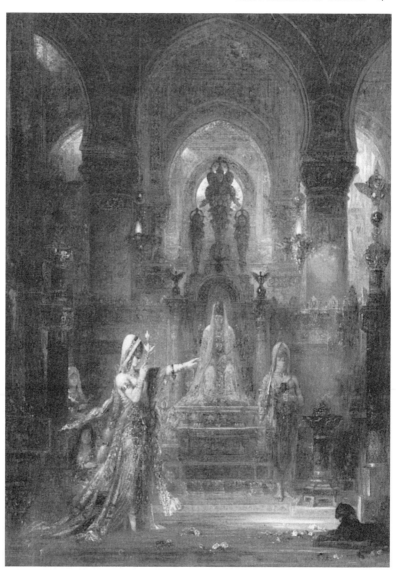

2. Gustave Moreau,
Salomé, 1876.

mythological aura of evil and sexual threat; hence the psychological
responses to the painting in Huysman's novel, *À Rebours* (*Against
Nature*) of 1884:

she was no longer just the dancing girl who extorts a cry of lust and lechery from
an old man by the lascivious movement of her loins; who saps the morale and
breaks the will of a king with the heaving of her breasts, the twitching of her belly,
the quivering of her thighs. She had become, as it were, the symbolic incarnation

of undying Lust, the Goddess of Immortal Hysteria, the accursed Beauty exalted above all other beauties by the catalepsy that hardens her flesh and steels her muscles, the monstrous Beast, indifferent, irresponsible, poisoning, like the Helen of ancient myth, everything that approaches her, everything that sees her, everything that she touches.[44]

The painting is 'read' in the light of literary presuppositions, which authenticate its repertorial detail, and then use it as the displaced stimulus to an erotic response. This has a good deal to do with the late nineteenth-century obsession with the figure of the threatening woman. Moreau's painting not only mediates the transition from Symbolism to decadence, but also leads directly enough to the extravaganza of Richard Strauss's opera *Salome,* on a text from Oscar Wilde, performed in 1905.

3 In Braque's *Grand Nu* of 1908, on the other hand, the symbolic and the erotic are deliberately withdrawn, as Braque himself points out, in a passage which stresses formal considerations of the kind demanded by Cézanne:

I couldn't portray a woman in her natural loveliness . . . I haven't the skill. No one has. I must, therefore, create a new sort of thing, the beauty that appears to me in terms of volume, of line, of weight, and through that beauty interpret my subjective impression. Nature is a mere pretext for decorative composition, plus sentiment. It suggests emotion, and translates that emotion into art. I want to express the Absolute, and not merely the factitious woman.[45]

This brings together a number of our themes—of technique ('volume . . . line [and] weight'), of subjectivity in expression ('through that beauty interpret my subjective impression'), and the refusal of Realism (in looking for the 'Absolute' rather than the 'factitious woman'). In doing so it recapitulates some of the profound changes since Moreau's time in the framework of ideas thought appropriate to the representation of the naked female body. By 1908 the erotic functions of the naked within painting are being subverted (and indeed many of the older conventions could be left to conservative Realist painting and the photograph).

Braque's remarks are also important for the way in which they ask the viewer to respond to his technical concerns. Talk of this kind becomes dominant within early Modernism, and it contributes a great deal to its élitist and hermetic character. The avant-gardist strategy of binding the audience as interpreter to the innovatory work of art by means of *critical* ideas grows—much aided by a proliferation of the specialized journals inherited from the Symbolist movement.

3. Georges Braque, *Grand Nu* (*Standing Female Nude*), 1908.

As a Modernist aesthetic becomes dominant in intellectual circles, a loyalty to it could be indicated, not just by a technical appreciation, but by seeing the work in the light of a significant idea. Modernist art was produced for an audience capable of decoding this relationship between stylistic medium and message. This alliance of art with an interpreter leads inexorably to the theory-dominated abstract and conceptualist art of Postmodernism. The Modernist artist begins to take advantage of the idea that the perception of art should be accompanied

by an awareness of the right kind of theory, and the avant-gardist critic becomes more and more hungry for technical innovations which he can explain. The growing emphasis on innovation in the first two decades of the century becomes a prime means for the disruption of the very idea that the arts should have a socially agreed reflective content.

Bibliographical Note

On the technological and scientific changes of this period in relation to artistic activity, cf. Stephen Kern, *The Culture of Time and Space, 1880–1918* (London, 1983), *passim*. The contrast between artistic movements is also a matter of generational change, on which see e.g. Carl F. Schorske, *Fin de Siècle Vienna* (Cambridge, 1981), esp. 214 ff., on the Secession and 'Ver Sacrum', and Robert Kohl, *The Generation of 1914* (London, 1980). The continuing influence of Modernist values is discussed in Suzi Gablik's *Has Modernism Failed?* (London, 1984). For a contrary account of distinctively Postmodernist concerns, cf. Christopher Butler, *After the Wake: An Essay on the Contemporary Avant-Garde* (Oxford, 1980), and Hans Bertens, 'The Postmodernist Weltanschauung', in Douwe Fokkema and Hans Bertens (eds.), *Approaching Postmodernism* (Amsterdam, 1986), 9–51, with bibliography. The terms 'modern', 'avant-garde', and 'modernité' can also be used to cover a wide range of post-1880 phenomena, including economic and bureaucratic modernization, and the Marxist critique of Modernist art privileges this social context. Cf. e.g. Eugene Lunn, *Marxism and Modernism* (London, 1985), and Marshall Berman, *All That Is Solid Melts Into Air* (London, 1983). The events of the First World War are outside the scope of this volume; for an anthology of the literary work of those on all sides who died, see Ian Cross (ed.), *Lost Voices of World War One* (London, 1988).

On the turn towards Modernism, and critical attitudes to the novel in England, see Peter Keating, *The Haunted Study: A Social History of the English Novel, 1880–1914* (London, 1989). On Bohemia, cf. e.g. H. Kreuzer, *Die Boheme* (Stuttgart, 1971); Jerrold Siegel, *Bohemian Paris, 1830–1930* (London, 1986); and, for painters in one city, John Milner, *The Studios of Paris in the Later Nineteenth Century* (New Haven, Conn., 1988). Matthew Arnold was also one of the first to define the Modern self as divided (cf. Ch. 3 below), and, for a general study of this theme in nineteenth-century English culture, cf. M. Miyoshi, *The Divided Self* (New York, 1969). Alexander Nehemas's 'Untruth as a Condition of Life', ch. 2 of his *Nietzsche: Life as Literature* (Cambridge, Mass., 1985), 42–73, is a sympathetic study of Nietzsche's scepticism. General studies of Nietzsche's influence include J. B. Foster, *Heirs to Dionysus: A Nietzschean Current in Literary Modernism* (Princeton, NJ, 1981); R. Hinton Thomas, *Nietzsche in German Politics and Society, 1890–1918* (Manchester, 1983); P. Bridgwater, *Nietzsche in Anglosaxony* (Leicester, 1972); and D. S. Thatcher, *Nietzsche in England, 1890–1914* (Toronto, 1970). There

are many studies of his influence upon individual writers. For Sacks as a Nietzschean unbeliever, see Karl Eibl, *Die Sprachskepis im Werk Gustav Sacks* (Munich, 1970). On the transition from Symbolism to Modernism cf. Michel Décaudin, *La Crise des valeurs symbolistes* (Toulouse, 1960; repr. Geneva, 1981), and Lawrence M. Porter, *The Crisis of French Symbolism* (Ithaca, NY, 1990). For the history of Diaghilev's ballet company, not least in relationship to Modernism, see Lynn Garafola, *Diaghilev and the Ballets Russes* (Oxford, 1989). The irrationalist tradition in poetry is analysed in Marjorie Perloff, *The Poetics of Indeterminacy: from Rimbaud to Cage* (Princeton, NJ, 1981). Richard Wollheim in *Painting as an Art* (London, 1987), 23–36, agrees with me that having a style is like knowing a language; and the analysis of music in terms of a language is common, as in e.g. Leonard Meyer, *Music, the Arts and Ideas* (Chicago, 1956). There are well-known problems in taking language as a model for non-verbal activities, and in seeing all the arts as expressed in languages. One has to be aware of points of disanalogy. I do not believe that any purely linguistic model for the arts is possible; though cf. Nelson Goodman, *Languages of Art* (Oxford, 1969), 177–224. For the background to Debussy's early work, see S. Jarocinski, *Debussy, Impressionism and Symbolism* (London 1976). George Heard Hamilton's 'Cézanne and his Critics', in W. Rubin (ed.), *Cézanne: The Late Work* (London, 1977), 139–50, gives a more circumstantial account of Huysman's judgement, 140 f. As he records, Cézanne was also perceived as 'childish', 'impulsive', 'gauche', 'naïve', and 'primitive' (both as fault and as virtue in terms of sincerity). Richard Shiff, *Cézanne and the End of Impressionism* (Chicago, 1984), discusses shocked reactions to Cézanne's lack of perspective, its relationship to Primitivism and to the atmospheric effects of Impressionism (esp. 169–75). On Monet and the series, cf. John House, *Monet, Nature into Art* (New Haven, Conn., 1986), ch. 12, 'The Evolution of Monet's Series', 193–204, and Paul Hayes Tucker, *Monet in the Nineties: The Series Paintings* (New Haven, Conn., 1990). For the Postmodern obsession with self-consciousness and reflexivity, see e.g. Hilary Lawson, *Reflexivity: The Postmodern Predicament* (London, 1985), and Linda Hutcheon, *A Poetics of Postmodernism* (London, 1988). The theme of the threatening woman recurs in the transition from the *fin de siècle* to the Modernist period. See e.g. Bram Djikstra, *Idols of Perversity: Fantasies of Feminine Evil in Fin de Siècle Culture* (Oxford, 1986), for a wide-ranging study of the iconography of this tendency. (He discusses Salome, 380–401.)

Notes

[1] Malcom Bradbury, 'Modernisms/Postmodernisms', in Ihab and Sally Hassan, (eds.), *Innovation/Renovation* (Madison, Wis., 1983), 322.
[2] This general attitude to painting underlies the theory promoted by Norman Bryson, for example, in his 'Semiology and Visual Interpretation', in N. Bryson *et al.* (eds.), *Visual Theory* (Oxford, 1991), 61–73.

3 Friedrich Nietzsche, *The Will to Power*, trans. W. Kauffmann and H. J. Hollingdale (New York, 1968), 409.

4 Peter Gay, *Freud* (London, 1988), p. xv, and citing Freud's 'Autobiographical Study' on 27.

5 Matthew Arnold, 'Heinrich Heine' (1863), repr. in *Lectures and Essays in Criticism*, ed. R. H. Super (Ann Arbor, Mich., 1962), 109.

6 Richard Ellmann (ed.), *The Artist as Critic: Critical Writings of Oscar Wilde* (London, 1970), 382. Wilde goes on to argue that through the critical spirit 'we shall be able . . . to make ourselves absolutely modern' (ibid.).

7 Thomas Mann, *Tonio Kröger*, trans. H. T. Lowe-Porter (Harmondsworth, 1955), 153 f.

8 James Joyce, *Stephen Hero* (London, 1956), 184, 190, 96.

9 Cf. Michael Fels, 'Die Moderne' (1891): 'Es ist unzweifelhaft richtig, daß etwas vom Geiste Ibsens, der von sich sagen konnte "Zu fragen ist mein Amt, nicht zu antworten", in diesem ganzen jungern Geschlechte lebt.' ('It is undoubtedly correct, that something of the spirit of Ibsen, who could say of himself "It's my job to ask questions, not to give answers", lives in the whole of this younger generation.') See *Die Wiener Moderne: Literatur, Kunst und Musik zwischen 1890 und 1910* (Stuttgart, 1981), 191.

10 Wassily Kandinsky, *Concerning the Spiritual in Art*, trans. M. T. H. Sadler (London, 1914; repr. New York, 1977), 14. I have chosen to cite this work from an English translation contemporary with early Modernism. The standard scholarly translation of Kandinsky's prose is *Kandinsky: Complete Writings on Art*, ed. Kenneth C. Lindsay and Peter Vergo, 2 vols. (Boston, 1982).

11 Cf. Richard Ellmann, *James Joyce* (Oxford, 1982), 142.

12 Hence, for example, the travesty and parody of religious language in poems like Georg Heym's 'Infernalische Abendsmahl' and Alfred Lichtenstein's 'Die fünf Marienlieder des Kuno Kohn' (also influenced by the satanic verse of Baudelaire). Cf. also Gustav Sack's poem 'Gott', 'Aus Furcht geboren und vom Wunsch verschönt' ('Born of fear and beautified by the wish'), of which the last two stanzas run :

> Oh Ding an sich! Oh Wahrheit! Letzter Grund!
> Nun stirbst du — dennoch fachte dieses Wort
> all unsrer Sehnsucht Narrenschmerzen und
>
> Gelüste an und unsre Welt verdorrt
> noch in den Dünsten, die dein toter Mund
> aushaucht, zu einem runden Narrenort.
>
> Oh thing-in-itself! Oh Truth! Last Ground!
> Now you're dying — even so the very word
> [God] arouses all the foolish pains of our desire and longing
> as our world withers away

now in the haze your dying mouth
exhales, to become a simple sphere for fools.

These poems are to be found in Silvio Vetta's anthology, *Lyrik des Expressionismus* (Tübingen, 1985), 161, 164, and 158.

13 Freud's own words as reported by Gay, *Freud*, 105.

14 René Ghil in 1923, cited in Roger Gibson, *Modern French Poets on Poetry* (Cambridge, 1961), 157.

15 Stéphane Mallarmé, 'Préface' to *Un coup de dés*, in Henri Mondor and G. Jean-Aubry (eds.), *Œuvres complètes* (Paris, 1945), 455.

16 Stéphane Mallarmé, 'Le Mystère dans les lettres', ibid. 386.

17 Arthur Symons, *The Symbolist Movement in Literature* (London, 1899), 108.

18 It was composed in various versions from 1865 (see Mondor and Jean-Aubry (eds.), *Oeuvres complètes*, 1448–67), published in 195 copies in 1876, illustrated by Manet, mentioned in Huysman's *À rebours* in 1884, and published in 1887 in the *Revue indépendante*.

19 Stéphane Mallarmé, cited in A. Thibaudet, *La Poésie de Stéphane Mallarmé* (Paris, 1926), 110, cited in A. G. Lehmann, *The Symbolist Aesthetic in France, 1885–1895* (Oxford, 1968), 299.

20 Nijinsky, in Diaghilev's ballet of 1912 to Debussy's music, gave himself seven nymphs to chase after: the one whom he wants as he sees her sunbathing flees, and he 'has to console himself with the scarf she has left behind' ending with 'a stylised jerk of the pelvis'. This shocked not a few and led to an attack on the ballet by Gaston Calmette in *Figaro*, as 'filthy and bestial' in its eroticism and 'animal realism'. But Diaghilev persuaded Redon and Rodin and others to reply, and the ballet (with the pelvic jerk removed) was approved by the police on 31 May. See Richard Buckle, *Diaghilev* (London, 1979), 224, 227.

21 Many Symbolists were interested in the unconscious, as in Edouard von Hartmann's *Philosophie der Unbewußten* (Berlin, 1869).

22 Cf. W. B. Yeats, *Autobiographies* (London 1956) 115 f.

23 George Steiner, *After Babel* (Oxford, 1975), 177.

24 Arthur Rimbaud, *Œuvres complètes*, ed. A. R. de Renéville and Jules Mouquet (Paris, 1967), 234.

25 'Il s'agit d'arriver à l'inconnu par le dérèglement de *tous les sens* . . . C'est faux de dire: Je pense. On devrait dire. On me pense. Pardon du jeu de mots.' ('It's a matter of arriving at the unknown by the disordering of *all the senses* . . . It's a mistake to say: I think. One should say: I am thought. Sorry about the pun.') Letter to Georges Izambard, 13 May 1871, in *Œuvres complètes*, 268. Rimbaud may perhaps have made a profound discovery in the philosophy of mind (cf. Daniel C. Dennett, *Consciousness Explained* (London, 1991), esp. 227–52.) He also initiates a disastrous series of surrenders by spaced-out artists to their medium, in the hope that something (at least psychologically) 'significant' might emerge. The later work of William Burroughs is an example.

26 Steiner, *After Babel*, 183.

27 S. Gilman *et al.*, *Friedrich Nietzsche on Rhetoric and Language* (New York, 1989), 252. This particular text was hardly well known until its enthusiastic rediscovery by Derrida and post-structuralist critics.

28 Fritz Mauthner, *Wörterbuch der Philosophie* (Munich, 1910), p. xi, cited in Alan Janik and Stephen Toulmin, *Wittgenstein's Vienna* (New York, 1973), 122. As they point out, Mauthner is here explicitly following Locke and Hume rather than Nietzsche.

29 Hugo von Hofmannsthal, 'Ein Brief', repr. in *Die Wiener Moderne*, 436, 437, 444.

30 For a discussion of the critical issues involved in the relationship of Modernism to Realism, see Astradur Eysteinsson, *The Concept of Modernism* (Ithaca, NY, 1990), ch. 5, 179–241.

31 Christopher Palmer, *Impressionism in Music* (London, 1973), 28.

32 *Debussy on Music*, ed. F. Lesure, trans. R. L. Smith (London, 1977), 15. From the *Revue blanche* (16 Apr. 1901).

33 *The Times* (3 Feb. 1908). I owe this quotation to Stella Tillyard.

34 Constant Lambert, *Music Ho!* (1934; repr. London, 1966), 38, 42.

35 J. K. Huysmans, *Certains* (1889; 5th edn., Paris, 1904), 42 f.

36 Émile Bernard, 'Paul Cézanne', *L'Occident* (Paris, July 1904), 17–30, cited in Lionello Venturi, *Cézanne* (Geneva, 1985), 43.

37 George Heard Hamilton, *Painting and Sculpture in Europe, 1880–1940* (Harmondsworth, 1967), 157.

38 Clement Greenberg, 'Modernist Painting', *Art and Literature*, 4 (Spring 1965), 193–201, repr. in Francis Frascina and Charles Harrison (eds.), *Modern Art and Modernism* (London, 1982), 5, 6.

39 Clive Scott, *Vers Libre* (Oxford, 1990), 5, 17 f., 59.

40 F. M. Marinetti, *Enquête international sur le vers libre* (1909), 39, cited in Scott, *Vers Libre*, 170.

41 Peter Jones (ed.), *Imagist Poetry* (Harmondsworth, 1972), 135.

42 My notion of such central ideas as part of the 'conversation of mankind' in a relativist world owes a good deal to Richard Rorty. Cf. his *Philosophy and the Mirror of Nature* (Oxford, 1980), esp. 365–94. For a further discussion of avant-gardist diffusion, see Ch. 6.

43 I here follow John R. Reed, *Decadent Style* (London, 1986), 135. His sources are cited in n. 11.

44 J. K. Huysmans, *Against Nature*, trans. Robert Baldick (Harmondsworth, 1959), 65 f.

45 Georges Braque, from an interview of 1908, published in 1910, repr. in Edward F. Fry, *Cubism* (London, 1966), 53.

2 | THE DEVELOPMENT OF A MODERNIST AESTHETIC NEW LANGUAGES FOR PAINTING AND MUSIC

1. Matisse and Expression

The major Modernists have an extremely respectful relationship to tradition. None of them began their careers as confrontational or avant-garde. This innate conservatism, which only arrives at a technical breakthrough after an exploration of the past, is one of the extraordinary strengths of early Modernism. The break with previous assumptions did not depend upon sudden conversion (of a kind which was later to be the aim of the typical avant-garde manifesto), but evolved by making art which shows a startlingly detailed appreciation of previous tradition, in masterpieces which often epitomize the very forms of taste that their
4 makers were later to subvert, as, for example, in Matisse's *La Desserte* (*The Dinner Table*) of 1897. This is a beautiful Impressionist picture, whose subject, as we shall see, he later restates in a Modernist style.

Matisse also explored the Symbolist legacy and neo-Impressionist
1 technique in work leading up to his *Luxe calme et volupté* (1904–5), the result of a summer spent with Signac and Cross in St Tropez. The painting was completed for the Salon des Indépendants of 1905, at which Signac bought it. Its title (given to it after it was completed) comes from Baudelaire's 'L'Invitation au voyage':

> Là bas tout n'est qu'ordre et beauté,
> Luxe, calme et volupté

and so declares its affinity to a favourite subject of the Symbolist painters: the sexual Golden Age, a return to origins through myths opposed to that of the Garden of Eden, which attempted to display an unselfconscious, guiltless sexuality. It uses the high-keyed colour of the revolutionary Fauve paintings which were to follow it; and it inspired Raoul Dufy to repudiate 'impressionist realism', which 'lost all its charm for me as I contemplated this miracle of the [creative] imagination at play in colour and drawing. I immediately understood the new pictorial mechanics.'[1] Its technique, which synthesizes the methods and subject-

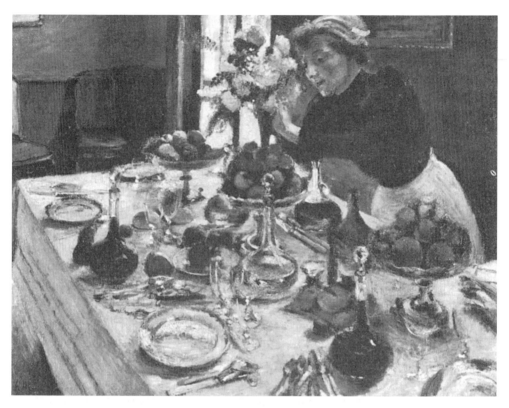

4. Henri Matisse, *La Desserte* (*The Dinner Table*), 1897.

matter of an earlier tradition, is of a kind to please its purchaser, who had in his *De Eugène Delacroix au néoimpressionisme* (1899) strongly advocated the pointillist methods of Seurat which we can see here. The standing and seated nudes also owe something to Cézanne's bathers; but the pose of the half-seated nude in the foreground goes back to Poussin's *Bacchanale* (in the Louvre), from which Matisse had copied. Very different kinds of painting come together within this canvas, with its neo-Impressionist blocks of colour, Gauguinesque figure drawing, and its composition 'as abrupt', says Hamilton, as that in Puvis de Chavannes's *Poor Fisherman*.[2] Matisse shows in an important letter to Signac that he was well aware of an unresolved tension in his painting, and its resolution led to his creation of a Fauvist style.

Did you find a perfect harmony in my *Bathers* picture between the character of the drawing and the character of the painting? To me they seem totally different from each other and even absolutely contradictory. One, the drawing, depends on linear or sculptural form, and the other, the painting, depends on coloured

forms. Result: the painting, especially because it is divisionist, destroys the drawing, which derives all of its eloquence from the outline.[3]

Luxe calme et volupté is a conservative work,[4] but its Cézannian structure and freedom from representational colour emerges strongly in the work of the summer of 1905, when Matisse worked at Collioure, a small fishing port near the Spanish border, with Derain. He had arrived there split in his allegiances—to the pointillist rationalism of Seurat, the expressive emotionalism of Van Gogh, and the more analytical approach available from Cézanne. Much of his work there, like the *Woman at the Window* and *The Siesta*, focuses our attention on the surface of the canvas, and so threatens to give primacy to its own articulation, over the attempt to see it as the record of an empirical perception. The balance between these two sorts of claim had of course been struck in many different ways before Matisse, but his work makes the conflict between the painting and the mimetic illusion central to our appreciation. It is the brush stroke which is the most immediate 'material object' to our vision, and it articulates the surface of such

II paintings and gives them energy, as in the *Woman in Japanese Robe by the Water*, which is an extreme example. Her body is devoid of outline, and we are left to contend with the varying textures of the brush strokes and the pure colour of their pigment. In this way Matisse follows Mallarmé in painting 'not the object but the effect that it produces'. But to achieve what he then wanted, Matisse had to go even further, and rearrange the conventional 'distinctions between drawing and painting, design and colour'[5] which had obstructed him in *Luxe calme et volupté*. In disrupting these formerly sacrosanct distinctions Matisse was guided by two central ideas: of individual emotional expression, and of pleasure in design.

III These radical aims are most dramatically achieved in the great *Open Window, Collioure* painted that summer. In this painting there are still Impressionist and neo-Impressionist uses of the brush stroke, as in the contrast between the areas inside and outside the window. But the scene through it does not recede to a vanishing-point, as one might expect. It advances, because the indoor colour is no darker than that of the view outside, so that the harbour scene is brought forward to the picture plane, using the window as a frame.

This central motif keeps apart the broad areas of flatter, complementary colour in the room; these colours are very intense, side by side yet apart, with a navy blue transom above which is an 'abrupt arbitrary

seeming dark accent'[6] giving radiance to the other colours. These juxta-positions, like the red, blue, white, and orange at the right of the window, signal a play with pure colour, and it is consistent with this that the squiggly separate brush strokes of the harbour scene do not harmonize into an overall sensation of light, as in Monet. That kind of Impressionist atmosphere is no more than an echo from the past, as Matisse experiments with the use of pure high-keyed oil paint. This is a central characteristic of the Fauvist style: 'we rejected imitative colours, and with pure colours we obtained stronger reactions—more striking simultaneous reactions.'[7] Matisse uses the word 'simultaneous' here for a very important reason. It is essential to the justificatory idea behind his experiments, because he thinks of the effect of his colours as musical—so that he can create a chordal effect, by getting them to work together on the surface of the painting. Their range of harmonies can be quite independent of any need to be plausibly representative of an object. This analogy, between colour play and the invention of new chords within the language of music, is central to Matisse's concerns, and it frequently occurs in the discussion of advanced painting in this period.

The *Open Window* also has an immensely complex spatial structure; its sketchy, spontaneous drawing interacts marvellously with the basic stability of rectangular forms which are nearly abstract, set off by the plants and the swaying boats. It implies the time to look, in a purely domestic context, and seems to be something we could all see. We might say that this painting, rather symbolically interpreted as a symptom of early Modernism, challenges the viewer by deliberately failing to carry through the conventional techniques of the *contre-jour* by leading us through the window to a scene beyond, and instead makes its ambiguously interpretable frame the centre of attention. There is a formal self-consciousness here which has profound consequences for later painting.

Similarly radical implications derive from Matisse's portrait paint-ings, whose anti-realism was even more of an affront to contemporary *IV* viewers. The *Portrait of Mme Matisse* (1905) (also known as *The Green Line*) became notorious for its loud line of green, punctuating the nose, and for its startling juxtaposition of colours. The orange to the left comes forward while the green to the right recedes, so that an artificial depth is created, and each side of the head seems to be set in a different spatial perspective. The background is violet to vermilion on the left, on the right it is green, and so approximately complementary to the colours

of the cheeks. This treatment of the face takes apart its elements, and so subverts and foregrounds the usual grammar of representation. Its threat to conventional notions is more disturbing than a similarly constituted treatment of landscape or still life would be, because our human identity is involved. We can see how this may be if we ask some naïve questions, which might well have seemed sensible enough in 1905. Why is there red in the hairline? Why is there a green stripe up the forehead? Why is the face half pink and half yellow, without a plausible modulation between the two which will signify a shadow?[8] Other features are even more baffling: why does she have a green eyelid and a red eyelid? Is there a twisting to the right of the lower neck, or is she wearing some kind of garment we cannot fully interpret? What is the motivation for the 'Japanese' effect in the representation of a woman we presume to be French? There is also a deliberate confusion here as to scale and genre, for what may be acceptable as a shorthand convention in a drawing will be far less so when it is executed in oils as a Salon 'portrait'. There is a deliberate lack of depth, and a Van Goghian use of expressive colour, but without his intense psychological involvement. *The Green Line* therefore contrasts with the much more carefully three-dimensional *Femme au chapeau* (*Woman in a Hat*) of earlier the same year, and so 'anticipates the dialogue between the flat and the modelled' in much of Matisse's subsequent painting, which portrays a single subject in different stylistic modes.[9]

I have already noted the ambivalence implied by this kind of free movement between artistic conventions—it implies that there can be no single, valid way of seeing a subject, and so the way is open to the deliberate exploitation of stylistic variation (which comes to a climax in the eighteen different styles of each episode of Joyce's *Ulysses*). This type of analysis reminds us of the self-consciousness of the artist's methods, a concern which is noted in the contemporary reaction to Matisse's painting. But the critics saw as defective what the avant-garde was later to claim as a virtue, that is, possession of a 'theory' to rationalize anti-naturalism. Though André Gide thought Matisse more defensible than Van Gogh in this respect:

I listened to the visitors and when I heard them exclaim in front of a Matisse: 'This is madness!' I felt like retorting, 'No sir, quite the contrary. It is the result of theories. . . When M. Matisse paints the forehead of this woman apple-colour and the trunk of a tree an outright red, he can say to us, 'It is because—'. Yes, this painting is reasonable, or rather it is reasoning. How far removed from the lyrical excesses of van Gogh![10]

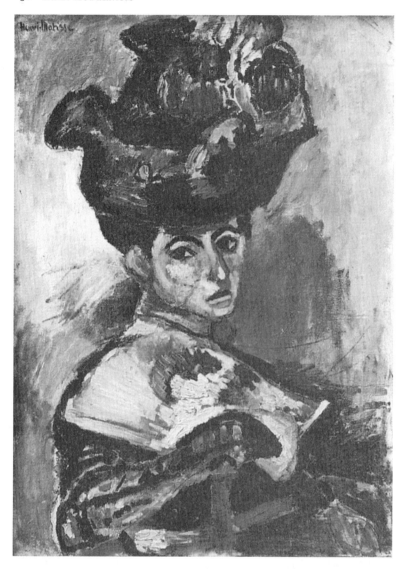

5. Henri Matisse, *Woman with Hat (Femme au chapeau)*, 1905.

Maurice Denis makes the same comparison with Van Gogh, but he sees Matisse's work as 'something even more abstract; it is painting above every contingency, painting in itself, the pure act of painting', and also points to its Expressionism: for 'strange contradiction, this absolute is limited by the one thing in the world that is most relative: individual emotion.'[11] He sees the Modernist move towards abstraction in painting here, and he also grasps the artist's reliance upon an expressive rela-

tionship between colours and the emotions which he projects through them on to the subject.

The magnificent result of this ambivalence between a simplifying abstraction and representation is to be seen in *Le Bonheur de vivre*, which abandons the contemporary world for that of Symbolist fantasy and literary association.[12] It was begun in October 1905, and shown with the *Portrait of Mme Matisse*, at the Indépendants in 1906. Leo Stein bought it, and Picasso saw it in his drawing-room. Its materials all derive from, and compete with, earlier art. Its art nouveau-like arabesques in the rhythmic drawing of the body transform work like Ingres's *Le Bain turc* of fifty years earlier, which had been shown at the Salon d'Automne in 1905. It is even closer in theme to Ingres's *L'Age d'or* (*The Golden Age*), which has a similar sinuous linearity, a dancing circle at its centre, a pair of standing lovers at the left, and a pair of reclining figures in the foreground. Flam also notes the influence of scale discrepancies derived from Oriental art, of Carracci's *Reciproco amore* (*Love Reciprocated*), of parallels to Watteau and prehistoric cave painting, and notes that the piping boy on the right derives from the Giorgione *Concert Pastoral* in

6. Henri Matisse, *Le Bonheur de vivre* (*Joy of Living*), 1905–6.

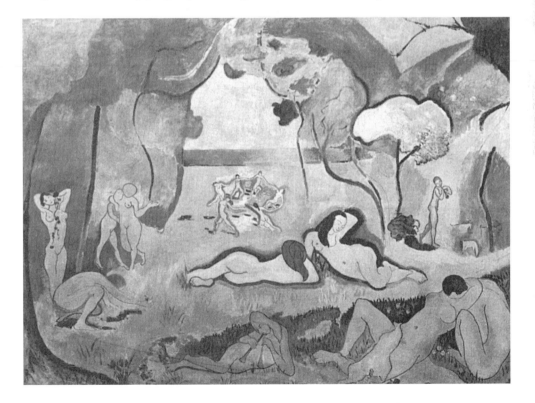

the Louvre.[13] This eclectic and achronological reworking of aspects of
past tradition is central to the allusive aesthetic of many Modernist
works, which affirm their own contemporaneity by drawing attention
to their transformation and juxtaposition of past styles. This sense of
quotation contributes to the peculiarly stagey effect of the image, as it
works through the 'flats' of its receding design, and gives the impres-
sion, not that we look through a window on to the Golden Age, but that
we are present at the enactment of a scene from it, as if they are all about
to dance something from Maurice Ravel's ballet *Daphnis and Chloe* of
1912. The figures vary bewilderingly in size, as they are not seen from a
single viewpoint. We are in the complex imaginary space of fantasy,
teased by the painting's elaborate pattern of allusion to art history.

In the summer of 1907 Matisse went to Italy, and was deeply
impressed by Giotto, Duccio, and the Siennese primitives. Back at Col-
lioure by August 1907, he worked on *Le Luxe I,* which is once more the
result of eclectic influences, from Cézanne and the Japanese print to
Puvis and early frescoes. The failure to resolve all these may have led to
its exhibition in the Salon d'Automne of 1907 as a 'sketch', and the
second version, *Le Luxe II* (probably from the autumn of 1907) is more
finished, possibly because the first had been criticized at the Salon. It
has a peculiar importance because it was so widely exhibited (in
London and Cologne in 1912 and in New York in 1913). Here three-
dimensionality is merely implied in a decorative art whose pale tans,
turquoises, pinks, and flat planes have a remarkable economy. And yet
Matisse's drawing has tremendous implications of expressive contour
in very few lines, as a few strokes manage to imply volumes. Matisse's
intentions are interestingly different from those of Braque cited earlier;
for him, 'charm' and the erotic are still very much at issue:

Suppose I want to paint a woman's body: first of all I embue it with grace and
charm, but I know that something more than that is necessary. I will condense
the meaning of this body by seeking its essential lines. The charm will then be less
apparent at first glance, but it must eventually emerge from the new image,
which will have a broader meaning, once more fully human.[14]

Work like this established Matisse's 'Fauvism' as a potentially dominant
style.[15] It is, I think, typical of much Modernist innovation in that it
examines the elements of representation—perspective, modelling, the
effects of light—and subtracts some of those which most conspicuously
made for 'realism', in favour of others. Conventional modelling goes, as
does colour faithfully reproduced as impressionist atmosphere, or the

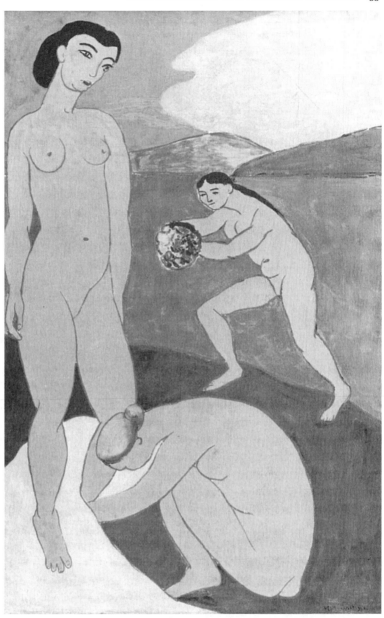

7. Henri Matisse, *Le Luxe
II*, 1907.

reflection from a lighted surface. Colour and line become functions
of the internal economy of the design.[16] The bright, urgent colours
of Fauvism, and the cunning distortions of its drawing, still have an
extraordinarily immediate appeal. They dramatize everyday visual
experience by making it seem on the canvas to be made up of raw

sensations—and so maintain a hedonist tradition in art, which tends to be suppressed in the theoretical debates inspired by more aggressively avant-garde work.

Although Matisse's subjects continue to be those of tradition, his new decorative organization of the canvas is entirely distinctive, and most dramatically so in the *Harmony in Red* (*Harmonie rouge*) (1908), in which the pictorial space is not just flattened out, but patterned by the repetition of the flower motif in wallpaper and table-cloth. This creates a tense equilibrium between the horizontal and the vertical, and threatens the identity of the objects in the room, which are drawn into the all-pervasive medium of the red background to the picture. It is remarkable as an index of Matisse's progress through technical experiment, in that its subject is the same as his Impressionist *La Desserte* of 1897. The table, now parallel to the picture plane, is less profusely furnished, but keeps its *compotier* and flower vase in the centre of the picture. The window introduced at the left could well be another

8

4

8. Henri Matisse, *Harmony in Red*, 1908.

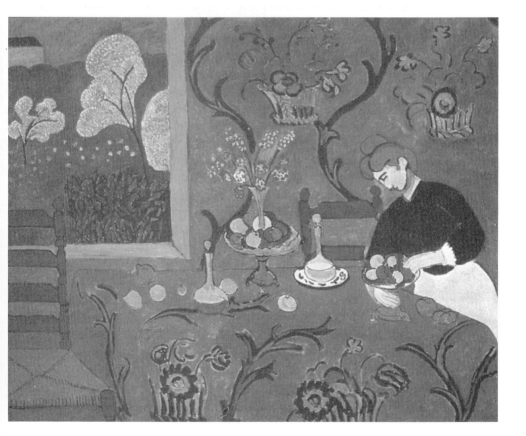

painting, and it no longer provides the source of light for an image which is wholly unatmospheric, and suggests no particular time of day. In 1897 the student Matisse had produced an extraordinarily virtuosic study of highlights and reflections—but, as a Fauve, he shows that once the premiss that colour may be non-representational is accepted, there are entirely new possibilities for pattern and the decorative in twentieth-century art.

The *Harmonie rouge* was shown in the Salon d'Automne of 1908 along with a number of pictures made on similar premisses, which derive from ideas of colour harmony, flattened space, and the interplay between an arabesque linear patterning and the human figure. They were shocking enough to lead to a total misconstrual of Matisse's intentions and temperament. The *Revue de la quinzaine* saw the *Harmonie rouge* as

the expression, acute to the point of tragedy, of modern torment . . . [Matisse] has sought principles less in nature than in himself and in the mathematics of his art . . . One senses in him a perpetual tension, a nervous exacerbation that is not particularly natural to him, I believe, but that signals the unhealthy stare of a spirit overburdened by experimentation and ambition.[17]

Matisse's own *Notes of a Painter*, published at Christmastime in 1908, make clear the far from tormented ideas behind such painting, in a classic statement of the Expressionist aesthetic:

The entire arrangement of my picture is expressive: the place occupied by the figures, the empty spaces around them, the proportions, everything has its share. Composition is the art of arranging in a decorative manner the diverse elements at the painter's command to express his feelings.[18]

This claim, to make the criterion of success for a picture the expression of the painter's feelings (and to ask for a corresponding response in the spectator) is radically new because the feelings brought about by Matisse's approach to the figure, and to colour, space, and proportion, are not to be seen as a more or less reasonable reaction to the objects represented, because it echoes their place in some favoured narration of human life. His approach to expression is therefore far more abstract than this, and demands that we begin to learn a language of painting— that, for example, we correlate our emotional responses to pure colours. He thus goes beyond the Expressionist theory of Van Gogh, who gives colour a symbolic role, to be reinforced by a dramatically involving subject-matter. Van Gogh tells us that he 'tried to express the terrible

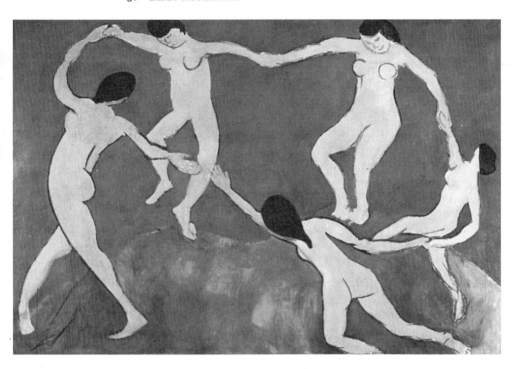

9. Henri Matisse,
La Danse I, 1909.

passions of humanity by means of red and green' in his *The Night Café* (1888), in order to convey 'the idea that the café is a place where one can ruin oneself, go mad or commit a crime in an atmosphere like a devil's furnace, of pale sulphur'.[19] He relies upon an allegorical association of ideas, of sulphur yellow with ideas of hell, and so on—whereas Matisse would claim that colour and shape alone and in themselves, even when abstracted from such contexts, can carry an emotional effect.

The emotional commitments typical of the previous generation of Post-Impressionists are no longer central. After Matisse, the artist can adapt any conventional subject (the nude, the studio) to his expressive aims, since he is not conveying information: 'I cannot copy nature in a servile way; I must interpret nature and submit it to the spirit of the picture.' And the emotional effect of the whole is meant to be as object free and abstract as our response to music: 'From the relationship I have found in all the tones there must result a living harmony of colours, a harmony analogous to that of a musical composition.'[20] This appeal to the idea of musical harmony runs right through the Modernist period, and, as we are about to see, provided an extraordinary new freedom on

the road to pure abstraction. The first step was to simplify, as Matisse
noted with respect to his *La Danse* (1909):

9

> We are moving towards serenity by simplification of ideas and means. Our only
> object is wholeness. We must learn, perhaps relearn, to express ourselves by
> means of line. Plastic art will inspire the most direct emotion possible by the
> simplest means.[21]

The central circle of dancers here is borrowed from *Le Bonheur de vivre*,
and carries the symbolism of accord and agreement of the earlier
picture towards far more Dionysian and primitive implications; hence
its stylistic indebtedness to the Bacchic dancers on Greek vases. Music
and the interlinking of bodies become metaphors for one another,
within the simple triad of green earth, blue sky, and pink flesh.

2. Kandinsky and Abstraction

Wassily Kandinsky, whose early work was much influenced by Matisse,
judged that the 'rhythmic composition' of *La Danse* had 'an internal life
and consequently a sound'.[22] But this may only be perceived if 'the
viewer's soul is mature enough to perceive the *pure inner sound* of this
line'.[23] For him, the harmony of a painting does not simply give the
aesthetic pleasure of Matisse's *Notes*; it can tune up the soul. He takes
from Steiner and other theosophists a theory of electrical vibrations,
which are given off by particular thoughts and feelings, and are
communicable to the initiated through colours and forms.[24] He uses
this material to explain the 'meaning' of colours—for example, yellow
'in any geometrical form' is aggressive in character and 'typically earthy'
and 'may be paralleled in human nature with madness'. Blue is typically
'heavenly' and restful; it echoes grief as it turns to black. And so on.[25] The
personality of the artist can transmit such thoughts *into* the picture,
which then broadcasts its own spiritual vibrations, rather as a musical
source transmits waves of sound, so that 'Colour is the keyboard, the
eyes are the hammers, the soul is the piano with many strings. The artist
is the hand which plays . . . to cause vibrations in the soul.'[26]

Kandinsky's search for harmony in his work and the claim for its
religious significance went hand in hand. But they depended on an
abstraction more radical than that which he believed to be accessible to
Matisse as a painter within the Impressionist tradition, although he saw
him by 1910 as having surpassed Cézanne, Van Gogh, and Gauguin in
allowing the use of pure colour to overpower the definition of objects.

II, 8 (As, for example, in the *Woman in Japanese Robe* and the *Harmonie rouge*.) Kandinsky believed that if physical matter was in any case on the point of dissolving in the coming Apocalypse, there was little point in continuing to represent aspects of the natural world in painting.

This left the characteristics of a new, alternative form of painting (and the responses it might evoke) far from clear—despite the hints Kandinsky had derived from the images of 'spiritual forms' in works like Annie Besant's and C. W. Leadbetter's *Thought Forms* of 1902. For chords in music are part of a language with a conventional syntax—there are acceptable ways of getting from one to the other (soon to be disrupted by Schoenberg). But he who produces colour 'chords' can rely upon no such conventional background organization. They may be no more than the vibrating analogues of the 'significant' emotions which Kandinsky saw as part of an apocalyptic drama, in which he had cast himself in the role of prophet.[27]

He was moving towards the invention of abstractions which would be full of symbolic meaning, and so bring about the spiritual transformation of the viewer. (This has been an intended effect of much abstract painting after him, in Mondrian and Rothko, for example.) The representational object is 'progressively' banished from his painting for intellectual motives which are deeply conservative. This is because the theosophical mysticism his painting was meant to serve was as antipathetic to a secularizing twentieth-century culture, as it was to the materialism and positivism it had attacked in the nineteenth century. The conservatism of Kandinsky's position emerges in his assertions that those who accept that 'Heaven is empty' or 'God is dead' are 'democrats and republicans', and that such atheists and socialists inhabit the 'great segment of the triangle' of the political world, and are 'putting their trust in purposeless theory and in the working of some logical method'.[28]

His starting-point is that of Yeats and other Symbolists; against science, positivism, Naturalism, and other 'anti-religious' and 'decadent' tendencies of the late nineteenth century. Like Scriabin, Kandinsky looked for a solution to this loss of faith by turning to the internal world of spiritualism, in the hope that Christianity might be brought to incorporate the 'ancient wisdom' of previous religious cults. He turned to the theosophical tradition and to folk art, to assemble a repertoire of symbolic objects, persons, and landscapes, such as the horse and rider, which could symbolize the artist and his medium (as well as the knight St George and the riders of the Apocalypse). He also frequently represents the drowning man of the Deluge, the trumpets of the Apocalypse,

and the walled city or castle on a mountain (the *feste Burg* of faith).[29] In adapting them for painting he simplifies their usual forms of representation, to the point at which they become mere sign or gesture. But even when such motifs have taken on their most abstract guises, they are supposed to retain an emotional impact upon the viewer which can transform his or her consciousness, and lead towards a 'Spiritual Revolution'. Such an approach to the making of art is obfuscatingly intuitive, given its grandiose claims to put the painting in contact with a higher spiritual world, but it also generated a tension between abstraction and representation which was to haunt later artists.

Scholar-critics of Kandinsky's work seem to find themselves compelled to argue that, 'behind' his abstractions, there still lurk the (literally) sketchy representations of symbolic objects. These become less and less clearly visible in the three distinct kinds of 'symphonic' work which Kandinsky claimed to make, which he thought moved beyond the 'plain melodic constructions with a plain rhythm' of work like that of Cézanne. They are progressively more abstract and reliant on subconscious feeling. The 'Impression' is 'a direct impression of outward nature, expressed in purely pictorial form'; the 'Improvisation' is 'a largely unconscious, spontaneous expression of inner character, the non material nature'; and the 'Composition' is 'the expression of a slowly formed inner feeling, which comes to utterance only after long maturing'. In this, the most serious of Kandinsky's genres, 'Reason, consciousness, purpose, play an overwhelming part. But of the calculation nothing appears: only the feeling.'[30]

10 In an 'Impression' such as *Lyrical* (1911) the motif of horse and rider, which Kandinsky uses again and again to symbolize the relationship between the artist and his creative powers, conscious and unconscious forces, is stripped down (partly under the influence of children's drawing[31]) to a few lines. The Fauvist art he had seen also simplifies, but this horse and rider has none of the sophisticated implications that

V Matisse can give to the body. In *Impression 3 (Concert)* the relationship between abstraction and musical thinking is affirmed. The large contrasting areas of black and yellow here may be meant to have the significance suggested in *Concerning the Spiritual in Art.* A picture painted in yellow supposedly gives out a spiritual warmth, and can be seen as 'approaching the spectator'. The 'inner harmony' of black, on the other hand, is 'a silence with no possibilities'. The image avoids any merely accurate reproduction of the external world, for this would imply too great a respect for social reality as part of the secular

10. Wassily Kandinsky,
Lyrical, 1911.

bourgeois order (in the hierarchy of colours, green is the 'bourgeoisie', and 'self-satisfied, immovable, narrow').[32]

VI

6

The way in which Kandinsky goes 'beyond' Matisse is perhaps best shown by looking at the *Improvisation 27 (Garden of Love)* of the following year (1912). This is another painting on the theme of the sexual Golden Age, and is very probably influenced in subject by Matisse's *Bonheur de vivre* (which Kandinsky may have seen at the Steins').[33] The couples in the lower right in both pictures are similar, and Kandinsky replaces Matisse's circle of dancers by a yellow circular form symbolizing the sun. Around this sun-circle there are three couples, two reclining and one sitting, who symbolize the good. The motif of the couple very likely derives from the thinking of some of Kandinsky's theosophical contemporaries such as Wolfskehl and George—who, like Yeats, and for similar reasons, saw sex as a means of communication with cosmic forces.[34] However, Matisse's classical pastoral idyll is given a moralizing biblical turn; the black snake, moving downward from the right centre towards the middle, suggests the Garden of Eden, though Long suggests that this and 'areas of black and grey' here may

'symbolise materialistic forces rather than sex in Kandinsky's visual scheme'.[35] On either interpretation, *Improvisation 27* is a work as much concerned with cultural diagnosis as it is with the projection of a Golden Age or an utopian future, and it retains a link to history (of a kind) through its metamorphosis of biblical themes.

It also refuses any naturalistic illusion of depth. By turning away from 'the third dimension' of material objects 'into the realm of the abstract' Kandinsky wanted to construct 'some ideal plane which shall be expressed in terms of the material plane of the canvas'. This 'revolt from dependence on nature' is justified, not simply because it may assist our 'realisation of the inner working of form and colour'; but also because it can produce effects which Kandinsky asserts are 'so far unconscious'.[36] His work depends in its appeal to the unconscious upon a general theory of the mind which was to attempt to dominate the literary culture of the Modernist period. This reliance upon the psychologically ineffable led to an uncertainty of interpretation which struck Apollinaire, who, on seeing some of these *Improvisations* exhibited, thought them 'pas sans interêt, car elles représentent à peu près seules l'influence de Matisse. Mais Kandinski pousse à l'extrême la théorie de Matisse sur l'obéissance à l'instinct et n'obéit plus qu'au hasard' ('not without interest, since they are about the only works to show the influence of Matisse. But Kandinsky carries Matisse's theory on obeying one's instinct to an extreme, and ends up obeying no more than chance').[37]

Kandinsky's progress is complicated by the fact that the paintings in which he most resolutely explored this dimension of painting, his *Compositions*, are extremely abstract but nevertheless tempt the interpreter to recuperate their imagery back to the more explicit representations to be found elsewhere in his work.[38] We can see how such difficulties grew, if we compare the *Compositions II, IV*, and *VII*.

11 *Composition II* was destroyed in the Second World War, but an important oil study for it of 1910 survives. It is a visionary fantasy:

> Sometimes harmonious pictures appeared to me in dreams . . . Once, in the midst of typhoid fever, I saw a whole picture with great clarity . . . finally, after many years, I succeeeded, in *Composition II*, in expressing the essentials of this fever vision.[39]

Long argues that this painting and its study incorporate 'two opposite aspects of the Revelation—destruction and salvation'.[40] Its elements to the left seem to be lightning, falling trees, tumbling towers, dark clouds,

11. Wassily Kandinsky, *Sketch for Composition II*, (*Oil Sketch*), 1909–10.

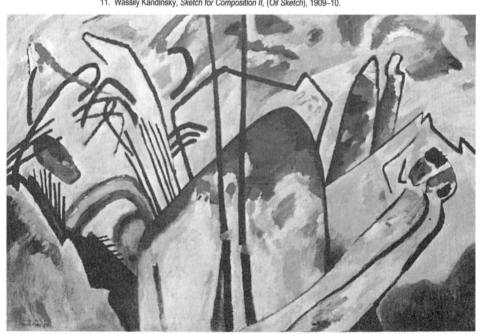

12. Wassily Kandinsky, *Composition IV*, 1911.

a boat with an upright figure in it, and figures submerged by waves.[41] (At the sound of the second trumpet in Revelation, 'a third of the sea became blood, a third of the living creatures in the sea died, and a third of the ships were destroyed' (Rev. 8: 9). On the right we see the reclining couples of the garden of love series, and in the middle, 'two horses with riders,—one white and the other blue—appear engaged in conflict as they leap towards each other across a white elongated tree form.'[42] The symbolism of horse and rider evolves in Kandinsky's work from St George or the Christian knight (vanquishing materialism) to the apocalyptic riders of the Revelation of St John: 'Then I saw heaven opened, and behold, a white horse! He who sat upon it is called Faithful and True, and in righteousness he judges and makes war . . . He is clad in a robe dipped in blood' (Rev. 19: 11–13).

In *Composition II* the themes of Deluge, apocalyptic conflict, and Paradise combine, but to what effect it is difficult to say: Kandinsky thought that the painting had the 'tragic' theme of contemporary chaos, and he seems to have arrived at this belief by seeing the Symbolist work of Maeterlinck as peculiarly symptomatic. As Long reminds us, 'he compared the helplessness of the lost and frightened to a drowning swimmer, he also mentioned how Maeterlinck conveyed the nightmare in his plays by the use of gloomy mountains and wind. At the same time he described how hope existed within the nightmare as a tiny glimmer of light, which many believed was only a dream.'[43] It is an allegorical painting, whose symbolic figures demand an analogical interpretation, because they simply do not make sense as an illusionist scene. Their connection with one another cannot possibly be that of a single stretch of historical or even fictional narrative. They are at best heretical elements in juxtaposition from the archi-narrative of Christianity.

These same elements were to be metamorphosed further in work like the *Composition IV* of 1911, which develops the motifs of the middle and lower right in *Composition II*. Here the representational imagery is still fairly obvious by reference to the earlier work: from left to right, there are horses in conflict, a rainbow (of Salvation), boats rowing towards a mountain and castle, three men with spears, and yet another reclining couple. But Kandinsky's ideas about this painting are remarkable for their conceptual abstraction. He seems to believe that its lines and colours, and the harmonizing or discordant relationships between them, will give rise to an inchoate awareness of war-like imagery of apocalyptic significance. For him, colour and line correlate directly to emotions, and so he draws our attention to 'Two Focal Points', the

'tangled lines' and the 'moulded summit of the blue [mountain]' which 'are separated from each other by two vertical black lines (spears)', and tells us that 'the yellow is cold. This bright-fresh-cold to the sharp-agitated (War) is the principal contrast of the picture.' He also notes

1. The harmony of the **peaceful** masses with each other.
2. **Peaceful** movement of the components, principally toward the right and upward.
3. Principally **sharp** movement toward the left and upward.

and goes on to make six more similar points.[44] He labels the conflicting emotional responses he wants for his picture, but the basis for the dialectical division he describes is far from obvious. The difficulty here lies in his idea that he is working with a language of colours and shapes which evoke specifiable emotions, and the belief (which he holds along with many of his abstract painter successors) that the disposition of the painting ensures that we will unconsciously have the 'correct' emotional response, even if we cannot conceptualize it by calling narrative associations to the aid of the abstract.

VII If we now look at a painting at the far limits of this line in Kandinsky's early development, the *Composition VII* (completed in November 1913), we find it, I think, virtually impossible to 'read', even as this kind of religious allegory. Kandinsky had asserted by 1913 that such pictures are 'gegenstandlos' ('objectless') and indeed there are no easily identifiable object-relations in it to offer a fixed position for the spectator, so that its gaseous and celestial space seems to expand and contract. Interpretation becomes increasingly desperate. Hamilton thinks that 'the ceaseless flux of psychic experience may have been represented' here,[45] Overy that 'the forces of dissolution appear almost to take command, equilibrium is barely preserved in the turbulent landscape of the mind',[46] and Professor Long manages an allegorical commentary all the same. She sees motifs such as the mountain and the boat, which can still apparently be identified with the help of comparison to other works, and the many studies for this picture.[47]

Kandinsky had experimented with several different centres for this composition. In the final version, there is a large enclosure around a central 'couple' (in the irregular oval shape there is apparently a double curve indicating the presence of two heads). This enclosure 'has acquired a vaguely triangular edge' so that

Kandinsky's attempt to combine the themes of God and love is realised in this

combination of triangle and couple. This could be interpreted in several ways. For example, Gippius had described the sexual act in the form of 'an iscosceles triangle, the vertex indicating Christ, the left corner the 'I' (man), and the right corner the 'you' (woman).' A more obvious interpretation is that the triangle represents the Christian Trinity and the couple within it is meant to indicate man's attempt to realise God's love.[48]

Kandinsky's yearning for the revival of an almost vanished occultist symbolism and his Modernist tendency to make abstractions which vaguely suggest living forms are at their most difficult to reconcile in this image. The later history of painting will be haunted by these biomorphic and Surrealist abstractions, which claim to express the subconscious workings of the mind, and so are indifferent to rationalist forms of interpretation.

In discussing the Expressionists in 1915, Wyndham Lewis described Kandinsky as 'the only PURELY abstract painter in Europe' and his works as 'etherial, lyrical and cloudlike—their fluidity that of the Blavatskyan soul':

But he is so careful to be passive and medium-like, and is committed, by his theory, to avoid almost all powerful and definite forms, that he is, at the best, wandering and slack.[49]

That is the problem. Very few spectators of this type of painting can respond to them as Kandinsky wished. Subjectivism, intuition, and *Gestalt* expression are to the fore (as they will be in much later, particularly American, painting), and the analogy with music has to carry the main burden of suggesting the nature of abstract effects, with the claim that when 'representational forms' are made abstract, they can 'best reveal the inner sound of the painting'. Were we to be properly tuned in we could gain a mystical insight into the nature of reality, as it would 'become possible to hear the whole world as it is without representational interpretation'.[50] But this is a view to which it is difficult to attach much sense, even if its ancestry goes back to Plato and Kirchner, and to more recent intuitions of the 'immanent will' within the universe, as advocated by Wagner and Schopenhauer. Kandinsky's kind of thinking has a crucial position within the history of art; and leads to the artistic investigation of subconscious and automatic processes in Dada and Surrealism after 1916. Kandinskyan biomorphic abstraction is therefore of immense significance for later abstract Expressionist painting, and it shows us a disintegration under the stress of emotion, which presages

the gestural 'existentialism' of much later action painting.[51] And yet its aim in the early decades of the twentieth century was essentially conservative, in opposing a mystical sense of totality (and of the utopian) to what many, like Max Weber, saw as the analytical fragmentation of Modern society under the stress of scientific logic. Kandinsky attempted 'to preserve a diminishing number of real or imagined areas of privileged experience from obliteration by those thought-forms—secularism, functionalism, materialism and rationalism—which have established themselves as the conceptual basis of late capitalism'.[52] His work pretends to open up an epiphanic access to realms created by the artist-prophet, as 'Each work originates just as does the cosmos—through catastrophes which out of the chaotic din of instruments ultimately bring forth a symphony, the music of the spheres. The creation of works of art is the creation of the world.'[53]

The essential idea here comes from Symbolism—it is that of the autonomy of the work of art, so that 'the more an artist uses abstracted forms, the deeper and more confidently will he advance into the kingdom of the abstract'.[54] But the notion of metaphorical interrelation, which supported the claims of the Symbolist poets to create alternative worlds, here passes over from natural language, via colour, to music. Kandinsky's apocalyptic clash of worlds gives rise to a 'symphony', which is obviously autonomous and abstract, and has no practical application to the 'bourgeois reality' that he and Mallarmé so much despised. In aiming at 'spiritual' purity, such painting claims to bypass all such 'worldly' realistic contexts (even if its originating archetypal imagery may be derived from the Bible, folk art, and a Romantic and fantasized past). As it developed, abstract art tended to boost this ambivalent relationship to other symbolic modes of thought by marrying itself to obscurantist poetic effusions which purported to interpret it. It has been very difficult for non-geometrical abstraction to escape from the occultist origins out of which Kandinsky developed it.

3. Schoenberg and Atonality

In January 1911 Kandinsky and his friend the painter Franz Marc heard a concert of Schoenberg's music, including the *Quartet No. 2*, Op. 10, and the *Three Piano Pieces*, Op. 11. Marc described his reactions to the concert in a letter to his friend August Macke, also a painter. It enthusiastically endorses the parallel between painterly abstraction and music,

and is acutely aware of the way in which innovatory experiment can subtract from traditional forms:

Can you imagine a music in which tonality (that is, the adherence to any key) is completely suspended? I was constantly reminded of Kandinsky's large *Composition*, which also permits no trace of tonality . . . and also of Kandinsky's 'jumping spots' in hearing this music, which allows each tone sounded to stand on its own (a kind of *white canvas* between the spots of colour!) Schoenberg proceeds from the principle that the concepts of consonance and dissonance do not exist at all. A so called dissonance is only a more remote consonance— an idea which now occupies me constantly while painting . . . Schoenberg seems . . . to be convinced of the irresistible dissolution of the European laws of art and harmony.[55]

This last remark points to a very controversial aspect of Schoenberg's thought: the extent to which his most subversive discoveries could be considered law-like, or 'necessary', or even progressive. In the process of overthrowing earlier conventions for tonal expression, Schoenberg claimed to follow an inexorable logic, whose aim was evolutionary rather than disruptive, because 'a hand that dares to renounce so much of the achievement of our forefathers has to be exercised thoroughly in the techniques that are to be replaced by new methods . . . no new technique in the arts is created that has not had its roots in the past.'[56] This retrospection was central to his thinking throughout his career. He seems to have needed to synthesize past discoveries, as if to make his predecessors redundant, before he could make any experimental advance. His *Pelleas und Melisande* (1903), for example, outdoes the tone poems of Richard Strauss in its rich polyphony, its opulent orchestration, and the complexity of its organization, for Schoenberg the conservative also gave his tone poem the four-movement form of the classical symphony. This led to a shocking inflation of his reticent Symbolist source. Where Maeterlinck demands a subtle evocation of mood on the border of fantasy and dream, Schoenberg's emotional expression is wildly extravagant.[57] He perversely transforms the plot into one which supports a Nietzschean–Straussian self-assertion, and a grandiose Wagnerian thematic transformation. The piece is full of an Expressionist love of violent feeling, which is hardly subdued by the near-impossible ingenuity of the formal demands the composer makes on himself.

This competitive relationship to tradition licenses his charge of superficiality against those critics who saw 'anarchy and revolution' in

his later works of 1908–11: 'on the contrary, this music was distinctly a product of evolution, and no more revolutionary than any other development in the history of music.'[58] He claims merely to have 'adjusted' the 'laws of musical aesthetics', but this adjustment led to radically new formal procedures and an atonal language for music which still cause severe difficulties for many listeners.[59]

The analogy with language may help us to appreciate the essential problems which arise from Schoenberg's work in this period more clearly.[60] Rather as mature speakers come to command the syntactic forms of their language while rarely needing to think about them explicitly, listeners to music seem to be able to pick up its harmonic conventions without any technical knowledge. Anyone who can 'carry a tune', or anticipate the options for its next note, or make a cadence, is able to follow some of the basic conventions of traditional harmony in constructing a musical 'sentence'. Atonal music, on the other hand, disrupts such conventional syntactical expectations. The melodic phrases *within* the musical sentence may retain a high degree of traditional expressivity (as the disrupted and ambiguous syntax in Mallarmé's poetry can suggest powerful but intermittent forms of reference to a common world). In such cases, individual phrases may strike us as very like those with which we have become familiar, even though they seem to lack conventional logical relationships to one another.

Schoenberg's disruption of conventional harmony at the level of the 'sentence' leads on to larger-scale problems in constructing the 'paragraphs' of the musical argument. Music before Schoenberg had generally moved towards or away from well-established tonal reference points, as a varied tune may repetitively imply the chord progression of its underlying harmony, or a series of modulations between keys may lead to a cadential 'end' which we perceive as temporary or final. These features help us to know 'where we are' in traditional music, in terms of a harmonic structure which guides us through the structural blocks of the exposition of themes, their development, the movement towards a conclusion in a coda, and so on.

When such underlying structures are challenged, it is much more difficult for the listener, because the multiply ambiguous short-term syntax of the piece permits the piling up of dissonant phrases that cannot be resolved in familiar cadences. Schoenberg saw these dissonances, not as objects to be proscribed by the 'laws' of tonality, but as (admittedly rather remotely) consonant additions to the language of

music—new compound nouns and verbs, so to speak. Although the term 'atonality' indeed entails the subtraction of a previous convention, Schoenberg wished to give it a much more positive interpretation, by seeing dissonances as 'advanced' forms which give rise to more complex types of chord sequence. The perceived difference between consonance and dissonance, which could be so painful for the listener, was for him just one of degree, and, in any case, dissonances had come to win acceptance throughout the history of music. His chords, once 'emancipated' from conventional tonal constraints, therefore demanded reinterpretation as sonorities in their own right. But then what will happen to the implicative, logical connections between chords?

These problems preoccupied Schoenberg throughout his development, for his 'emancipation of the dissonance' placed unprecedented strains upon the receptive capacity of the listener. This was because in earlier compositions the harmonic reference-points implied throughout a composition were reinforced by repetition, which helped to fix them in the mind of the listener, whereas for Schoenberg, these repetitions and nodal points became impossible in their traditional forms, because the dissonant chords he allowed in his music did not imply them. His music seemed to be in a state of perpetual flux, as indeed he admits:

1. Substantially, I say something only once, i.e. repeat little or nothing.
2. With me, variation almost completely takes the place of repetition . . .[61]

He seems to have hoped that the difficulties he thus caused were basically those of increased *complexity*: and that frequent experience of his music could overcome them. He had merely extended tradition.[62]

Such features are typical of the *Kammersinfonie* (*Chamber Symphony*) for fifteen solo instruments in E major, Op. 9 (completed in 1906 and first performed in 1907).[63] By writing a symphony for chamber ensemble, Schoenberg could develop to an unprecedented degree of complexity the contrapuntal interplay which had already helped to weaken tonal progression in the symphonies of Mahler. He attempts to synthesize so many past procedures here, that the form itself begins to come apart. The sheer speed with which it develops its themes, for example, is bewildering.

A new type of unity is attempted here, by putting the major themes of the work into all sorts of contrapuntal relationship with one another. It is important to note that Schoenberg claims to have profited in doing this from 'the miraculous contribution of the subconscious',[64] which

forged for him relationships between the themes of the work of which he was not consciously aware in the process of composition. An 'emancipated' harmonic system thus allows the composer not so much to create as to discover relationships between its parts, uninhibited by the need to observe 'conventional' methods of unification, or aware-ness of audience response. This notion, that you can lay down the ground rules for a language and then discover its interrelationships, has had extraordinary consequences for Modernist and for Postmodernist art, particularly when supported by the idea that the artist can rely upon the unconscious in making them. Processes of which the artist is *ex hypothesi* unaware are allowed to usurp any compromise with the con-ventional demands of an audience. In the *Kammersinfonie*, Schoen-berg's abandonment of the unifying effects provided by underlying harmonic movement led to a stylistic confusion, upon which Stravinsky acidly remarked:

At times the *Kammersymphonie* sounds to me like a joint creation of Wagner, Brahms, and Strauss, as though one of these composers had written the upper line, one the bass, etc. . . . Nevertheless the *Kammersymphonie* is more poly-phonic than the work of any of these composers.[65]

As the older types of symmetry and proportion are abandoned, and the conventional building blocks of music became more difficult to discern, the emphasis inevitably fell on the remaining smaller elements of the language, such as the motif and the interval, so that 'the expres-sive values of these tiny elements therefore took on an inordinate significance; they replaced syntax'.[66] Dissonances are inexorably 'emancipated' because they are bound to occur when asymmetric and independent melodic lines of the music collide with one another, as in the *Second String Quartet* (composed in 1907–8), where 'the individual parts proceed regardless of whether or not their meeting results in codified harmonies'.[67] The result seems most violent when dissonant intervals (such as minor seconds, sevenths, tritones, or augmented fourths) result, and the chordal tensions they bring about are not resolved.

Such procedures brought about a basic conceptual difficulty, quite apart from their disturbing emotional effects. The function of dis-sonance in earlier music had been, sooner or later, to be resolved into consonance (like the famous dominant seventh of *Tristan*). The dis-sonances in Schoenberg's music seemed meaningless, because they did not lead to the resolution that one might expect. He found in writing

his *Second Quartet* that 'the overwhelming multitude of dissonances cannot be counterbalanced any longer by occasional returns to such tonal triads as represent a key'.[68] And if dissonance had hitherto always depended on its contrast with consonance within the individual work, what would be left if consonance or tonality were to be removed entirely? How would one organize dissonance? Schoenberg worked towards an answer to these questions in this quartet, which develops through the unorthodox harmonic challenges of its first movement into the radically 'new air' of atonality in the fourth. Egon Wellesz's report of the first performance shows how provocative it was:

The first movement had hardly begun when, enraged by the unexpected C in the fifth bar, the music critic named Karpath jumped up from his seat and shouted 'Stop it!' Unperturbed, the Rosé quartet went on.[69]

This movement is in fact quite reassuringly tonal in organization. Its themes are short, self-contained, and presented before a fairly consistently triadic harmony. But in the fourth movement, notated without a key signature, we arrive at a 'free atonality', and do so with the unprecedented addition of a soprano to the string quartet. The tonic key here, which is still felt at some nodal points (including the ending), is F# major, but long stretches are atonal. The Introduction to the movement (before the voice enters) gives us a flavour of the full tonality we are about to lose, in a process which is to be like 'Becoming released from gravitation—passing through the clouds into thinner and thinner air, forgetting all the troubles of life on earth', as Schoenberg puts it.[70] He is paraphrasing the text by Stefan George which he uses in this movement, whose accompaniment is grave, almost self-consciously beautiful, and wholly unaggressive. It patiently adapts the classical model of theme and variations to a revolutionary purpose. George's poem *Entrückung* sings of a release from earth-bound concerns, which may well symbolize the 'natural' law-governed language of tonality:

> Ich löse mich in tönen, kreisend, webend,
> Ungründigen danks und unbenamten lobes
> Dem grossen atem wunschlos mich ergebend.

I give myself to sound, circling, weaving, perfectly contented, giving myself up to the great breath of depthless thanks and unbounded praise.

The singer finally rises above the last clouds of the physical world to swim 'In einem Meer kristallinen Glanzes' ('Into a sea of crystal brilliance') :

> Ich bin ein Funke nur vom heiligen Feuer
> Ich bin ein Dröhnen nur der heiligen Stimme.

I am no more than a spark of the holy fire; I am no more than a drone to the holy voice.

There is a problem here: Schoenberg has escaped the logic of traditional tonality, by following another logic, that of the spoken language. It is the flow of the text which facilitates the development of an atonal form:

I discovered how to construct larger forms by following a text or a poem. The differences in size and shape of its parts and the change in character and mood were mirrored in the shape and size of the composition, in its dynamics and tempo, figuration and accentuation, instrumentation and orchestration. Thus the parts were differentiated as clearly as they had formerly been by the tonal and structural functions of harmony.[71]

The text evades the formal problems raised by atonality, by guaranteeing a verbal continuity; but Schoenberg slipped away from this perception by claiming to rely upon a wholly inner-directed emotional intuition in matters of form, rather than upon any general awareness of the interpreted meaning of his text. In his article 'On the Relation to the Text', published in Kandinsky's *Blaue Reiter Almanack* in 1912, he claimed that he had 'no idea' of the poems set by Schubert, and that once he had read them he 'found that I had gained nothing in the understanding of the lieder'. He believed, as did Kandinsky, that one can grasp the essence of something, even a poem, in a non-verbal, non-object-related sense. Indeed he claims, so far as Schubert is concerned, that he 'had quite obviously grasped the content, the real content, perhaps even more profoundly than if I had clung to the surface of the verbal ideas'. In writing his own lieder he therefore claims to achieve this type of insight merely by being 'intoxicated by the sound of the first words in the text'.[72] His 'direct contact' with this sound made him 'sense what necessarily had to follow', and (so far as his George settings were concerned) ensured that 'My understanding was so complete that it could hardly have been equalled and never surpassed by analysis and synthesis'.[73]

Schoenberg's defence of his use of the text involves some vital general assumptions about the nature of the mind, and in particular about the intuitive certainty by which he claimed to grasp what he calls a 'necessary' development in his work. These justificatory ideas

are very much akin to those of Kandinsky, and they underpin a variation on the Expressionist aesthetic, which Schoenberg develops towards the far more violent works of 1909–11, including the *Three Piano Pieces*, Op. 11, the *Five Orchestral Pieces*, Op. 16 and the one-act opera, *Erwartung*, Op. 17, whose forms are the open ones of free association.

If we put the *Three Piano Pieces*, Op. 11, beside Ravel's *Gaspard de la nuit* (1908) or Debussy's *Préludes* (1910–13), we can appreciate, as did Franz Marc in the letter quoted earlier, that Schoenberg's methods of composition were by now wholly unprecedented. The third piece in particular, completed 7 August 1909, has a density and variety of gesture which is astonishing, right from 'Its ff opening, at once highly dissonant and densely contrapuntal, [which] culminates in a fff chord in bar 33 which contains 8 different notes',[74] to its climactic conclusion in 'a whirlwind of sounds which gradually loses momentum and disintegrates into the rhythmic discontinuity of the final bars'.[75] The tempo, texture, and dynamics of the piece all change so rapidly that continuations and phrase motions seem wholly unpredictable. Phrase confronts phrase, hence Schoenberg's later judgement that he had learnt by this period 'to link ideas together without the use of formal connexions, merely by juxtaposition'.[76] In making these he relies upon an intense emotional conviction, so that in the absence of the usual connections, the events of his music ultimately depend upon an intuitive free association. These three piano pieces are thus an early example of a formal principle which is central to much Modernist work—that of juxtaposition. Conflicting elements are presented, not as an ellipsis awaiting expansion, but with any linking wholly suppressed. The artist-creator depends upon the assumption that the result will ultimately be perceived to hold together by virtue of something—which underlies and ultimately justifies the emotional impact of the piece. This is as often as not held to lie within the artist's own (often unconscious) psychology. It (usually) feels right to him. This is about the purest form of Expressionism, and Schoenberg practised it with an extraordinary persistence in these years.

The volatile expression of deep-lying emotions is explicit in the *Five Orchestral Pieces* ('Premonitions', 'Yesteryears', 'Summer Morning by a Lake', 'Peripeteia', and 'The Obbligato Recitiative') of the same summer of 1909. Schoenberg told Richard Strauss that they were 'certainly not symphonic, they are the absolute opposite of this, there is no architecture and no build-up. Just a colourful, uninterrupted variation of colours, rhythms and moods.'[77] Hence the poetic evocation

of the programme note for the first performance of the work at the Queen's Hall in London, under Henry Wood, on 3 September 1912, which appeals to a fair number of the technique-justifying ideas to which we have already referred—the subconscious, dreams, and the cosmic inner rhythms of mental life:

This music seeks to express all that dwells in us subconsciously like a dream; which is a great fluctuant power, and is built upon none of the lines that are familiar to us; which has a rhythm, as the blood has its pulsating rhythm, as all life in us has its rhythm; which has a tonality, but only as the sea or storm has its tonality; which has harmonies, though we cannot grasp or analyse them nor can we trace its themes.[78]

Ernest Newman reported that the work at this performance 'seemed so destitute of meaning and so full of discords that the audience laughed audibly all through the performances, and hissed vigorously at the end'. Schoenberg, 'one of those advanced composers of our day who make people like Richard Strauss seem quite old fashioned', was only willing to conduct a later performance in London in 1914, he reports, on the condition that 'perfect silence be maintained'. Applause was given to a much better performance, and Newman commented that 'Discords that on paper look unendurable and meaningless are tinted in such a way that one feels only a vague and often most alluring effect of atmosphere and distance'. The third piece, he thought, was 'impressionism pure and simple' and Schoenberg had used dissonance 'as a tonal language, complete and satisfying in itself, owing no allegiance or even lip service to consonance . . . It is amazing how far we can already go with him, how strangely beautiful and moving much of this music is.'[79]

Schoenberg's emotional struggle here does not depend (despite the evocative titles given to these pieces) on the autobiographical narrative support which he saw as underlying the symphonies of Mahler (and in a lesser way Strauss). It arises from mental processes for which a narrative impulse is not easily available, which arise from what Schoenberg in 1909 called the 'unconscious', to which we can only respond with our own. The 'artistic impression . . . is indeed released by the work of art but only if one has available receiving apparatus tuned in the same way as the transmitting apparatus. To convert an artistic expression into an artistic judgement, one must be practised at interpreting one's own unconscious feelings.'[80]

He depends here on exactly the same argument Kandinsky used in relation to abstraction. Schoenberg was very much aware of the larger

intellectual context in which such ideas were current,[81] and his convictions indeed found a strong ally in Kandinsky, who initiated a remarkable correspondence with him just after the concert referred to at the beginning of this chapter:

In your works, you have realised what I, albeit in uncertain form, have so greatly longed for in music. The independent progress through their own destinies, the independent life of the individual voices in your compositions, is exactly what I am trying to find in my paintings.

He goes on to develop the emancipating parallel between the harmonies of music and the abstract use of colour and shape in painting which I have already emphasized. But he denies any rational calculation in the matter.

I am certain that our own modern harmony is not to be found in the 'geometric' way, [of Cubism] but rather in the antigeometric, antilogical ['antilogischen'] way, and this way is that of 'dissonances in *art*', in painting, therefore, just as much as in music. And 'today's' dissonance in painting and music is merely the consonance of 'tomorrow'.[82]

Schoenberg replied affirming his belief in 'what you call the "Unlogical" ['die Unlogische'] and I call the "elimination of the conscious will in art"', For 'art belongs to the *unconscious*! One must express oneself! Express oneself *directly*! Not one's taste or one's upbringing, or one's intelligence, knowledge or skill. Not all these *acquired* characteristics, but that which is *inborn, instinctive*.'[83] At the end of the year, on 14 December 1911, he reaffirms this alliance between music and painting, and its emotional basis: 'We search on and on (as you yourself say) with our feelings. Let us endeavour *never* to lose those feelings to a theory.'[84] These exchanges are remarkable, for their common definition of an Expressionist aesthetic, their commitment to a visionary notion of the nature of the (irrational, instinctive) artist, and their belief in the underlying unity of the arts. What justified such commitments, for both men, was what Kandinsky called 'inner necessity', and Schoenberg saw as a response by the artist to the inner and ineluctable demands of the unconscious. For Kandinsky 'The *most important thing . . . is whether or not the form has grown out of inner necessity*' and 'bears the stamp of the *personality*'.[85] Dahlhaus goes so far as to say that such beliefs amount 'to a Romantic religion of art' arising from the nineteenth-century theological assumption that 'the substance of religion consisted in subjective emotion'.[86] The general importance of such

positions for the psychology of Modernist art will be discussed later: the point to note here is the equation between a 'necessary' progress within the language of an art form, and the 'necessity' of the inner processes of the visionary artist, who therefore sees himself as the medium of change within an evolutionary history, rather than as its inventor or discoverer.

4. Braque, Picasso, and Cubism

Cubism is revolutionary, long lived, and diversely interpreted, and its changes in technique were as immediately and disconcertingly obvious to the beholder as those of Schoenberg and Kandinsky. The latter saw its geometric abstraction as entirely antithetical to his own methods. And yet, once Cubist painting had become widely known, there is hardly an innovative painter who was not tempted to defend his own work in relationship to it, hence Kandinsky's dark remarks, and Schoenberg's reply that neither of them would sacrifice their feelings to such a theory. Although it is popularly supposed that the history of Modernist painting, after the revolution brought about by Braque and Picasso, can largely be seen as a series of attempts to confront or to compromise with its lessons, this is clearly an exaggeration, given the Expressionist strain of Matisse and Kandinsky, and the later intervention of Surrealism.[87] The dominance of Cubism and its progressivist claims seemed obvious to the many for whom the French tradition was central, such as Michel Puy, for whom, in 1911, it was 'the culmination of the work of simpli-fication undertaken by Cézanne and continued by Matisse, and then Derain'.[88]

This 'work of simplification' makes early Cubism an extension of the attack on realism, as we shall see in Braque, who moved from a Fauvist style of painting towards a Cubist abstraction from it, which was largely inspired by Cézanne. But his work then evolved with startling speed towards painting in which representational elements are not much more than alluded to, so that the image serves intuitively conceived expressive purposes of a very complex kind. Its implied aesthetic, if not its method, is in the end very similar to that of Schoenberg and Kandinsky, though not perceived to be so at the time. This is because as Cubism 'progresses', subservience to an object (and hence the ability of a spectator to 'read' from the painting to nature), is so adroitly blocked, that the rationale for the painting has ultimately to lie within the artist's creative play.

I agree with William Rubin that the early development of Cubism is

13. Georges Braque,
Landscape at La Ciotat,
summer 1907.

almost entirely due to Braque's work at La Ciotat and L'Estaque.[89] His
13 *Landscape at La Ciotat,* of the summer of 1907, borrows its configuration
from Cézanne and its colours from Fauvism; but its high horizon, and
its forms spilling outwards and downward, become paradigmatic for
Cubism, as does its general effect of sculptural relief.[90] This architectural
pyramid will even spill over from landscape to portraiture. But the
advance to Cubism proper depended upon a far more obvious kind
of geometrical simplification, as in the *Landscape at L'Estaque* (*The
Viaduct*) of the autumn of 1907, a change made the more dramatic by
a drastic restriction of the range of the Fauvist palette. Braque's work
during his third stay at L'Estaque in the summer of 1908 becomes
14 'cubist' in the most obvious sense. In his *Houses at L'Estaque* (August

14. Georges Braque,
Houses at L'Estaque,
August 1908.

1908), radically simplified, building-block houses rise up a hill away
from a rather tubular tree. The colour is non-descriptive, the blue sky is
eliminated, and the picture once more advances towards the spectator.
It is almost surprising that there can be a photograph of such a scene,
which reveals that the form of the tree is radically altered, and that there
is a geometrization of the foreground knoll.[91] When this work (rejected
by the Salon d'Automne) was exhibited for the first time at Kahnweiler's
in November 1908, Braque was described by the art critic Vauxcelles as

an exceedingly audacious young man . . . the misleading ['déroutant'] example of
Picasso and Derain has emboldened him. Perhaps he has also been unduly
obsessed by the style of Cézanne and recollections of the static art of the

Egyptians . . . He despises form, reduces everything, places and figures and houses, to geometrical complexes ['des schémas géometriques'], to cubes.[92]

This reduction and simplification was annexed by Apollinaire to an argument concerning the autonomy of the work when he asserted in the catalogue that 'each work becomes a new universe with its own laws', in Braque's 'monument to an effort which no one . . . before him had yet attempted'.[93] The first of these assertions affirms a reflexivity and obsession with method which was central to the contemporary interpretation of Cubism, and the second may well be right, for although we do not know what Picasso thought of Braque's pictures of L'Estaque,his paintings of 1908–9 suggest the attempt to catch up, as in his *Landscape: la rue des Bois* of August to September 1908. But neither this, nor his *Bread and Fruit Dish on a Table* of early 1909, with its Cézannist flattening of perspective, is in any way as sophisticated as the work of Braque at this time.

In any case, Braque had by then made a further advance, for in early 1909 he painted in his studio an image whose compression of discoveries into a small space makes it comparable to Matisse's *Open Window, Collioure*. As Golding remarks, in his *Le Port* (*Harbour, Normandy*), first exhibited at the Salon des Indépendants in April 1909, 'the optical sensation is comparable to that of running one's hand over an immensely elaborate, subtly carved sculpture in low relief'.[94] Its apparent recessions in perspective back to a vanishing-point are contradicted by passages which lead the eye forward again to the picture plane. Ground plan and background space are both virtually eliminated, and yet the picture purports to represent objects—two boats, two lighthouses, harbour walls—which are in 'reality' very far apart. They appear here to be squashed together within the picture plane, as if they were toy-like models. But this painting does not just simplify the object, as did the previous ones: it demonstrates a remarkably new conception of the space between them, to the point of contradiction. It makes everything, sea, sky, boats, and the space in between, seem equally solid, and locked together in the picture plane.

With the notions of geometrization and spatial continuity in common, Braque and Picasso worked together in the summer of 1909 on very similar assumptions, as we can see if we look at work like Picasso's *Landscape at Horta*, Braque's *Chateau of La Roche Guyon*, and Picasso's *Reservoir, Horta*. They already had in common an interest in the perspectival ambiguity implicit in the coloured planes of late Cézanne,

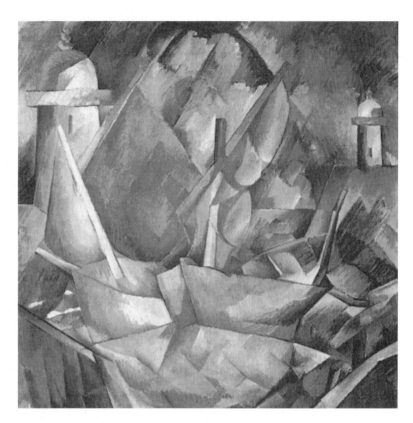

15. Georges Braque, *Le Port* (*Harbour, Normandy*), May–June 1909

which use their areas of colour to create an illusion of depth and also as helping to design the surface of the picture. But they go beyond their predecessors in treating these planes in a deliberately contradictory manner, because they completely banish any naturally conceived light source, which would confer a unified sense of perspective. The light comes from various directions, so that it contributes to the design, and thus relief is indicated by the arbitrary juxtaposition of darks and lights rather than by naturalistic shading. Picasso's *Reservoir* leaves no space to read between the houses, and puts them into ambiguous interrelationships. The painter no longer respects the identities of the separate objects before which he stands, but 'materializes' the space between them.[95] Jaques Rivière argued in 1912 that this was the 'Third and perhaps last mistake' of the Cubists, in showing an object 'prolonged in all directions and armed with incomprehensible fins'.[96] He fixes upon a central Cubist practice; but not naïvely so, because he wrote at a time

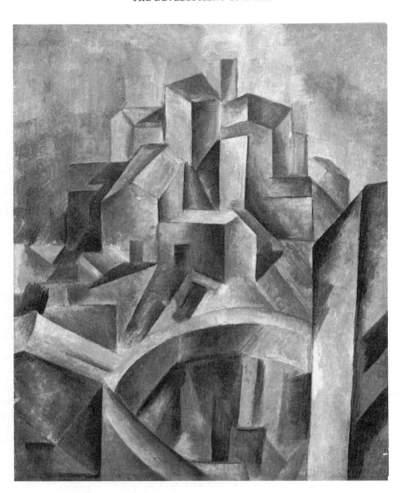

16. Pablo Picasso, *The Reservoir at Horta de Ebro*, summer 1909.

when there still seemed to be viable alternatives to this kind of work (as indeed there were).

The conventional landscape subject was far more open to such rearrangement than the human face. In Cubist portraits the idea of the image as the record of an act of psychological penetration is brutally discarded, for example by an aggressive de-emphasis of the importance of the eyes as a site of self-revelation, even in so legible a work as Picasso's *Woman with Pears* (1909). The portraits of 1910–11, which are central to the Cubist aesthetic as it was ultimately to be broadcast throughout Europe, were developed from the landscapes we have con-
17 sidered towards a more 'hermetic' form of Cubism. Picasso's *Girl with a Mandolin (Fanny Tellier)* (1910) is interesting in this respect, because it

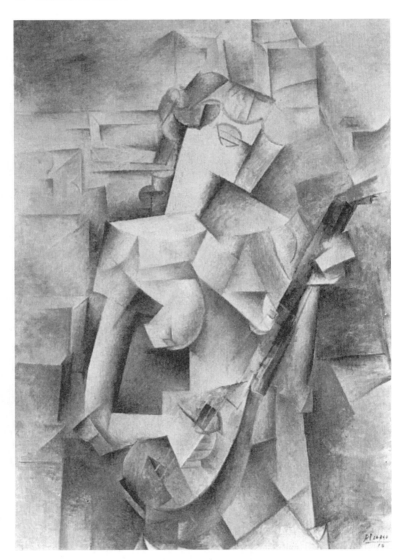

17. Pablo Picasso, *Girl with Mandolin (Fanny Tellier)*, spring, 1910.

is unfinished (its model refused to come for more sittings), and so may reveal the nature of the armature upon which later portraits were elaborated. (It may also be inspired by Corot's *Woman with a Toque*.) It has no pretensions to being a recognizable portrait, and its lyrical and relaxed quality may be entirely due to the fact that the painting is not finished. There is all the same an 'advance' on the boldly simplifying statement of paintings like the *Reservoir*, because the mode of representation is far more complex, less like a simplified model of its subject,

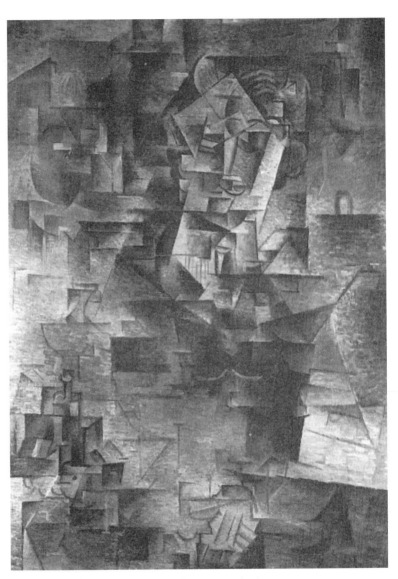

18. Pablo Picasso, *Portrait of Daniel-Henry Kahnweiler*, autumn 1910.

and far more concerned with the articulation of the surface of the painting.

This linear articulation is emphasized in Braque's and Picasso's work of 1910–11 by a near monochrome restriction of colour (hence Delaunay's later remark, 'but they paint with cobwebs, these fellows!').[97] This may be because innovatory development in one area demands a compensatory simplification of other elements in the language of a

genre. The spectator is asked to appreciate the analysis of space within the picture plane; and colour, as Braque himself pointed out, would provide the distraction of 'sensations which would interfere a bit with space'.[98] The painter who wants us to think about the critical category of space is allowing his work to become to some degree about itself, as geometrical analysis threatens to overwhelm any sense of a human

18 subject. In Picasso's *Portrait of Daniel-Henry Kahnweiler* (1910) (containing no particularly Kahnweiler-like features, except perhaps the right eyebrow and the hair above it) the flattened polygonal face area is teasingly surrounded by a scatter of representational elements, such as the watch-chain, the hands in the lap, the bottle and glass to his right, the table behind him, and the wooden sculpture mask from New Caledonia on the wall in the upper left-hand corner, as an ironic echo to the face. The pleasure of such painting depends not a little upon our appreciation of varying grades of tension between abstraction, which breaks the 'rules' or syntax of perspective, and leads to 'contradictions', and our attempt to resist it in the search for representation.

The resolution or non-resolution of this tension is a central strand in all Modernist painting. But here the self-conscious analysis of the language of painting is cognate with the post-Symbolist desire to create an autonomous work, subject to its 'own' laws, and contemptuous of social reality. This stylistic autonomy leads through time to another more doubtful value—that of the unique (and ultimately lucrative) recognizability of an artist's work, as the sign that a distinctive style has been achieved. In this case there is a remarkable stylistic convergence between Picasso and Braque, to be seen in two portraits of musicians,

19 Braque's *Le Portugais* (with a guitar on the bridge of a boat, with a harbour in the background) of the autumn of 1911 to early 1912, and

20 Picasso's *Ma Jolie*, of the winter of 1911–12, who seems to be playing a zither. These are both deeply 'hermetic' works, whose musical themes are symptomatic of the rapport between visual abstraction and musical response.[99] But such traditional subjects were also good candidates for a Cubist 'deconstruction'. I say 'deconstruction' to point to the way in which Cubist painting deliberately shows up the contradictions which arise when a three-dimensional object is represented on a flat surface, particularly a stringed instrument, 'with its clear oppositions of curved and rectilinear shape, solid and void, line and plane'. Furthermore, the juxtaposition of human figure and instrument 'presented an opportunity to confound the anatomy of man and guitar in [a] kind of punning between the animate and the inanimate'.[100]

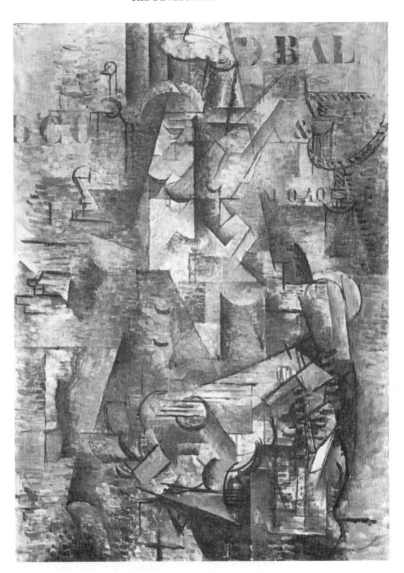

19. Georges Braque, *Le
Portugais* (*The Emigrant*),
1911–12.

The letters and numbers on the surface of the paintings also bring
Cubist painting ever closer to the paradoxes to be found within a verbal
language: in the Braque, the D BAL, the D CO,& and 10,40 are perhaps
fragments from posters on the wall of a bar (e.g. part of GRAND BAL) and
in the Picasso the MA JOLIE, the treble clef sign, and the four-line music
staff allude to the song which is the title of the picture ('O Manon, ma
jolie, mon coeur te dit bonjour'), and therefore to its subject, Eva

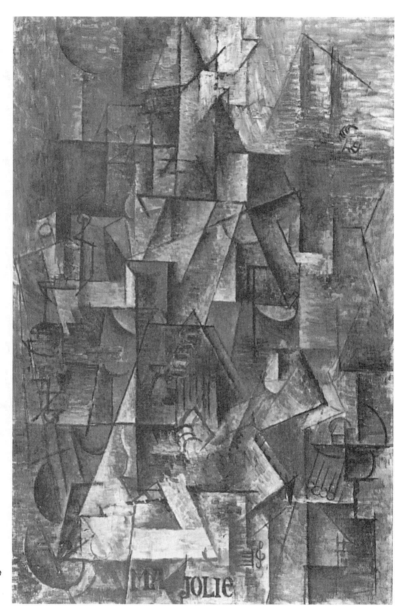

20. Pablo Picasso, *Ma Jolie*
(*Woman with a Zither or
Guitar*), 1911–12.

(Marcelle Humbert). The stencilling leads right on to Jasper Johns, the
affirmation of the flat surface, and the 'materiality' of the picture. But
it also has a more literary, punning, and rhyming function. For as
Rosenblum notes, the presence of such features can lead us to read
geometric forms such as the arcs and planes which surround them, as

rhyming within the picture, so that in the Picasso the four-line music staff 'becomes an analogue of the four finger like parallels (perhaps the chair's tassels) in the lower right and the strings of the musical instrument (slightly below center)'.[101] Such fragmented representations of things are no more to be considered reliable mimetic labels for reality than are the words which denote them. Everything here is part of an artificial language, whose conventions can be revealed and broken within an art which aims at a defamiliarizing, estranging relationship to reality. The constant rearrangement of the pictorial planes in such images attacks the (mimetic) illusion which can allow us to 'forget' that we are looking at an artificial contrivance. It reveals the (relativist) conventions by which it has been made, which clearly vary from picture to picture, while retaining a number of stylistic similarities. As we interrogate these pictures for mimetic clues, as if they were complicated interlocking puzzles, and find a nose, a bit of hand, the fret of the guitar, or teasingly 'legible' letters, we find that they refuse to come together to make a single object or sitter.[102] Their geometry demands an awareness of the painter's processes and intentions.

This is a long way from the moody introspective faces of Picasso's Blue Period, or the startling colour harmonies of Matisse's portrait of his wife, and it has profound consequences for the Modernist view of the person: John Berger says that 'by reducing the body to an organisation, comparable with that of a city, [the Cubists] assert the unmetaphysical nature of man'. [103] But this may be an undeserved philosophical compliment. The Cubists are too often credited with having had a new view of reality, whereas it seems that neither Picasso nor Braque were really capable of this kind of thought. The question of the further purposes of this early analytical Cubist technique seems to be an open one.

Picasso and Braque's technical changes have been well summarized by John Golding as 'the construction of a painting in terms of a linear grid or framework, the fusion of objects with their surroundings, the combination of several views of an object within a single image, and of abstract and representational elements in the same picture'.[104] This sounds entirely rational and calculating; however, I believe that even analytical Cubist method is intuitive in execution, as we can see if we ask the question why any part of the image is exactly where it is. As in the case of tonality, once the justificatory procedures of (Renaissance) perspective were overthrown, no new method could be invoked. By this I mean that in tonal music and perspectival painting alike, all the parts of the picture can in theory be explained in terms of a carrying

convention which makes the work coherent. But Schoenberg, Kandin-
sky, Picasso, and Braque have it in common that no such justification
of each part by the reference to an externally defensible convention
is possible. The parts literally do not have to work together, and so
demand a different kind of critical justification.

The responses which Cubism aroused at this time have tended to be
paradigmatic for notions of the 'Modern' and of the avant-garde in the
pre-war period. Like Schoenberg's 'inexorable' disruption of the aural
perspective offered by traditional harmony, its discoveries were de-
fended as akin to those made in experimental scientific research. Roger
Allard wrote as early as 1911 that 'No interested and impartial observer
could doubt that, of all arts, painting now occupies the most advanced
point on the ideal curve of evolution',[105] and this 'advanced point' was
seen as largely motivated by theory, as was that previously occupied by
Matisse. Henri Guilbeaux thus wrote disapprovingly in 1911 of Cubism's
'exclusively linear research, [and] systematisation to excess'.[106] The
claim is that Cubism developed, by making technical advances which
were 'progressive', as if painting were like science, and had an optimum
single line of development as it triumphed over nature. Such claims
were frequently made for Cubism, and the many pictures painted by
Braque and Picasso in this period can indeed be seen as breaking down
the conventions for perspectival representation in a manner which
seems entirely logical in retrospect.[107] One picture is analysed by critics
as the 'appropriate' successor of another, so that the more and more
emancipated treatment of the spatial interval, like that of the dissonant
interval or chord, could free the picture space for new and contra-
dictory (dissonant) implications, which in turn demanded further
investigation. However, such 'theoretical' claims are only implicit in the
paintings and discovered by critics, since the Cubism of Braque and
Picasso did not arise out of a self-advertising avant-garde movement,
and these two artists at least said virtually nothing about it. It was
Picasso's friend André Salmon who owlishly remarked that 'Painting,
from now on, was becoming a science, and not one of the less
austere'.[108] Picasso himself later attempted to strike a more dismissive
note:

Mathematics, trigonometry, chemistry, psychoanalysis, music and what not,
have been related to Cubism to give it an easier interpretation. All this has been
pure literature, not to say nonsense, which has only succeeded in blinding
people with theories.[109]

Once the paintings of Braque and Picasso and many others like them by lesser artists were on public view, the 'Cubists' were perceived as an avant-garde movement, who excited satellite exhibitions like those of the Section d'Or, and were to be explained in treatises like Gleizes's and Metzinger's *Du cubisme* published in 1912. Cubism *and* its accompanying theory, like the *Blaue Reiter Almanack* of Kandinsky and his allies, helped to make the public aware of the existence of an élitist avant-garde. Its conventions thrive on ambiguity, so that the burden of interpretation is carried by the viewer, and yet early Cubism is at base just as 'Expressionist' as the work of Kandinsky, because the placing of most of the elements within the picture plane is intuitive and unconstrained by mimetic convention. Indeed Gleizes and Metzinger asked for a reconstruction of the artist's own mental processes, in which 'the spectator, himself free to establish unity, may apprehend all the elements in the order assigned to them by creative intuition'.[110] More important for later developments because more intelligible, is Metzinger's statement that the Cubists had 'uprooted the prejudice that commanded the painter to remain motionless in front of the object'.[111] The contradictions of the work could be imagined to have arisen from the superimposition of different observational perspectives, and this led to the notion that the experience of passing time was somehow contained within Cubist painting. Thanks no doubt to the contemporary influence of Bergson, this view was very popular. Leo Werth in 1910 spoke of the aim to 'transfer on to the plane of a picture the sensations and reflections which we experience with the passage of time'.[112] But the effect of the paintings we have looked at is surely not one of a shifting viewpoint, and such philosophical positions are not of much use in interpreting these paintings. Taken together, indeed, early Cubist paintings do not present any very coherent 'view of life', as Impressionism and Fauvism did in terms of city life, tourist landscape, and bourgeois pleasure. Nor do they reflect the manners of men or the appreciation of nature in any way that is accessible to the usual kind of poetic support, because everything within the picture plane tends to become still life. It is this contemplative lack of relationship to social activity that does as much as anything to enforce the formalist consideration of Cubism, and to devalue by contrast the experimental painting of the Modernist period which retained a commitment to subject-matter.

5. Language and Innovation

The Cubist achievement in Paris had an extraordinary influence on perceptions of the Modernist movement in all the arts. Rosenberg goes so far as to argue that 'Modern art doesn't begin at any identifiable point, but the modern situation of art undoubtedly began with Cubism', because it so decisively made the link between art and its critical–theoretic appreciation. In finally ending the reign of common-sense nature, it encouraged every subsequent art movement to 'propound its own conception of reality', so that 'A painting in a language in progress could not be understood simply by looking at it'.[113] In a work like Picasso's *Portrait of Vollard* (Spring–Autumn 1910), according to Fry, 'The real subject is not Vollard but the formal language used by the artist to create a highly structured aesthetic object'.[114] In fact it is yet another pyramidal landscape, with a castle head on top.

It has been thought that the language experiments of Gertrude Stein in the same period echo or parallel this Cubist breakdown of the elements of representation in painting. Her own 'portraits' of Matisse and Picasso largely depend upon the changed emphases derivable from the extended repetition with slight variation of syntactic forms, so that parts of the sentence repeat themselves, rather as the parts of an object might in a painting. A sample of the opening of 'Picasso' runs

One whom some were certainly following was one who was completely charming. One whom some were certainly following was one who was charming. One whom some were following was one who was completely charming. One whom some were following was one who was certainly completely charming.

Some were certainly following and were certain that the one they were then following was one working and was one bringing out of himself then something.[115]

And so on. It might be thought that this willingness to reorder the sentence, without reference to any very obvious mimetic (or informational) considerations, is 'abstract' and like the recombination of forms in Cubist painting, which draws attention to itself with a similar insouciance with regard to any commitment to the depiction of an object. Stein's *Tender Buttons* (1911; published 1914) similarly presents us with a series of still-life descriptions of common objects, of obscure (and very likely sexual) metaphorical import. These are for the most part in a kind of timeless continuous present, analogous to the untensed self-presentation of the object in still-life painting. As Stein explains:

In my beginning it was a continuous present a beginning again and again and again, it was a series it was a list it was a similarity and everything different it was a distribution and an equilibration. That is all of the time some of the time of the composition.[116]

Marjorie Perloff thinks that the objects in *Tender Buttons* are 'fragmented and recomposed as they are in Cubist still life'.[117] For example :

A CARAFE, THAT IS A BLIND GLASS

A kind in glass and a cousin, a spectacle and nothing strange a single hurt colour and an arrangement in a system to pointing. All this and not ordinary, not unordered in not resembling. The difference is spreading.[118]

Or

A BOX

Out of kindness comes redness and out of rudeness comes rapid same question, out of an eye comes research, out of selection comes painful cattle. So then the order is that a white way of being round is something suggesting a pin and is it disappointing, it is not, it is so rudimentary to be analysed and see a fine substance strangely, it is so earnest to have a green point not to red but to point again.[119]

But David Lodge seems right to see work like this as closer to Surrealism than to Cubism, 'since it does not confine itself to merely changing the relationship of contiguous planes and of parts to wholes as they are in nature . . . but presents an object in terms of other objects often far removed from it and from each other in context'.[120] Most interpretations of these pieces try to rationalize their metaphors by assuming a hidden figurative conceptual framework (for example 'Box' as indicating the female genitals).

Stein's early work is of great significance as an exercise in the examination of the foundational elements in the art of writing, and of the sentence in particular:

Besides the nouns and the adjectives there are verbs and adverbs. Verbs and adverbs are more interesting. In the first place they have one very nice quality and that is that they can be so mistaken. It is wonderful the number of mistakes a verb can make and that is equally true of the adverb.[121]

To an extent this is like the experimentalism of her contemporaries, of whom she was acutely, if not particularly accurately, aware. Gertrude Stein was not, however, a particularly influential innovator *within* the early Modernist period—her time seems to have come later, with the

various experiments in linguistic combination and recombination of the Postmodernist period, and also as supporting evidence for a critical–theoretic position which sees much gay writing as a category-transgressing type of activity.

I have shown that the work of Kandinsky and Schoenberg, even though its gaze is turned inward, was just as much a language in progress; and that Matisse's simplificatory representation, and equally Expressionist reliance upon instinct, provided an inspiring premiss which worked through Braque and others to the whole Modern movement. In cutting itself off from previous conventions the works described above attempted to construct worlds of their own—even to be locked into an inexorably personal experience (as Kandinsky attempts to construct a private language, and Stein applies evasive metaphor to a semi-censored sexual experience). This is hardly surprising—for as the relativist idea of a plurality of languages spread into those which could be invented for works of art, attention was inevitably turned towards the individual's creative conventions. And so, as Nicholas Cook points out, Schoenberg's work reflects the idea that 'music's ultimate significance lies not in the effect it makes on an audience, but in the integrity with which it expresses the composer's personal vision', as he attempts to make his idea comprehensible to the listener.[122] This idea had to be specified in technical terms, so that Schoenberg (and his many successors) ran the risk of composing only for trained listeners capable of an analytic response.[123]

The Cubists similarly produced a shift from the unreflective enjoyment of the perceptual in art towards the conceptual.[124] As André Salmon was to put it once Cubism was well established: 'The great law that dominates the new aesthetic is the following: conception overrides perception';[125] and Picasso was also to remark that 'Through art we express our conception of what nature is not'.[126] It can be argued that once Modernist painting abandons the recording of perceptions, it becomes a language of signs, so that Impressionism, for example, would be devoted to the recording of perception and Cubism would be a system of signs. The move away from Realism would then be manifested by a use of the surface of the painting to make something that has to be interpreted as more or less conventional, rather than as an indirect record of an act of perception of an external world. Such signs may reveal the ways in which we conceive of the external world, which means that art of this kind does not (really) represent, but rather shows how the mind might use signs to remind itself of aspects of the external

world. (And so even Realist and Impressionist painting can be inter-
preted as a system of such conventions.) But, in the move towards
Modernist self-conscious abstraction, one can go beyond the steady
simplification of the observed object towards the thinking up of various
kinds of conventional signs for it.

The exact interrelationship between this conceptualization and per-
ceptual conventions is far from clear. (Apart from anything else we need
to preserve our intuition that realist art is indeed in some sense realis-
tic.) Those art theorists who advocate a sign-based analysis are usually
trying to show how realist art is actually conventionally organized by the
sign (and the ideologies controlling it): i.e. it has a 'semiotic'. But they
tend to have little to the point to say about the kinds of abstraction we
have been discussing. We obviously need some kind of contrast
between the perceptual and the conceptual, and we have to accept that
they interact in very complex ways, particularly in this period. That is
why so much Modernist painting, in its move towards the conceptual,
can be so perplexing and disturbing to the viewer, as it explores lan-
guages which are more and more private in character.

The basic strategy for innovation, which made the Modernist
movement more radical than its predecessors, was therefore its move-
ment beyond an early stage of stylistic metamorphosis, towards a re-
imagining of the foundational properties of the arts. As I have argued,
the willingness to do this arose partly from a negative background of
scepticism—a reaction against the social sanctions for the certainties
of the nineteenth century, in favour of the claim to autonomous forms
of discourse for art. But it also led more positively, as we have seen in
some detail, towards a willingness to find out what would happen if
basic logical (syntactic), perspectival and representational (object-
related), or implicative (tonal) conventions were not just modified, but
discarded.

This re-imagining was successful because it was at the same time
conservative. All of the artists whose work we have analysed above
mastered past conventions before undertaking this analytical approach
to art. The early Modernists were perhaps the last avant-garde to
apprentice themselves to the production of major work in earlier
styles.[127] An acute awareness of the past and the technical ability to
reproduce it ensured that the early advances of the Modernists were
made through a stylistic metamorphosis of the genres of the previous
tradition (thus opening up various strategies of allusion, even between
such chronologically close but divergent works as Matisse's *Bonheur de*

vivre and Kandinsky's *Garden of Love*). But it also led to a subtractive, essentially simplifying approach to the elements of past work; as in the substitution of the purer light-reflecting pigment of Fauvism for the complex atmospheric local colour of Impressionism, the reduction of landscape to its underlying geometry in Cubism (following Cézanne), the elimination of repetition along with its supporting harmonic organization in Schoenberg, and, in Kandinsky, the progressive elimi-nation of the objects of the external world from the image, in favour of an abstract suggestion of their emotional effects.

The analytic cast of these developments demanded critical languages to support them. As I have suggested, these frequently depended on analogical alliances with other arts (building on the synaesthesia of the immediately preceding Aesthetic and Symbolist traditions). In particu-lar, the language of musical analysis is used to interpret abstract visual art. As painting discarded referential commitments, it justified itself by turning to an art which could arouse feelings without the representation of any kind of object. And if coloured shapes do not depict, they can at least harmonize to soothing effect in Matisse, or be the discordant equivalents of cosmic conflict in Kandinsky. In the process, notions of pattern and design entered into a dialectic with the representational commitments of painting, and within quite conventional genres, such as the landscape (which even Kandinsky can be seen as making) or the portrait. In the most abstract cases, it was claimed that a 'new language' was being invented (or discovered) which correlated colour and non-representational shape with emotion.

Although Kandinskyan and other types of abstraction clearly arrive at a stylistic consistency, the notion that abstract shapes can be correlated in anything like a systematic manner to feelings is doubtful, even when the emotional response is indubitably a strong one. For example, when Robert Hughes looks at Kandinsky's *Black Lines No. 189* of 1913, he sees

three scratched black peaks which may be mountains in the top half of *Black Lines no 189*, but these hardly count as a subject. What does count is the sense of well-being, spring-like joy, induced by the bloom and transparency of its primary colour patches—red, blue, yellow, white—softly expanding towards the eye like halation-patterns in fog.[128]

Such feelings clearly do not need to be rationalized by then being directed towards an actual object—indeed they seem to vary system-atically with the changes in the kind of abstract design that we are looking at. If we look at a whole range of Kandinskys (or Rothkos or

Mondrians or even Monets), there are significant variations in our emotional response, and maybe even ones about which we could to some extent argue which do not depend on finding a plausible real-life object for an analogue, as Hughes does in referring us to the experience of fog. But this should not entrap us in the misleading notion that there is a kind of language of emotion in abstract art, or lead us to believe, with Kandinsky, that it can be rationalized by the effects on us of a partly hidden or obscured natural object.

All of the artists discussed in this chapter believed in the evolution of art, and thought their own work progressive, as they experimented, at far greater length than I have been able to indicate here, with innovatory conventions. This often had results which could be surprising even to their perpetrators, and it was only to be expected that quasi-scientific ideas of experiment (and research) would be applied to them, because, on Modernist premises, you could make art to see what happened, rather than attempt to satisfy a contract to produce particular kinds of effect upon an audience. This foundational rather than rhetorical character of early Modernism also seemed to encourage the analogy with science, in Cubism, and even in the work of Kandinsky, whose formal experiment was supported by the 'science' of occultist investigation into a lost or buried 'ancient wisdom' which could provide the true metaphoric and symbolic foundations of surface languages. The systematic investigation of such symbols (and their associated myths) was indeed described as a science by Frazer, Freud, Jung, Kerenyi, and others in this period, as they attempted to assess the implications of such beliefs for a scientific psychology.

Once the new languages have been mastered, as in the *Harmonie rouge*, Kandinsky's later *Compositions*, Picasso's and Braque's hermetic portraits, and Schoenberg's *Three Piano Pieces*, Op. 11, a more general realization that the most basic binding conventions of previous artistic languages could be radically modified was bound to grow. The ends which such modifications envisaged varied, as we move from Mallarmé's plea for an (internally echoing) language, hieratically removed from everyday concerns, to the realization that avant-gardist conventions can be put into a merely playful or game-like relationship to a subject-matter,[129] as when Braque ironically paints a realistic nail and its shadow at the top of his Cubist *Violin and Palette* of 1909–10. The distinctions between object and context, the grammatical rules of a natural language, the articulation of the part of a musical work through traditional harmony, and the perceptual demands of post-Renaissance

spatial perspective, could all be called into question, to a greater or lesser degree, according to the courage or conviction of the artist.

One effect of all this, as we shall later see in detail, was to put in doubt the logic of rationality itself. 'Mere juxtaposition', in Schoenberg's phrase, can supersede previously accepted logical and formal connections, and the audience can be left to fill in the gaps which result, so far as seems appropriate. In music, painting, and literature the logic which is usually expressed by an explicit syntax began to be replaced by an (unconsciously driven) associative juxtaposition, in relying upon intuitions which became more and more difficult to interpret, even when justified by an appeal to the exceptional, and often dreamlike, nature of the experience being expressed.

Modernist work is allowed to incorporate ambiguity and contradiction—in the conflict and complex implications of the unresolved discord, the impossible materialization of space, the apocalyptic tension between colour shapes with an emotional charge, and the oscillation between brush stroke as object in itself and as representation of something other, these contradictions deny the transparency of the medium. They inevitably draw our attention to the language of the work, which the artist may be tempted to make more and more 'about' its own procedures. As previous conventions, experienced by the artist as a limit to self-expression, begin to disappear, the discursive significance of literature, music, and painting is threatened, in favour of an interest in the artist's psychology. (As in Schoenberg's preference for his own intuition, as opposed to the implications of the mere 'verbal surface' of the text, and Picasso's lack of interest in reproducing his sitters' mere appearance.) It is not surprising then that conservative critics accused the Modernists of being in the grip of a hidden theory. Such radical deviations must have been dictated to them by some anarchic, foreign idea. (The Cubists were indeed attacked in these terms in the French Chamber of Deputies.)[130] They then attempted to exclude the innovating artist from the society of all reasonable persons, by proclaiming that the ideas involved were mad or revolutionary. Even Cézanne could be seen as late as 1910 as one of a number of 'insensate revolutionaries', and the Post-Impressionist exhibitions in London as evidence of 'horror', 'madness', 'infection', 'sickness of the soul', 'putrescence', 'pornography', 'anarchy', and 'evil'.[131]

It may seem that such responses could not possibly have been directed to what we now see as the 'actual content' of innovatory art. But bafflement about this 'content' inexorably led to attacks on the

mental state of the artist, as having been equally confused in the creative process, though for more disreputable reasons. Hence the accusations of childishness, irrationality, or plain insanity made against Schoenberg, for example, in Walter Dahms's description of the *Three Piano Pieces* Op. 11: 'First a child taps the piano aimlessly, then a drunk smacks the keys like mad, and at the end someone seats his —— on the keyboard.'[132] This may be mere abuse, but it comes from a critic then thought authoritative. Hugo Leichtentritt revealed a similar emotional disturbance in his reactions to Schoenberg's *Five Orchestral Pieces*:

It is a tragicomic spectacle to see Schoenberg conducting this crazy cat music, urging on the players with an entranced or despairing expression on his face. These sounds conjure up hideous visions; monstrous apparitions threaten— there is nothing of joy and light, nothing that makes life worth living! How miserable would our descendants be if this joyless, gloomy Schoenberg would ever become the mode of expression of their time! Is this destined to be the art of the future???[133]

Even as late as 1934, Constant Lambert found the *Kammersinfonie* 'as disquieting an experience as meeting a respected family found in a state of half-maudlin, half-truculent intoxication'.[134] A notorious concert at which it was to be performed (on 13 March 1913 in the Musikverein in Vienna) had to be abandoned, once it had arrived (via Webern's *Six Pieces for Orchestra*, Op. 6), at a performance of Alban Berg's second and fourth *Altenberg Lieder*. Members of the audience shouted that 'admirers of this misguided kind of music should be sent off to Steinhof' (the local lunatic asylum),[135] and protesting noise-makers had to be removed by the police. A doctor in a subsequent court action gave it as his judgement that such music was damaging to listeners' nervous systems, and could lead to 'severe depression'.[136]

The point of this narrative is not of course any serious analysis of the dismal Viennese response to atonal music—painful though it was to the original participants. It survives with a representative status, as an anecdote of the avant-garde. No doubt much of the experimental music of the early decades of the twentieth century was received with that same intensely committed resignation as attends many such performances today, and those who had come to Schoenberg's concert looking for trouble found it. The underlying burden of such responses, even when rationalized by political accusations of anarchism and so on, is the fear of the irrational. But many artists in the Modernist period, including Schoenberg and Kandinsky, claimed that their art

was intended to be independent of normal thought processes, and aimed at a transformation of consciousness, to be achieved often enough through the liberation of the unconscious.[137] And so the nature of the unconscious became an issue central to the development of Modernist art.

It is far from coincidental that this period developed psychoanalytical theories, which purported to show that the mad may indeed make sense, and that so many artists were later to be encouraged by such theories to proclaim their reliance upon subconscious processes as in the Surrealist movement. From the beginning of the period, long before Freud was at all well known, the idea of the 'inner necessity' of the unconscious (often enough inspired by Schopenhauer) threatened to move into the conceptual space previously occupied by imagination, and, as we have seen, it was the common inspiration of Schoenberg and Kandinsky. Even in Matisse's work, according to Apollinaire in 1907, 'Instinct was found again. You at last subordinated your human consciousness to the natural unconscious.'[138] The accusation that innovative art was the result of mental disturbance was symptomatic then, not just of large-scale shifts in the paradigms for artistic convention, but also of a clash between incompatible conceptual frameworks to describe the workings of the mind. A deep philosophical change was taking place, so that Modernism, as it became a movement, developed not just an implicit aesthetic, part of which I have outlined above, but made equally challenging assumptions about the nature of the artist and the psychological responses for which the new art might call. The development of new languages for the arts was therefore part of a larger change in ideas about the nature of human nature itself. To this I now turn.

Bibliographical note

For the relationship of much Modernist music to the past, see Joseph N. Straus, *Remaking the Past: Musical Modernism and the Influence of the Tonal Tradition* (Cambridge, Mass., 1990). On Symbolism and inter-art analogies see e.g. D. M. Hertz, *The Tuning of the Word: Musico-Literary Poetics of the Symbolist Movement* (Carbondale, Ill., 1987).

Notes

[1] Raoul Dufy, cited in John Elderfield, *The 'Wild Beasts': Fauvism and its Affinities* (New York, 1976), 32, who cites it as first reported in Marcelle Berr de Turique, *Robert Delaunay* (Paris, 1930), 81.

2 According to George Heard Hamilton, *Painting and Sculpture in Europe* (Harmondsworth, 1967), 159. *The Poor Fisherman* had been exhibited in the Salon d'Automne in the previous year, 1904. But Matisse's painting is closer in subject-matter to Puvis's *The Pleasant Land* of 1882.

3 Letter of 14 July 1905, cited in Pierre Schneider, *Matisse* (London, 1984), 98.

4 Picasso would have seen *Luxe calme et volupté* in the spring of 1905 and it may well have inspired him to competition in the magnificent *Saltimbanques* of the same year, which also has strong Impressionist, Symbolist, and literary associations, and a composition indebted to Puvis de Chavannes.

5 Jack Flam, *Matisse, the Man and his Art, 1869–1918* (London, 1986), 123.

6 Lawrence Gowing, *Matisse* (London, 1979), 51.

7 Henri Matisse, cited in Georges Duthuit, *The Fauve Painters* (New York, 1950), 43.

8 Part of the answer may be that Matisse is engaged once more as a good traditionalist in the stylistic metamorphosis of one of his predecessors, in this case Manet's *Portrait of Berthe Morisot with a Bunch of Violets* (1872) where the skin tones are similarly divided into light and dark.

9 Flam, *Matisse*, 146. Cf. the two versions of *The Young Sailor*, *Le Luxe I* and *II*, and the *Piano Lesson* and the *Music Lesson*.

10 André Gide, in the *Gazette des Beaux Arts*, on the Salon d'Automne, 1905: cited in Alfred H. Barr, Jr., *Matisse, his Art and his Public* (1951; repr. London, 1975), 63. He saw the *Femme au chapeau* and other similarly shocking pictures exhibited at the Salon in 1905, but not *Madame Matisse*.

11 Maurice Denis, 'Le Salon d'Automne, 1905', in *L'Ermitage* (15 Nov. 1905), 317–19, and cited in Flam, *Matisse*, 140.

12 Flam, *Matisse*, 157, directs us to 'L'Après-midi d'un faune':

> These nymphs, I want to perpetuate,
> > so clear
> Their light carnation, that it drifts in the air
> Drowsy with tufted slumbers.
> > Did I love a dream?

But there are a few difficulties here—for if anyone has to be the priapic Faun, it is the spectator. Flam also thinks the painting echoes the poem's imagery, in its 'airy disjunction', in the rhymes between the figures and particularly in paralleling Mallarmé's 'Inert, all things burn in the tawny air' ('l'heure fauve'). But this is to push inter-art analogy too far.

13 Flam, *Matisse*, 159 f.

14 Henri Matisse, *Notes of a Painter* (1908), repr. Jack D. Flam (ed.), *Matisse on Art* (Oxford, 1973), 36.

15 The term seems to have been used originally by Vauxcelles in 1905 as a mere witticism, but, by 1907, when the influence of Matisse and Derain was obvious—upon Friesz and Dufy, for example, Vauxcelles's frequent use of the

term gave it currency as describing a movement. Late in this year the tech-niques that were to lead to analytical Cubism began to attract painters such as Braque and Derain, who had up to now been painting in a Fauvist style, and Fauvism and Cubism could soon be perceived as alternative modes of response to Cézanne.

[16] Though it has to be admitted that in the work of minor Fauves, like Marquet, Valtat, and Van Dongen, one can find that an Impressionist subject-matter and organization are given a Modernist tang by the use of strong and appar-ently arbitrary colour.

[17] Flam, *Matisse*, 234, quoting the *Revue de la quinzaine* (Nov. 1908), 161. For a more detailed account of critical responses to Fauvism see Roger Benjamin, 'Metaphor and Scandal at the Salon', in J. Freeman (ed.), *The Fauvist Land-scape* (New York, 1990), 241–68.

[18] Henri Matisse, in *La Grande Revue* (25 Dec. 1908), repr. in Flam (ed.), *Matisse on Art*, 36.

[19] Van Gogh, in Herschel B. Chipp, *Theories of Modern Art* (Berkeley, Calif., 1968), 36, 37, from two letters to Theo Van Gogh of 8 Sept. 1888 and the other n.d., but Sept. 1888.

[20] Henri Matisse, *Notes*, in Flam (ed.), *Matisse on Art*, 37.

[21] Henri Matisse, cited in Gowing, *Matisse*, 95, no reference given. The second version, *Dance II*, is more expansive, more obviously Dionysian in its energy, and with a far starker contrast of primary colours.

[22] Wassily Kandinsky, 'On the Question of Form', in Klaus Lankheit (ed.), *The Blaue Reiter Almanack* (London, 1974), 182.

[23] Ibid. 168.

[24] On this theory, see Sixten Ringbom, *The Sounding Cosmos* (Åbo, 1970), 120–8.

[25] Wassily Kandinsky, *Concerning the Spiritual in Art*, trans. Michael Sadler (1914; repr. New York, 1977), ch. 6, 'The Language of Colours', 37 f. I have preferred to use Sadler's contemporary translation, but I also give page references to *Kandinsky: Complete Writings on Art*, ed. Kenneth Lindsay and Peter Vergo, 2 vols. (London, 1982); in this case, *Writings*, 181.

[26] Kandinsky, *Concerning*, 25; *Writings*, 160.

[27] As we can see from his play *Die gelbe Klang* (*The Yellow Sound*) in Lankheit (ed.), *Almanack*, 207 ff.). 'The invisible Moses descends from the mountain and sees the dance round the golden calf. But he brings with him fresh stores of wisdom to man. First by the artist is heard his voice, the voice that is inaudi-ble to the crowd.' (Kandinsky, *Concerning*, 8; *Writings*, 137).

[28] Kandinsky, *Concerning*, 10; *Writings*, 139, trans. as 'believing in infallible remedies, and prescriptions of universal application'.

[29] I find the attempt of Mark Cheetham, *The Rhetoric of Purity* (Cambridge, 1991), to ally his work to Hegel and Schopenhauer as 'philosophical traditions, that consciously or not, he ratifies' (79) less than convincing. But cf. ibid. 83 ff.

[30] Kandinsky, *Concerning*, 57; *Writings*, 218.

[31] Cf. Kandinsky's views on children's art in Lankheit (ed.), *Almanack*,174 ff.

[32] Kandinsky, *Concerning*, 36, 39, 38; *Writings*, 183, 185.

[33] Rose-Carol Washton Long, *Kandinsky: The Development of an Abstract Style* (Oxford, 1980), 103, suggests that the pastel tone and dominant colour scheme of orange and yellow may have been suggested by the earlier work. The composition is much simplified but retains 'the curving format found in the famous work of Matisse'.

[34] Long, *Kandinsky*, also cites (105) Zinaida Gippius, who believed that the sexual act was 'an act of creation—one creates in oneself and in one's beloved the image of God and restores both partners to an absolute unity'. As in Yeats, the circle may be resolved into a sphere by sexual intercourse.

[35] Ibid. 104.

[36] Kandinsky, *Concerning*, 44, 46; *Writings*, 194, 197.

[37] Guillaume Apollinaire, in Leroy C. Breunig (ed.), *Apollinaire on Art*, trans. Susan Suleiman (London, 1972), 214. He saw *Improvisations Nos. 24 (Troika 2)*, a study for the *Garden of Love*, and *26 (Rowing)*, at the Indépendants in Mar. 1912.

[38] Hence the basic thesis of Professor Long, that 'In 1911 and early 1912 most of his motifs are easily recognisable and are often of a religious nature, usually related to *The Revelation to John*. While the majority of these motifs in the works of middle and late 1912, 1913, and 1914 can be identified only with the help of sketches and earlier related works, they remain indispensable to his purpose' (*Kandinsky*, 74).

[39] Wassily Kandinsky, cited in Jelena Hahl-Koch, *Arnold Schoenberg/Wassily Kandinsky: Letters, Pictures and Documents*, trans. J. C. Crawford (London, 1984), 205, from a supplement to the Russian version of Kandinsky's *Reminiscences* (1918; originally published in German in *Der Sturm* in 1913).

[40] Long, *Kandinsky*, 110.

[41] Similar to those in the paintings called *Deluge*, cf. Long, *Kandinsky*, 193–5.

[42] Ibid. 110.

[43] Ibid. 111 f.

[44] Kandinsky, in Hahl-Koch, *Arnold Schoenberg*, 206 f.; *Writings*, 384. His remarks were originally published in Herwarth Walden's *Sturm Album* (Berlin, 1913). The painting was exhibited in Berlin by Walden in 1912.

[45] George Heard Hamilton, *Painting and Sculpture in Europe* (Harmondsworth, 1967), 213.

[46] Paul Overy, *Kandinsky: The Language of the Eye* (London, 1969), 16.

[47] See Long, *Kandinsky*, 120 ff., and her plates, 148–55. The boat is lower left, with the black semicircular outline of its hull intersected by three parallel lines for the oars. The mountain leans out at an angle in the upper right corner, with a blue greenish colour, outlines in yellow-white, and a red patch to be associated with the walled city at its peak. In the upper centre there are trumpets associated with the Last Judgement, in slim golden rectangular

forms quite different from those in previous pictures with the titles of *Last Judgement* or *All Saints Day*. Long also sees an arched bridge and hills in the lower right. Tiny boats and the image of the horse and rider also appear in the studies.

[48] Ibid. 122.

[49] Wyndham Lewis, in *Blast II* (1915; repr. Santa Barbara, Calif., 1981), 40. More rudely, 'He allows the Bach-like will that resides in all good artists to be made war on by the slovenly and wandering spirit', 43.

[50] Kandinsky, in Lankheit (ed.), *Almanack*, 164.

[51] Particularly that by De Kooning, Gottlieb, Guston, Hofman, Gorky, Baziotes, and Pollock; cf. Irving Sandler, *Abstract Expressionism* (London, 1970).

[52] Richard Sheppard, 'Kandinsky's Œuvre, 1900–14: The Avant Garde as Rear Guard', *Word and Image*, 6 1 (Jan.–Mar. 1990), 42.

[53] Wassily Kandinsky, 'Ruckblicke', in *Kandinsky 1901–1913* (Berlin, 1913), p. xix; *Writings*, 373.

[54] Kandinsky, *Concerning*, 32; *Writings*, 169.

[55] Franz Marc, letter of 14 Jan. 1911, repr. in Hahl-Koch, *Arnold Schoenberg*, 136.

[56] 'A Self Analysis' (1948), in *Style and Idea: Selected Writings of Arnold Schoenberg*, ed. Leonard Stein and trans. Leo Black (London, 1975), 76.

[57] Such excesses are inappropriate to Maeterlinck's *Pelléas*, which had been set by Debussy as an opera; it was first performed in 1902, but was then unknown to Schoenberg. Yeats thought that Maeterlinck's characters were 'faint souls, naked and pathetic shadows already half vapour and sighing to one another upon the border of the last abyss' ('The Autumn of the Body', 1898), and Debussy's setting perfectly suggests this trembling upon the edge of inarticulacy and *non sequitur*, in the tactful subordination of its orchestral accompaniment to the flow of speech.

[58] Arnold Schoenberg, cited in Willi Reich, *Schoenberg* (London, 1971), 48.

[59] Cf. Nick Cook, *Music, Imagination and Culture* (Oxford, 1990), 178–84. He speculates that such difficulties partly arose from the severely anti-popular stance of many advanced composers from Schoenberg on, much reinforced by the attitudes of Theodor Adorno.

[60] Carl Dahlhaus reminds us that 'The categories that combine to make up Schoenberg's musical poetics, categories such as idea [Gedanke], development, consequence and logic, are an expression of the tendency to conceive of a musical work in an almost unmetaphorical sense as discourse, as a tonal thought process', *Schoenberg and the New Music* (Cambridge, 1987), 75.

[61] Arnold Schonberg, 'New Music: My Music' (*c.*1930), in *Style*, 102.

[62] Ibid. 127.

[63] The work has five sections, making it a symphony in several movements or, in Berg's later interpretation, a symphony in one sonata movement, with an adagio and scherzo episodes interpolated. Previous models include the Liszt piano sonata, and Schoenberg's own first string quartet of 1905.

[64] Schoenberg, *Style*, 84.

[65] Igor Stravinsky and Robert Craft, *Dialogues* (1968; repr. London, 1982), 106.

[66] Charles Rosen, *Schoenberg* (London, 1975), 29.

[67] Arnold Schoenberg, 'My Evolution' (1949), in *Style*, 86.

[68] Ibid.

[69] Egon Wellesz, *Arnold Schoenberg*, trans. W. H. Kerridge (1925; repr. New York, 1969), 6. For other recollections of early performances, cf. Joan Allen Smith, *Schoenberg and his Circle* (New York, 1986), 65–128.

[70] Jim Samson, *Music in Transition* (London, 1977), 112, quoting from U. Rauchhaupt, *Schoenberg, Berg and Webern: The String Quartets*, trans. E. Hartzel (Hamburg, 1971), 49.

[71] Schoenberg, *Style*, 217 f.

[72] Ibid. 144. 'In all music composed to poetry, the exactitude of the reproduction to the events is as irrelevant to the artistic value as is the resemblance of the portrait to its model' (ibid. 145).

[73] Ibid. 95.

[74] John C. Crawford, 'Schoenberg's Artistic Development to 1911', in Hahl-Koch, *Arnold Schoenberg*, 181.

[75] Samson, *Music*, 183.

[76] Arnold Schoenberg, 'My Evolution' (1949), *Style*, 78.

[77] Arnold Schoenberg, cited in H. H. Stuckenschmidt, *Arnold Schoenberg, his Life, Work and World* (London, 1977), 70.

[78] Cited in Nicolas Slonimsky, *Music Since 1900* (3rd edn., New York, 1949), 127–8; this is not by Schoenberg but by Krug, see Willi Reich, *Alban Berg* (London, 1965), 223–5.

[79] Ernest Newman, *Testament of Music* (London, 1962), 111 f. Originally published in 1914.

[80] Schoenberg, 'On Music Criticism' (Oct. 1909), *Style*, 195. Cf. his remarks on the language of the subconscious in our response to Wagner, ibid. 192.

[81] His library in 1913 contained, according to Stuckenschmidt, *Schoenberg*, 183, volumes by Balzac 12, Dehmel 10, Rilke 9, Kraus 12, Ibsen 5, George 11, Hauptmann 6, Maeterlinck 18, Strindberg 28, Kant 11, Schopenhauer 6, Bergson, Nietzsche, and Plato all 4, Aristotle 2, and a volume of Swedenborg's letters. And up to 1919 it expanded to include the complete works of Altenberg, Kandinsky, Kokoschka, Weininger, and Kraus.

[82] Wassily Kandinsky, letter of 18 Jan. 1911 to Schoenberg in Hahl-Koch, *Arnold Schoenberg*, 21. He also sent a portfolio of his works.

[83] Arnold Schoenberg, letter of 24 Jan. 1911, ibid. 23.

[84] Schoenberg, ibid. 38.

[85] Kandinsky, *Blaue Reiter Almanack*, 153, 150. And this is paralleled in the *Almanack* by Hartmann's article 'On Anarchy in Music': 'In all the arts, and especially in music, every method that arises from an inner necessity is right' (ibid. 113).

[86] Dahlhaus, *Schoenberg*, 82. This attitude, more prone to illusion and fantasy than any dogmatism, developed according to Dahlhaus 'from Wackenroder's emotional devotion via Schopenhauer's metaphysics of the will to Sigmund Freud's psychology of the instincts, which was adopted by Schoenberg' (ibid. 82 f .).

[87] For the inevitable reaction, see Christopher Green, *Cubism and its Enemies* (New Haven, Conn., 1987). Kirk Varnedoe, *A Fine Disregard: What Makes Modern Art Modern?* (London, 1990), shows that a convincing account of Modernist painting can be given without Cubist claims at its centre.

[88] Michel Puy, in Edward Fry, *Cubism* (London, 1966), 65.

[89] William Rubin, 'Cézannisme and the Beginnings of Cubism', in *Cezanne, the Later Work* (London, 1978), 151–202.

[90] Ibid. 158; Rubin shows that Braque's *Landscape at L'Estaque* of Oct.–Nov. 1907 is almost a 'paraphrase' of Cézanne's *Bend in the Road at Montgeroult* of 1898. For Braque's considerable achievement as a Fauvist landscape artist, see Judi Freeman, *The Fauvist Landscape* (Los Angeles, 1990), *passim*, and esp. 215–38.

[91] This photograph by D.-H. Kahnweiler is reproduced in Rubin, *Cézanne*, 178, and in Fry, *Cubism*, pl. 10.

[92] Louis Vauxcelles, in *Gil Blas* (14 Nov. 1908), cited in Fry, *Cubism*, 50.

[93] Guillaume Apollinaire, ibid. 49.

[94] John Golding, *Cubism, 1907–1914* (London, 1972), 77.

[95] Cubism's making the 'subject' no more important than its background is seen by Stephen Kern, *The Culture of Time and Space, 1880–1918* (London, 1983), 8, as a symptom of a 'levelling of hierarchy in various areas of western culture'; and yet the connection urged here is surely analogical rather than causal. This sort of allegorization bedevils much interpretation of Cubism. Thus Fritz Novotny (in 1938) saw the relationship of the Cubist object to it surroundings in a rather different but equally analogical way. For him, Cubism represented an 'alienation of objects from reality' and was the symptom of a culture plagued by nihilism, that 'affirmed the unreality of place' (Fritz Novotny, *Cézanne*, 141–3, 188, cited in Kern, *Culture*, 148).

[96] Jacques Rivière in Fry, *Cubism*, 79.

[97] Robert Delaunay, cited in Golding, *Cubism*, 14.

[98] In Georges Braque, 'La Peinture et nous' (an interview with Dora Vallier, published in 1954), 16, cited in Golding, *Cubism*, 114 f.

[99] Cf. the similar parallels between the earlier Picasso, *Accordionist* (summer 1911) and Braque's *Man with a Guitar* (summer 1911).

[100] Robert Rosenblum, *Cubism and Twentieth Century Painting* (New York, 1966), 48.

[101] Ibid. 65.

[102] 'If illusion is due to the interaction of clues and the absence of contradictory evidence, the only way to fight its transforming influence [in Cubism] is to

make the clues contradict each other and to prevent a coherent image of reality from destroying the pattern in the plane' (Ernst Gombrich, *Art and Illusion* (London, 1956), 281 f.). But he is analysing a rather later and far more 'legible' Braque of 1928.

[103] John Berger, *Success and Failure of Picasso* (Harmondsworth, 1965), 59.

[104] Golding, *Cubism*, 10.

[105] Allard in Fry, *Cubism*, 63.

[106] Henri Guilbeaux in *Hommes du jour* (24 June 1911), cited in Mark Roskill, *The Interpretation of Cubism* (Philadelphia, 1985), 43.

[107] For an extended sequence of pictures see e.g. the exhibition catalogue, William Rubin (ed.), *Picasso and Braque: Pioneering Cubism* (New York, 1989).

[108] André Salmon (1912), in Fry, *Cubism*, 82. He may well have been aware of the absurd mathematical analogies for Cubist painting that were soon current: 'if geometry owes its certainty to the suggestions of our senses, why not reverse the process and go from geometry to nature? Or again, why not, starting from nature, arrive at a mathematics accessible to the sense, a mathematics that would be art?' (Leon Werth on Picasso in 1910, in Fry, *Cubism*, 57.) And Roger Allard writes about the 'quadratic equations and ratios' in Cubism two years later (ibid. 71). He says the artist brings 'order into mathematical chaos by bringing out its latent rhythm'. And Gleizes and Metzinger in their widely distributed *Du cubisme* of 1912 refer to 'Riemann's theorems' and the 'non-Euclidean scientists' (cf. Fry, *Cubism*, 106).

[109] Pablo Picasso in 1923; see Fry, *Cubism*, 168.

[110] Gleizes and Metzinger, cited in Fry, *Cubism*, 109.

[111] Metzinger in 1911, ibid. 66.

[112] Leo Werth in Fry, *Cubism*, 57. This judgement is very likely influenced by the Bergsonian notion of 'durée'—the idea that present experience carries past experience wrapped up in it, rather than simply being the last in a succession of discrete moments. (See below, Ch 3.)

[113] Harold Rosenberg, 'The Cubist Epoch', in *Art on the Edge* (London, 1976), 162, 163.

[114] Fry, *Cubism*, 20.

[115] Gertrude Stein, *Look at Me Now and Here I Am: Writings and Lectures, 1909–45*, ed. Patricia Meyerowitz (Harmondsworth, 1971), 213.

[116] Gertrude Stein, 'Composition as Explanation', ibid. 29.

[117] Marjorie Perloff, *The Poetics of Indeterminacy: Rimbaud to Cage* (Princeton, NJ, 1981), 102.

[118] Stein, *Look at Me*, 161.

[119] Ibid. 163.

[120] David Lodge, *The Modes of Modern Writing* (London, 1977), 152. On the parallel with painting in Stein, cf. also Michael J. Hoffmann, *The Development of Abstraction in the Writings of Gertrude Stein* (Philadelphia, 1965), 161–81; and Wendy Steiner, *Exact Resemblance to Exact Resemblance: The Literary Portraiture of Gertrude Stein* (New Haven, Conn., 1978), 131–60.

[121] Gertrude Stein, 'Poetry and Grammar', in *Look at Me*, 126. William Gass is one of the critics who are most aware of the way in which Stein experimented with the structure of the sentence; see his 'Gertrude Stein and the Geography of the Sentence', in *The World within the Word* (Boston, 1979), 63–123. He discusses A CARAFE, 82–4, and A BOX, 90–8; he concludes, after much ingenious interpretation of the sound and other patterns in the paragraph, that the latter is 'an ironic argument, (the jest in "suggesting") for lesbianism on the grounds that such sexual practices preserve virginity, avoid God's punishment, and do not perpetuate original sin' (98).

[122] Nicholas Cook, *Music, Imagination and Culture* (Oxford, 1990), 8. Cf. Schoenberg in *Style*, 285, and cf. Cook, *Music*, 180 ff.

[123] Dangers fully spelt out by Cook, *Music, passim*, esp. 166, and, with reference to the *Five Orchestral Pieces*, 197 f.

[124] The view that art exists to re-create our perceptual experience, so that the painter's image can be more or less matched to our experience of the external world, is a plausible view of art elaborated by Ernst Gombrich in his classic *Art and Illusion* (London, 1962), and elsewhere.

[125] André Salmon, 'L'Art nègre' (1920), from 'Propos d'atelier', cited in William Rubin (ed.), *Primitivism in Twentieth Century Art*, i (New York, 1984), 247.

[126] Pablo Picasso in 1923, cited in Fry, *Cubism*, 166. Cf. also Norman Bryson, 'Semiology and Visual Interpretation', in id. *et al.* (eds.), *Visual Theory* (Oxford, 1991), 61 ff.

[127] Hence the Symbolist eroticism of Schoenberg's Wagnerian *Verklärte Nacht* (*Transfigured Night*) (1899), the Brahmsian classicism of his *First String Quartet* (1905), Stravinsky's *Piano Sonata* of 1903–4 (an 'inept imitation of late Beethoven' according to his *Memories and Commentaries* (London, 1960), 28), and his *Symphony in Eb* of 1906. Even *The Firebird* (1910) follows Rimsky and Tchaikovsky, with hints of the more advanced Debussy, Scriabin, Dukas, and Ravel. Picasso's Blue and Rose periods (of *c*.1902–4) echo Degas and other Impressionists and the Symbolist theatre, in his many images of the Bohemians, Circus people, and outcasts of the city, and give rise to at least two masterpieces. These are *La Vie* of 1903–4, strongly related to the Symbolism of other 'cycle of life' pictures, and the magnificent *Les Saltimbanques* of 1905, with its strong Impressionist and Symbolist associations.

[128] Robert Hughes, *The Shock of the New* (London, 1980), 301. He continues: 'Such works represent Kandinsky's painting at its best, and their conviction as painting rises above the eager fatuities of Kandinsky's own philosophising.' For Long the picture represents a Steinerian 'spirit land', though she says that Kandinsky referred to this work in 1936 and 1937 as one of the few from 1913 which did not derive from a physical source. There are yet again a reclining figure and couple in related crayon and water colour studies, but she admits that no trace of these persists into the later work (Long, *Kandinsky*, 135).

[129] Cf. Wittgenstein's reliance upon notions of game and convention after his failure to fix language on to the world in the *Tractatus*.

[130] Cf. Patricia Leighten, *Reordering the Universe: Picasso and Anarchism, 1897–1914* (Princeton, NJ, 1989). 96 ff.

[131] Cf. Charles Harrison, *English Art and Modernism, 1900–1930* (London, 1981), 47.

[132] Walter Dahms, cited in Frederick V. Grunfeld, *Prophets without Honour* (London, 1979), 150.

[133] Hugo Leichtentritt, in *Signale* (Berlin, 1912), cited in Nicolas Slonimsky, *Lexicon of Musical Invective* (New York, 1969), 150.

[134] Constant Lambert, *Music Ho!*, 249.

[135] Newspaper report, cited in Stuckenschmidt, *Schoenberg*, 185.

[136] Ibid. 186.

[137] Schoenberg himself, in writing his opera *Die Gluckliche Hand* (1911), had attempted to follow Kandinsky's *Gelbe Klang* in 'the renunciation of any conscious thought, any conventional plot' (Hahl-Koch, *Arnold Schoenberg*, 54). His aim (as he later stated it for a projected film of the work) was

The utmost unreality!

The whole thing should have the effect (not of a dream) but of chords. Of music. It must never suggest symbols, or meaning, or thoughts, but simply the play of colours and forms. Just as music never drags a meaning around with it, at least not in the form in which it [music] manifests itself, even though meaning is inherent in its nature, so too this should simply be like sounds for the eye, and so far as I am concerned everyone is free to think or feel something similar to what he thinks or feels while writing music. (Ibid. 100.)

[138] Guillaume Apollinaire, interview with Matisse, reported in *La Phalange* (15 Dec. 1907), repr. in Leroy C. Breunig, *Apollinaire on Art* (London, 1972), 37.

THE MODERNIST SELF

1. Internal Divisions

Joseph Conrad

Joseph Conrad's *Heart of Darkness* (1899) anticipates many of the philosophical and psychological concerns of the early decades of the twentieth century concerning the nature of personal identity. It also poses its questions against a fantastic, even Symbolist, background which leads to deep ambiguities, and is an early contribution to a long debate on the nature of the 'civilized' and the 'primitive', which affects all the arts in the Modernist period. Conrad's narrator Marlowe is a 'shameless prevaricator'[1] whose story shows how 'absurdity, surprise, and bewilderment' are part of 'that notion of being captured by the incredible which is of the very essence of dreams' (*HD* 39). His journey up the African river Congo to find the ivory hunter Kurtz at the Inner Station 'was like travelling back to the earliest beginnings of the world' (*HD* 43) and is also, as many interpreters of this 'dream' have noted, a journey into the primitive layers of the self. 'The thing was to know what he [Kurtz] belonged to, how many powers of darkness claimed him for their own' (*HD* 70). As the story progresses, the question becomes: what can one learn from an immersion in the primitive?

Kurtz may seem to be an enlightened European, 'an emissary of pity and science, and progress' (*HD* 36), and when he makes his report to the International Society for the Suppression of Savage Customs he tells his readers that white men appear to savages as 'supernatural beings' who can do unlimited good (presumably of an imperialist kind) 'by the simple exercise of [the] will' (*HD* 72). His hypocrisy and Nietzschean contempt for his inferiors breaks out in a later emendation to his script: 'Exterminate all the brutes!' (*HD* 71). For Kurtz's 'soul was mad' (*HD* 95). He has 'gone native', and taken part in barbaric rites, partly because he 'lacked restraint in the gratification of his various lusts' (*HD* 83), and yet he is one to whom 'knowledge' may have come at the last. In communicating it he can say little more than 'The horror! The horror!' (*HD* 100), a

mere cry, which Marlow thinks 'was an affirmation, a moral victory, paid for by innumerable defeats, by abominable terrors, by abominable satisfactions' (*HD* 101). The nature of these experiences is far from clear to the reader, for this text is a good example of Modernist scepticism. It is full of indications of the epistemological inadequacy of its own narrative, with its smile 'of undefinable meaning' (*HD* 97), its 'unspeakable rites', and its spell-like 'stillness of an implacable force brooding over an inscrutable intention' (*HD* 48, cf. 87).

The mystery of Kurtz is that of a self whose overt morality is a rationalization of the desire to dominate, and so finds itself uneasily poised between the 'civilized' and the 'primitive'. The 'forgotten brutal instincts' (*HD* 94) of men may indeed be recovered, by the kind of investigation which shows how their place in our personal history recapitulates the history of the race. Conrad and many of the anthropologists of his time and Freud and Jung all agree that 'The mind of man is capable of anything—because everything is in it, all the past as well as all the future' (*HD* 52).[2] Marlow's story of an encounter with an alien civilization, like Freud's, is directed towards our learning about ourselves:

> They howled and leaped, and spun, and made horrid faces; but what thrilled you was just the thought of their humanity—like yours—the thought of your remote kinship with this wild and passionate uproar. Ugly. (*HD* 51)

Conrad's fable raises issues which are central to the thought of the early twentieth century. First, and most obvious perhaps, that of the self-deception involved in the justification of our instinctive impulses. Secondly, Conrad sees, along with many others, that such contradictions are not just on the surface, but divide the personality. We may find, in what he still calls the 'soul', a disquieting evolutionary legacy in the form of archaic subconscious impulses.[3]

Friedrich Nietzsche

Conrad's text arises from a form of dualism, which superseded Platonic–Christian notions of reason embattled against the passions in the Modernist period. The moral interpretation given to this new dualism led to profound changes in many people's framework of ideas. The reason or conscience, upon which traditional moral theory had so much relied, comes to be seen, under the influence of thinkers such as Nietzsche and Freud, as the inherently unreliable arbiter of a 'system of relations between various passions and desires',[4] many of which may even be unconscious or repressed. As the realization grew that the argu-

ments of reason (and of authority) are inherently likely to camouflage disreputable motives, self-distrust and scepticism became widespread. This painful revelation of suppressed feeling was dramatized for the Moderns not just on the familiar moral scene of everyday self-deception, but most particularly in the institutions of marriage and the family (by Ibsen, Wedekind, and Strindberg), and demanded an extrapolation on to the larger canvas of society. As the turn-of-the-century work of these writers makes clear, the stresses and strains of emotional conflict can radically distort our perception of the external world (an effect to be seen also in the painting of Van Gogh and Munch). This can lead to all sorts of fraudulent behaviour, secretly subservient to a passion-driven Will to Power, which official morality vainly attempts to deny.

On this view, the most widely accepted religious commitments and social principles may be seen as little more than masks for self-interest. Hence Nietzsche's attack on Christianity, as a 'slave morality' which rationalizes the (originally) lowly position of its adherents by exalting humility. It therefore purported to despise the wealth and power of its early oppressors as 'really' unfulfilling obstructions to the deferred and other-worldly happiness of salvation. For Nietzsche this attitude simply masks a not very sublime form of sour grapes, and arises out of a particular moment in history. It can have no universal pretensions. Indeed one of his most important arguments in *On the Genealogy of Morals* is that *all* such moral values arise to meet particular historical conditions and so are relative to one another, and, what is more, deviously express the power and social position of those whose interests they serve, so that 'political supremacy always gives rise to notions of spiritual supremacy'.[5] At the most bleak, the values of those in power can be a mere façade for moral nihilism. So far Nietzsche and Marx (and Kurtz) have a lot in common. But Nietzsche goes on to argue that the invention of new values, and of a new 'noble' morality independent of such forms of self-deception, is necessary, and that it will grow out of 'triumphant self-affirmation'.[6]

The belief that the universalizing arguments of philosophy and theology may actually arise from disreputable motives promoted a sceptically relativist approach to ethics. In a period in which so many relied on obedience to authority to order their lives, such doubts could lead to a radical subjectivism. Once God and his means for transmitting moral imperatives are discarded, men and women can find themselves existentially alone, and intensely divided between the conformist pressures of society and an awareness of their own deeper motivations. The

result is a division within the self; so that what one might for convenience call the psychoanalytic revolution completed the Darwinian one.

'My hypothesis', says Nietzsche, is the 'subject as multiplicity'.[7] His attack on the unitary, atomistic soul or self as a fiction is related to his relativism and his hostility to religion.[8] 'The truth' about the world is not waiting out there to be discovered; nor is an objectively given, uninterpreted self, although it is the task of philosophy and religion to pretend that they are: 'The demand for truthfulness presupposes the knowability and stability of the person. In fact, it is the object of education to create in the herd member a definite faith concerning human nature: it first invents the faith and then demands "truthfulness".'[9] One of Nietzsche's counters to this dogmatic certainty is his use of political metaphors to describe a self, which he sees as inherently divided, into 'a multiplicity of subjects, whose interaction and struggle is the basis of our thought and our consciousness in general'.[10]

The revolutionary consequences of widespread speculations of this kind, by which the individual enters into Modernist literature as the field of conflicting forces and drives, are still a matter of intense concern.[11] The essential premiss is that the individual may be subject to the dissolution of an identity which attempts to contain competing mental systems. It receives a typical formulation in Strindberg's preface to *Miss Julie* (1888), where he describes his characters (who are nevertheless naturalistically presented) as 'conglomerations of past and present stages of civilisation, bits from books and newspapers, scraps of humanity, rags and tatters of fine clothing, patched together as is the human soul'. By the time of his *A Dream Play* (1903) this conception of character is brought within an Expressionist narrative structure, which Strindberg emphasizes as having a 'disconnected but apparently logical form' as in a dream, in which 'The characters split, double, multiply; they evaporate, condense, scatter and converge.'[12] The work I wish to study in what follows develops these disturbing notions of dream, fantasy, and internal self-division, as innovative resources for new styles of expression. These are often, as we have already seen, hostile to the 'bourgeois' logic of everyday reality, and attempt to explore the unconscious.

Sigmund Freud

Freud was much influenced by such nineteenth-century views. As Rieff

concludes, he 'is radically anti-Kantian . . . his theory of cognition in service to the emotions, the egoistic self, the will, completes the psychologising of philosophy initiated by Schopenhauer and Nietzsche'.[13] He came to see the causes of our precariousness of identity as lying within a hidden narrative of sexual development, which we can now see as part of the politics of the late nineteenth-century, bourgeois family. He was willing to apply his clinical diagnosis to the culture as a whole, and his social criticism reinforces the temptation to see the early Modern period as the dawn of a 'Freudian' era. But whatever the cultural fortunes of psychoanalysis at a later date, to see Freud as uniquely influential before 1914 would be a mistake.[14] He recognized the long nineteenth-century intellectual prehistory of the unconscious, and his work has to be seen first of all as an attempt to systematize all this speculation in the form of a 'science' which was to guide therapy.[15]

The Interpretation of Dreams (published in November 1899)[16] explores an inner world which interacts with the literature of his time. It struck him that his own case histories were 'like novellas', and 'they lack, so to speak, the serious stamp of scientific method'.[17] His essentially literary method of interpretation moves towards a Nietzschean preoccupation with the role of archaic impulse within the psyche. For as the dream narrative is 'scientifically' explained and systematized as an allegory, within which 'incidental detail can always be significant', its levels of interpretation emerge as the 'manifest and the latent content' of the dream, once the 'psychical material that has been suppressed comes to light'. (He refers us to Anatole France's *Le Lys rouge* here.) [18]

In attempting to fulfil suppressed wishes and to escape moral judgement, dreams parallel poetic creation, and reveal a division of the personality between 'currents or systems', one of which constructs the wish, while the other exercises censorship.[19] Such conflicts have their sources in childhood, for

The deepest and eternal nature of man, upon whose evocation in his hearers the poet is accustomed to rely, lies in those impulses of the mind which have their roots in a childhood which has since become prehistoric. Suppressed and forbidden wishes from childhood break through in the dream.[20]

Freud sees childhood as recapitulating the archaic; the childhood of the individual and the primitive beginnings of the race interact. Both Freud and Jung credit Nietzsche with the insight that our dreams contain some primeval relic of the atavistic element in man's nature. This is why Freud supports his talk of children and their sexual rivalry by

reference to myths, legends, and literature from the past which show us the 'father's despotic power'.[21]

The cultural context in which such doctrines arose helps us to see that what Freud shares with the Modernism of the first two decades of the century is not so much a clinical pathology as the belief that the culture around us needs to confront mythical and patriarchal orders from the past. This is a position common to Freud, Jung, and many others—and it is far more important for our understanding of ideas about the self in the modern period than Freud's more specifically clinical views about the centrality of our sexual behaviour.[22] In a letter of 1910, Jung, also much influenced by Nietzsche, urges upon Freud the need to

revivify amongst intellectuals a feeling for symbol and myth, ever so gently to transform Christ back into the soothsaying god of the vine, which he was, and in this way to absorb those ecstatic instinctual forces of Christianity for the one purpose of making the cult and the sacred myth what they once were—a drunken feast of joy where man regained the ethos and holiness of an animal.[23]

From this point of view, contemporary life is as much shot through with archaic survivals as is the individual life with the primitive sexual drives of early childhood. For as Freud puts it, 'the prehistory into which the dream work leads us back is of two kinds—on the one hand, into the individual's prehistory, his childhood, and on the other, in so far as each individual somehow recapitulates in an abbreviated form the entire development of the human race, into phylogenetic history too'.[24] Since Freud approves of von Hartmann's idea that the association of ideas in artistic creation is governed by the unconscious,[25] *The Interpretation of Dreams* already suggests a parallel theory of cultural interpretation, in which the self emerges as the site of internal conflicts between (primeval) instinct and cultural authority, so that 'civilised behaviour' is perpetually threatened from within.[26] We are all expected to 'sublimate' in obedience to dominant ideologies, and a price for this always has to be paid. The instincts for Freud are (amongst much else) the primitive chaos of the Romantics and so beyond logic.[27] It would not have surprised him, had he been interested, that the work of Expressionist artists like Kandinsky and Schoenberg, driven by the 'inner necessity' of the unconscious and the instinctual, should so often derive from primitive sources.[28] Indeed he adapts the 'blind natural will' of Fichte, Schelling, Hegel, Schopenhauer, von Hartmann, and Nietzsche, so that his libido is 'an only slightly personalised version of Schopenhauer's Will'.[29] The determining logic of history in German philosophy is metamorphosed

into the overdetermining past of the individual. This conception of the personality, as made up of competing systems, driven by instinct and sexual tension, capable of dreaming (without knowing it) of times long past, and very imperfectly controlled by the beliefs imposed on it by authority, is an essential part of the German-speaking culture of early Modernism.

Its Nietzschean aspect was sustained in Freud's hostility to religion as an illusion (which masks archaic familial tensions). He tells Jung that 'the ultimate basis of man's need for religion is *infantile helplessness,* which is so much greater in man than animals. After infancy he cannot conceive of a world without parents and makes for himself a just God and a kindly nature, the two worst anthropomorphic falsifications he could have imagined.'[30] His idea that sexual expression inevitably conflicts with official culture, and in particular with religious authority, was all pervasive at the turn of the century.[31] It is hardly surprising to find that these are the central themes of Freud's 'Civilised Sexual Morality and Modern Nervous Illness' of 1908, in which he tells us that the children of fathers who have moved to the 'metropolis', where 'all is hurry and agitation' are subjected to a 'modern city life' which is 'constantly becoming more sophisticated and more restless' and to a modern literature which is 'predominantly concerned with the most questionable problems, which stir up all the passions, and which encourage sensuality and a craving for pleasure'.[32] Unfortunately 'Our civilisation is built up on the suppression of instincts' which is 'sanctioned by religion' and 'nervous illness' is the product of this 'intensification of sexual restrictions'.[33] One might be able to avoid such dire consequences by cultural 'sublimation', at which homosexuals are particularly adept, whereas women, 'as being the actual vehicle of the sexual interests of mankind', are 'only endowed in a small measure with the gift of sublimating their instincts'.[34]

A number of works of this period with artists as their central characters test out these ideas about the nature of the subjective, and the internalized conflict between the civilized and the regressively primitive. In making this investigation they also begin to exploit broadly 'Freudian' cultural assumptions, about the ways in which self-revelation, through dream, metaphor and symbol, might take place in the text as in dreams. The language of Modernist literature begins to be seen as capable of taking on new types of implication, concerning the underlying motivation of its authors and their personae; and also to adapt experimentalist modes of expression to the more precise tracking of

actual (elliptical, disjointed, juxtapository) mental processes. The William Jamesian stream of consciousness begins to provoke the theoretical ideas that will explain it. The introspection of the Modernist protagonist is more and more distanced from the (only apparent) rationalist lucidity of their nineteenth-century predecessors. The climax of a book by George Eliot or Henry James may come within a long, virtuous process of conscience-stricken self-possession— whereas, as we shall see, the Modernist hero is far more threatened by disintegration, under the pressures diagnosed by Ibsen, Nietzsche, Freud, and many others.

Thomas Mann

Freud made his own study of an artist in 1910. He saw Leonardo da Vinci as a repressed homosexual, who probably never 'embraced a woman in passion' and whose 'sexual instinctual forces' were sublimated in his 'professional activity'.[35] There is a similar tension between homosexuality and creativity in Mann's *Death in Venice*, published in 1912. This novella turns on *fin de siècle* speculations concerning the relationship between sickness, decadence, and art, but it also has an extraordinary closeness to the ideas we have so far discussed (although Mann does not seem to have been aware of Freud at this stage).[36] Like Freud's *Interpretation of Dreams*, it has a disguised confessional dimension, for Aschenbach's historical writings and projects are largely Mann's own.[37] It is amongst many other things an account of the threat to the authority of the writer, once the 'Decadent' or 'Freudian' sources of his inspiration come to light; for Mann puts into his hero's dreaming subconscious not an inexorable family romance, but an archaic conflict between Apollo and Dionysus, partly derived from Nietzsche's analysis of the opposition between them in his *Birth of Tragedy*. Aschenbach's decline from an identification with the values of bourgeois society, and great authority as a writer, to a preoccupation with myth, and a literally deadly introspection, depends on a process which Mann is careful to show has a psychological inner necessity. His death is both a 'relaxation of will' and a fate ('gefügiges Mißgeschick'—'submission to misfortune'), brought about by his confrontation in Venice with the person of the young boy Tadzio, who is on holiday there with his family. This may be an encounter with the Platonic ideal of Beauty underlying all art, or merely a 'decadent' homosexual desire which threatens to marginalize and destroy the writer once he loses the ability to sublimate it in work

which, like Aschenbach's prose epic on Frederick the Great, and his novel *The Abject*, supports the dominant authority.

Aschenbach is subject to conflicts which make him exemplary for the transition from Symbolist to Modern. In his career as a Realist writer previous to his experiences in Venice, he had 'sacrificed to art . . . the powers he had assembled in sleep',[38] but on his arrival it is as though 'things about him were just slightly losing their ordinary perspective, beginning to show a distortion that might merge into the grotesque' (*DV* 20). When he sees Tadzio, he thinks of 'the noblest moment of Greek sculpture' (*DV* 26), and a contest between a Realist classicism and the Apollonian ideal on the one hand, and Symbolist dreams and the Dionysiac on the other, begins for him at this point. His successive visions steadily metamorphose Tadzio into 'a tender young god': 'It was like a primeval legend, handed down from the beginning of time, of the birth of form, of the origin of the gods' (*DV* 35). This self-justificatory archaism soon takes on the interpretative unreliability of the irrational, as the intertwined diseases of cholera and homosexual passion gain a grip on Aschenbach. 'But', says Mann in parallel to Freud, 'the truth may have been that the ageing man did not want to be cured, that this illusion was far too dear to him. Who shall unriddle the puzzle of the artist nature?' (*DV* 50).

The 'illusion' by which he is 'spell bound' is one of 'a world possessed, peopled by Pan' (*DV* 52), and the Dionysiac passion of such a world has a decadent Bohemianism which 'welcomes every blow dealt to the bourgeois structure' (*DV* 56 f.). Hence Aschenbach's satisfaction at the way in which the Italian authorities and hotel-keepers deceive their clientele concerning the progress of the cholera epidemic, whose arrival from India is cunningly made to follow the journeys of Dionysus.[39] As his 'study' (*DV* 44) of Tadzio progresses, the dialectic between the processes of creation and those of disease achieves a greater prominence. Aschenbach comes to see himself as a kind of Pygmalion, struggling 'in cold fury to liberate from the marble mass of language the slender forms of his art', which would 'body forth to men as the mirror and image of spiritual beauty' (*DV* 46), and is driven to give the homoerotic aspects of his art a didactic rationalization by summoning up a 'lovely picture' of the relationship between Socrates and Phaedrus (*DV* 47).

At the climax of the tale, Aschenbach thinks of 'returning home, returning to reason, self-mastery, an ordered existence' (*DV* 70) and to self-reintegration. But that night he has a fearful dream, whose 'theatre seemed to be his own soul, and . . . left the whole cultural structure of a

life-time trampled on, ravaged, and destroyed' (*DV*70). This Nietzschean confrontation between Dionysus and Apollo (or in Freudian terms libido and superego), which runs right through Modernist literature, from *Heart of Darkness* to Lawrence's *The Plumed Serpent*, inexorably calls into question the boundary between an idealized waking fantasy suitable for literature, and the primitive, liberating regression of dreams, in which

Horned and hairy males, girt about the loins with hides, drooped heads and lifted arms and thighs in unison, as they beat on brazen vessels that gave out droning thunder, or thumped madly on drums. . . . he craved with all his soul to join the ring that formed about the obscene symbol of the godhead . . .

The unhappy man woke from this dream shattered, unhinged, powerless in the demon's grip. (*DV*71 f.)[40]

When Aschenbach gazes for the last time upon Tadzio at the beach, the hotel barber having, he believes, restored his 'youthful blood' with cosmetics and dyes, his grotesquely 'Rouged and flabby mouth uttered single words of the sentences shaped in his disordered brain by the fantastic logic that governs our dreams' (*DV* 76). And yet, as Tadzio finally walks away from him towards the sea, the Platonic myth of divine beauty revives:

It seemed to him the pale and lovely Summoner out there smiled at him and beckoned; as though with the hand he lifted from his hip, he pointed outward as he hovered on before into an immensity of richest expectation. (*DV*79)

The description of the instinctive feelings which arise in Aschenbach as he approaches his end is counterposed to a web of mythological allusions in Mann's prose, as echoes of Plato's *Symposium* and *Phaedrus* and the *Erotikos* of Plutarch evoke the eternal forms of beauty, and impart a 'spiritual' dimension to the homosexual impulse.[41] The final ecstatic vision of Tadzio on the beach is thus ambiguously poised, between apotheosis and decline, religion and poetry, Platonic vision and sexual debauchery, all competing within the consciousness of the observer, and left to the reader to resolve. This internal psychological process, which is very like a physical sickness, and the dream-like symbolism which is so ambiguously related to it, is also to be found in the artist figures of Proust, Musil, and Lawrence (who nevertheless thought Aschenbach 'the last sick sufferer from the complaint of Flaubert' at the same time as he was himself developing a post-Freudian conception of character).[42]

Death in Venice is also significant within the context of the Modernist development of new types of linguistic expression, for the way in which it dramatizes the divided consciousness through the technique of allusion or hidden quotation. It shows how the self may divide within language once it becomes split off from its 'own' voice, and a language of citation takes over. The subject becomes the container for a number of conflicting discourses. Plato is (and is not) part of Aschenbach's 'own' thought. Is he responsible for these sentiments? Are they 'his' thoughts? Or are they the Plato within him, whose mythical poetic expression participates in an archetypal language of an Unconscious, for which he may be the less responsible? These speculations about the relationship of the subject to its own thoughts are of considerable consequence. Mann's ambiguous handling of the theme allows us to see Aschenbach's Platonic references as a Forsterian valorization, through the Greek 'tradition', of homosexual longing, or as a feeble rationalization, or as a reminder of the eternal problem of Beauty, or as another variation on the topos of the Wagnerian *Liebestod*, as the hero's consummatory death comes with a hallucinatory vision of the beloved across the sea. Of course we know that Mann is orchestrating these disparate effects; but as he does so we see a theory of mind coming into view; one which allowed it to be invaded by, and divided into, competing discourses, none of them trustworthy—and all of them likely to be the servants of desire. As Socrates reminds Phaedrus in *Death in Venice*, 'We poets cannot walk the way of Beauty without Eros as our companion and guide'; and Freud similarly argues in his *Leonardo* that 'What an artist creates provides at the same time an outlet for his sexual desire'.[43]

James Joyce

The identity of Joyce's Stephen Dedalus also emerges from conflict, between the erotic, the authority of the religious, and an emerging aesthetic of escape. But Joyce also shows how a split in consciousness may be mediated by language. For Stephen not only has a conflictual relationship to an 'English' language and literary tradition that threaten not to be his own,[44] but he is also deeply preoccupied by the disjunction between his (unique) consciousness and (public) language. His earliest meditations depend upon a parody of the relationship of the individual to what seems to be the God-given order, as he writes out his address in the Universe on the flyleaf of his geography book (*PA* 15). Stephen thinks

that God has a picture that can put everything in its place, and that although everyone prays to him, in a Babel of different languages, there is a single viewpoint (His) from which everything can be understood, including him. But Joyce leads Stephen from this theological orthodoxy into a comic contradiction: 'God remained always the same God and God's real name was God' (*PA* 16).

Although theology may attempt to guarantee a single world order for him, Stephen learns that in politics, on the other hand, there are 'two sides' (*PA* 17), which divide families, and, as he develops, his 'mind' is the site of just such 'constant voices' concerning Catholicism, 'national revival', and so on: 'it was the din of all these hollow sounding voices that made him halt irresolutely in the pursuit of phantoms' (*PA* 84). This disjunction, between the struggle to form an autonomous conscious-ness and the demands of public languages, will continue to haunt him, and leads inexorably towards his final renunciation of 'nationality, language, religion' (*PA* 203) in favour of 'silence exile and cunning' (*PA* 247).

These themes in the book come to a climax with his revelatory experiences on the seashore, which like Aschenbach's are shot through with borrowed rhetoric. As he meditates on 'a phrase from his treasure'—'A day of dappled seaborne clouds' (which is in fact borrowed from Hugh Miller's *The Testimony of the Rocks* (1857)), 'The phrase and the day and the scene harmonised in a chord' (*PA* 170). Stephen, despite his echoing indebtedness to the rhythms of Newman and the swooning of Pater in this episode, assumes that there is no problem with language as such. He believes it to be adequate to the expression of the artist's inner self as well as to mimesis, as it brings together 'an inner world of individual emotions mirrored perfectly in a lucid supple periodic prose' (*PA* 167) and a 'reflection of the glowing sensible world through the prism of language' (*PA* 171). But his success in this art of reflection is ironically undercut, as the narrator (whom we know to be looking back on his 'former self') quite fairly incorporates 'Stephen's' words into his own commentary: 'Disheartened, he raised his eyes towards the slow drifting clouds, dappled and seaborne' (*PA* 171).

This sly insertion of a twice-borrowed phrase raises once more an issue concerning identity which is central to Modernist concerns. (Though it has often falsely been thought to be a peculiarly Postmodern one.) What is it that shapes our view of reality—the individual con-sciousness, or 'vision' or 'soul' in the vague terms in which Stephen (or Kandinsky) conceives of them, or an inherited system of language? And

if we do inherit such a system, how do we resolve our conflict with it? Joyce and the artists discussed in the previous chapter all succeed in this act of transformation—at the cost of constructing a new kind of implicit psychology to support such changes.

For Joyce it is the erotic which provides a perpetual undertow to Stephen's progress, from the kiss that makes the climax of the second chapter (*PA* 101) to his epiphanic vision on the seashore at the climax of the fourth. Here, after the flight of his soul which allows him to renounce those disembodying 'inhuman voices that had called him to the pale service of the altar' (*PA* 169), he wades along the strand with 'a new wild life . . . singing in his veins' (*PA* 170). He is moving from the imperfectly internalized voices of authority, to one which may seem to be his own, as an artist: as 'A girl stood before him in the midstream . . . like one whom magic had changed into the likeness of a strange and beautiful bird' (*PA* 171). When she feels the 'worship of his eyes', no doubt imperfectly sublimated by the religious notions used to describe it, 'her eyes turned to him in quiet sufferance' and Stephen's cheeks are 'aflame', his body 'aglow', as 'Her image had passed into his soul forever' (*PA* 172). As he falls asleep on the sand, the decadent erotic imagery of his dreams has the same balanced ambiguity as those of Aschenbach after *his* vision:

His soul was swooning into some new world, fantastic, dim, uncertain as under sea, traversed by cloudy shapes and beings. A world, a glimmer, or a flower? Glimmering and trembling, trembling and unfolding, a breaking light, an opening flower, it spread in endless succession to itself, breaking in full crimson and unfolding and fading to palest rose, leaf by leaf and wave of light by wave of light, flooding all the heavens with its soft flushes, every flush deeper than the other. (*PA* 172)[45]

The whole of the *Portrait of the Artist* thus shows the extraordinary difficulties of any attempt at a self-creating entry into a new world, and the necessity for it. Stephen arrives at an aesthetic which he admits is still Scholastic, and at a theory of the Flaubertian impersonal artist some way from the Yeatsian aims of the ending of the book (cf. *PA* 238 f. and 250 ff.). This ironic gap is typical of a self-portrait which leads us to ask whether its main protagonist could actually have written it. Stephen's own centrality to the book depends upon a stylistic instability (which will become one of the main virtues of *Ulysses*), as he attempts to become independent, not only of the authoritarian ideologies of nationality and religion, but also of those stylistic modes from the

Symbolist past which he metamorphoses in arriving at his vocation. That he will ultimately become 'Modern' is indirectly demonstrated for us by the experimentalism of the style invented by Joyce for the opening pages' description of his childish consciousness:

Once upon a time and a very good time it was there was a moocow coming down along the road and this moocow that was coming along the road met a nicens little boy named baby tuckoo . . .

His father told him that story: his father looked at him through a glass: he had a hairy face.

He was baby tuckoo. The moocow came down the road where Betty Byrne lived: she sold lemon platt.

> O, the wild rose blossoms
> On the little green place.

He sang that song. That was his song.

> O, the green wothe botheth

When you wet the bed first it is warm then it gets cold. His mother put on the oilsheet. That had the queer smell. (PA 7)

Anthony Burgess describes this opening as 'the first big technical breakthrough of twentieth-century prose writing and, inevitably, it looks as if anybody could have thought of it. The roots of *Ulysses* are here—to every phase of the soul its own special language.'[46]

T. S. Eliot

Eliot's Prufrock (1911) finds all sorts of languages to express the phases of his soul—and in doing so shows how stylistic instability is appropriate for a divided self, as the opening line suggests. Is his love song by him or about him?[47] Allusion and juxtaposition create here a character comically divided between the sexual demands of the present and the inhibitory grandeur of the past. Its Donnean invitation, 'Let us go then, you and I' announces an equation in the poem between its own tortuous textual development and its action, through

> Streets that follow like a tedious argument
> Of insidious intent
> To lead you to an overwhelming question . . .

Prufrock aims to 'force the moment to its crisis' and would have 'squeezed the universe into a ball', and so models himself on the hidden

narrative of Marvell's 'To His Coy Mistress'. This functions as the sub-
conscious of the text, in revealing Prufrock's suppressed preoccupation
with time and with sex; with time which can expand and contract for 'a
hundred visions and revisions', before clock time intervenes with the
seductive possibilities of 'the taking of a toast and tea'. His social unease
compels the projection of his personality into various stylistically
distinct personae (Lazarus, John the Baptist, Hamlet) which are aspects
of the divided self. For when the self speaks to the self in this way, there
is a 'dédoublement' —the term which Eliot himself uses, when he says
that Laforgue used irony 'to express a dédoublement of the personality
against which the subject struggles'.[48] This uncertainty is made comi-
cally apparent by the parody of past literary styles. Prufrock's defensive
posturings are all subconsciously motivated, because he evades the
central erotic concern of the poem (which harks back to the decadent
theme of the Salome-woman as castrating threat):

> [But] though I have wept and fasted, wept and prayed,
> Though I have seen my head (grown slightly bald)
> brought in upon a platter,
> I am no prophet—

The man who had thought earlier that he 'should have been a pair of
ragged claws | Scuttling across the floors of silent seas' brings his poem
to an end by imagining his death by drowning, within a revelatory
'epiphanic' experience which, like that of Stephen Dedalus on the
shore, guards itself against its own sentimental intensity by taking
refuge in stylistic parody—in this case, of Swinburne. Prufrock and
Stephen and Aschenbach engage the reader in *passé* fantasies which
external reality can always threaten to puncture.

> We have lingered in the chambers of the sea
> By sea-girls wreathed with seaweed red and brown
> Till human voices wake us, and we drown.[49]

For Mann, Joyce, and Eliot, an erotic encounter on the seashore
brings a kind of defeat which may be variously sublimated or compen-
sated for by the artist's visionary power; Aschenbach looks through
Tadzio to the 'immensity of richest expectation', Stephen swoons 'into
some new world, fantastic, dim, uncertain as under sea', and Prufrock,
true to the comic inversions of Eliot's poem, actually drowns *out* of his
fantasy into reality at the sound of a human voice. They also depend
upon a highly symbolic form of expression; and all feel that the usual

modes of discourse will fail them. This is a paradoxical attitude for the artist to take—particularly when they are producing masterpieces like these. Their confidence that they can use symbol and 'epiphany' to move beyond realist modes is justified by some new (and ultimately disturbingly irrationalist), assumptions about the nature of language. We saw earlier how Hofmannsthal was led to a hope that an epiphany of the object would save him from despair; in much Modernist writing these objects (and persons) are made to declare themselves in a revelatory and symbolic manner. The central assumption here is, I believe, summarized by Ernst Cassirer in 1925: 'all mental processes fail to grasp reality itself, and in order to represent it, to hold it at all, they are driven to the use of symbols.'[50] Where literal language gives out, we are driven to symbol, in the dream and in literature. This sort of belief ties in very well with the Modernist distrust of Realism, and indeed Cassirer goes on to point out that 'From this point it is but a single step to the conclusion to which the modern sceptical critics of language have drawn; the complete dissolution of any alleged truth content of language and the realisation that this content is nothing but a sort of phantasmagoria of the spirit.'[51] The desire to investigate this 'phantasmagoria' in creative writing (as well as in the clinical work of such as Freud and Jung), does much to explain the use of myth and symbolism in Mann, Joyce, and Eliot, and much of the Modernist tradition. We will encounter some more examples in the following section. Of course a belief in the perpetual presence of symbol within language is far from new—it underlies Symbolism (in Yeats, for example), and the notion that all language may be intrinsically metaphorical runs from Shelley and Herder to Nietzsche. But in this period such thoughts reinforced the feeling that primitive or dream-like symbolic material might have a peculiar status in expressing and helping us to confront the profound problems of life and personal identity.[52] Philosophy is challenged, not just by the fact that psychological explanations are given for its activities, but also by the resurgence of dream and myth as alternative sources upon which to rely for the meaning of life.

The texts we have been discussing are also exemplary of the scepticism about conventional social judgements which I have emphasized: Aschenbach ceases to be capable of writing his projected works, Stephen escapes religion and nationalism—and Prufrock is incapable of facing up to a very conventional social situation except in the disguises of Hamlet, and Attendant Lord, and many others. This divided subjectivity is symptomatic of a profound tension between two frameworks of

ideas, that of a society which assumes that moral judgements are certain and universalizable, and that which sees the sympathetic understanding demanded by the new psychology as calling into question previously held notions of sexual behaviour and moral responsibility. This historical change (broadly, from Kantian to Freudian assumptions about morality) brings in a tension between those who wished to depend upon the stability of the well-defined social roles which our protagonists disrupt, and those who followed Nietzsche and others in favouring the development of an idiosyncratic, creative, and created self, one which goes far beyond the mask and persona of the Aesthetes. The ideas with which we have been concerned, which divided the self, also put into question the universality of many of the moral conventions which societies had thought necessary. For all the writers I have cited present a shifting, perspectival world, in which moral obligations arise out of a contingent historical and personal narrative, in which the individual's drives and wishes and fantasies are seen as inherently likely to conflict with social demands.

The Modernists thus faced along with Freud the suggestion that personal causes may undermine universalizing pretensions. The belief, for example, that the (good or bad) acts of individuals such as Kurtz, Aschenbach, Dedalus, or Prufrock may stem from 'infantile', 'sadistic', 'obsessional', or 'paranoid' dispositions, carries the implication that such labels will have different resonances for each individual, as they arise out of just such specific narratives of a life as literature now offers.[53] Freud is simply of his time in helping to break down an attachment to the notion that we have a central rational 'self'. Being 'reasonable' cannot be a form of assent to law, or authority, but becomes a perpetual stoic struggle—and so Freud

aims at making reason prevail in one sense, as a force to destroy those illusions which have an incapacitating, obviously infantile or primitive basis—for example that of a belief in God. Perhaps his hostility is not unrelated to the fact that the notion of God provides one of the main metaphors to underwrite claims to universalism.[54]

What emerges for the Moderns who accepted this kind of scepticism (and Eliot for one did not after 1926—while certainly being a sceptic in this earlier period) is a relativism which is typical of the Modernist narrative. An affirmation of the value of the creative individual outside social convention is of course hardly surprising in writings about artists. But such texts had exemplary force in a period in which the belief grew

that the unconscious of every man and woman may be, not only libidi-
nously dissentient, but creatively poetic, as we have already seen in the
cases of Kandinsky and Schoenberg (and will see later in Dada and Sur-
realism). For along with a rational scepticism there went a speculative
desire to know more about the nature of the unconscious and the
instinctive, upon which so many artists were willing to rely. Could a sub-
mission to it offer a liberating form of regression? Could one break out
of restrictive contemporary conventions towards the primitive, without
succumbing to the dangers encountered by Kurtz and Aschenbach?

2. Subjectivity and Primitivism

He remembered her: her astonishing cultured elegance, her diminished, beetle
face, the astounding long elegant body, on short, ugly legs, with such protuber-
ant buttocks, so weighty and unexpected below her slim long loins. She knew
what he himself did not know. She had thousands of years of purely sensual,
purely unspiritual knowledge behind her. It must have been thousands of years
since her race had died, mystically: that is, since the relation between the senses
and the outspoken mind had broken, leaving the experience all in one sort, mys-
tically sensual. Thousands of years ago, that which was imminent in himself
must have taken place in these Africans.[55]

21. Henri Matisse, *Blue Nude* (*Nu Bleu—Souvenir de Biskra*), 1907.

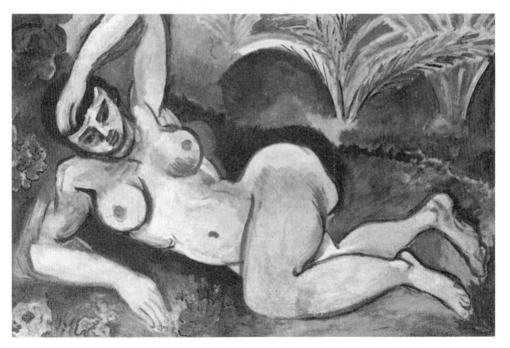

In *Women in Love* (1915), Lawrence's hero Birkin is looking at a primitive statue from 'West Africa', one of his 'soul's intimates'. His Marlovian curiosity about the 'sensual' source of her secret knowledge and power is a constant theme in the relationship between primitive and innovatory art in this period. Statuary like this particularly inspired painters, who, following Gauguin, were seeking modes of expression which might free them from the sexual, psychological, and aesthetic preconceptions of their own society. In what follows I shall, as in the previous section, look at some major examples within a general tendency to produce works which centre upon the relationship between the primitive, the irrational, and the erotic. These turn, as did the texts by Mann, Joyce, and Eliot, upon some typically contradictory male attitudes towards women in this period.

Matisse was credited with having taken the 'first step into the land of the ugly' beyond the rather calm, contented, and glamorous work in the line from Gauguin to Derain.[56] His painting was intended to be a 'return to the essential principles which made human language . . . the principles which 'go back to the source',[57] and we have seen part of this in the relationship of *Le Luxe* to the work of Giotto. But to go further (and notably past his respect for Cézanne), he turned to the primitive, and

21 the most notorious result was his *Nu bleu* (*Blue Nude*) (1907), a rude challenge to mildly salacious academic painting on the Venus theme as shown in the Salons.[58] Its aggressive sexual confrontation derives from beliefs not so different from those of Birkin, in a 'primitive' intensity and violence. Her 'ugliness'—in the deformation of the bulbous breasts, the spherical head, and elongated torso—echoes common features of African sculpture. Matisse admitted later (in 1939) that should he meet 'such a woman in the street, I should run away in terror. Above all I do not create a woman, *I make a picture.*'[59]

Les Demoiselles d'Avignon

Picasso very likely responded to Matisse's *Blue Nude* in his *Les Demoi-*
22 *selles d'Avignon.*[60] It depends upon techniques which precede the analytic Cubism we have already discussed, but its influence on the caricatural representation of women in painting, through Picasso's own later work to de Kooning and beyond, has outlasted analytical Cubist methods, and has a comparable importance to them in the context of the ideas which motivated the Modernist movement. Indeed, the significance of this particular image has come to lie as much in the way in

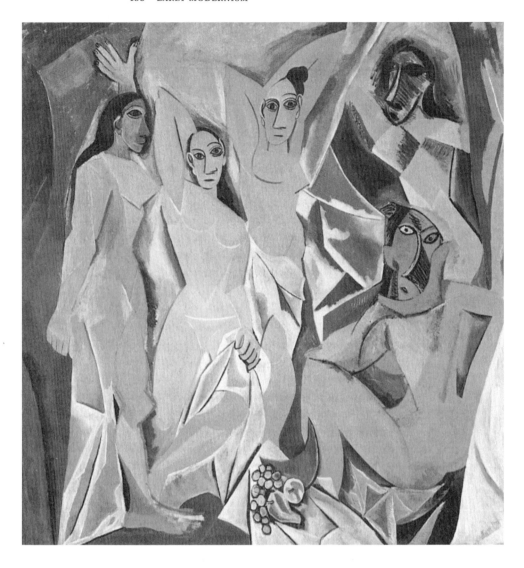

22. Pablo Picasso, *Les Demoiselles d'Avignon*, 1907.

which it has been incorporated into the writing of art history, as in its historical relationships with the work surrounding it.[61]

The ugliness and threat of the *Demoiselles* breaks decisively with the sophisticated hedonism of the tradition in which Matisse and the Fauves most often worked. In it two languages for representation confront one another, as established assumptions for the representation of the nude confront Picasso's appropriative reinvention of 'African' themes. This conflict seems to me to arise from an internal

psychological division between attraction and repulsion, classical superego and primitive libido, and results in an aggressive attack on the image of women which may disguise a deep fear. (It was interestingly enough preceded in 1906 by a number of neo-classical nudes.) Picasso's destruction of the conventionally erotic figure is not compensated for by any hedonistic formal justification for distortions like the striation on the standing figure's mask-like face, which is echoed on her breast, as if that were wooden too. There is no overall aesthetic unity, such as we might find in Cézanne and Matisse. Indeed a sense of the arbitrary and surprising is part of what Picasso taught those who followed him.

In challenging the canons of 'beauty' he also rejects conventional perspective, as his surfaces slide into one another, and the free space of the room is obliterated in a 'wildly jagged articulation' and 'shrieking lack of harmony'. Never before had there been a painting 'with such a system of internal torques, volume made into a twisting scything line'.[62] Although dramatic discovery may be suggested by the curtain pulled back, we find that we have to read the picture across its surface, rather than into a perspectival stage setting, to divine its story. It looks out at us, and challenges the masculine appropriative erotic assumptions behind the mythological genre of 'beauty on parade'. This is a brothel.[63] This contrast between the echoes of a classic treatment and contemporary shock arises from Picasso's allusive adaptation of his grouping from the painting of the past. It echoes and adapts Iberian sculpture, Egyptian art, El Greco, Ingres, Gaugin, Cézanne, and old master painting, and subjects them to an anguished libidinal distortion.[64] It seems to agonize at the loss of the very tradition of erotic painting from Rubens to Toulouse-Lautrec, which it helps to destroy.

The *Demoiselles* is the site of many visions and revisions—and far from being a completed work. There is a stylistic barrier within it, which is almost a species barrier, and its consequent divisions of purpose make it essentially unfinished and abandoned. For the primitive masking and hatching features got into the *Demoiselles* in the autumn of 1907, after a summer break, in which Picasso underwent the 'shock' and 'revelation' of the primitive art in the Trocadéro museum. He overpainted the two figures on the right, which X-rays show to have been originally in the same style as the rest of the picture.[65] This partial overpainting reveals an interest in African art, which moves beyond the original 'Iberian' conception of the left-hand side.[66] Hence the uneasy mixture of contrasting styles that we now see, but none of the heads in the *Demoiselles* resembles any particular African or other work that

Picasso could have seen beforehand. Those noted by scholars may be similar, but they are not potential sources.[67]

The primitive features of the work struck Gelett Burgess in 1910, when he wrote his celebrated 'Wild Men of Paris' article, which reveals the peculiarly condescending light in which exotic art was then seen:

I had mused over the art of the Niger and of Dahomey, I had gazed at Hindu monstrosities, Asian mysteries and many other primitive grotesques; and it had come over me that there was a rationale of ugliness as there was a rationale of beauty; that, perhaps, one was but the negative of the other, an image reversed, which might have its own value and esoteric meaning. Man had painted and carved grim and obscene things when the world was young. Was this revival a sign of some second childhood of the race, or a true rebirth of art?[68]

Certainly the latter, because the primitive helped to foreground, not what the artist sees when confronted by a naked model, but the conceptual role of the conventions for representation, and, as we have seen, this approach led on to Cubism. But the *Demoiselles* is typical of much art influenced by the exotic in this period. It is not so much a homage to primitive art and its functions, as the theft of some of its stylistic conventions, as we can see if we compare the slashes that Picasso puts on the faces in this (and other pictures), with an account of Yoruba conventions by the anthropologist Clifford Geertz. It is not that the Yoruba lack a formal aesthetic appreciation of such lines, far from it; but for them their point is also symbolic:

Line of varying depth, direction, and length, sliced into their cheeks and left to scar over, serves as a means of lineage identification, personal allure, and status expression; and the terminology of the sculptor and of the cicatrix specialist— 'cuts' distinguished from 'slashes' and 'digs' or 'claws' from 'splittings open'— parallel one another in exact precision.[69]

Any such significance is of course wholly absent from Picasso's 'African' art, which appropriates but does not translate.[70] Its interaction with the context from which it is taken lacks the resonance of the literary allusion we have found in Modernist texts, because their differing cultural contexts are not in any significantly well-informed critical interaction (as indeed they are in Mann and Eliot). The effect is perhaps supposed to be liberating here, as in Lawrence, in a far more basic sense. Steinberg speculates that the Africanization of the human figure derives from a view of the primitive as 'l'energie sexuelle à l'état brut en tant qu'image de la force vitale' ('sexual energy in its crudest state, as an image of the life force').[71]

This seems simple enough, as three of the girls stare out at us, their angularity denying their desirability, and challenge the male gaze of patriarchal tradition, in which the woman is usually offered by the male painter to the male viewer as a desirable object. But they pay the price of being ugly; they endure Picasso's revenge upon the feared *femme fatale*, so prominent in turn-of-the-century painting. One might even suggest that the imposition of the mask upon them connotes decapitation—a reverse castration, in Freudian terms. And a reply to all those Judiths. For the painting has been interpreted as exorcizing a fear of syphilis (a theme of its early sketches, in which a medical student and a sailor, both associated with sexual disease, appear).[72] The painting is, at the very least, the site of contradictory feelings about women, which oscillate between 'Dionysian release' (surely a phrase whose 'primitivist' connotations dignify the brothel), and the fear of death.[73]

Such psychological depth as the *Demoiselles* has derives from conflict—its destructive attitude to artistic convention parallels an aggressive attitude towards women that will haunt all Picasso's work. Although it has an extraordinary range of formal allusion, it avoids any deep engagement with the ideas which might help to explain the significance of its primitivism. For this deeper relationship we have to turn back to the German-speaking tradition which, as we have seen, sees the primitive passion underlying the order of myth.

Erwartung

Richard Strauss's *Elektra*, composed from 1906 to 1908, brought to expression the regressive hysteria that fascinated Freud. It also looks for the primitive core of Greek myth, by releasing the Dionysian energies of revenge, through the threatening female of *fin de siècle* culture, in as advanced a Modernist form as Strauss could manage. Its dissonant bitonality symbolizes the conflicts within his savagely hysterical heroine (later described by Stravinsky as a 'catatonic Valkyrie').[74] She is, as one Freud-inclined commentator puts it,

a latterday Brunnhilde who, traumatised by the death of her father-god Wotan (Sophocles' Agamemnon) is now concerned only to do to death all subsequent impostors, her murderous mother and even herself. Life has become for her no more than the desire for cataclysmic revenge upon a world that would not allow her to remain a child.[75]

Strauss could hardly have seen her so explicitly as a victim of the family romance; but in Max Reinhardt's production of Hofmannsthal's text in

1903 he had encountered a female protagonist even more threatening, and frustrated, than the Salome he took from Oscar Wilde (whose morbid psychology was also worked up to a hysterical climax in death). Once avenged by Orestes, Elektra performs a wild stamping dance of triumph, and as her frenzy raises her to the gods she dies (or collapses 'rigid' according to Hofmannsthal's stage directions).

When Ernest Newman saw a performance in London in 1910, he found that Strauss's music was 'discontinuous' and 'incoherent' (sure symptoms of innovation), and in a sense it is, for Strauss (like Picasso) modernizes his sources in a peculiarly incongruous manner.[76] Elektra's final dance of triumph may purport to be both Dionysiac and 'Modern' in suggesting a sexual hysteria,[77] but it takes place to an accompaniment which irresistibly suggests another more sophisticated and indeed urban context. It is an Expressionistically distorted Viennese waltz. Newman thought it a 'vulgar dance by which Strauss tries to convey to us that a woman's brain is distraught'.[78]

Schoenberg thought Strauss's *Elektra* a masterpiece: the fourth scene in particular, in which Clytemnestra recounts her dreams, had some considerable influence on his approach to the problems of suppressed antagonism, nightmare, and guilt in his monodrama *Erwartung*, composed in 1909.[79] His text is, however, far less sophisticated, and exploits an inarticulacy which more nearly reveals the hidden logic of dream. It is very close indeed to later literary experiments with stream of consciousness writing, which concentrates on (apparently) disordered pre-speech thoughts. He also, though for rather contingent reasons, comes close to the presentation of a Freudian case history in art, because his text was provided by a medical student, Marie Pappenheim, who was a relative of the Bertha Pappenheim who had been Joseph Breuer's patient 'Anna O' from 1880 to 1882 and who then became Freud's.[80] The text is a series of ejaculatory sentence-fragments, which suggest subterranean unconscious relationships which go far beyond those in any previous literature.[81] It is perhaps the most psychologically disturbed work that Schoenberg ever wrote: the tortured, illogical monologue of a woman who, like Elektra, proves to be preoccupied by murderous revenge. As she wanders alone through a wood at night, she stumbles over a dead body, which is eventually revealed to be that of her lover, who has deserted her, and whom, we come to suspect, she may herself have murdered.

By this fourth, climactic scene of the encounter with the corpse, the woman's 'dress is torn, her hair in disarray. Her face and hands are

bleeding', and she feels that should she see her lover, 'the unknown woman (her rival) will drive me away' (later, she is 'the witch, the trollop . . . I The woman with white arms'). When the woman 'touches something with her foot', the scene turns on her slow realization, and ours, that she may have killed him. She takes his cold hand and reminds him that he was going to spend the night with her, as indeed he has done. She lies down beside him and reproaches him for his 'staring, terrible' eyes. (A *Salome*-like necrophilia is suggested here: 'Just now your mouth yielded to my kisses . . . I Your blood still drips with a gentle pulse. I Your blood is still alive.') As dawn comes, the piece turns towards its final *Liebestod*:

> How heavy your parting kiss . . .
> Another interminable day of waiting . . .
> but you won't wake up again.
> A thousand people pass by . . .
> I cannot pick you out.
> All are alive, their eyes aflame . . .
> Where are you?
>
> It is dark . . .
> your kiss, like a beacon in my darkness . . .
> Oh, you are here . . .
> I was seeking . . .

Pappenheim's text was apparently only a rough draft, but Schoenberg set it as it stood, in a feverish eighteen days of continuously inspired composition. He later described his work of this period as 'this nightmare, this unharmonious torture . . . these unintelligible ideas . . . this methodical madness'.[82] *Erwartung* has proved his contention, by resisting all subsequent attempts to give it a formal analysis. Its music is remarkable in having no discernible thematic development, and no repetition; each motif is abandoned after a few seconds, and this reinforces our sense of the random association of ideas in the text.[83] The work thus depends for such forward movement as it has on the logic of the text, and on a continuously changing rhythmic texture, which gives an impression of great speed. And yet, as Payne notes:

The disconnectedness of the woman's half-spoken thoughts, the excited spurts and sudden hesitancies find a response in mercurially contrasted fragments, and the pace and density changes sometimes from bar to bar, such is the speed of Schoenberg's musical thought. Phrases whose rhythm and harmonic tension seek a dynamic outlet are balanced by absolutely static paragraphs. These

various facets of musical feeling in time cancel each other out and create a complex state of immobility.[84]

Time and psychology are thus in a revolutionary relationship in *Erwartung*. From classical to Wagnerian opera and beyond, the tempo and rhythmic movement of the singer's accompaniment can seem to drive along the psychological processes of the text at 'unrealistic' speeds. The dissolution of classical forms seemed to allow for musical accompaniment to reflect the 'real time' psychology of stage drama (as, for example, it seems to do in Debussy's setting of *Pelléas and Mélisande*), so that dramatic response and musical development are more realistically integrated. But Schoenberg's idea of his protagonist's identity is developed beyond this, because he aims at the evocation of subconscious, fantasy processes: 'In *Erwartung* the aim is to represent in *slow motion* everything that occurs during a single second of maximum spiritual excitement, stretching it out to half an hour.'[85] His contention is enthusiastically endorsed by Adorno, who says that *Erwartung* 'develops the eternity of the second in four hundred bars',[86] and so the whole thing may be but a passing dream.

This relationship between symbolic fantasy and unconscious processes in *Erwartung* is part of a basic development in the ideas which underpin much of the Modernist movement. Its expression of angst and alienation leads inexorably towards the Surreal, as we regress to a primitive world of raw emotion. The conventions for conscious control are abandoned in the text and the music, in favour of a non-sequential, intuitive, expressive placing of all the elements of the accompaniment. The connection between nightmare symbolism, produced by the dissolution of personality under stress, and dissonance seems so inexorable, that it is hardly surprising that many listeners still persist in associating *all* atonalism and dissonance with angst and irrationality.[87]

Many have thought that if any sense is to emerge from *Erwartung* it will have to do so in the light of psychoanalysis. Mellers tells us that in it we enter 'the dark wood of the unconscious',[88] and, as Constant Lambert mockingly put it, *Erwartung* 'with its vague hints of necrophilia brings in the Krafft-Ebing touch (Jung at the prow and Freud at the helm) which is the twentieth century's only gift to the nineties'.[89] Adorno wishes us to believe that 'The first atonal works are case studies in the sense of psychoanalytical dream case studies', as the woman here 'is consigned to music in the very same way [!] as the patient is to

analysis . . . the entire symbolism of the unconscious is wrung from her'. The 'seismographic registration of traumatic shock becomes, at the same time, the structural law of the music. It forbids continuity and development.'[90] But *Erwartung* does not seem to aim at an interpretable symbology (of the kind we find in Schoenberg's later work). We are in a decontextualized world, in which the identity of the speaker is so much at risk that, like the woman in Beckett's *Not I*, she hardly amounts to a case history. She is tortured by the music, pushed to extremes, driven by hysterical jealousy, and prone to a primitively murderous treachery. *Erwartung*, as we might expect from the misogynist cultural context of Austria in this period, is more like revenge than therapy.

The Rite of Spring

Erwartung sacrifices the woman to solipsism and madness, and this parallels its revolutionary musical language, which lies completely outside that of the collective. Stravinsky's barbaric sacrifice of woman in *Le Sacre du Printemps* (*The Rite of Spring*) affronts its audience on the other hand as a public ceremonial act. By the time of its production in 1913 the aggressive impulses with which we have been concerned were ripe for the further rationalization offered by an anthropological context, which could give to violent emotional material the ritual distance of 'myth'. The ballet's *mise-en-scène* derives principally from Nicholas Roerich, an authority on the culture of the ancient Slavs, whose aim was to represent 'a number of scenes of earthly joy and celestial triumph':

the first set should transport us to the foot of a sacred hill, in a lush plain, where Slavonic tribes are gathered together to celebrate the spring rites. In this scene there is an old witch, who predicts the future, a marriage by capture, round dances. Then comes the most solemn moment. The wise elder is brought from the village to imprint his sacred kiss on the new-flowering earth. During this rite the crowd is seized with a mystic terror . . . After this uprush of terrestrial joy, the second scene sets a celestial mystery before us. Young virgins dance in circle on the sacred hill amid enchanted rocks; then they choose the victim they intend to honour. In a moment she will dance her last dance before the ancients clad in bearskins to show that the bear was man's ancestor. Then the greybeards dedicate the victim to the god Yarilo.[91]

Stravinsky's innovations here are as challengingly violent as those of the *Demoiselles* and *Erwartung*. For some, it marks a parting of the ways in Modern music (with all composers after 1913 supposedly belonging to

the Stravinsky or the Schoenberg camp), and is often cited as a classic example of confrontational Modernism, largely because of the reaction of its very first auditors. Conservatives like Pierre Lalo were outraged:

it consists of the most dissonant and unharmonic music that has yet been written. Nobody has practised the system and cult of the false note with so much ambition, zeal, and sourness of temper. From the first to the last bar of the work there is not a note that one expects, unless exactly the note beside it, the one that shouldn't be there . . . These notes are set down with the intention to convey the impression of sheer, gruesome falsity.[92]

The bassoon solo which opens the *Rite* is based on a theme from Lithuania and like the opening horn calls of *Oberon*, it leads us into a fantasy world of prehistory (to be realized at its most engagingly ludicrous in Walt Disney's *Fantasia* to this music). Stravinsky, in an interview in *Montjoie!*, pointed out that the prelude was supposed to express a primitive sexual fear: 'c'est le trouble vague et profond de la puberté universelle' ('it is the vague and profound stirrings of a universal puberty'), 'une sorte de cri de Pan' ('a kind of cry of Pan'), in which 'La matière musicale elle-même se gonfle, grandit, se répand' ('the musical material itself swells up, grows, spreads itself').[93]

Debussy was among the first to make the acquaintance of the *Rite*, by playing a piano version of the work for four hands with Stravinsky in the spring of 1913. He reported that 'we were dumbfounded, overwhelmed by the hurricane that had come from the depths of the ages and taken life by the roots'.[94] His concept of spring had been very different from Stravinsky's—his symphonic poem *Printemps* of 1888 had been concerned with 'the slow and arduous birth of things in nature, a gradual awakening and finally the joy and ecstasy of new life',[95] whereas the *Rite* derived from a recollection of 'the violent Russian spring that seemed to begin in a hour and was like the whole earth cracking'.[96] The process of its composition began with Stravinsky's dream in 1910 of 'a scene of pagan ritual in which a chosen sacrificial virgin danced herself to death',[97] and its realization came from an ability to 'tap some unconscious "folk" memory'.[98] This quasi-involuntary, subjectivist explanation of its inspiration echoes the doctrinal of survivals mentioned earlier:

very little immediate tradition lies behind *Le Sacre du Printemps*. I had only my ear to help me. I heard and wrote what I heard. I was the vessel through which *Le Sacre* passed.[99]

Debussy remarked, 'c'est une musique nègre',[100] and so placed the *Rite* firmly in the context of the primitivism of this time. This background of pastiche helps to account for an emotional ambivalence about violence in much of Stravinsky's early work. As Boulez points out, it oscillates 'entre la violence et l'ironie—les deux faces de la *simplification*', and this is typical of many Modernist works.[101] Mellers points to a similar distancing when he says that we are 'deliberately liberating the libido'.[102] Like the *Demoiselles* and *Erwartung*, the *Rite* uses immensely sophisticated means towards the expression of what are supposed to be 'simple' primitive and hitherto unconscious emotions. It is regressive and therapeutic at the same time. Its choreography contrasts with the music by having a distanced, archetypal quality, in which 'Le cycle annuel des forces qui renaissent et qui retombent dans le giron de la nature est accompli, dans ses rhythmes essentiels' ('the annual cycle of the forces, which are reborn and fall again in a natural rotation, is accomplished, according to their essential rhythms').[103]

The *Rite* thus expresses a far more distanced psychological violence than the first of Schoenberg's *Five Orchestral Pieces* which preceded it, or Bartok's stylistically more similar *Magic Mandarin* which came after it in 1919. It is neither neurotic nor sexually obsessive, and its primitivism ties it (with Picasso) to the context of parodistic re-creation typical of its time. Cocteau gets its essentially theatrical nature nearly right, and also, less to his credit, evokes the romantic fantasizing nature of many responses to it at the time, when he describes the *Rite* as 'a symphony, impregnated with wild sadness, of primitive earth, camp and farmyard noises, fragments of melodies emerging from the depths of time, animal pantings, profound upheavals, the Georgics of a prehistoric age'. [104]

Its main technical innovation lies in its extraordinarily complex rhythms. Constant Lambert, even though he thought the *Rite* was 'merely the logical outcome of a barbaric outlook applied to the techniques of impressionism' and showed Stravinsky's 'complete lack of any melodic faculty', nevertheless recognized that its 'outstanding feature' was its 'rhythmic experiment':

There are rhythms suspended in space, arbitrary patterns in time, forming a parallel to Debussy's impressionistic use of harmonies detached from melodic reasoning.[105]

The major role of rhythm is at its most obvious when interjections are thrown asymmetrically against an ostinato, as in the horn calls of 'Augures printaniers'.[106]

Adorno attacks the *Rite* in a comparison of Stravinksy with Schoenberg, for playing 'the familiar aesthetic game with barbarism', and as 'rousing only bodily animation instead of offering meaning'.[107] Its 'virtuoso composition of regression' (*PNM* 148) relies on the (rhythmic) elements of musical language, and shows an 'aversion . . . to the total syntax of music' (*PNM* 153) as explored by Schoenberg in *Erwartung* and the *Five Pieces*. For Adorno, Stravinsky does not attempt to emancipate the person into these speculatively Freudian and hence subjective realms, and so merely succeeds in evoking the social comprehension of a stylistic method. He is driven by the 'adolescent' desire to become a 'proven classicist', rather than 'a mere modernist' (*PNM* 136 f.), and so the *Rite* is a secretly conservative, 'organised "Fauvist" work', to be seen in the light of 'African sculpture' as an 'anti-humanist sacrifice to the collective' (*PNM* 145). It is part of a movement which, together with that of Picasso and others, attempts to conceal its 'reactionary telos' (*PNM* 146), in encouraging the audience to participate 'in collective powers in a state of magic regression' (*PNM* 159). For Adorno the main task of Modernism is to evolve, and, what is more, to do so in a law-governed manner as shown in the work of Hegel and Marx. Anything else would lack the inner necessity which we have seen as Schoenberg's and Kandinsky's psychological guiding principle. However this may be as cultural analysis, it displaces the central question about the nature of the self, which is that of our affinity to the primitive, whether we come closer to it as we regress emotionally, or whether we can get closer to it if we participate in mythical ritual. T. S. Eliot, whom we have already seen to be preoccupied by such questions, saw the *Rite* as failing to make this connection clearly enough:

It was interesting to anyone who had read *The Golden Bough* and similar works, but hardly more than interesting. In Art there should be interpenetration and metamorphosis. Even *The Golden Bough* can be read in two ways: as a collection of entertaining stories, or as a revelation of that vanished mind of which our mind is a continuation. In everything in the *Sacre du Printemps*, except in the music, one missed the sense of the present.[108]

As the language of rhythm, or the ambivalently emancipated dissonances of atonality, or the multiple perspectives of Cubism dominate a work, there is a very significant loss, which is compounded by the appeal to the primitive, collective, and mythical depths of the unconscious. It is part of the destruction of our sense of the individuality of human character, and of a corresponding critical commitment to a

personal sensibility as projected through an innovatory artistic language. In this respect Stravinsky, like Schoenberg, moves 'beyond' Debussy, Ravel, and Strauss, and contributes to a regressive 'objectification' of the individual, as merged into the archetypal and the unconscious. The danger for a later Modernism, paradoxically enough, is of the loss of personality; as it disintegrates, it threatens to congeal into mere archetype.

The work we have looked at in this chapter is significant because the division of personality analysed by Nietzsche and others made possible the presentation of the individual as the site of internal dialogue, of separate voices from past and present, of conscious and unconscious, no one of which can be fully adequate to the inner world of emotion, and no one of which can be thought of as fully our 'own', or as disclosing the nature of the 'true self'. In the comic disjunction between sexual desire and self-consciousness, one may even become aware of oneself as acting like someone else, as do Aschenbach and Prufrock.[109] This 'subject as multiplicity' is not *just* the product of the Freudian family romance, haunted without knowing it by the voice of the father (or mother), but can also be like the political forum that Nietzsche suggests (and which is taken up so strongly in Postmodernist thinking by Althusser and others). Elektra's devotion to her father, his 'voice' thundering out his theme in the subconscious of the orchestra, *and* the politics of her revenge, are inextricably bound up with one another.

It is the idea of psychological division which underpins the technique of allusion by citation in much Modernist work. This is an innovation for the language of the arts as significant as those discussed earlier. In destroying univocity it makes the very medium of literature and painting (and later, music) equivocal, because the *mélange* of styles which results reflects the dominance of historical relativism and doubts about a universally acceptable 'message' for the work. (As a look forward to *The Waste Land*, *Ulysses*, and the *Cantos* or to Satie's *Parade*, Stravinsky's *Pulcinella*, *Oedipus*, and *Apollo*, and Picasso's *Vollard Suite* will confirm.) I have put allusion in the context of the post-Nietzschean conception of the self in order to emphasize its psychological significance.

Psychoanalysis speculates on the kind of (single) language the subconscious may be thought to 'speak' independently of the reason, and Freud has to present it as a narrative which only becomes one once the patient or artist has spoken. In origin, it may be essentially imagistic

or symbolic (as in the dreams of Anna O, of Clytemnestra, or the protagonist of *Erwartung* or the epiphanies of Joyce). To that degree it perpetuates the Symbolist evasion of social discourse. But it nevertheless emerges in the works of art we have discussed as a language which can be interpreted, and tempts us to believe that as we speak we may reveal our inner divisions as we give our'selves' away, even in everyday slips of the tongue and jokes, as Freud was quick to point out.

The literary Modernists therefore, even when aware of the unconscious content of the symbol, tended towards a far more dialogic conception of internal division, one in which the individual's self-expression is in tension with the language of others, including that of invented myth, such as that to which Stravinsky offers a musical commentary. It both uses and is used by its allusion to other discourses. Of course my examples also reveal that 'below' this dialogue, of Aschenbach with Plato, of Stephen Dedalus with Aquinas, Newman, and Yeats, and of Prufrock with the hero-victims of the literary tradition, a unifying thread of subconscious erotic motivation may indeed be at work. This threatens to express itself in this period, not just in the usual forms of violent appropriation, or displaced religious worship, or wish-fulfilling fantasy, but as primitive impulse. Stravinsky expresses 'le trouble vague et profond de la puberté universelle'—'une sorte de cri de Pan'—and Schoenberg's protagonist expresses the primitive and regressive emotions of rejection and murderous resentment, loss and seeking, while surrounded by music which makes no concessions to the civilizing achievement of conventional order, its sequence minimally rationalized by a dramatic situation, and so almost purely gestural and ejaculatory. When the artist turns towards these forms of emotional expression, the result is often aggressive and disturbed—and so much so in Picasso's case that the *Demoiselles* is not just the expression of a dialogue between primitivism and the conventions of the past, but also an unresolved conflict between their languages.

Art of this kind is acutely aware that such tensions can be evaded by socially induced forms of self-deception, including those which produce 'conventional' or academic work. Many, like Lawrence, thought that the release of the primitive offered a way out from this kind of hypocritical oppression, and so wished to advance beyond the Bohemianism which Aschenbach described as 'welcoming every blow to the bourgeois structure'. The aim was not just a search for the pre-Fall sexual paradise of the Symbolist in the South Seas, but for a primitivism which might confirm the tension between the artist and *any* modern

society. The Symbolist search for the expression of sex before Christianity is extended by the Modernists to the (Nietzschean) search for primal energies before ethics.

This dangerous escape towards the instinctive was correlative to a willingness to rely on a psychological 'inner necessity' rather than upon rational forms of debate, and led to a withdrawal towards world-views which, like Rimbaud's, could only be achieved through the vision of the artist and an implicit defence of his or her intuition. For Kandinsky and Schoenberg, the placing of a brush stroke, the choice of a word, or a sequence of chords may simply feel right—and, despite the apparent extreme rationalism of its 'analysis', the marks in Cubist paintings ultimately have the same justification. This emphasis on the particular and the instinctive was immensely reinforced by Modernist beliefs about the primitive, which justified a withdrawal from the Realist world of painstaking empirical perception, to one of simpler, but emotionally direct, conception.

It is hardly surprising in view of all this psychic lability that the innovative features of the works I have discussed depend upon fragmentation of the conventions for representation, harmony, and regular rhythm. The *Demoiselles*' shock to our system comes from our trying to organize in perception a rhythmic articulation which refuses any regularity and yet which is insistently and anguishedly expressive. In Schoenberg's case this disarticulation of conventional rhythm in favour of perpetual invention also shows the fragility of the relationship between subjective time and public time.

The result was a transformation of the human image: in the gross distortion of conventional representations of woman in the *Demoiselles*, the obsessions of a personality under stress in *Erwartung*, and the casting aside of individuality to license sacrifice in the imagined mythical collective of the *Rite*. This Conradian submersion of the individual in the destructive element on the grounds that it thus makes contact with the mythical and archetypal can be an extraordinarily dangerous tendency in Modernism, and its worst examples involve a highly conscious political manipulation.[110] It reinforces a strong tendency towards acceptance of the irrational, for, as the cases of Kurtz and Aschenbach variously show, there is a very awkward borderline between sickness, madness, and immersion in the primitive. There may be a new kind of 'power of darkness' in the re-emergence of such 'forgotten brutal instincts' (*HD* 94). How far these can really be thought of as being 'in all of us' is an as yet unresolved part of the legacy of Freud and

Jung: Lawrence claims to work out some of these questions in his
Women in Love, with which I began. For this kind of innovation natural-
izes the mad, the apocalyptic, the absurd, and the sacrifice of the indi-
vidual to collective emotion, by bringing it within the bounds of art. It
also represents violent confrontation, as the consequences of 'lack of
restraint' are imagined, from Kurtz to Kokoschka and Stravinsky's
'hurricane that had come from the depths of the ages and taken life by
the roots'.

In the process the Western category of the 'beautiful' was put into
question. It is an aesthetic term which from now on loses its universal-
izing power. It seems to express a set of values from the past, which are
more appropriate to the Symbolism, aestheticism, and decadence of the
past, than to the concerns of Modernism. Whether Matisse's was the
first step into the land of the ugly hardly matters—once such steps had
been made, there was an Expressionist European art which wished to lie
outside the taming categories of aesthetic appreciation. (In this it con-
trasts with the Cubist tradition, which encouraged a contemplative for-
malism which, since Fry, Bell, and others, has falsely been thought to be
central to Modernist art.) This Expressionism struck the viewer, reader,
or hearer as apparently arbitrary in its distortions, and so it began to
demand a problematic psychological explanation (as did Freud's
patients). Schoenberg put atonal music and neurotic disorientation
into an anguished interaction, so that the notion of unity in the work is
also at risk. Only the tenuous thread of language holds *Erwartung*
together. Picasso moves his mythological scene to a brothel, but leaves
no evidence of this in his picture, and it is his friends and interpreters
who have to use suppressed evidence to help us to rationalize its
mixture of disgust and fear. We need this new framework of ideas to
explain work which goes so far beyond convention. Stravinsky thought
he was just possessed by the *Rite* (as we are in hearing it in the concert
hall) but as a ballet score it can be given an anthropological rationale, as
an expression of the 'mystic terror' and 'celestial mystery' of the
sacrifice of a Virgin to a Bear. Roerich's work justifies an extension of
that primitive excitement in ensemble dancing that Diaghilev had
already exploited (in work like the *Polovtsian Dances*) and to which
Stravinsky himself had given a nostalgic social context in *Petrushka*.

The exaggeration, distortion, and caricature of this art is central to
Picasso's later development, to German Expressionist work, to all of
Schoenberg's work before the war, and to much of the work we shall
discuss in subsequent chapters. It is deliberately affronting, and calls

into question the notion that art should give pleasure. And yet it is indeed 'aesthetic', as an art of immediate sensation. Its common denominator is too often the violence which so many Modernist thinkers and artists thought they could release from the divided self.

Bibliographical Note

For a philosophical history of notions of the self, see Charles Taylor, *Sources of the Self: The Making of the Modern Identity* (Cambridge, 1989). On Nietzsche and Freud see Paul Laurent Assoun, *Freud et Nietzsche* (Paris, 1980). Nietzsche's influence on Jung was also profound: as revealed in particular by his seminar on him in 1934-9, see *Nietzsche's Zarathustra*, ed. J. L. Jarrett, 2 vols. (London, 1989).

Notes

[1] Joseph Conrad *Heart of Darkness* (Harmondsworth, 1973), 35. Henceforward cited in the text as *HD*.

[2] Conrad and Freud are both indebted to the anthropological doctrine of survivals, by which the vestiges of earlier 'lower' cultures are to be found in later 'higher' ones, which is to be found in the standard works of Tylor, Waitz, Vogt, Lubbock, and Prichard. Freud, in positing 'the existence of a collective mind', later argues that 'the sense of guilt for an action has persisted for many thousands of years and has remained operative in generations which can have had no knowledge of that action' in *Totem and Taboo* (1913), in Sigmund Freud, *The Origins of Religion*, Penguin Freud Library, xiii (Harmondsworth, 1985), 220.

[3] Cf. Lionel Trilling: 'Nothing is more characteristic of modern literature than its discovery and canonisation of the primal non-ethical energies', *Beyond Culture* (New York, 1965), 19. Conrad's notion of the primitive is politically controversial. For a generally hostile account of his narrative here as 'imperialist' and 'racist', and as presenting a view of the primitive which is a 'cheat' and 'unable to transcend the very Western values it attacks', which builds on that of Chinua Achebe and others, see Marianna Torgovnick, *Gone Primitive: Savage Intellects, Modern Lives* (Chicago, 1990), 141–58.

[4] Friedrich Nietzsche, *The Will to Power* (1885; New York, 1968), 387.

[5] Friedrich Nietzsche, *The Genealogy of Morals*, vi, trans. Francis Golffing (New York, 1956), 165.

[6] Ibid., x. 170.

[7] Friedrich Nietzsche, *Werke*, iii (Munich, 1966), 473.

[8] Cf. Alexander Nehamas, *Friedrich Nietzsche: Life as Literature* (Cambridge, Mass., 1985), 172 ff.

[9] Nietzsche, *The Will*, 277. *Zarathustra* is centrally concerned with one conse-

quence of resistance to this situation, which is the need to create oneself, as the *Übermensch*. Nehamas, *Nietzsche*, 188 ff., compares Nietzsche to Proust as a self-creator out of the act of writing.

[10] Nietzsche, *The Will*, 490.

[11] e.g. in the post-Freudian work of Althusser, Lacan, and others. Cf. Kate Soper, *Humanism and Antihumanism* (London, 1985).

[12] August Strindberg, Preface to *A Dream Play* (1903), trans. Michael Meyer (London, 1982). The dreaming protagonist here (cf. 236–7), having had a vision of 'Christ Crucified by all right thinking people' (241) seeks a 'solution to the riddle of existence' (242) in the hope of escaping the Buddhist and Nietzschean cyclic return of history. At the climax of the play, the Kantian representatives of the Four (university) Faculties debate the nature of that which they expect to find when they open a mystical door (243) through which the dreamer's beloved is expected to come. But they discover 'Nothing' behind it (246).

[13] Philip Rieff, *Freud the Mind of the Moralist* (London, 1965), 51. Freud's misogyny arises from the same sources, cf. 173–6 and 181–3.

[14] See e.g. Judith Ryan, *The Vanishing Subject: Early Psychology and Literary Modernism* (Chicago, 1991), which studies the influence of William James, Ernst Mach, Franz Brentano, and others on many of the writers of the Modernist period, including Rilke, Stein, Kafka, and Hofmannsthal.

[15] He also had a number of competitors, such as Otto Weininger. Innovatory accounts of sexual development and sexual relations abound at the turn of the century.

[16] *The Interpretation of Dreams* sold only 351 copies before 1906, and was not reprinted until 1909. Cf. Hannah Decker, *Freud in Germany* (New York, 1977), esp. 'The Educated German Public and Psychoanalysis', 257–321, which reports its early reviews, 278 ff. (in lay periodicals and centring on the wish-fulfilment hypothesis), and concludes that there was no general awareness of Freud 'until the 1920s' (261). Donald Gordon, *Expressionism: Art and Idea* (New Haven, Conn., 1987), concludes that Freud's and Jung's 'early works . . . [were] not discussed or even known by artists, to my knowledge, until well into the First World War' (221).

[17] Sigmund Freud with Josef Breuer, *Studies on Hysteria* (London, 1953), 160. Freud's acknowledgement of the writer Arthur Schnitzler as 'a kind of Doppelgänger' working with 'the same presuppositions' also indicates his awareness of the context I have just sketched: 'Your determinism as well as your scepticism—what people call pessimism—your awareness of the truths of the subconscious, of the instinctual nature of man, your dissection of the conventional cultural certainties, the preoccupation of your thought with the polarity of love and death, all this appeared to me uncannily familiar' (Freud, letter to Schnitzler for his 60th birthday, 14 May 1922, cited in Ernest Jones, *The Life and Work of Sigmund Freud* (New York, 1951), iii. 443 f.) Ryan, *Vanishing Subject*,

127, reports that Schnitzler (whose writing career began in 1885) was not influenced by Freud until c.1927.

[18] Sigmund Freud, *The Interpretation of Dreams*, Penguin Freud Library, iv, trans. James Strachey (Harmondsworth, 1976), 126, 170, 215, 152.

[19] On wishes see Freud, *Dreams*, 200 ff., and on the parallel with poetry see Schiller, cited in *Dreams*, 177.

[20] Ibid. 346.

[21] Ibid. 356 ff. The 'primaeval ages of human society' (357) give rise to the stories of Kronos, Zeus, and Oedipus (discussed 362 ff.) whose power lies in a disguised sexual impulse. Freud believes by 1908 that 'myth and neurosis have a common core'; see William McGuire (ed.), *The Freud/Jung Letters* (London, 1979), 122.

[22] Freud's insistence on the role of sexuality in human development as he outlined it in his *Three Essays on the Theory of Sexuality* (1905)—with its central essay on 'Infantile Sexuality'—led by 1914 to a bitter divergence from Jung. See McGuire, *Freud/Jung Letters*, esp. 299 ff.

[23] Carl Jung, ibid. 176.

[24] Sigmund Freud, Lecture 13, 'The Archaic Features and Infantilism of Dreams' (1916), in his *Introductory Lectures on Psychoanalysis*, trans. James Strachey (Harmondsworth, 1973), 235.

[25] Freud, *Dreams*, 675 n. (though this is a reflection added in 1914, after his work on Leonardo).

[26] The book is also, given Freud's reliance on his own experience, a narrative of self-discovery, of which Freud himself is the secret hero. It is a disguised confessional self-portrait, as Carl Schorske, *Fin de Siècle Vienna* (Cambridge, 1981), 183–97, and others, e.g. Peter Gay, *Freud* (London, 1989), 98 ff. and 105–17, have pointed out. See also Didier Anzieu, *Freud's Self Analysis* (2nd edn., 1975; trans. Peter Graham, 1986).

[27] Rieff, *Freud*, 34.

[28] We have already noted Kandinsky's interest in primitive and folk art, which is obvious throughout the *Blaue Reiter Almanack*. But Freud was almost totally indifferent to Symbolist and Modernist art: cf. Jack J. Spector, *The Aesthetics of Freud: A Study in Psychoanalysis and Art* (London, 1972), 22 ff.

[29] Robert C. Solomon, *Continental Philosophy since 1750: The Rise and Fall of the Self* (Oxford, 1988), 143.

[30] Freud in McGuire, *Freud/Jung Letters*, 171; letter of June 1910. These letters are of course peculiarly revealing for the frank and simple programmatic statements of their writer's attitudes. Cf. also Peter Gay, *A Godless Jew: Freud, Atheism and the Making of Psychoanalysis* (New York, 1987).

[31] In Vienna, most notably in the work of Klimt and Schiele. Much of Schoenberg's work such as the *Verklärte Nacht* and the *Gurrelieder* implies such a view.

[32] Sigmund Freud, 'Civilised Sexual Morality and Modern Nervous Illness' (1908)

in *Civilisation, Society and Religion*, trans. James Strachey (Harmondsworth, 1985), 35 f.

[33] Ibid. 38, 39, 46. On the other hand, 'nothing protects [a woman's] virtue as securely as does an illness' (47). Cf. the chapters on 'The Cult of Invalidism' and 'The Collapsing Woman' in Bram Dijkstra, *Idols of Perversity* (Oxford, 1987), 25–82, which show that Freud is concerned here with a pervasive and idiosyncratic cultural phenomenon. He concludes his essay with remarks on the sexual misery of contemporary marriage.

[34] Freud, 'Civilised Sexual Morality', 42, 47.

[35] Sigmund Freud, *Leonardo*, trans. Alan Tyson (Harmondsworth, 1963), 101, 111, 115.

[36] On Mann and Freud cf. Frederick J. Hoffmann, *Freudianism and the Literary Mind* (Baton Rouge, La., 1957), 207 ff. Mann began reading Freud first in 1925. Psychoanalysts of course took Mann's work as a confirmation of their theories. Cf. ibid. 212.

[37] Cf. T. J. Reed, *Thomas Mann: Der Tod im Venedig* (Oxford, 1971), 26 ff. Mann's own homosexual impulses have also been closely scrutinized of recent years.

[38] Thomas Mann, *Death in Venice*, trans. H. T. Lowe-Porter (Harmondsworth, 1971), 10. Henceforth referred to in the text as *DV*.

[39] Cf. T. J. Reed, *Thomas Mann and the Uses of Tradition* (Oxford, 1974), 67 f.

[40] Reed, *Der Tod*, 177, points out that this passage is based in some detail on Erwin Rohde's account of Dionysian orgies in his *Psyche* (4th impr., Tübingen, 1907).

[41] Cf. Reed, *Der Tod*, 32 ff.

[42] D. H. Lawrence, *A Selection from Phoenix*, ed. A. A. H. Inglis (Harmondsworth, 1971), 282 (originally published in the *Blue Review* (July 1913)). Cf. Lawrence's *Fantasia of the Unconscious* and *Psychoanalysis and the Unconscious*, both published in 1923.

[43] *DV* 76, and Freud, *Leonardo*, 180.

[44] Cf. James Joyce, *A Portrait of the Artist*, ed. Chester G. Anderson (Harmondsworth, 1977), 189. Henceforward referred to in the text as *PA*. For some critics, English is the language of the oppressor, and it is also therefore a symptom of the divided self. Cf. Colin McCabe, *James Joyce and the Revolution of the Word* (London, 1978), 53 ff. But by *PA* 203 Stephen is telling Davin 'My ancestors threw off their language and took another . . . Do you fancy I am going to pay in my life and person debts they made? What for?'.

[45] Hugh Kenner, *Ulysses* (London, 1980), 7–11, offers a brilliant stylistic analysis of this passage. The scene is also suffused with hidden quotations from Dante (a parallel to Plato at the end of *Death in Venice*). It also may be to the point to remember here that this scene is rewritten by Joyce in the 'Nausicaa' episode of *Ulysses*. Cf. the fireworks at the climax.

[46] Anthony Burgess, *Here Comes Everybody* (London, 1965), 50.

[47] For Maud Ellmann, *The Poetics of Impersonality* (Brighton, 1987), 76: 'It is

unclear from the title whether Prufrock writes the lovesong or the song writes him, whether it is by him or *about* him. But the rhetorical obsessiveness suggests that the subject is entrammeled in his discourse like an actor imprisoned in a script, or an analyst conscripted in the transference.' The poem 'is in love with its own process of composition'.

48 'A Commentary', *Criterion*, 12 (Apr. 1933), 470. I owe this point to Piers Gray, *T. S. Eliot's Intellectual and Poetic Development, 1909–1922* (Brighton, 1982), who argues, 68 ff., that Bergson may have influenced Eliot with a particular thesis about this relationship.

49 Gray, *Development*, 82, compares the poem with Baudelaire's 'La Vie antérieure' for this motif.

50 Ernst Cassirer, 'Language and Myth in the Pattern of Human Culture', in his *Language and Myth* (1925; repr. London, 1946), 7.

51 Ibid. 7.

52 And the further consequences of all this for the presentation of myth and symbol in literature are to be seen in mainstream high Modernism, and indeed helps to explain the resurgence of a Symbolist aesthetic within it, in Wallace Stevens and the later Eliot, for example.

53 As Rorty points out, unlike the Christian vices and virtues, such psychological descriptions 'enable us to sketch a narrative of our own development, our idiosyncratic moral struggle, which is far more finely textured, far more custom-tailored to our individual case, than the moral vocabulary which the philosophical tradition offered us'; see Richard Rorty, *Contingency, Irony and Solidarity* (Cambridge, 1989), 32.

54 Ibid. 39. 'If there is a universal creator, there must *ipso facto* be some universal principles, of his, her, or its operation, to be "revealed" or discovered' (ibid.).

55 D. H. Lawrence, *Women in Love* (London, 1915), ch. 19.

56 Gelett Burgess, 'The Wild Men of Paris', publ. in the *Architectural Record* (New York, May, 1910), 402.

57 Henri Matisse, Statements to Laurent Teriade (in 1936), repr. in Jack D. Flam, *Matisse on Art* (Oxford, 1978), 74.

58 From Cabanel's *Birth of Venus* of the Salon of 1863 through to work like Collin's *Paresse* (of 1906).

59 Henri Matisse, *Notes of a Painter on his Drawing* (1939), in Flam, *Matisse on Art*, 82. Cf. also Jack Flam, 'Matisse and the Fauves', in William Rubin (ed.), *'Primitivism' in Twentieth Century Art: Affinity of the Tribal and the Modern*, i (New York, 1984), 228. This article gives a full account of Matisse's relation to Africa and the exotic.

60 Matisse thought the *Demoiselles* an outrageous attempt to ridicule the modern movement. Cf. *Les Demoiselles d'Avignon* (Paris, 1988), ii, 671 f.

61 It was seen by the public in two fugitive reproductions (in the *Architectural Review* of May 1910 and in the *Revue surrealiste*, 4, of 15 July 1925), and exhibited in 1916, and then 1937.

[62] Tim Hilton, *Picasso* (London, 1975), 79.

[63] Its original title, suggested by André Salmon, was *Le Bordel philosophique*. He uses the title in his *La Jeune Peinture française* (1912), and refers the painting to the Carrer d'Avinyo in Barcelona, where brothels were to be found. Evidence for a brothel as the intended scene of the work can be provided from its evolution though a number of studies. In some of them we see a medical student carrying a skull, which suggests that this was originally a *memento mori* painting, or at least one for which the fear of sexual disease is relevant. See William Rubin, 'La Genèse des Demoiselles d'Avignon', in *Les Demoiselles*, ii. 417 ff. The face of the seated woman on the right may suffer from a syphilitic malformation (ibid. 420, 423).

[64] e.g. the leaning diagonals of Cézanne's Bather pictures, and the interweaving of naked bodies reminiscent of Ingres. Its inclusion of a clothed man entering left in earlier studies looks back to Manet's scandalous *Déjeuner sur l'herbe*, and the brothel scenes of Toulouse-Lautrec and Degas. On El Greco (*Vision of the Apocalypse*), see Rubin in *Les Demoiselles* , ii. 464 ff. He also (ibid. 458 f.) thinks the face of the figure opening the curtain derives from Gaugin.

[65] Cf. Rubin, in *Les Demoiselles*, ii. 470 ff.

[66] This Iberian stage is clear from the late water-colour in Philadelphia of five nudes, the only study which presents five figures in their definitive positions.

[67] Cf. Rubin in *'Primitivism'*, i. 262.

[68] Burgess, 'The Wild Men of Paris', 402.

[69] Clifford Geertz, *Local Knowledge* (New York, 1983), 98.

[70] Hence Geertz's judgement that our response to 'exotic' art, under the influence of work like Picasso's, is often no 'more than an ethnocentric sentimentalism', since we lack 'an understanding of the culture out of which they come . . . most people, I am convinced, see African sculpture as Bush Picasso and hear Javanese music as noisy Debussy' (*Local Knowledge*, 119). The exhibition of tribal art at the Museum of Modern Art in New York, which gave rise to the Rubin volumes, was attacked on these and other grounds; cf. e.g. Torgovnick, *Gone Primitive*, 119–37.

[71] Leo Steinberg, in *Les Demoiselles*, ii. 348.

[72] Cf. ibid. 338 ff.

[73] M. M. Gedo, in *Picasso: Art as Autobiography* (Chicago, 1980), 78–80, even postulates that Picasso may have had a venereal disease, and Robert Hughes, *The Shock of the New* (London, 1980), 24, sees anxiety about impotence in the painting.

[74] Igor Stravinsky and Robert Craft, *Expositions and Developments* (London, 1962), 58.

[75] Peter Franklin, *The Idea of Music: Schoenberg and Others* (London, 1985), 27 f.

[76] Ernest Newman, *Testament of Music* (1934; repr. London, 1962), 118.

[77] See Karen Forsyth in Derek Puffett (ed.), *Richard Strauss: Elektra* (Cambridge, 1990), 20, referring to Rohde and Bahr and Bachofen and Freud. Despite the

common interpretation of *Elektra* as a psychoanalytic drama, she points out that Hofmannsthal probably did not read Freud's and Breuer's *Studies in Hysteria* of 1895 till 1904, after the play had been written (ibid. 20). Abbate (ibid. 120 f.) nevertheless sees the 'repetition language of hysterics' in the libretto. Bryan Gilliam, *Richard Strauss's Elektra* (Oxford, 1991), 28, asserts that Hofmannsthal was 'preoccupied' with the issues raised by the *Studies* and *The Interpretation of Dreams* 'at the time of *Elektra*'.

[78] Newman, *Testament*, 118. George Bernard Shaw was inclined to excuse all this, in asserting that the counterpoint in *Elektra* was as good as in Beethoven, and that its protagonist was engaged in 'struggles with the Life Force' (repr. ibid. 126).

[79] It was not performed until 6 June 1924 in the German Theatre in Prague under Zemlinsky. The Clytemnestra scene of *Elektra* was thought to be the most extreme by critics for its 'atonality' and 'complete anarchy'; cf. Willy Pastor, cited in Puffett (ed.), *Elektra*, 3, and is perhaps closest to *Erwartung*. Puffett also reports Mahler's reaction to hearing Strauss play this scene in 1906, ending 'Oh, how blissful to be modern' (ibid. 5).

[80] Anna O's case was reported on in Freud's and Breuer's *Studies in Hysteria* (1895; repr. London, 1953), 21–47. John Crawford in Jelena Hahl-Koch, *Arnold Schoenberg/Wassily Kandinsky*, trans. J. C. Crawford (London, 1984), 184, claims that Marie was 'powerfully influenced by Freud's exploration of the unconscious'.

[81] i.e. in Dujardin's *Les Lauriers sont coupés* (1887) or in Schnitzler's *Lieutnant Gustl* of 1900, frequently cited as precursor works for the stream of consciousness technique.

[82] Speech to National Institute of Arts and Letters (1947), cited in Charles Rosen, *Schoenberg* (London, 1975), 10. The huge atonal improvisation of *Erwartung* had been prepared for by the *George Lieder* of 1909, of which Schoenberg remarked, in a programme note for the first performance on 14 Jan. 1910, that he was 'conscious of having broken through every restriction of a bygone aesthetic' (cited ibid. 15). On the erotic significance of *Das Buch* and *Erwartung* as its sequel, cf. Schorske, *Fin de Siècle Vienna*, 349 ff.

[83] 'Both the Brahmsian and the Wagnerian tradition of "musical logic" have . . . been suspended', says Carl Dahlhaus, who nevertheless argues that *Erwartung* is composed motivically in 'contracted Wagnerian periods' with a Webernian compression; see *Schoenberg and the New Music* (Cambridge, 1987), 151.

[84] Anthony Payne, *Schoenberg* (Oxford, 1968), 35.

[85] Arnold Schoenberg, 'New Music: My Music' (1930), in Erwin Stein (ed.), *Style and Idea: Selected Writings* (London, 1975), 105.

[86] Theodor Adorno, *The Philosophy of the New Music* (London, 1973), 30. 'The listener . . . feels no particular urgency for a "resolution" of the alleged dissonances, but rather spontaneously resists resolutions as a retrogression into

less sophisticated modes of listening' (ibid. 33). This is a very Adornian listener indeed.

[87] It is away from this equivalence that the relationship between text and atonal music has later to move, as, for example, in the more classically organized, e.g. canonic, music of *Pierrot Lunaire* (1912).

[88] Wilfred Mellers, *Caliban Reborn* (London, 1968), 42.

[89] Constant Lambert, *Music Ho!* (1934; repr. London, 1966), 60.

[90] Adorno, *Philosophy*, 39, 42. He even thinks that the 'blotches' in the MS score were produced by the id! See 39 n. 9.

[91] Nicholas Roerich, cited in Eric W. White, *Stravinsky: The Composer and his Works* (2nd edn., London, 1979), 171, from a letter sent by Roerich to Diaghilev cited in Serge Lifar's *Serge Diaghilev* (London, 1940). On Roerich's sources and a study by Taruskin, cf. Pieter C. Van den Toorn, *Stravinsky and the Rite of Spring* (Oxford, 1987), 14 f.

[92] Pierre Lalo in *Le Temps* (Paris, June 1913). The melodic material of the work is in fact mainly diatonic, though disguised by chromaticism and repeated chords. The main harmonic technique of the *Rite* seems to be that of polytonal aggregation, i.e. to depend largely on 'an aggregation of notes formed by the superimposition of two chords with their root a semitone apart' (White, *Stravinsky*, 173). Cf. also the analyses of Francis Routh, *Stravinsky* (London, 1975), esp. 76, and Stephen Walsh, *Stravinsky* (London, 1988), esp. 44, 49.

[93] Stravinsky interview, repr. in Lilian Brion-Guerry, *L'Année 1913*, ii (Paris, 1973), 322, 323. This interview, turned into a 'declaration' as reported by Ricciotto Canudo in *Montjoie!*, was repudiated by Stravinsky (*Chroniques* (Paris, 1962), 59); cf. Van den Toorn, *Rite*, 4 ff. This opening is analysed by Pierre Boulez in his *Relevés d'apprenti* (Paris, 1966), 75–145, esp. 82 ff.

[94] Edwin Lockspeiser, *Debussy, his Life and Mind*, ii (Cambridge, 1978), 101.

[95] Debussy, letter to Baron of 5 Feb. 1887, cited in Edwin Lockspeiser, *Debussy*, i (London, 1966), 75.

[96] Igor Stravinsky and Robert Craft, *Memories and Commentaries* (London, 1960), 30.

[97] Stravinsky and Craft, *Expositions*, 140.

[98] Stravinsky and Craft, *Memories*, 98.

[99] Stravinsky and Craft, *Expositions*, 147–8. Stravinsky makes this assertion despite the (growing) evidence that he was careful to transcribe folk tunes appropriate to the various rituals involved. Cf. Walsh, *Stravinsky*, 42, and Van den Toorn, *Rite*, 9–16.

[100] According to *Expositions*, 142 n.

[101] Pierre Boulez, *Points de repère* (Paris, 1981), 314.

[102] Mellers, *Caliban*, 89.

[103] *Montjoie!* interview, 324.

[104] Jean Cocteau, *A Call to Order*, trans R. H. Myers (London, 1926), 43.

105 Lambert, *Music Ho!*, 34, 94, 49. He also thought it 'an aphrodisiac for the jaded and surfeited', 51.

106 Wilfred Mellers describes the expressive effects of this technique as depending entirely 'on the "melodic tonality" of incantatory phrases oscillating round a nodal point; on hypnotic patterns of rhythm, beginning corporeally, but becoming "additive" at points of maximum excitement; and on percussive dissonance. This latter element is sophisticated by the use of unresolved appoggiaturas, which emphasise the barbarism while giving it an edge of hysteria which may be modern rather than primitive' (Mellers, *Caliban*, 91).

107 Adorno, *Philosophy*, 140. Henceforward referred to as *PNM* in the text.

108 T. S. Eliot, in his 'London Letter' for the *Dial*, 71 (Oct. 1921), 453. The ballet was withdrawn after three performances in London.

109 Or, one might add, Yeats and Lawrence, who also believe in the invasion of modern man by archaic identities. See Robert Langbaum, *The Mysteries of Identity* (Oxford, 1977).

110 They underlie a latent Fascism, some of whose features can be seen in the later political works of D. H. Lawrence.

4 | THE CITY

1. The Individual and the Collective

The great city demands competition and invention. It disseminates images of the modernization process through newspapers, magazines, and books, and so challenges the citizen's creativity and desire to dominate. But it also threatens its inhabitants, who feel anonymous within the mass and cut off from the face-to-face relationships which were supposed to be typical of the smaller, 'organic' societies, from which so many of them had emigrated in the early decades of the nineteenth century.[1] The peculiar psychology of the city dweller had long been of particular interest to the artist and, for literary intellectuals at least, Baudelaire provided a classic description of it in his 'De l'héroisme de la vie moderne'.[2] He scorns the heroism of a public, political life in favour of the Bohemian underworld, which includes the criminal milieu described by Balzac through his Vautrin, Rastignac, and Birotteau. But the city's modernity is most particularly defined for him by the activities of the *flâneur* observer, whose aim is to derive 'l'éternel du transitoire' ('the eternal from the transitory') and to see the 'poétique dans l'historique' ('the poetic in the historic'). It is the sheer evanescence of the city experience which challenges the contemporary artist:

La modernité, c'est le transitoire, le fugitif, le contingent, la moitié de l'art, dont l'autre est l'éternel et l'immuable.[3]

Modernity consists in the transitory, the fugitive, the contingent—and makes half of art, of which the other part is the eternal and immutable.

By the turn of the century, however, the city seemed to many to be a transitory spectacle far less manageable than that celebrated by Baudelaire and his Impressionist succcessors. In Georg Simmel's article on 'The Metropolis and Mental Life',[4] the basic perspective is far from that of the detached and aristocratic *flâneur*; it is that of the newcomer, suddenly subjected to a disorientating 'intensification of nervous stimulation', so that 'with each crossing of the street . . . the city sets up a

deep contrast with small town and rural life' and its 'deeply felt and emotional relationships'.[5] These feelings are echoed in Rilke's *The Notebooks of Malte Laurids Brigge* (1910). His hero's reflections on Paris are like those of many other poets and painters, and he can only find 'solace' in a reminder of country life:

The electric street cars rage through my room with ringing fury. Automobiles race over me. A door slams. Somewhere a window-pane falls clattering. I can hear the big splinters laughing and the smaller ones sniggering. . . . An electric car rushes up excitedly, then away overhead, away over everything. Someone is calling. People are running, overtaking each other. A dog barks. What a relief: a dog! Towards morning even a cock crows; and that brings immeasurable solace. Then all at once I fall asleep.[6]

Urban novelists like Dickens and Zola had tended to demonstrate their mastery of the interrelationships between groups in the city, often making it seem rather like a village. But Simmel and Rilke are concerned by the isolated and divided psychology analysed above (and taken over by Freud in 1908, as we have seen). Simmel goes on to emphasize an aspect of subjective experience in the town, which is central to the concerns of philosophers, poets, and painters in the early twentieth century, from Bergson to Joyce and Virginia Woolf—that is, its effects upon the rhythms of consciousness. His countryman has 'a steadier rhythm of uninterrupted habituations' which is 'rooted in the more unconscious levels of the psyche', whereas 'Metropolitan man' has to develop a 'protective organ' of intellect to cope with the novelty of his experience and its speedier rhythms.[7] An inability to make those explanatory causal patterns which most easily arise from the habitual leads, as we shall see, to the representation of urban experience by montage techniques.

Simmel also argues that the lonely depersonalization of metropolitan society provokes a new defensive intellectualism, which is not simply the reflex of social processes, but leads the exceptional individual to preserve an interior life of introspection against the overwhelming and machine-like activities of city life. His subjectivity is threatened, because the metropolis has 'outgrown' personal life in developing all those state institutions which many saw as a threat, and which Kafka makes the setting for a nightmare of persecution.

Here in buildings and educational institutions, in the wonders and comforts of space-conquering technology, in the formations of community life, and in the visible institutions of the state, is offered such an overwhelming fulness of

crystallised and impersonalised spirit that the personality, so to speak, cannot maintain itself under its impact.[8]

In the light of an analysis which points to the bureaucratization, objectification, and alienation of a modernizing metropolitan society, the theological allegorizing of the city as subject to demonic possession, in the poetry of Becher, Wegner, and particularly Georg Heym, looks distinctly passé, indeed Baudelairean. In Heym's *Der Gott der Stadt*

> Vom Abend glänzt der rote Bauch dem Baal,
> Die großen Städte knien um ihn her.

> The red belly of evening gleams at Baal,
> The great cities kneel around him.

The pagan god is worshipped with the Christian incense of factory smoke, while 'Wild as the dance of corybantes, the music I Of the millions rumbles through the streets'.[9] More in line with the analysis of a peculiarly Modernist consciousness is the literature which expresses feelings of threat as symptoms of psychological overload:

> Die Nächte explodieren in den Stadten
> Wir sind gefetzt vom wilden, heißen Licht
> Und unsere Nerven flattern, irre Fäden,
> Im Pflasterwind, der aus den Räden bricht.[10]

> Nights explode in the cities
> We are torn by wild, hot light
> And our nerves flutter, like threads astray
> In the pavement winds, that break out of wheels.

In the early Modern period poets and painters therefore struggled once more to mediate between conflicting conceptual frameworks; those which they saw as newly appropriate to the city, and those which they thought had been imposed on it by *passéiste* 'art'. Imagery which assimilated the city to the natural object was particularly suspect in this regard. The German painter Ludwig Meidner attacked Monet and Pissarro as 'two lyricists who belonged out in the country with trees and bushes. The sweetness and fluffiness of these agrarian painters can also be seen in their cityscapes.'[11] (Almost as fluffy Impressionist painting of the city was to be found in Berlin, in work by Max Liebermann, Max Slevogt, and others.) The poetry anthology, *In steinernen Meer—Großstadtgedichte* (1910), stated in its Introduction that 'Das Leben in der Natur kann für den Großstadtmenschen nicht mehr die eingige und

nicht mehr Hauptquelle der Poesie sein' ('For the inhabitant of great cities, life in Nature can no longer be the sole, and no longer the main, source of poetry').[12] And Lisbeth Stern, a socialist cultural critic, wrote in 1903 that 'The countless voices of the big city, which blend into a powerful roar . . . speak a more meaningful language to the modern artist than nature does'.[13] The Modernists thus tended to resist those metaphors and symbols which had metamorphosed the city into the more 'acceptable' aesthetic realm of the natural object—in Impressionist painting and much turn-of-the-century verse. For example, Le Gallienne's

> Like dragonflies the hansoms hover,
> With jewelled eyes to catch the lover;
> The streets are full of lights and loves,
> Soft gowns and flutter of soiled doves.[14]

It is the refusal of this aestheticizing imagery which is shocking in a poet such as T. S. Eliot, who associates the city with 'our special modern *dreck*, with banal and contemptible people, [and] with hasty and vividly unpleasant sex'; 'he does not oppose the city to the ample bosom of nature. In his inability to do so lies his modernness and his despair.'[15] The fantasy of escape to the countryside becomes a subject for parody (notably in the poetry of Alfred Lichtenstein).[16]

According to Spengler's *Decline of the West*, 'the gigantic megalopolis, the *city as world* suffers nothing besides itself and sets about *annihilating* the country picture'. Nor are its inhabitants much to be admired: 'In place of a type-true people, born of and grown on the soil, there is a new sort of nomad, cohering unstably in fluid masses, the parasitical city-dweller, traditionless, utterly matter-of-fact, religionless, clever, unfruitful, deeply contemptuous of the countryman.'[17] These artistically inclined 'nomads' could defend themselves against such larger social forces by making a village in the city out of *la vie de Bohème*, which provided a cast of characters to represent the encounter of the individual with city life (as, for example, the outcasts in the painting of Picasso's Blue Period). As Roters puts it:

In den Porträts, dem des Kunsthändlers, des Journalisten, des Kritikers, des Bohemiens, des Schiebers, aber auch des Bettlers und der Dirne, wird der Großstädter sowohl in seiner Personlichkeit wie als Typ erfaßt, und vom Kunstler liebevoll-erbarmungslos physionomisch analysiert.[18]

In portraits, of art dealers, journalists, critics, bohemians, conmen, and even of beggars and whores, the inhabitant of the big city can be grasped, as a personal-

ity and as a type, and their physiognomy analysed by the artist with a pitiless affection.

Poems like Becher's 'Frauen im Cafe', Stramm's 'Freudenhaus', Wegner's 'Montmartre', and Stadler's 'Heimkehr' exploit the night-world of bars, cafés, whores and procurers. 'Um harte Häuser humpeln Huren hin und wieder, | Die melancholisch ihren reifen Hintern schwin-gen' (The whores hobble in and out of rough houses | sadly swinging their ripe behinds from side to side) according to Lichtenstein in 'Die Nacht'. Such work moves away from a Naturalist sympathy or disgust, towards a Modernist sarcasm and irony.[19]

The strains and tensions inherent in city life thus helped to provoke the antagonistic solidarity which is typical of the avant-garde, in the studios of the Bateau Lavoir in Paris, the theatres and lecture halls in which Futurist 'manifestations' took place all over Europe, and the many literary cafés, in which poets like Apollinaire collected material for poems. The editors of Modernist magazines such as *Aktion* and *Der Sturm* also brought their contributors together for art exhibitions and poetry readings, and private clubs were often the sites for heated procla-mations of the new. Even Pound and his friends in Kensington could rely to some degree on the Aerated Bread Company. I believe that in all these groupings there was a primary tension in their confrontation with the city, between an introspective alienation and a celebration of the sheer energy and collective diversity of life (ultimately, the contrast between *The Waste Land* and *Ulysses*). It is the latter response which is most distinctive of early Modernism. It sees the city as the site of a new kind of sensibility, which can only express itself through disjunction and juxtaposition. This meant that, in the turn to Modernism, and the self-reflexive, stylized representation of experience we have already seen it promote, an interest in the city demanded a repudiation of the Natural-istic dominance and explanation of an earlier generation, in favour of subjectivist techniques of intuition and free association.

2. The Futurists

The Futurists were by far the most important of the avant-garde group-ings which made life in the modern city central to its concerns. The manifesto of the five self-declared Futurist painters (Giacomo Balla, Umberto Boccioni, Carlo Carrà, Luigi Russolo, and Gino Severini) promised on 11 April 1910 to display 'the frenetic life of our great cities

and the exciting psychology of night life', and to 'glory in our day to day world splendidly transformed by victorious science'.[20] Their many manifestos produced a climate of ideas throughout Europe which attempted to keep significant painting once more subject orientated and 'literary' in contrast to the abstraction of the Cubists and Kandinsky.[21] Above all, by taking a widely publicized and aggressive position, with which other movements had to come to terms, they posed two vital questions. The first concerned an appropriately Modernist urban subject-matter, and the second the search for an adequate mode for the presentation of its psychological effects. Their assumptions about psychology arose out of a deep anti-intellectualism, which owed a good deal to the visionary derangement of Rimbaud. Marinetti, the leader of the movement, deliberately challenges the symbolic coherence of the Baudelairean vision by demanding a fearless confrontation with the irrational: 'Let us throw ourselves to be devoured by the Unknown not because we are desperate, but simply to replenish the bottomless reservoirs of the absurd!' (*FM* 20)[22] even if this means that he and his painter colleagues will have to 'bear proudly and bravely the smear of "madness" ' (*FM* 26).

This is not entirely new; but it was made to seem so by being accompanied by an aggressively dismissive view of all past solutions. At the beginning of his first manifesto, originally published in *Le Figaro* in February 1909, Marinetti suggests to his friends that they go on a journey away from Symbolism in their three 'snorting beasts' of cars: 'Let's go! Mythology and the Mystic Ideal are defeated at last!' Like Mr Toad, whom he much resembles, Marinetti drives his car into a ditch, where he joyfully imbibes the essence of industrial modernity: 'O maternal ditch! almost full of muddy water! Fair factory drain! I gulped down your nourishing sludge.' There is a nice hint of primitivist regression here, as Marinetti also associates the ditch with 'the blessed black breast' of his Sudanese nurse (*FM* 21). He and his colleagues emerge from this conversion-and-rebirth experience, 'smeared with good factory mud', to 'declare their high intentions':

We intend to exalt aggressive action, a feverish insomnia, the racer's stride, the mortal leap, the punch and the slap . . . Except in struggle there is no more beauty. No work without an aggressive character can be a masterpiece. (*FM* 21)

Their example of an acceptably modern object is 'a roaring car that seems to ride on grapeshot', which confronts the past by being 'more beautiful than the *Victory of Samothrace*' (*FM* 21). Indeed one might as well 'destroy the museums, libraries, [and] academies of every kind' (*FM*

23). The broader political dimensions of Marinetti's aggression are also revealed here when he says that he will 'scorn' women and 'glorify war'. [*FM* 22][23] Above all he appeals to youth, to emancipate itself from past tradition and to seek a heroic inspiration in contemporary life.

For the Futurist the city is the environment in which the museum-bound culture of the past can be subverted, and new boundaries between art and life evolved. For Marinetti is the ancestor of all later performance and political (e.g. Situationist) art—in a Futurist assembly, a theatrical performance, a lecture, a poetry reading, or a concert was given the character of a political meeting, in which the audience's contribution, by discussion, expressing outrage (usually), or even riot, was caught up in the theatrical and experimental character of the whole. The most vociferous objections to the Futurist avant-garde were used to confirm its importance. This confrontation of the bourgeoisie in an attempt to give to art the importance of political agitation no doubt owed a good deal to the ideas of Proudhon, Bakunin, Nietzsche, and Sorel, and helped to bring avant-gardist behaviour out of Bohemia into a public space. Having begun as not much more than an advertisement for an artistic movement in a French newspaper, Futurism was among the first of many avant-gardist groupings to hope that artistic achievement would follow image and notoriety. In particular it promised an urban subject-matter which was also to be stirred up and given a crudely Expressionist, dynamic quality, which contests the individualist defeatism analysed earlier, by appealing to the crowd:

We will sing of great crowds excited by work, by pleasure, and by riot . . . we will sing of the vibrant nightly fervour of arsenals and shipyards blazing with violent electric moons; greedy railway stations that devour smoke plumed serpents; factories hung on clouds by crooked lines of their smoke; bridges that stride the rivers like giant gymnasts . . . adventurous steamers that sniff the horizon . . . (*FM* 22)

Like so much in this period that proclaims its newness by the indiscriminate use of the future tense, such declarations tacitly suppress their debts to the past, and to contemporaries. Marinetti's celebratory attitude to city life in fact owes a good deal to the Unanimists, whose central idea was that the group could transcend the divided individual. Hence Jules Romains's assertion, as one of the leaders of the Unanimist group, that 'the bonds of feeling between a man and his city . . . the large movements of consciousness, the colossal passions of human groups' were 'capable of creating a profound lyricism or a superb epic cycle'.[24] If

we attempt to escape from the internal divisions of subjectivism into its opposite, the self-abnegating and unifying aims of the collective, we can realize that 'l'homme n'est pas ce qu'il y a de plus réel au monde. On admet la vie d'ensembles plus vastes que notre corps' ('Man is not the most real thing in the world. We should acknowledge the life of groups much larger than our single body'). Romains urges an awareness of the 'organic consciousness' of the group. This can manifest itself rhythmically, if we 'hollow out our souls', 'emptying them of individual dreaming', so that 'the souls of groups will of necessity flow' through the 'canals/ditches' ('rigoles') we have thus made. It is within the city that such rhythms of collective life manifest themselves most strikingly, because in it

L'espace n'est à personne. Et nul être n'a réussi à s'approprier un morceau d'espace pour le saturer de son existence unique. Tout s'entre-croise, coincide, cohabite. Chaque pont sert de perchoir à mille oiseaux.

Space doesn't belong to anyone in particular. And no one has succeeded in appropriating for themselves a bit of space, in order to saturate it with their unique existence. Everything interpenetrates, coincides, cohabits. Each bridge is a perch for a thousand birds.

The city literally imposes the patterns of group life, because its architectural division of space into city blocks and roads articulates the basic rhythms of contemporary existence.

Les rues n'ont pas de centre fixe, pas de limites vraies; elles se contentent d'une longue vie vacillant que la nuit aplatit jusqu'au ras de néant. Les places et les squares prennent déjà des contours, serrent davantage le noeud des rhythmes.[25]

Roads don't have a fixed centre, no true limits; they are happy with a long vacillating life which is flattened out by night to the level of nothingness. Public cross roads and residential squares are already taking upon themselves a contour, upon whose rhythmic interlacings they are taking an ever stronger grip.

The individual willing to situate himself or herself correctly in relation to such geometrical perspectives would be in touch with the basic rhythms and energies of the universe. The public buildings which were crystallized and imposing and rigid for Simmel, are dynamic and liberating for Romains, as they continued to be for writers like Musil and Woolf (in her essay on 'Modern Fiction').

This interaction between individual and environment could be literally perceived in Modernist painting. For this philosophy of the close interrelation between person, object, and environment could

seize upon Cubist techniques, which had merged object, observer, and world within a kind of observational geometry (if for far more purely formal aesthetic purposes). Severini's *Le Boulevard* (1911), for example, shows strollers through the city as united by the pervasive rhythms of its triangular construction. This parallels Romains' 'Une autre âme s'avance' from his *La Vie unanime*:

23

> Qu'est ce qui transfigure ainsi le boulevard?
> L'allure des passants n'est presque pas physique;
> Ce ne sont plus des mouvements, ce sont des rhythmes,
> Et je n'ai plus besoin de mes yeux pour les voir.[26]

> What is it that transfigures the boulevard?
> The gait of the passers by is hardly a physical one
> They are no longer making movements, but rhythms
> And I no longer need my eyes to see them.

This painting grows out of Severini's obviously neo-Impressionist *Printemps à Montmartre* of *c*.1909, and is a striking example of Modernist stylistic metamorphosis.

Futurist painting had begun by expressing a far more isolated psy-

23. Gino Severini, *The Boulevard*, 1911.

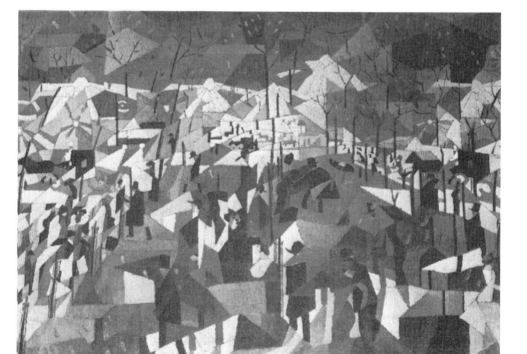

chology, which came to the avant-garde from Bergson, who profoundly influenced attempts to represent the passing of time in Modernist art, particularly by sustaining the idea (also found in Simmel), that subjective experience has a peculiarly rhythmic character. Bergson's central argument is that the present carries the past with it. It is 'swollen' by memory, in our experience of 'durée'.[27] He defines this 'pure duration' in his *Essai sur les données immédiates de la conscience* (1889) as

the form which the succession of our conscious states assumes when our ego lets itself *live*, when it refrains from separating its present state from its former states. For this purpose it need not be more absorbed in the passing sensation or idea; for then, on the contrary, it would no longer *endure*. Nor need it forget its former states: it is enough that, in recalling these states, it does not set them alongside its actual state as one point alongside another, but forms both the past and the present into an organic whole, as happens when we recall the notes of a tune, melting, so to speak, into one another.[28]

Our perceptions are full of memories; the details of past experience mingle with the immediate and present data of our senses, as 'every perception fills a certain depth of duration, prolongs the past into the present, and thereby partakes of memory'.[29] This interactive conception of memory encouraged the allusive approach to the personal past to be found in many Modernists. For Bergson, as for Freud and others, the personality cannot be seen as a mosaic or Humean bundle of bits of past experience, but is involved in a continuous interactive process. Such views were peculiarly consonant with the Expressionist aesthetic, because they gave to each individual a uniquely intuitive rhythm of experience, and a flexible durée.[30] The rhythms of free verse, as we have seen, and the very proportions of pictures like Severini's are to be thought of as uniquely their (and his) own. Pound also believed in an 'absolute rhythm' in poetry 'which corresponds exactly to the emotion or shade of emotion to be expressed. A man's rhythm must be interpretative, it will be therefore, in the end, his own, uncounterfeiting, uncounterfeitable.'[31] This essentially introspective view of the personality treats subjective experience as betrayed by the kind of thinking demanded by the sciences, which purport to describe and measure the parts of an external world, theoretically independent of our observation.

The idea that a work of visual art can express this kind of temporal process came into French art criticism with early Cubist painting, which could be interpreted as showing the temporal process or durée of its own creation, as the artist shifted his point of view. As Metzinger put it,

'the whole image radiates in time; the picture is no longer a dead portion of space.'[32] The Futurists attempted to liven up this temporal space, by showing how an (urban) content could imply the Bergsonian processes of memory, and by making spatial equivalents for the rhythm of the intuitions which occurred within the experience which the image tried to express.[33]

24 A painting like Russolo's *Memories of a Night* (*Ricordi di una notte*) (1911) thus attempted to produce equivalents for psychic duration, and for the manner in which the memory may link elements from the past and the future through common images. It is remarkable in its conflation of the processes of memory and of dream, achieved by superimposing incompatible images within the same pictorial space of an implied consciousness. The rising sun above and the electric lights below indicate a temporal succession in the thoughts of a young woman, whose head appears in full face at the upper left, and again in profile on the right, where she looks down on an admiring male

24. Luigi Russolo,
Memories of a Night
(*Ricordi di una notte*), 1911.

audience. Above her there are shadowy houses, and a running horse. Behind her, elongated figures walk through the streets. The perspectivally inconsistent size and location of the picture's objects are no doubt clues to their psychological importance for the woman, but no very certain interpretation of the painting seems possible.[34]

Such a painting does not propose any very distinctive model for formal organization. The spectator is left to speculate about the narrative relationship between its elements. But the Futurist belief in the 'dynamism' of modern life worked towards a far more distinctive form of expression, in paintings organized around what they called 'lines of force'. These were supposed to articulate the canvas as well as dramatize the psychological interdependence between the energies which the 25 city both made possible and co-ordinated. In Boccioni's *The City Rises* (*Città che sale*) originally called *Lavoro* (*Labour*) of 1910–11, for example, the dynamic is that of collective labour, as man and horse (a rather *passéiste* subject, in view of the Marinettian worship of the machine) are at work on a construction site. The final version of this very large painting gives an impression of swirling violent activity, which Boccioni said reflected his understanding of Marinetti's injunction that 'No work which does not have an aggressive character can be a masterpiece'. The light of the sun conducted along the central horse's mane is an overpowering force within the painting, as Boccioni adapts divisionist technique to convey the impression of a huge magnetic field activated by light. The human figures caught within its rays are deprived of any individuality. Their heroic strivings symbolize the 'dogged work' (Boccioni's phrase) of the collective, in a painting whose scientific and secularizing purpose was that of 'erecting a new altar to modern life vibrant with dynamism', and, what is more, 'one no less pure and exalting than those raised out of religious contemplation of the divine mystery'.[35]

This secularizing emphasis on the human energies of the group VIII dominates Carrà's equally monumental *Funeral of the Anarchist Galli* (*Funerali dell'Anarchio Galli*).[36] Unfortunately we cannot now perceive the original dynamics of his theme, as the upper third of the painting has been overpainted with a static Cubist articulation. The psychological interest here arises not simply out of the interactive ensemble of figures, but also from its political implication, that the death of the martyred individual can awaken the potentially heroic force of the concerted masses.[37] Romains's poem 'Le Groupe contre la ville' published in *La Vie unanime* similarly praises the collective force of a funeral procession:

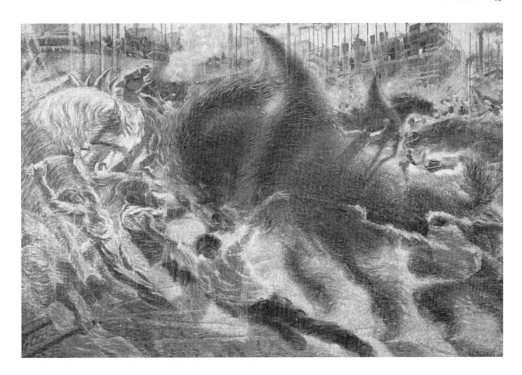

25. Umberto Boccioni, *The City Rises* (*La Città sale*), 1910–11.

L'âme a péri dans l'homme et renaît dans le groupe
 Plus robuste qu'avant;
Elle serre comme une croûte entre ses dents
 Une seule idée.
Elle sait que l'état, obstrué d'injustices,
Souffre, car il n'est pas unanime et divin;
Le cortège a juré de ne pas vivre en vain,
Et rêve obscurément que ce soit par ses mains
 Que l'ordre s'accomplisse.[38]

The soul has died in the man, and is reborn in the group
 more robust than before;
it grips a single idea, like a crust between its teeth.
It knows that the state, choked by injustices, suffers,
because it is not unanimous and divine.
The funeral procession has sworn not to live in vain,
and dreams obscurely that order might be brought about at its hands.

The underlying aesthetic of poetry and picture is once more Expressionist, as we can gather from the Futurist Exhibition Catalogue of 1912 for Paris and London, which speaks of 'force lines', such that 'Every

object reveals [by its lines] how it would resolve itself were it to follow the tendencies of its forces'. This too has its parallel in Romains's poetry: the same poem thinks of the object as imposing a rhythmic configuration on its environment:

> En avant des hommes
> Le corbillard.
> Le rhythme sort de lui comme un rayonnement;
> Autour de lui la multitude, incohérente
> Naguère, est devenue un ensemble vivant.[39]

> In front of the men
> the hearse.
> Rhythm comes out of it like a light-ray;
> all about it the multitude, incoherent
> and disorganized till now, has become a living group.

This results in a deformation which depends, for painter and poet, not just on 'the characteristic personality of the object' but also on a primitive animistic projection which makes it express 'the emotions of the onlooker', who can see how 'every object influences its neighbour, not by reflections of light (the foundation of *impressionistic primitivism*) but by a real competition of lines and by real conflicts of planes'. (*FM* 48)

These internal tensions should follow 'the emotional law which governs the picture', which is 'the foundation of Futurist *primitivism*' (*FM* 48). This notion of primitivism derives from the complex of ideas concerning feeling and instinct analysed earlier,[40] but it also looks to science. As the Impressionists had analysed the basic element of *light*, so will the Futurists analyse and represent *movement.* They were much encouraged in the belief that this was possible, by the development of 'chronophotography' to make diagrammatic analyses of sequences of human and animal movement, as in the work of Marey, Eadweard Muybridge, and others.[41] Many of their pictures (such as Balla's *Young Girl Running on a Balcony* (1912)) echo the features of this kind of photographic work,[42] but the issue here is not so much their interest in making a Cubist-influenced 'analysis' of motion,[43] as an empathetic projection by the artist. Moving objects are, by a kind of pathetic fallacy, subjected to the 'laws' of feeling as their rhythms are realized on canvas, and the spectator, sucked in by force lines, '*must in future be placed in the centre of the picture*' (*FM* 48), so that his or her experience shares this dynamic, Bergsonian quality. In the 'phases of a riot', for example, 'the crowd

rushing with uplifted fists and the noisy onslaughts of cavalry are trans-
lated upon the canvas in sheaves of lines corresponding with all the
conflicting forces, following the general law of violence of the picture'
(*FM* 48).

The spectator is involved in the struggle, because its depiction turns
upon a rhythmic interdependence between subject, object, and envir-
onment, as in the images we have already looked at. The basic principle
here is Bergsonian *and* Unanimist, for the Bergsonian hostility to the
scientific point of view insists that its division of the world into inde-
pendent bodies, each outlined and separate from the others, is an
arbitrary exercise: things are only individuated by their relationships to
everything else (rather as in Saussurean Structuralism).[44] This relativist
dependence of spatial division upon an act of conception is also to be
found in Braque's *Le Port* (1909) and its successors. But what the Cubists
discovered by an abstracting analysis of the static geometrical relations
between object and surroundings was important to the Futurists as
expressing essentially philosophical and literary attitudes, like those of
the Unanimists, to urban experience.

15

The influence and adaptation of Cubism to these ends is obvious in
Boccioni's *Simultaneous Visions* (*Visioni simultanee*) and *The Street
Enters the House* (*La Strada entra nella casa*) of 1911. Both pictures
closely resemble Delaunay's Tower series, in which the buildings of
Paris (as in the Champ-de-Mars version of the same year) also seem
about to collapse and converge. But the conflict of perspectives in
Boccioni has a psychological justification which goes beyond Delaunay;
it manifests the bewildering changes in visual sensation which were
thought typical of the city, as we 'enter into the overwhelming vortex
of modernity through its crowds, its automobiles, its telegraphs, its
bare lower-class neighbourhoods, its sounds, its shrieks, its violence, its
cruelties, its cynicism, its implacable careerism'. [45] In *La Strada entra
nella casa* the subject is a building site and its scaffolding (another
dynamic and concerted group activity) is seen by Boccioni's mother
from a balcony, which projects into the picture plane. Its technique of
interpenetrative spatial disruption is supposed to represent the
affective character of the spectator's perceptual experience—and what
Boccioni says about this establishes his position with respect to an idea
of immense importance for the painting and poetry of the period—that
of simultaneity.

IX

In painting a person on a balcony, seen from inside the room, we do not limit the

scene to what the frame of the window renders visible; but we try to render the sum total of visual sensations which the person on the balcony has experienced; the sunbathed throng in the street, the double row of houses which stretch to right and left, the beflowered balconies, etc. This implies the simultaneousness of the ambient, and, therefore, the dislocation and dismemberment of objects, the scattering and fusion of details, freed from accepted logic, and independent from one another. (FM 47)

Once 'freed from accepted logic' we may discover the Bergsonian psychology which inderlies such a picture, which is 'the synthesis of *what one remembers* and of *what one sees*' (FM 47). Boccioni also interpreted urban dynamics in terms of a more overtly geometric and analytical approach to form, as, for example, in his *Forces of a Street* (1911), with its clear triangular organization. But it is temporal rather than merely spatial relationships which most concerned Boccioni in this period, and they are most seriously demonstrated in relation to underlying emotions in his great triptych, the *Stati d'animo (States of Mind)* of 1911.

The series centres on a subject—the railway station—inherited from the Impressionists (and indeed from illustrative painters such as Frith). But with the evolution of new ideas concerning the interdependence of man and machine, it maintained its power as a contemporary subject *par excellence.* Boccioni's three images express the successive human emotions of 'those who go', 'those who say farewell', and 'those who remain', in contrast with the impersonal automatism of the machine.[46] There are two versions, the first of which is fluid and Bergsonian, and the second more Cubist in articulation, more rigid and monumental. The internal history of the triptych is one of stylistic metamorphosis, as Boccioni reinterprets available styles to achieve the Modernist expression of collective experience in the city.

The first version aims at a complex articulation of collective states of mind as they change through time, without recourse to Russolo's

26 panoply of dream-like symbolic objects. The vaporous oil study for *Gli adii (Those who say farewell) I* has an abstract quality, with its opposed surging lines, perhaps representing gas and steam. The oil study for

27 *Quelli che Vanno (Those Who Go) I* also depends upon a rhythmical and repetitive articulation, as its nearly horizontal oblique lines suggest wind-driven rain and speed, within a predominant greenish blue black. The yellow lamp-lit heads of the passengers peer through the murk as the fragments of houses and villages to be seen in the background flash

28 by. The oil study for *Quelli che Restano (Those Who Remain) I* comes

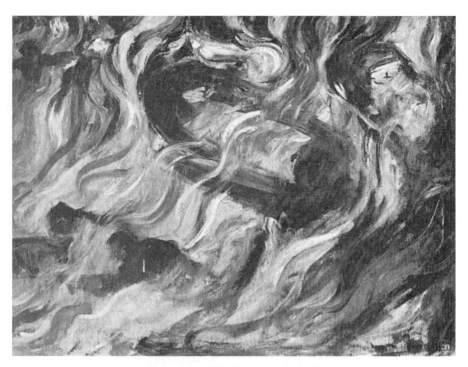

26. Umberto Boccioni, *States of Mind I: The Farewells (Gli Addii)*, 1911.

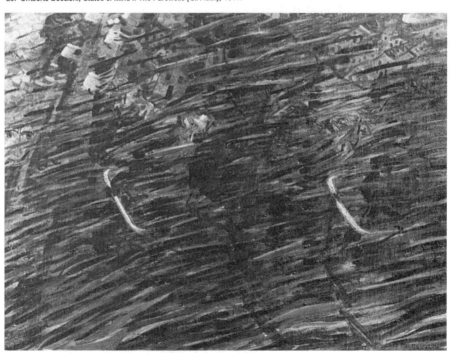

27. Umberto Boccioni, *States of Mind I: Those who Go (Quelli che vanno)* , 1911.

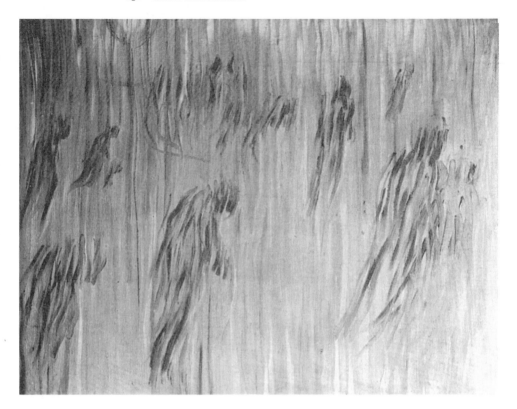

28. Umberto Boccioni,
*States of Mind I: Those who
Stay (Quelli che restano)*,
1911.

closest to emotional shock; as Marianne Martin notes, it is 'calligraphic', understated, and bleak, its ghostly passengers dangling 'like puppets' at a minimal angle to the vertical stripes of green which surround them, as if they are deprived by depression of independent motion.[47]

The far greater second version, shown at Bernheim Jeune in 1912, metamorphoses the dynamic Impressionism of the first series into something more assertive, by the insertion of mimetic detail and the use of Cubist grid-like structures which interact with the more fluidly expressive symbolism of 'lines of force'. Each picture thus retains the Bergsonian rhythmic identity and characterization of its predecessor; indeed Boccioni's interpretation of this work is primarily concerned with this match of rhythm and line to emotion:

[in *Those Who Stay*] perpendicular lines, undulating and as it were worn out, clinging here and there to silhouettes of empty bodies, may well express languidness and discouragement.

[In *The Farewells*] Confused, and trepidating lines, either straight or curved,

mingled with the outlined hurried gestures of people calling one another, will express a sensation of chaotic excitement.

On the other hand, horizontal lines, fleeting, rapid and jerky, brutally cutting in half lost profiles of faces or crumbling and rebounding fragments of landscape, will give the tumultuous feelings of those who go away. (*FM* 49)

X The centre-piece, *The Farewells*, is the most reworked of the triptych. The 'chaos of gaseous matter painted in bold expressionist swirls'[48] of its first version has become a spiral movement, faceted into Cubist planes, and the distorted geometry of the locomotive turns it into a Cubist icon, on which is superimposed the stencilled number 6943, in the manner of Picasso or Braque. (There is also perhaps a mild homage to Delaunay in the circularly shaped clouds of steam and smoke, and the Tower-like iron pylon in the top left.) The rigidly masculine machine dominates the undulating and embracing figures which surround it in the oval shapes to left and right. Like so many of his contemporaries, Boccioni calls upon the language of music to explain that 'the mingled concrete and abstract are translated into *force lines* and rhythms in quasi musical harmony' here; and he thinks that the 'combinations of figures and objects' are like 'chords'. The state of mind in *Those Who Go* on the other hand is 'represented by oblique lines on the left', whose colour is supposed to convey 'the sensation of loneliness, anguish and dazed confusion'.[49] The mask-like heads are indebted to a Cubist caricatural shorthand, and the other elements of the picture, the wheels, smoke, and so on, are also ambiguously mixed together in one form. *Those Who Stay* 'wade sadly through a forest of pale green perpendiculars' whose rhythms of descent indicate 'their depressed condition and their infinite sadness dragging everything down towards the earth', as the 'mathematically spiritualised silhouettes render the distressing melancholy of the souls of those who are left behind'.[50]

The Cubist overpainting here is no doubt partly intended as a sign of avant-gardist credentials, but it still did not go far enough for Apollinaire, who deplored the Futurist need for a dramatic 'subject' and emotional commitment. In doing so he defends formalist values:

while our avant garde painters no longer paint any subject in their pictures, the subject is often the most interesting thing in the canvases of *pompiers*. The Italian Futurists can scarcely pretend to renounce the benefits of the subject, and that could well be the obstacle against which their plastic intentions will come to grief.[51]

This hostility may have been influenced by the fact that the Futurist exhibition in Paris which showed these images coincided with the deeply intransigent defence of Cubism aroused by the Section d'Or exhibition in this same year, 1912. For example, from Maurice Reynal:

> what finer idea can there be than this conception of a *pure* painting, which shall in consequence be neither descriptive, nor anecdotal, nor psychological, nor moral, nor sentimental, nor educational nor (lastly) decorative? Painting in fact must be nothing but an art derived from a disinterested study of forms.[52]

The Futurists counter-attacked by accusing 'Picasso, Braque, Derain, Metzinger, Le Fauconnier, Gleizes, Leger, Lhote etc.' of obstinately continuing 'to paint objects, motionless, frozen, and all the static aspects of Nature'. In doing so they revealed that they were the traditionalists, who worshipped Poussin, Ingres, and Corot, thus 'ageing and petrifying their art with an obstinate attachment to the past' (*FM* 46). Cubist work was confined to the studio, when what was needed was a painting more immediately involved in contemporary urban experience.[53] This demand for a content which could establish a rhetorical relationship to an audience, rather than a contemplative appreciation of art's formal procedures, depended upon the dynamic, free associationist psychology of early Modernism, which was more important to the Futurists than the perhaps more obviously 'progressivist' abstraction of Cubism.

29 Delaunay made a very interesting attempt at this time to resolve the tension between the dynamic and the static, the narrative and the analytical, in his *Ville de Paris* triptych, which is very likely a response to Boccioni. Its tripartite division is like that of the *Stati d'animo*, in so far as each part has a characterizing linear and rhythmic structure as, for example, the verticals of the central group are penetrated by circular rhythms, which then 'explode out of the dynamic right hand section'.[54] Delaunay later said that he had tried to create 'rhythmic harmonies' between the 'landscape, woman, and the tower', but felt that the fragmentation of the painting had obstructed this intention.[55] He brings together imagery associated with the past, present, and future of Paris, to contest the Futurist jibe that French painting was *passéiste* because it ignored the modern urban world. The left section is a view over rooftops (also to be found in Delaunay's *Ville* series) combined with the view from his studio in the quai du Louvre. The reassuringly touristic image of a boat on the Seine seems to preoccupy the left-most of the Graces in the centre. They are a mixture of Pompeian wall painting, Botticelli's *Primavera*, and more recently Metzinger and Le Fauconnier. They may

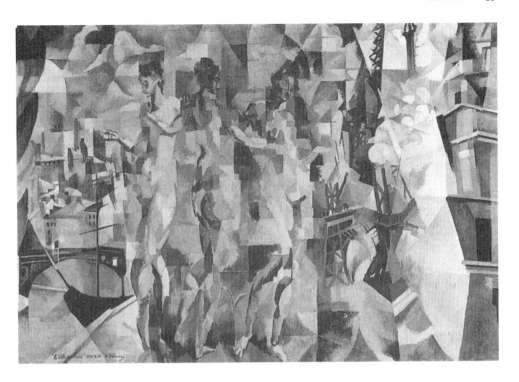

29. Robert Delaunay, *Ville de Paris*, 1912.

also have a (not exactly topical) significance, which reveals the ambition of the painting. For they may be inspired by Zola's *L'Œuvre* (*The Masterpiece*) (1886), a novel in which the hero Lantier (a character partly based on Cézanne) is obsessed by the attempt to represent the essence of Paris by three women bathers, who assume a symbolic character for him.[56] If Spate is right in this conjecture, this amounts to a peculiarly respectable attempt to displace Zola's less reputable vision of the dominance of the female body over Parisian society, in his novel about an immensely successful *grande horizontale*, *Nana* (1880). There is an uneasy relationship here, between the allegorical, the descriptive, and the abstract elements in the painting; and this reflects a great susceptibility to avant-gardist debate at the time of its making. Apollinaire indeed thought that it had a peculiarly Gallic summarizing value, and 'epitomised without any scientific paraphernalia, all the efforts of modern painting'—but then his criticism is full of bombastic compliments of this kind.[57]

3. The Poet in the City

The poet Blaise Cendrars thought that his friend Delaunay had faced 'A multitude of new problems' including those of 'analogies, correspondences, spiritual and physical contrasts, questions of perspective', as well as 'abstract questions such as unanimism and synthesis', and had succeeded in making 'the whole personality of Paris enter into him'.[58] Such efforts at heroic ingestion were much encouraged for the Moderns by the preceding work of Whitman, Verhaeren, and Rimbaud, all of whom influenced Cendrars, and also Apollinaire, who took on the 'whole personality of Paris' in the same year as Delaunay, and in a similar manner:

> Écoutez-moi je suis le gosier de Paris
> Et je boirai encore s'il me plait l'univers
>
> Écoutez mes chants d'universelle ivrognerie
>
> Listen to me—I am the gullet of Paris,
> and I'll go out and drink the whole universe if I feel like it.
>
> Listen to my songs of universal drunkenness.

In this poem, 'Vendémiaire', he expresses his mood of cosmic intoxication, evoked by a walk through the city, and it is this motif of the journey which so often provides a rationalizing thread for the Modernist association of ideas (as we saw in Eliot's 'Prufrock'). Within this genre (of which Baudelaire and Laforgue are the most influential predecessors), twentieth-century poets could give the experiences of the nineteenth-century *flâneur* observer a Modernist psychological interpretation. Hence Eliot's interest in 'the possibility of fusion between the sordidly realistic and the phantasmagoric, the possibility of the juxtaposition of the matter-of-fact and the fantastic', for which he acknowledges Baudelaire.[59] His early poetry, much of it written in Paris in this period, is concerned with the same Bergsonian and imagistic conception of memory as we found in the Futurists.

His 'Rhapsody on a Windy Night' is indeed remarkably reminiscent of the *Ricordi*, as Eliot experiments with a 'Bergsonian method'[60] which is manifested by the Laforguean rhythmic idiosyncrasy of its free verse, and by his controlling analogy between music and an introspectively experienced durée. The poem turns upon the tension between psychological time and the public and the spatially signalled signs of its passing, from twelve o'clock to four o'clock, as Eliot's protagonist passes by street lamps, each one of which 'Beats like a fatalistic drum'. He is

also preoccupied by the way in which the images of memory elide or conflict with those provoked by the 'lunar synthesis' (a Kantian notion) of the street scene, as light reveals the order of space. Should such a logic be dissolved, madness beckons:

> Whispering lunar incantations
> Dissolve the floors of memory,
> And all its clear relations,
> Its divisions and precisions.

Memory 'throws up high and dry' the images of 'A twisted branch upon the beach' or 'A broken spring in a factory yard', and it is the hidden common denominators that we may discover between such images which are the clue to much of Eliot's later method, and demand a broadly post-Freudian psychological interpretation. The imagery of the early part of the poem is metamorphosed when the moon, originally the Kantian guarantor of the 'synthesis' of experience, becomes a whore, who 'winks a feeble eye', 'smiles into corners', and

> is alone
> With all the old nocturnal smells
> That cross and cross her brain.[61]

As this repeated imagery is cut off from any definite reference, it has to be seen as the cognate of subconscious symbolic processes, as the twisted corner of the pin-like prostitute's eye (trying to hook him) is associated by the narrator with the twisted branch he once saw on a New England beach, or the lick of the cat's tongue, or a stick held out to a crab.

This kind of interrelationship between mental states typifies the Modernist poetry of the period. Marinetti was also working towards Bergson in the spring of 1911, in his thoughts about Futurist free verse as a 'perpetual dynamism of thought, an uninterrupted stream of images and sounds [which] alone can express the ephemeral, the unstable, the symphonic universe which is found within us . . . [in] A succession of lyric states'.[62] This fluidity can sometimes make it very difficult to find much focus or depth in the personality behind the stream of consciousness, particularly when it offers a Whitmanesque inclusiveness, rather than the concentration we find in Eliot, as in Cendrars' *Pâques à New York* (1912). This poem melodramatically laments a lost faith, when Christ fails to 'rise' for the poet in New York.

> Seigneur, la Banque illuminée est comme un coffre-fort,
> On s'est coagulé le sang de votre mort. (119–20)

> Lord, the radiant bank is like a safe
> in which they've coagulated the blood of your death.

Such imagery may startle by the impudence of its juxtaposition of the bank vault and the tomb of the Resurrection, but it lacks psychological inwardness, and the teasing, almost novelistic hints of a hidden narrative. This is because Cendrars tends to assert his emotions rather than to realize a plausible correlative for them within the poem:

> Je descends à grands pas vers le bas de la ville,
> Le dos voûté, le coeur ridé, l'esprit fébrile.

> I walk with great steps down town,
> My back bowed, my heart wrinkled, my mind feverish.

When he returns to his room, exhausted by his walk, he is 'nu comme un tombeau' ('naked as a tomb'), and experiences a more overt and less convincing association of images than Eliot:

> Cent mille toupies tournoient devant mes yeux . . .
> No, cent mille femmes . . . Non, cent mille violoncelles . . .

> A hundred thousand moles whirl about before my eyes . . .
> No, a hundred thousand women . . . No, a hundred thousand cellos . . .

Apollinaire's 'Zone', written in the summer of 1912, was very likely influenced by this poem,[63] with its 'cast of prostitutes, Jews, Poles, the quest for a faith, the ending in bleak despair'.[64] But the rhapsodic self expression of Whitman is married here to a far more artful juxtaposition of free verse line and paragraph. The technique of its central vision is of great importance for later Modernism, because, like Cendrars, Apollinaire juxtaposes the powerful symbols of the past to the furniture of the modern world. Christ 'rises' here as an aeroplane:

> C'est Dieu qui meurt le vendredi et ressuscite le dimanche
> C'est le Christ qui monte au ciel mieux que les aviateurs
> Il détient le record du monde pour la hauteur.[65]

> It's God, who dies on Fridays and rises up again on Sunday
> It's Christ who goes up into the heavens better than any aviator
> He's got the world record for height.

The churches of Paris are seen as aircraft hangars, and the Eiffel Tower as a shepherdess, with buses for sheep. This childlike dislocation helps the poem to express a nostalgia for youth, a tactful loss of faith, and a renunciation of the past, which prepare us for the self-conscious contemporaneity of the sequel:

> À la fin tu es las de ce monde ancien.
>
> Bergère ô tour Eiffel le troupeau des ponts bèle ce matin
>
> Tu en as assez de vivre dans l'antiquité grecque et romaine.

> In the end, you're tired of the ancient world
>
> Shepherdess O Eiffel Tower the flock of bridges is bleating this morning
>
> You've had enough of living in the antique world of Greece and Rome.

This ironic deflation of the pastoral comes as preparation for the Modernist counter-imagery to that of antiquity, and it is largely Marinettian in content:

> Tu lis les prospectus les catalogues les affiches qui chantent tout haut
> Voilà la poésie ce matin et pour la prose il y a les journeaux.[66]

> You read prospectuses, catalogues, advertising posters which sing out loud
> That's what poetry is this morning, and for prose we've got the newspapers.

The speaker's day nevertheless begins with a prayer, to which the sheer incongruity of the vision of the Ascension of Christ gives a kind of nostalgic irony. This agnostic detachment is reinforced by Apollinaire's expression of a split in the speaker's personality, marked in the poem by an internal dialogue between 'Je' and 'tu'. As he returns home, the speaker makes a final juxtaposition of the contemporary and the primitive, which derives from visual art, inspired by the primitive and the exotic, of which Apollinaire was well aware:

> Tu marches vers Auteuil tu veux aller chez toi à pied
> Dormir parmi tes fétiches d'Océanie et de Guinée
> Ils sont des Christ d'une autre forme et d'une autre croyance
> Ce sont des Christ inférieures des obscures espérances
>
> Adieu Adieu
>
> Soleil cou coupé

> You walk towards Auteuil you want to go home on foot
> To sleep among your fetishes from Oceania and Guinea.
> They are Christs in another form, and from another creed
> They are inferior Christs for obscure hopes

> Farewell farewell
>
> Sun neck cut.

However poor in spirit the speaker may feel in the street, he has reassuringly up-to-date Modernist icons to worship at home, and his farewell here alludes to the past of Baudelaire's 'Harmonie du Soir', while making an entirely up-to-date suppression of redundant syntactic forms.

4. Beyond the Stream of Consciousness

Simultaneism

This kind of poetry, through its repeated imagery, was peculiarly fitted to exemplify the Bergsonian view of the present as composed of all the past that is present to consciousness, in a mixture of interpenetrating states of mental being. But writing of this kind could also surround the durée of personal memory with a larger historical context, by exploiting the 'past' evoked by literary allusion *as if* that were also part of memory (as indeed Eliot was to argue that it should be in 'Tradition and and Individual Talent'). In such poetry, states and events beyond the speaker can be presented as if they were in simultaneous interpenetration, independent of any single source of perception or observation. (To use a favoured analogy of the time, they are like the parts of a newspaper, which is a one-day collage of simultaneous stories, upon which it is impossible to impose a single master narrative.) Such considerations inspired the Modernists to make texts and paintings of events which coexisted within the work of art in a manner inaccessible to the ordinary serial experience of a single individual. These are the simultaneist techniques which are central to the Modernism of the pre-war period, licensed by a scepticism about the nature of personal identity and of explanation, and aimed at disrupting the conventional view of reality by causing surprise. The claim to have been the first to express or theorize the simultaneist view was much disputed amongst Barzun, Apollinaire, and Cendrars. Whatever the truth of such typically avant-gardist claims to anteriority in naming the technique, its point is for all a psychological one, because simultaneism marks a further development in the Modernist conception of personal identity. For the fully Bergsonian work depends upon an implied biographical unity or stream of consciousness, which may be fluid, and often enough disjunctive, but which also

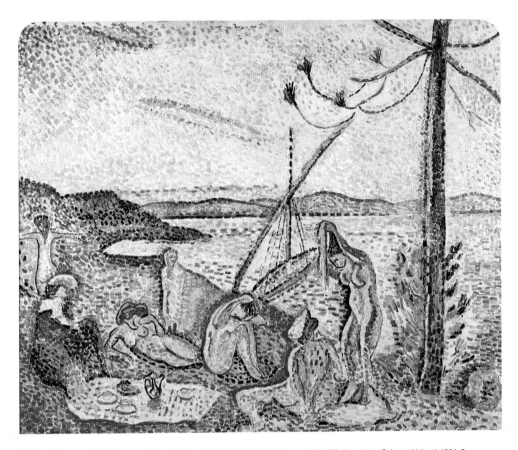

I. Henri Matisse, *Luxe, Calme et Volupté*, 1904–5.

II. Henri Matisse, *Woman in Japanese Robe by the Water*, 1905.

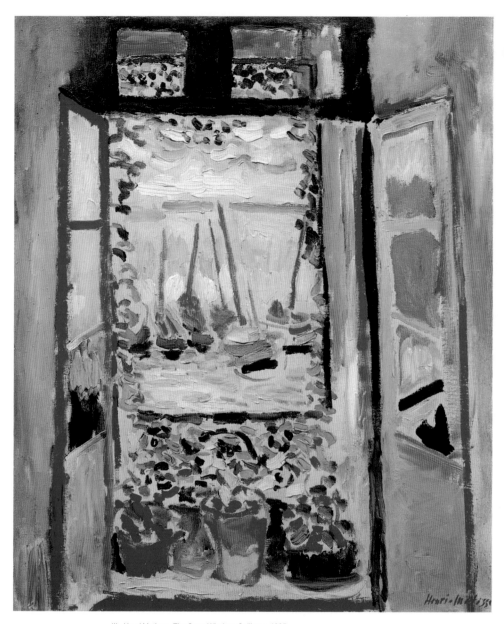

III. Henri Matisse, *The Open Window, Collioure*, 1905.

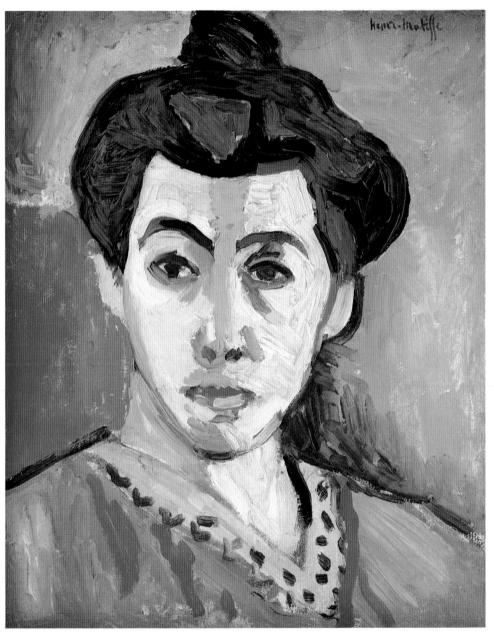

IV. Henri Matisse, *Portrait of Madame Matisse* (*The Green Line*), 1905.

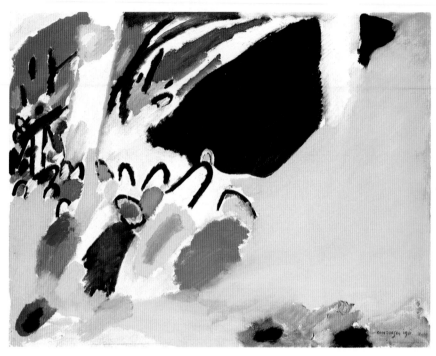

V. Wassily Kandinsky, *Impression III* (*Concert*), 1911.

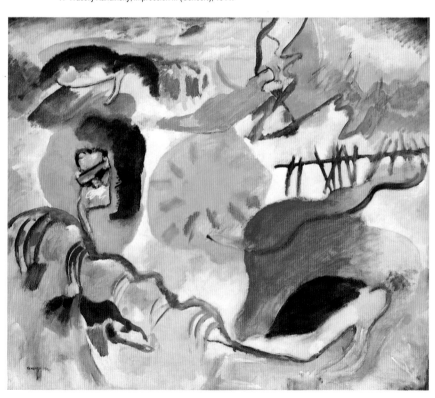

VI. Wassily Kandinsky, *Improvisation 27* (*Garden of Love*), 1912.

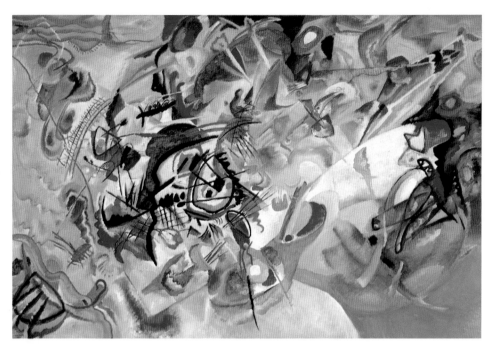

VII. Wassily Kandinsky, *Composition VII*, 1913.

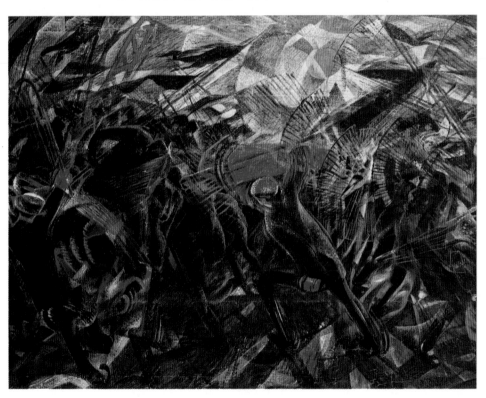

VIII. Carlo Carrà, *The Funeral of the Anarchist Galli*, 1911.

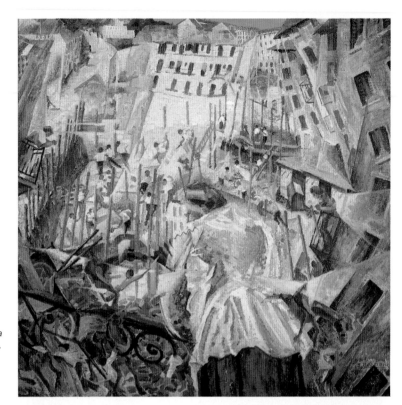

IX. Umberto Boccioni, *The Street Enters the House*, (*La Strada entra la Casa*), 1911.

X. Umberto Boccioni, *States of Mind II: The Farewells* (*Gli Addii*), 1911.

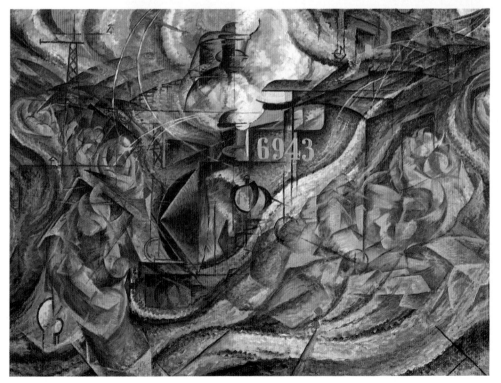

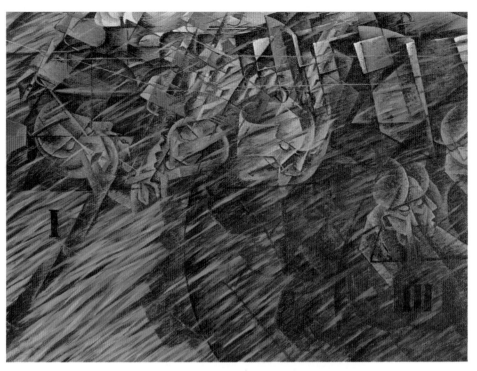

XI. Umberto Boccioni, *States of Mind II: Those who Go (Quelli che vanno)*, 1911.

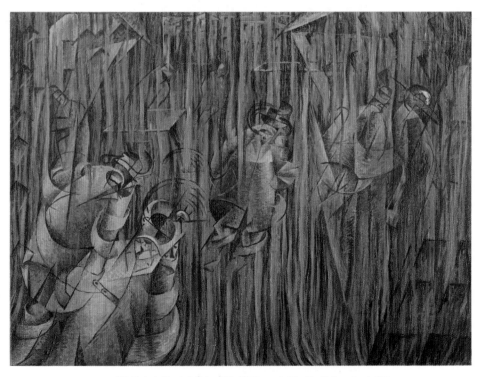

XII. Umberto Boccioni, *States of Mind II: Those who Stay (Quelli che restano)*, 1911.

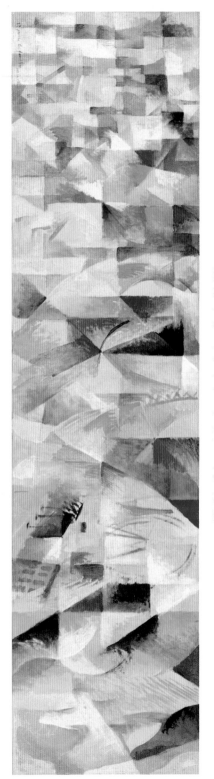

XIII. Robert Delaunay, 2e Représentation. Les Fenêtres. *Simultaneité*, 1912.

demands an interpretative sympathy which preserves our idea of the single narrator or *persona* behind it, as we have seen from the poems discussed so far. Of course we can attempt to read all poetry by reference to a single speaker, but in this period there were plenty of avant-gardist attempts to show that such a limitation could be transcended. Indeed the attempt to interpret collective states of consciousness steadily grows in importance through the period, partly under the influence of the sociology of Durkheim and others, in anthropological studies of tribal consciousness, and under the influence of depth psychologists like Jung, who believed that we may all share in the archetypes of the collective unconscious. All these collectivist ideas in due course had their effects on literary narrative, and the Unanimists led the way.

Barzun's *L'Ère du drame* (published at the end of 1912) therefore urged the abandonment of a 'psychologie unilatérale' in favour of a collective vision, a 'polyphonie des voix simultanées du monde', which could (on Unanimist principles) express human solidarity.[67] The poem, which abandons the single consciousness as its central focus, can allow disparate voices to show how the usual conflicts between 'individual' and 'universal' orders might be transcended.[68] This theory was supposed to have received its revelatory exemplification in his poem, entitled *Voix et acclamation de la ville*,[69] in which four and then seven voices express their enthusiasm for an 'aéronef' ('airship'). Human voices, in co-operation with the machine, rejoice in the onomatopoeic sounds which accompany them:

> Le Chef Pilote: Que les moteurs *vrombissent* et rugissent.
> Les moteurs: —— vrom, vromb, vreueu, vron, ron, ou, or, ou, or, meu

The propellers and the wind also speak, and later the voices of Hommes, Artisans, Poètes, Femmes, Adolescents, Soldats, and Vieillards, in various combinations, all express their praises, which begin 'gloire aux ...', as though they have all wandered in out of the triumphal scene in Verdi's *Aida*. Barzun's aims are distinguished, not so much by these confusedly contrapuntal techniques, as by his democratizing political motivation—which is quite distinct from the élitist allusiveness of Apollinaire and Eliot.

Cendrars' *Prose du Transsibérien*, on the other hand, makes a different kind of claim to simultaneism. It records the thoughts of a single speaker, in a Boccionian synthesis of what one remembers and of what one sees, held together by Rimbaudian nostalgia. For Cendrars, the

poem is abandoned 'Aux sursauts de ma mémoire . . .', but this trust in subconscious memory seems to be the limit of the intellectual sub-structure of the poem, in which, he claims

> j'ai
> rassemblé les éléments épars d'une violente beauté
> Que je possède
> Et qui me force.

> I have
> brought together the scattered elements of a violent beauty,
> which I possess
> and which compels me.

Cocteau slyly referred it back to Rimband's 'Le Bateau ivre' in saying that the *Prose* evokes 'a veritable drunken train'[70] as Cendrars echoes in his poem:

> Le bruit des portes des voix des essieux grinçant sur les
> rails
> congelés

> The noise of doors voices axles grinding on
> rails
> all congealed

He journeys in the company of 'la petite Jehanne de France' towards an exotic fantasy land—'la Patagonie, qui convienne | à mon immense tristesse' ('Patagonia, which suits my immense sadness'), and his explo-rations depend upon a Whitmanesque cataloguing, of

les légendes les dialectes les fautes de langage, les romans policiers . . . la chair des filles, le soleil, La Tour Eiffel, les apaches, les bons nègres, et le rusé d'Européen qui jouit goguenard de la 'modernité'.[71]

legends, dialects, grammatical errors, detective stories . . . whores' flesh, the sun, the Eiffel Tower, apaches, the good blacks, and the crafty European who enjoys modernity while mocking it.

The anxiety-laden rhythms in consciousness of the train journey are metaphorically equated with the passing of

> Toutes les gares lézardées obliques sur la route
> Les fils télégraphiques auxquels elles pendent
> Les poteaux grimacants qui gesticulent et les étranglent

so that:

Le monde s'étire s'allonge et se retire comme un accordéon qu'une main sadique
 tourmente
Dans les déchirures du ciel . . .

All the stations, lizarding obliquely along the track
The telegraph wires they hang from
The grimacing posts which gesticulate and strangle them . . .
The world stretches out, elongates itself and contracts like an accordeon tor-
 mented by a sadistic hand
Through the gaps of the sky . . .

He remembers the old houses in Paris which leant over him 'Comme
des aïeules' ('Like ancestors'), and where 'Les moteurs beuglent comme
les taureaux d'or' ('Motor cars bellow like golden bulls') and 'Les vaches
du crépuscule broutent le Sacré Coeur' ('The twilight cows browse the
Sacré Coeur'). He invokes his home as a 'Gare centrale débarcadère des
volontés carrefour des inquiétudes' ('Central station embarking point of
the will cross-roads of unease') but, far away from it, he wishes to return
to Paris for a drink at the Lapin Agile, in the 'Ville de la Tour unique du
grand Gibet et de la Roue' ('City of the unique Tower, of the great Gibbet
and of the Wheel').

As Perloff judges, the nomadic disjointed narrative of the *Prose*
'becomes a way of avoiding a confrontation with the hidden self',[72] and
it is hardly resolved by this sentimental ending, with its allusion to the
painting of Delaunay. Cendrars is more experimental in his mixing
together of 'high' and 'low' cultural references—like Apollinaire, to
newspapers, songs, posters, *faits divers*, and touristic stereotypes. This
has a populist aim, and may bring him closer to the Barzunian concep-
tion, for Cendrars saw the montage techniques derived from the cinema
as a means of combining images and rhythms that revealed the nature
of the urban community as a

Remue-menage d'images. L'unité tragique se déplace. Nous apprenons. Nous
buvons. Ivresse. Le réel n'a plus aucun sens. Aucune signification. Tout est
rhythme, parole, vie. Il n'y a plus de démonstration. On communie.[73]

Swirling jumble of images. Tragic unity is displaced. We learn. We drink. Drunk-
enness. The real no longer has any sense. No meaning. Everything is rhythm,
speech, life. There are no more proofs. We're all in communion.

His claim that his *Prose* was the first text to aim at simultaneist effects

30 actually depends not so much upon this kind of associative juxtaposi-
tion of ideas within the verbal text, as upon its interaction with the
painting by his wife Sonia Delaunay (Terk) which accompanies it. Her
imagery to the left of the poem is to be 'read' vertically, and is supposed
to key in its accompanying verse, horizontally laid out in a range of
colours and typographical founts, like music, giving it varying amounts
of 'loudness' or emphasis. As Apollinaire explained, this is supposed to
give the poetry and the painting together the chordal structure of music,
and 'train the eye to read with one glance the whole of a poem, even as
an orchestra conductor reads with one glance the notes placed up and
down the bar, even as one reads with a single glance the plastic elements
printed on a poster'.[74] What the poem demands, according to Apolli-
naire, is a new mode of thinking which accepts the contingency and
interrelatedness of things, without attempting to subject it to a unifying
and unified consciousness (which would give it a linear interpretation
and a single purpose). A purely abstract musical effect from the con-
junction of the disparate is all that is required. So far as this poem is con-
cerned, such demands may be fantasy, for very few readers would be
able even to attempt so peculiarly musical an accomplishment. In any
case, there is no way in which the text can be read even intermittently as
a series of chords to accompany the colours which 'key' it in the clef
position. The *Prose du Transsibérien* is nevertheless significant as one of
the earliest attempts at the interaction between poetry and an almost
wholly abstract painting.[75]

In the same period, Robert Delaunay broke away from Cubism
towards a more purely geometrical abstraction from the object in his
Fenêtres (*Windows*) series, and initiated a new phase of painting in
Europe generally, one which involves a further theorizing of the notion
of Simultaneity. The sequence was probably begun in April 1912, and it
depends upon poetry, borrowing Symbolist connotations from
Mallarmé's poem 'Les Fenêtres', in which a dying man, 'feverish and
starving for the blue sky', turning his back on life, clings to window case-
ments, and feels blessed as

> Dans leur verre, lavé d'éternelles rosées,
> Que dore le matin chaste de l'Infini
>
> Je me mire et me vois ange! et je meurs, et j'aime
> —Que la vitre soit l'art, soit la mysticité -
> A renaître, portant mon rêve en diadème,
> Au ciel antérieur où fleurit la Beauté!

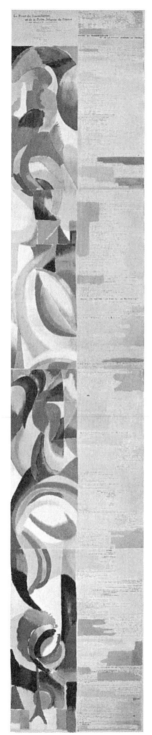

30. Sonia Delaunay, *La Prose du Transsibérien*, 1912.

In their glass washed with eternal dews
gilded by Infinity's chaste morning,

I look at myself and see myself as an angel! And I die, and I love
—whether the glass be art or mysticism—
to be reborn, wearing my dream like a diadem,
in the earlier heaven where Beauty flowers![76]

The paintings also create another world of abstraction and colour-harmony, for in them Delaunay advanced beyond the analytical Cubism implicit in the Tower series and *La Ville*, which tend to focus on a central organizing object. He aims at a carefully balanced interaction of colours from the spectrum, and so worked his own variation on the avant-gardist idea of simultaneity: for the *Fenêtres* are generally 'constructed so that no colour can be perceived in isolation and can only be seen "simultaneously" with all the others. And the aim was a mystical one, consonant with Mallarmé's; for he believed that our absorption in this pictorial simultaneity could give us an intuitive grasp of the simultaneity, the unity of all existence'.[77] He was interested, not so much in things, as in following the Impressionists, by studying the effects of light as a general force animating all nature.[78] The *Fenêtres* refuse any dominant light source, and so decentralize structure into an abstract pattern, and, like Monet's late works, their variations can be extended indefinitely. Spate compares the oval-shaped canvas of
31 *Fenêtres simultanées* of 1912 with Monet's paintings of the lily ponds in his garden (*Nénuphars*), which are also without focus or boundary, and points to the 'schematically conceived' movements of light here, as in 'the diffuse light of the central area, or the ray of light from the upper right', which contribute to a 'new abstract structure'.[79]

XIII In paintings like the *2e Representation. Les Fenêtres. Simultaneité. Ville. 2me partie 5 motifs* (1912), the use of the recurrent 'motif' has a musical significance, as 'variations on a theme', for Delaunay told Kandinsky that he had discovered relationships between colours which were 'comparable to musical notes'.[80] Hence Klee's later comment, in 1917, that in 'Trying to make the time element prevail on the model of a pictorial fugue, Delaunay chose a format whose length was impossible to take in at a glance', and so had to be serially viewed.[81] It is indeed likely that Delaunay's aesthetic aim was as mystical as Mallarmé's and as abstract in its intended effects as Kandinsky's, for, following Leonardo and Mallarmé, he says that 'our soul exists in a state of harmony and harmony is only engendered by the simultaneity with

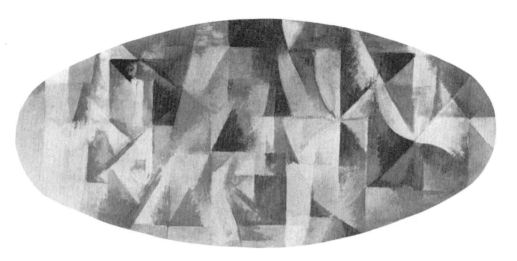

31. Robert Delaunay,
Fenêtres simultanées,
1912.

which the measure and proportions of light arrive through the eyes to our soul'.[82]

Apollinaire wrote a poem, 'Les Fenêtres', which he used as a preface to the catalogue of an exhibition of Delaunay's paintings on this theme in the Sturm galleries in Berlin in 1912. But the relationship between Delaunay's aesthetic and Apollinaire's poem is far from clear, despite the fact that it indeed mentions windows and colours. It opens:

> Du rouge au vert tout le jaune se meurt
> Quand chantent les aras dans les forêts natales
> Abatis de pihis
> Il y a un poème à faire sur l'oiseau qui n'a qu'une aile
> Nous l'enverrons en message téléphonique
> Traumatisme géant
> Il fait couler les yeux
>
> From red to green all the yellow languishes
> When the macaws sing in their native forests
> Giblets of pihis
> There is a poem to be made on the bird who has but one wing
> We shall send it as a *message téléphonique*
> Giant traumatism
> It makes your eyes run[83]

Nothing quite seems to follow here, and the poem reads as well backwards as forwards.[84] The juxtaposition of its images was part of an attempt to 'habituer l'esprit à concevoir un poème simultanément

comme une scène de la vie' ('get the mind used to grasping a poem simultaneously, as we do a situation in everyday life').[85] But the logic of the poem is far less stable (with its almost total lack of syntactic subordination) than that of the geometric repetitions in Delaunay's window paintings.[86] Apollinaire believed with Cendrars and Marinetti that rapidity of notation should be the aim of poetry, and that this laconic 'style télégraphique' was a resource to which 'l'ellipse donnera une force et une saveur merveilleusement lyriques' ('ellipsis will give a marvellously lyric force and savour').[87] These ellipses could be used to do away with the sequential connections of implied narrative, and so Apollinaire developed towards making a poem as the visual artist makes a collage.

One of the most successful examples of this is Apollinaire's 'poème conversation', 'Lundi rue Christine' (1913), which is constructed from scraps of separate, simultaneously conducted, overheard conversations. If the poem has a common denominator, it is the negotiations of the city—burglary ('si tu es un homme tu m'accompagneras ce soir'—'if you're a man you'll come along with me this evening'), café life, playing games, paying the landlady, and so on—all easily observable elements of what Apollinaire called 'le lyrisme ambiant' ('the lyricism of the ambient'):

> Trois becs de gaz allumés
> La patronne est poitrinaire
> Quand tu auras fini nous jouerons une partie de jacquet
> Un chef d'orchestre qui a mal à la gorge
> Quand tu viendras a Tunis je te ferai fumer du kif.

> Three gas lamps lighted
> The patronne has T.B.
> When you're through we'll play a game of backgammon
> An orchestra conductor with a sore throat
> When you come to Tunis I'll see that you smoke some kif.[88]

With a sly and punningly lying reflexivity, the poem hints at its difficulties—'Ça a l'air de rimer' ('that seems to make sense/rhyme'). But it doesn't, in either sense. The narrative fragmentation here is brought about by that kind of anaesthetized synecdochal observation which is the staple of much Modernist poetry and painting:

> Vous êtes un mec à la mie de pain
> Cette dame a le nez comme un ver solitaire
> Louise a oublié sa fourrure

Moi je n'ai pas de fourrure et je n'ai pas froid
Le Danois fume sa cigarette en consultant l'horaire
Le chat noir traverse la brasserie

You're a crummy one
That lady has a nose like a tapeworm
Louise forgot her furs
Me I have no furs and I'm not cold
The Dane smokes his cigarette as he consults the timetable
The black cat crosses the brasserie.[89]

Parts of the poem seem to emanate from the habitués of the café, who may go on a journey, others from an impersonal recording of decor, and others from a moralizing observer, in juxtapositions so bizarre as to defy any rational explanation.

Il me dit monsieur voulez-vous voir ce que je peux faire d'eaux fortes et de
 tableaux
Je n'ai qu'une petite bonne.

He said to me monsieur do you want to see what I can do in the way of etchings
 and pictures
I only have one little maid.[90]

As Renaud suggests, the poem is a kind of 'readymade langagier'.[91] The lack of any specifiable conversational context leaves fragmentary signs of the human to lie side by side on the page, in much the same way as the imagery in the recently developed collage painting of which Apollinaire was well aware.

Collage

In early 1912 his friend Picasso had produced work which moved away from the Cubist analysis of objects in relation to the solidified space around them, towards a synthesis or building up of separate objects on the picture plane, whose relationships could be as intriguingly defamiliarizing as Apollinaire's scraps of conversation.[92] As Picasso put it, in a work like his *Bottle of Suze* (1912):

32

If a piece of newspaper can become a bottle, that gives us something to think about in connection with both newspaper and bottles, too. This displaced object has entered a universe for which it was not made and where it retains, in a measure, its strangeness. And this strangeness was what we wanted to make people think about because we were quite aware that our world was becoming very strange and not exactly reassuring.[93]

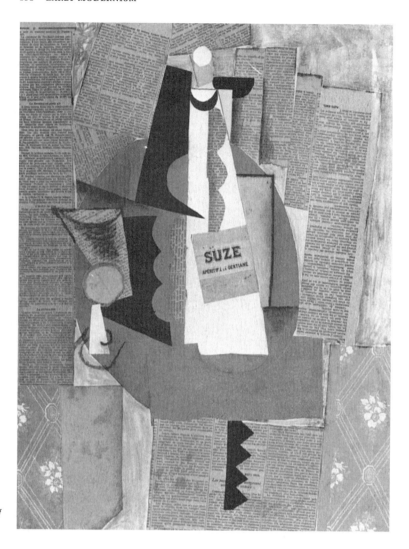

32. Pablo Picasso, *Bottle of Suze*, autumn 1912.

Collage technique allowed for an interpretative dislocation like that in poetry, because shapes which imply objects could also be linked by poetic analogy, verbal association, and visual punning, for example by exploiting the similarities between a violin and a mask-like face.[94] The aim was not just the formal one of making intriguingly ambiguous geo-metrical relationships work within the picture plane, but of eliciting associations which could reinforce this strangeness. To this end verbal fragments were often made part of the image.[95] The content of the bits of newspapers used could thus provoke sly verbal/visual puns, as in

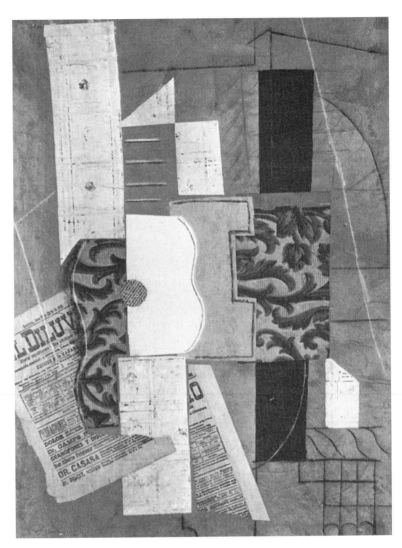

33. Pablo Picasso, *Guitar*, spring 1913.

33 Picasso's delightful *Guitar* (1913) which shows how the style can relax into a witty diffusion of comic meaning. For the guitar may also be seen as outlining a man and woman making love, and the triangular wedge of newspaper at bottom left contains a newspaper advertisement for 'DR CASASA, specialist in genital complaints'. This leads to a poetic if Freudian joke, as the print in 'The round sound hole of the guitar secretes a printed echo of the "lengthy ovations" which had been given to a speaker who had upheld the "principles of liberty" '.[96] And the title of the paper is *El Diluvio*.

In his *Calligrammes* Apollinaire explores the relationship of word and object, by giving his text the visual organization of a collaged painting. His typography is usually arranged to outline a common object (as for example in 'La Cravate et le montre').[97] But he also develops the considerations we saw Cendrars urge for his *Prose*, in that he thinks he is inventing a new kind of logic for the literary work. The connections made by movements of the eye are supposed to inspire an innovatory type of inference:

> *Psychologically* it is of no importance that this visible image be composed of fragments of spoken language, for the bond between these fragments is no longer the logic of grammar but an ideographic logic culminating in an order of spatial disposition totally opposed to discursive juxtaposition . . . It is the opposite of narration.[98]

Only considerations from painting make this even intelligible, but Apollinaire's visually organized poems rarely manage to exploit on the page anything like the sophisticated relationships between objects typical of collage proper. His typographical rearrangements are forms of 'autoillustration', which make words take on the visual form of an object.[99] There can also be an analogical relationship between objects, as in 'La Mandoline l'oiellet et le bambou', where 'the circular female shape of the mandolin and the male shape of the opium pipe give rise to the flower, which announces the new (and symbolist synaesthetic) "loi des odeurs"',[100] for the different ways of 'reading' the mandolin (even if rather simply Freudian ones) are broadly comparable to the ambiguous reading of objects in Cubist collage.

34 The *Lettre-Océan* of 15 June 1914 is perhaps most successful in synthesizing such influences. The words of the poem are set out to represent an address, stamps, and postmark, and the message-bearing wireless rays (the '[T]elegraphie [S]ans [F]ils') of the Tour Eiffel ('sur la | rive | gauche | devant | le pont | d'Iéna'—'on the left bank in front of the Iéna bridge') as if on a postcard to 'mon frère Albert à Mexico'. The Eiffel Tower radiates radio messages on the left, and presumably 'hears' a number of Barzun-like noises on the right, from sirens, buses, gramophones, and the creaking shoes of the poet as he walks the streets. The various messages arranged into objects amount to a 'poème conversation simultané dont la lecture n'est pas, comme dans *Lundi rue Christine*, soumise à un ordre quelquonque' ('a simultaneist poem conversation whose reading is not, as in *Lundi rue Christine*, subject to some kind of order').[101] Indeed the 'order' is made by the roving eye—

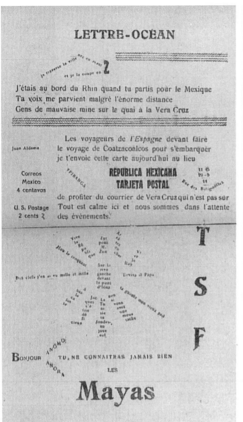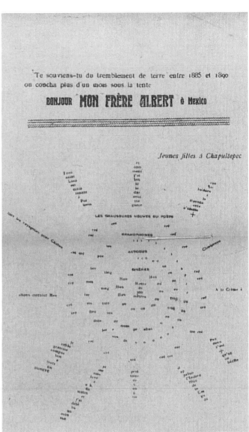

34. Guillaume Apollinaire, *Lettre-Océan*, 1914.

which is as usual sufficiently in the grip of Gutenberg to attempt to scan from left to right down each of the two pages.[102] The poem does not simply imitate an object. It can lead one to ask how the spatial arrangement of a series of messages might affect their meaning. Apollinaire, writing under the pseudonym of 'Gabriel Arbouin', argued that this kind of work brought about a 'revolution' in the use of the mind, 'parce qu'il faut que notre intelligence s'habitue à comprendre synthético-idéographiquement—au lieu de analytico-discursivement' ('because our intelligence has to get used to understanding synthetico-ideographically, rather than analytically and discursively').[103] Like its companions it is basically game-like in disposition, and has little to say even if its technique can raise theoretically interesting questions of semiotics.[104]

Parole in libertà

In Apollinaire's hands the syntax of the utterance is left in a conventional form. His ideographic arrangements may liberate new strategies of comprehension, but in adapting collagist technique it has little to say about language itself. It is not radically innovatory in the foundational sense we discussed earlier, but Marinetti went much further along this road in propounding his doctrine of 'parole in libertà'.[105] He also aimed at the presentation of simultaneous impressions, without respect to the narrative constraints involved in fixing a single observer's position within time and space. Indeed the very notion of a psychologically interesting individual observer, which still lies at the heart of the inspiration of Apollinaire and Cendrars, now comes under attack. For if one can get beyond that, the individual's obedience to the grammatical conventions of natural language may cease to be of much interest. Marinetti would have thought that the writing of Apollinaire and Cendrars discussed above was still implicitly centred on a novelistic obsession with the psychology of the first person, the dominating 'I'. To get beyond this he takes up an extremist Nietzschean position concerning the division of the self, given that there are 'multiple and simultaneous awarenesses in a single individual' (FM 96). He urges the innovator to 'Destroy the I in literature; that is, all psychology . . . [and] to substitute for the psychology of man, now exhausted, the lyric obsession with matter'.[106] Of course much of this programme could not be carried through, since all uses of language by avant-garde artists tend to imply speakers or observers with human purposes (speakers indeed like Marinetti himself, famous for his madly dramatic recitation of his works). But his intervention is significant in that it showed how the disruption of language could be tied to a distinctive view of the nature of the self.

To these ends a new typography is necessary, which uses a mixture of founts, type sizes, and colours in order to combat the nauseating lyricism of *passéiste* verse (FM 104).[107] The spatial awarenesses they impose can be used to achieve a 'Multilinear lyricism', as the different sense modes might, for example, be assigned to different and parallel lines of text (FM 105) and the most important analogies can be given a heavier type face. The single word itself may be orthographically deformed in the interests of 'lyric intoxication' and onomatopoeia, to achieve 'the sonorous but abstract expression of an emotion or a pure thought' (FM 106) (in a kind of scat-singing which is a more evolved version of the primitive grunt).

As we have seen in Apollinaire's collage poems, such visual effects are intended to make the relationship of the text to a single stream of consciousness problematic. But Marinetti's theory has the further innovatory implication, that the writer does not so much discover the internal semantic limits of a natural language, as play a game with it. The aim is not to guarantee a merely individual understanding, but to make the text the multi-dimensional analogue for the dynamic and collective processes which much Futurist painting also attempted to capture:

I combat Mallarmé's static ideal with this typographical revolution, that allows me to impress on the words (already free, dynamic and torpedo-like) every velocity of the stars, the clouds, aeroplanes, trains, waves, explosives, globules of sea foam, molecules, and atoms. (FM 105)[108]

Marinetti's aim, through the disruption of syntax, metre and punctuation, is to produce a 'lyrical intoxication', which will abolish the reassuring musical continuities of *vers libre*, in favour of an abrupt, instantaneous, telegraphic form of communication. This takes advantage of collagist juxtaposition, which, as Marinetti points out, is the symptom of a uniquely Modern psychological state, brought about in particular by the influence on everyone's 'psyche' of 'the great newspaper (synthesis of a day in the world's life)'. He thus anticipates many later thinkers, including Marshall McLuhan, in attributing specific and enduring psychological effects to the new media, such as the telephone, telegraph, train, bicycle, automobile, and ocean liner, as 'Man multiplied by the machine' is brought into 'a fusion of instinct with the efficiency of motors' (FM 96–7).

Marinetti thus contradicts the dystopian account of city life once more; far from being dominated by all this technology, it can give us a most exciting sense of the 'acceleration of life to today's swift pace', a 'Dread of the old and the known', a 'Love of the new, the unexpected', a freedom from the old 'sense of the Beyond', and an 'unbridling of human desires'.[109] He imagines for us a 'lyric excited friend', a 'gifted narrator' who, in accounting for his impressions, 'will begin by brutally destroying the syntax of his speech', so that 'The rush of steam-emotion will burst the sentence's steampipe, the valves of punctuation, and the adjectival clamp' (FM 98). The sensations which are thus conveyed (like those of the Unanimists), will be bound up to the 'entire universe' and 'cast immense nets of analogy across the world' (FM 98). These demand the crossing of categorial boundaries, and in particular those between

man and machine—an animal compared to a man is banal, whereas a fox terrier seen as a 'trembling Morse code machine' is not (*FM* 99). The text should work like the telegraph, as the poet's imagination can 'weave together distant things *with no connecting strings*, by means of essential *free* words' (*FM* 98). To this end we must 'make use of the adjective as little as possible', as it arrests intuition, and defines nouns too minutely. Furthermore, 'in a violent and dynamic lyricism the infinitive verb might well be indispensable' (*FM* 101) in contributing to the 'speed of the style'.[110]

Marinetti's emphasis on the anti-individualist psychology of typographical rearrangement is an extreme version of Unanimism and Simultaneism, and it is hardly surprising that his most convincing examples stem from the battlefield, in which so much that is threateningly simultaneous happens, the individual (dependent on the collective) is very likely to disappear, and any search within such events for the hidden narrative pattern (which Marinetti despised) is unlikely to succeed. See for example, the 'bombardamento' section of Marinetti's *Zang tumb tumb*, which has the orchestral dimension we saw aimed at by Cendrars, or at least a percussive one.[111] Here is the 'Art of Noises' indeed:

ciang		**ciak**		[PRESTO]		**ciacaciaciaciaciaak**	
su	giù	là	là	intorno	in	alto	attenzione
sulla	testa	**ciaak**	bello				Vampe
				vampe			
vampe						*vampe*	
	vampe						*vampe*
		vampe		ribalta	de	forti	die-
			vampe				
tro	quel	fumo	Sciukri	Pascià	communica		te-
lefonicamente	con	267	forti	in	turco	in	te
desco	allô	**Ibrahim**		**Rudolf**		**allô**	**allô**
Ciang		**ciak**		[PRESTO]		**ciacaciaciaciaciaak**	
up	there	over	there	there	in	there	high up attention
on	the	head	ciaak	lovely			flames
				flames			
flames						*flames*	
	flames						*flames*
		flames		footlights of the positions be-			
			flames				

hind that smoke Sciukri Pasha communicates te-
lephonically with 267 positions in turkish in ger-
man hallo **Ibrahim Rudolf hallo hallo**

The frequently encountered demand that innovative techniques be used to shatter *passéiste* assumptions about the psychological unity of the artist, and to put in question the value of the attempt to dominate experience by subjecting it to a unifying description, was significant for all areas of Modernist activity. The city poets in particular reinforce a general tendency towards stream of consciousness as a primary mode of expression, and one which concentrates on presentness in narrative, as opposed to historical reflection. It is this kind of presentness to personal memory and its particularity that Virginia Woolf will defend as essential to modern fiction, as the author's 'attempt to come closer to life, and to preserve more sincerely and exactly what interests and moves them, even if to do so they must discard most of the conventions which are commonly observed by the novelist. Let us record the atoms as they fall upon the mind in the order in which they fall . . . '[112] This may indeed, as she suggests, lead to 'the dark places of psychology'.[113] And so, as Modernist writers eliminate causal relationships and put events from different periods side by side, they escape from the threatening narratives of other persons' history, by imposing upon their plots the Bergsonian process of personal memory. They salvage the bits from past history that they want, or redeem fragments from the chaos of a present which has become incomprehensible in terms of traditional organizing narrative. There is an extraordinary internalization of a confusing external experience (of multiplicity, uncertainty, and conflict) into a collage whose form imposes upon us the simultaneity of things, precisely by depriving them of the usual forms of analytical interconnection. The question then haunts the rest of Modernist (and Postmodernist) art, whether this is not in fact a kind of defeat, accepted by Eliot and refused by Joyce, a renunciation of the attempt to give an order to things, a despair of history, and a submission to the 'lyricism of the ambient' that will end up with work like John Cage's music, which can admit any of the sounds that happen to be around into itself. In refusing to attempt to reconstruct the psychology of internal division, Modernist experimental writing offered a line of escape towards the irrational. We will see this later on in the Dada movement in Zurich, but it is also well prepared for by earlier work in the German tradition, to which I now turn.

5. Berlin

In January 1911 Jakob Van Hoddis published a poem which for many German writers and artists marked the transition into a Modernist framework of ideas:

> Dem Bürger fliegt vom spitzen Kopf der Hut.
> In allen Lüften hallt es wie Geschrei,
> Dachdecker stürzen ab und gehn entzwei,
> Und an den Küsten—liest man—steigt die Flut.
>
> Der Sturm ist da, die wilden Meeren hupfen
> An Land, um dicke Dämme zu zerdrücken.
> Die meisten Menschen haben einen Schnupfen.
> Die Eisenbahnen fallen von den Brücken.

> From bourgeois pointed pates hats fly into the blue,
> All winds resound as though with muffled cries
> Steeplejacks fall from roofs and break in two,
> And on the coasts—we read—flood waters rise.
>
> The storm has come, the seas run wild and skip
> Landwards, to squash big jetties there.
> Most people have a cold, their noses drip.
> Trains tumble from the bridges everywhere.[114]

The poem's absurdity seems to have had a liberating effect comparable to that of Jarry's *Ubu Roi* in 1890s Paris. It provided the occasion for interpretations which put into circulation a number of central Modernist ideas. In it, said J. R. Becher, Hoddis 'expresses in a broken, fragmentary, and almost crazed voice the strange mood of the century', in which 'the catastrophic . . . is inconceivable without a simultaneous triviality', so that 'all things intermingle . . . [W]e seemed to be in the grip of a new universal awareness, namely the sense of the simultaneity of events'.[115] This comic simultaneism makes the absurdly trivial dripping noses run along with the disastrous *faits divers* of the newspaper (as celebrated by Marinetti). But the tone is one of defensive indifference, and there is an ironic incongruity in this anti-poem which anticipates the chaotic and threatening displacement of common objects in much Dadaist painting of the city, particularly in the work of George Grosz. For many German artists the sense of the Modern is not celebratory, but is haunted by the apocalypticism we noted earlier.

This poem and the many it influenced are often interpreted as symbolic disruptions of the bourgeois order, because their line by line

enumeration (*Reihungsstil*), centred on images of catastrophe, refusing to accept that the urban scene can have any emotionally satisfying interconnectedness. The poem is in tension between ironic distance and an insane disorientation or anaesthesia.[116] We are distanced from feelings about events, partly because, as many Moderns were quick to realize, the poem is like the newspaper and the cinema in mediating experience to us through a montage of highly selective and disparate images.[117]

This juxtapository comedy in 'Weltende' was developed towards a much more pessimistic evocation of a society of outcasts and grotesques in Lichtenstein's parody of it in 'Die Dämmerung'. This poem conveys a far more appalled sense of the absurdity of the world, in which

> An einem Fenster klebt ein fetter Mann.
> Ein Jüngling will ein weiches Weib besuchen.
> Ein grauer Clown zieht sich die Stiefel an.
> Ein Kinderwagen schreit und Hunde fluchen.
>
> A fat man is sticking to a window.
> A youth wishes to visit a soft woman.
> A grey clown pulls on his boots.
> A pram screams, and dogs curse.[118]

As Hamburger remarks, these two interlinked poems seemed new in that they 'consisted of nothing more than an arbitrary concatenation of images derived from contemporary life . . . They were a kind of collage.'[119] They are a far cry from Apollinaire's celebratory 'lyricism of the ambient', and their spaced-out dream logic is central to much Expressionist experiment in Germany, with its characteristic focus on the ugly and the bizarre.[120] Their staccato assertion and syntactic compression are also far more dramatically aimed towards a dissociated imagism than their French counterparts. Vietta and Kemper believe this to be the symptom of a new anxious mode of consciousness within the city, and cite Lichtenstein's 'Punkt' in evidence:

> Die wüsten Straßen fließen lichterloh
> Durch den erloschenen Kopf. Und tun mir weh.
> Ich fühle deutlich, daß ich bald vergeh -
> Dornrosen meines Fleisches, stecht nicht so.
>
> Die Nacht verschimmelt. Giftlaternenschein
> Hat, kriechend, sie mit grünem Dreck beschmiert.

Das Herz ist wie ein Sack. Das Blut erfriert.
Die Welt fällt um. Die Augen stürzen ein.[121]

The empty streets flow blazing
through [my] guttering/extinguished head. And hurt me.
I feel quite clearly, that my time will soon be up—
[Even] rose thorns do not sting my flesh like this.

The night is going mouldy. Poisonous lamplight
has crawlingly smeared it with green filth.
Heart is like a sack. Blood freezing.
The world drops dead. Eyes collapse/implode.

The relationship between subject and object is inverted here: the streets are burning out the human subject as object ('Subjekt und Objekt der Wahrnehmung "stürzen ein" '—'The subject and object of perception collapse into one another').[122] This kind of anguished pathetic fallacy is the root metaphor for much work in which the victimized individual blames the city (or his fantasy of its 'gods') for its oppression, as in the apocalyptic paintings of Ludwig Meidner, which echo the preoccupations of his friends the poets Heym and Hoddis and Lotz. For him:

A street isn't made out of tonal values but is a bombardment of whizzing rows of windows, of screeching lights between vehicles of all kinds and a thousand jumping spheres, scraps of human beings, advertising signs, and shapeless colours.[123]

For this kind of subject, he says, the 'decorative and ornamental designs' of Kandinsky or Matisse are definitely not in order—it is Delaunay who 'inaugurated our movement with his grand vision of the Tour Eiffel'. The dynamic properties of light in these paintings 'set everything in space into motion' so that 'the towers, houses lanterns appear suspended or swimming in air', or even to 'totter and collapse' as 'lines, although actually parallel, shoot up steeply cutting across each other. Gables, smokestacks, windows are dark, chaotic masses, fantastically foreshortened and ambiguous.'[124]

This overheated Futurist rhetoric might lead us to expect work like that of Boccioni and Carrà; but Meidner's early painting is generally devoid of the lines of force and geometrical abstraction which we shall see in other German painters.[125] His *Apokalyptische Landschaft* (*Apocalyptic Landscape*) of 1912–13, for example, not so much of the city as of the waste land outside it, is full of Kandinskyan symbolic furniture—a stormy sea, a mountain top with a castle on it, and wigwams or

35

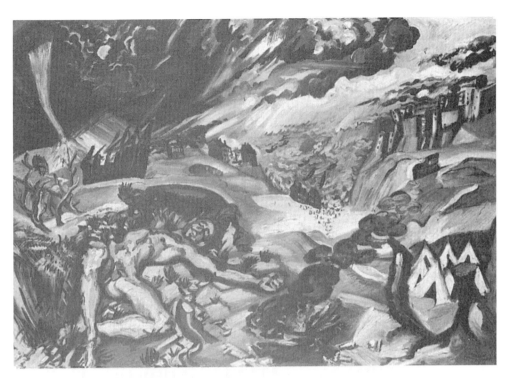

35. Ludwig Meidner, *Apocalyptic Landscape (Apokalyptische Landschaft)*, c.1913.

tents.[126] The impact of the painting depends upon raw psychological self-exposure—at its focal point, a naked, martyred man lies prone in a peculiarly voluptuous position.[127] He may be the deposed Christ, the last Adam, or Abel, or the innocent noble savage sleeping by his tent, while the comets of Heym's poem 'Umbra Vitae' streak past overhead.[128] Meidner's landscapes after this one begin to show the influence of the strongly diagonal Futurist forms of organization echoed in his 'Introduction' cited earler.[129] Biblical fantasy supports a masochistic

36 neurosis here, as also in his *The City and I* (*Ich und die Stadt*) (1913) in which buildings and churches 'fall down' not towards the viewer, as in Boccioni and Delaunay (to whom it is indebted), but are used to make a distorted halo for Meidner's self-portrait, whose staring image owes a good deal to Munch. It is an introverted version of Munch's *Der Schrei* (*The Scream*) of 1893. And, as Eliel suggests, it is also a reply to Boccioni's

IX *The Street Enters the House* of 1911, shown in Berlin in 1912. Where the Futurists suggest an excited interpenetration of the observer and the dynamism of modern city life and work, Meidner expresses discord and alienation by turning his central figure away from a disintegrating chaos.[130] As Meidner put it:

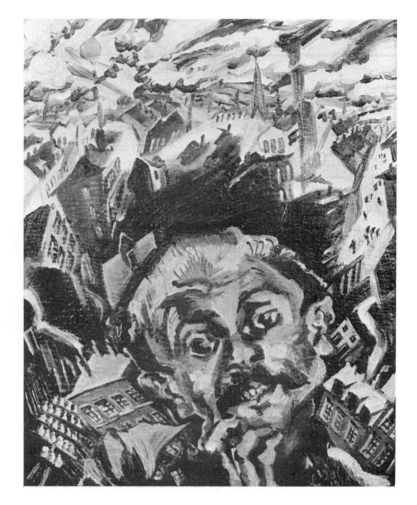

36. Ludwig Meidner *The City and I (Ich und die Stadt)*, 1913.

> The City nears. My body
> crackles. The giggles of the city
> ignite against my skin. I hear
> eruptions at the base of my skull. The
> houses near. The catastrophes explode
> from their windows, stairways silently collapse.
> People laugh beneath the ruins.[131]

The emotional tone here is dark and self-pitying, compared to the grotesque caricatures of Hoddis and the ironic urban unease of Lichtenstein, and again derives quite clearly from the world of Georg Heym. The neurotic sense of doom is reminiscent of the chiliastic tone of so

many of the poems in Kurt Pinthus's later summatory collection of Expressionist poetry, *Menschheitsdämmerung* (1920).

However, the most striking expression of such feelings, which are not so much those of political estrangement or mockery of the bourgeois order, as states which border upon neurotic dissociation, is surely to be found in the early poetry of Gottfried Benn. Strong emotions, issuing in a not always immediately intelligible sequence of images, are central to Modernist poetry and painting, but the power of Benn's writing seems to arise also from a detached and estranging technique parallel to that of Lichtenstein. He expresses his detestation of bourgeois life with the literally clinical detachment of the trained doctor: the poems he published in *Morgue* in 1912 are designed to shock, and their tone is aggressively revolutionary and surprising. It is hardly surprising that he was much influenced by Marinetti.[132]

'Kleine Aster' ('Little Aster'), which opens the sequence, moves from the bizarre fact of a drayman's corpse with an aster between its teeth, to the autopsy-performing speaker's use of his chest cavity as a vase for it, in a gesture which parodies the placing of flowers on a grave:

> Ich packte sie ihm in die Bauchhöhle
> zwischen die Holzwolle,
> als man zunähte.
> Trink dich satt in deiner Vase!
> Ruhe sanft,
> Kleine Aster!
>
> I packed it into his chest cavity for him
> between bits of wood-wool
> while he was being sewn up.
> Drink your fill in your vase!
> rest in peace
> little Aster!

This surreal juxtaposition of post-mortem dissection with the rites of burial is represented as being no more than a matter of fact adaptation to clinical circumstance. The poem's deliberate clumsiness and insouciance, its irregular rhyme scheme, and its perverse subject-matter ensure that the sentimentality of these concluding lines is read as no more than parodic.

This gory flower pot introduces a sequence of corpses, whose fortunes reflect the indifference of the modern city to its underclass with a far bitterer pathos and specificity than the Baudelairean condescension

expressed by Cendrars and Apollinaire.[133] The dead beer porter is followed by a drowned woman who proves to be a rat-infested Ophelia, by a dead prostitute who, once on the slab, is found to possess a single gold-stopped tooth which the mortuary assistant steals to go dancing, by a 'nigger' with his head kicked in by a horse, and by more dead bodies which lie around, 'Den Schädel auf. Die Brust entzwei' ('Their skulls opened up. Their chests split') in 'Requiem'. After a wonderfully grotesque appendix operation (in 'Blinddarm'), death is defeated and goes back to a cancer ward, where 'Bett stinkt bei Bett', and a man and woman see as they walk through it

> dieser Klumpen Fett und faule Säfte
> das war einst irgendeinem Manne groß
> und hieß auch Rausch und Heimat.[134]

> This lump of fat and rottensmelly juices,
> that was once some big man or other,
> and also means drunkenness and home.

These poems and others like them elicited the outrage at which they no doubt aimed: Benn was famously described as a 'hellbound Breughel' ('HöllenBreughel') in a review of *Morgue*, which found it disgusting and perverse.

Welch eine zügellose, von jeglicher geistiger Sauberkeit bare Phantasie entblößt sich da; welche abstoßende Lust am abgründig Häßlichen, welches hämische Vergnügen, Dinge, die nun einmal nicht zu ändern sind, ans Licht zu ziehen.[135]

What an unbridled imagination, devoid of all mental hygiene, is here laid bare; what sordid delight in the abysmally ugly, what debased pleasure in dragging into the light of day things which cannot be changed.

The poet Stadler's reaction to Benn's work was far more perceptive: he thought the 'life arousing' power of Benn's verse justification enough:

Mit einer unheimlichen Schärfe und Sachlichkeit läßt Benn den Vorgang aufleben, erst mit ein paar Meisterstrichen die Situation andeutend, dann in Rede und Gegenrede überspringend, ohne alles Sentiment, fast brutal, als handele es sich um nichts als einen nackten ärtzlichen Operationsbericht.[136]

With an uncanny sharpness and objectivity, Benn brings events to life, first indicating the situation with a couple of master-strokes, and then switching abruptly to dialogue, without any sentimentality, almost brutally, as if it were nothing more than a bare doctor's report on an operation.

For Benn, the modern city is a 'pathological syndrome' in which the 'drive to amusement' ('Amusierbetrieb') is as much to be dissected as bodies in the Anatomical Institute.[137] This disenchanted understanding of city life is expressed most fully in the five poems of his *Nachtcafé* sequence (brought together in his collection, *Fleisch*, in 1917). The title-poem of 1912 recalls Lichtenstein, not least in its synecdochic reduction of persons to their ugliest features—greasy hair, sycosis, and goitre. While the ''cello has a quick drink' and 'The flute | belches throughout two beats', the denizens of the café communicate, as for example

> Grüne Zähne, Pickel im Gesicht
> Winkt einer Lidrandentzündung.
>
> Green teeth, pimples on his face,
> waves to conjunctivitis.

and

> Bartflechte kauft Nelken,
> Doppelkinn zu erweichen.
>
> Sycosis buys carnations
> to mollify double chin.

These negotiations go on in a montage rather like Apollinaire's. But the atmosphere suddenly changes, once the pianist, most incongruously, plays some Chopin:

> H moll: Die 35. Sonate.
> Zwei Augen brüllen auf:
> spritzt nicht dies Blut von Chopin in den Saal,
> damit das Pack drauf rumlatscht!
> Schluß! He, Gigi!
>
> B flat minor, sonata op. 35.
> A pair of eyes roars out:
> Don't splash the blood of Chopin around the place
> for this lot to slouch about in.
> Hey, Gigi! Stop!

But the smell of sex overcomes the speaker's protests as

> Die Tur fließt hin: Ein Weib:
> Wüste. Ausgedörrt. Kanaanitische braun.
> Keusch. Höhlenreich. Ein Duft kommt mit. Kaum Duft.
> Es is nur eine suße Vorwölbung der Luft
> gegen mein Gehirn.

Ein Fettleibigkeit trippelt hinterher.

The door dissolves: a woman.
Desert dried out. Canaanite brown.
Chaste. Full of caves. A scent comes with her. Hardly scent.
It's only a sweet leaning forward of the air
against my brain.

A paunched obesity waddles after her.[138]

The montage effects produced by this fragmentary objective description are counterposed to their opposites—hints at a synaesthetic, heavily metaphorized psychological reaction on the part of the observer (to the splashing blood of Chopin, or to the cave-like smell of a woman). The poet, who as a *flâneur* observer of city life, had traditionally prided himself on his skill in diagnosing the attitudes and occupations of those he observes, is metamorphosed here from the aristocrat of the nineteenth century into the clinical observer of the sex-obsessed body politic in the twentieth. Such people are to be found again and again in the painting of the Neue Sachlichkeit which succeeded to Expressionism after the war—in Dix, Grosz, Schad, and others. Benn's minimally notational reports on eyes, noses, music, drinking, and looking all become grotesque metaphors for one another. They were radically experimental in their exploitation of 'das Nicht-Kausale, die "Zusammenhangsdurchstoßung", das Plotzliche, das Schock- und Sprunghafte' ('the anti-causal, the breaking up of coherence, the sudden, the shocking and the disjointed') which are the essence of his poetry during this period. [139]

In the later poems of this sequence Benn evokes further the grotesques of the city; they are pitifully ugly beings (as in Georg Grosz, who made a drawing in 1918 of 'Dr Benn's Nachtcafe') rather than the picturesque or emaciated but refined objects of compassion we find in early Picasso, Cendrars, or Apollinare:

Ich sitze im Geruche einer Frau.
Der klingt aus Heliotrop und Unterleib zusammen
und scheint mir süß, da diese Frau mir fremd ist.
Ihr Freund arbeitet in der Hosentasche. (poem II)

I'm sitting in the odour of a woman,
which resounds with heliotrope and underwear mixed together,
and seems sweet to me, because this woman is a stranger to me.
Her friend works in trouserpockets.

and so

> Die Leiber spielen aufeinander
> unerhörte Melodien.[140]
>
> Bodies play unheard melodies to one another.

In such a world women are 'Ein zu blödsinniges Pack!' ('an imbecile rabble') who get beaten up (poem III, *GFE* 96) and whose sexual relations are grotesque:

> Der Ober rudert mit den Schlummerpunschen.
> Er schwimmt sich frei. Fleischlaub und Hurenherbste,
> Ein welker Streif. Fett furcht sich. Gruben röhren:
> Das Fleisch ist flüssig; gieß es, wie du willst,
> Um dich;
> Ein Spalt voll Schreie unser Mund.[141]
>
> The waiter rows through with the slumber-punch.
> He swims away. Flesh foliage and whore's autumn leaves make a wilted strip.
> Fat fears itself. Pits roar open:
> Flesh melts away; pour it out for yourself as you wish;
> our mouths are agape and full of cries.

We know something about the state of mind underlying such poems from a curriculum vitae which Benn published as the epilogue to a collection of his poems in 1921. Having pointed out that he had suffered deeply from his loss of interest in his hospital practice in which he specialized in sexual diseases ('Ich versuchte, mir darüber klar zu werden, woran ich litt'—'I tried to make clear to myself why I was suffering'), he goes on to say:

> I delved into descriptions in the psychological work of the French school of that condition known as alienation or depersonalisation of the sphere of perception a condition in which nothing that modern culture calls an intellectual faculty [Geistgabe] is important, but where everything civilization, led by academic psychiatry, had made unrespectable [anrüchig] and labelled neurasthenia ... [Nervenschwäche, Ermüdbarkeit, Psychasthenie]

And he sees this condition as somehow primitive, a symptom of 'the deep, limitless, mythically ancient alienation between the ego [dem Menschen] and the world'. He concludes that it is

> impossible to go on existing in society, and impossible to get out of it in life or work; the nervous wreckage caused by its antithetical structure is too transparent; and too contemptible this eternal coital compromise between fat-bellied antinomies.[142]

The desire not to compromise with the contradictory demands of society, and the feeling that alienation arises out of something which was 'deep, limitless and mythically ancient' led Benn towards the post-Nietzschean primitivism we have already emphasized, and to a growing emphasis on sheer irrationality. Having reduced men and women from their Hamlet-like pretensions to the merely bodily state,[143] he goes on to question all rationality. His interest in prehistory reinforces the desire to regress to an 'authentic community in which the strong could exult in their vitality—uninhibited by Christian morality or humanistic scruples'.[144] In 'Gesänge' (1913) he wants to get back to the instinctive (Dionysian) self:

> Oh, dass wir unsre Ur-ur-ahnene wären.
> Ein Klümpchen Schleim in einem warmen Moor.
> Leben und Tod, Befruchten und Gebären
> Glitte aus unseren stummen Säften vor.
>
> Would that we were a prehistoric horde.
> A lump of mucus in the dank, warm earth.
> Out of our silent juices would be poured
> life, death, fertility and giving birth.[145]

He goes on to imagine 'Nietzsche's Dionysus presiding over a pre-Darwinian landscape of organic 'harmony'.[146]

The belief that the primitive impulse can discredit the rational is further sustained in Benn's prose, most obviously so in his play of 1914, *Ithaka*, a satirical attack on the scientific, or any other, belief in rational method. A professor stains rat brains so that one can tell the long-haired and short-haired ones apart—provided that they are 'similar in age, fed on candy sugar, play for half an hour daily with a puma kitten and defecate twice nightly at a body-temperature of 37.36 C'.[147] But one of his students, Lutz, announces in class that the student body prefers 'mysticism' to scientific 'conditionalism', a dispute which is further stirred up by Benn's anti-hero Rönne, the professor's assistant, who believes that the 'systematisation of knowledge—is the most puerile brainwork imaginable!' (I 75). When Lutz tells the professor that it suits his 'shit like lump of a brain' to 'work out the statistics of bowel-blockages when you're not hard at it fucking'.(I 76), Rönne supports him by asserting the social antagonism which lies underneath his accusation: 'for all I care we could have stayed jellyfish. For me the whole history of evolution is useless. The brain is a blind alley. A bluff to fool

the middle classes' (I 77). He is haunted by the pure sensations of the bodily, to which Benn reduces so many of the protagonists of his poems. Through Rönne Benn makes a Freudian equation between the bodily, the sexual, and the primitive:

Something finds association inside one. Some process takes place inside one. All I can feel now is my brain. It lies on my skull like a lichen. It gives me from above a feeling of nausea. It lies everywhere ready to pounce: yellow, yellow, brain, brain. It hangs down between my legs. . . . I can feel it distinctly knocking against my ankles.

Oh if I could return to the state of being of a grassy field . . . (I 77)

Another pupil, Kautski, follows Rönne in imagining the recovery of a new 'dawn' which has been there since 'the primal stage of the world'. It is regressive, but also Mediterranean and Greek: 'full of the whirring of doves' wings, with the thrill of marble from sea to sea, dream and ecstasy . . .' (I 79). Rönne agrees: 'The Mediterranean was there; from primeval times; and it is there still.' 'Ithaka! Ithaka!' he shouts as he grabs the professor, who sees all this as 'fantasy' and recommends the teaching of philosophy as an antidote and dies, asserting as he chokes that 'Logic will triumph', while Lutz smashes him repeatedly with his forehead, as he shouts:

We are the young generation. Our blood cries out for the heavens and the earth and not for cells and invertebrates . . . We must have Dream. We must have Ecstasy. Our cry is Dionysos and Ithaka! (I 79)

Benn articulates an attitude to the primitive that leads on through Futurist iconoclasm to Dada; in another direction it leads to Fascism. At this stage of his career he embraces that disinhibiting, transformative primitivism we discussed earlier. But there was at the same time a debate about primitivism amongst avant-garde painters which in many ways recapitulates Benn's progress towards a vision of anarchic irra-tionalism, and which begins to visualize for us the kinds of human beings he describes for us in his poetry.[148]

In 1911 Wilhelm Worringer published an essay which took a route back to the primitive which paralleled that of Benn, but which attempted to avoid these Nietzschean psychological demands by an appeal to the metaphysical. In appraising the new endeavours of the 'synthetists and expressionists' of Paris he maintained that the forms they discovered through primitive art were not a sudden fad but a historical necessity.[149] For a return to the primitive was the only way in which inspiration could

be found in an art not conditioned by the illusionism of the Renais-
sance. This anti-realism is sanctioned, not just for formal reasons, but
because Worringer (like Kandinsky) 'felt more affinity with the mystic
vision of primitive art than with the rational perception of the Western
tradition'.[150] The critic Hermann Bahr gave these considerations a very
Benn-like interpretation when he argued in 1916 that the artist can 'trust
the outer world—or himself . . . As primitive man, driven by a fear of
nature, sought refuge within himself so we too have to adopt flight from
a "civilisation" which is out to devour our souls.'[151]

As we have already seen, such arguments were part of a general
strategy for confronting dominant religious values, and rationalizing
the release of emotional and sexual inhibition through art.[152] This
challenging sexuality, inspired by primitive and Fauvist art, is to be
found in much of the early work of Kirchner.[153] His *Girl under a Japanese
Umbrella,* for example, completed in 1909 but dated by Kirchner back
to 1906, was painted after he had seen Matisse's work at Cassirer in
Berlin in January 1909. It has the *Blue Nude*'s bumpy *déhanchement,*
unnatural colour, and flattening of the rising hip and thigh to the picture
plane. (Kirchner even more brutally so than Matisse.) As Gordon points
out, the green umbrella is even more 'exuberant' than the *Blue Nude*'s
palm fronds, and the Expressionist style here is indeed 'more arbitrary,
more spontaneous, and more rudely constructed' than the French.[154]
The Fauvist freedom from the local colour of the natural object has not
inspired any attempt to find 'pleasing' or decorative colour harmonies
here, and the model 'Dodo' (Doris Grohse) here suggests a kind of eroti-
cism which we are expected to link to the frankness of the poses in the
screen above the reclining figure, which is copied from one Kirchner
made for his studio, and is derived from Oceanic art.[155] In this painting,
as in many others by Kirchner and his colleagues of Die Brücke, an
angular, distorted, and violently emotional style is developed from the
techniques available from abroad. This eclectic appropriation extended
the bias of the Fauves and the Futurists towards 'a primal level of
emotion untouched by knowledge of academic art, art history, and
indeed history at large'.[156]

This emotional posture, when turned towards the city, tended to
produce painful contradictions (as we have seen in Benn). It had to
produce an extraordinary simplification of its subject-matter in order to
succeed, and not infrequently expressed an aggression like that of the
poets. The mood is rarely other than tense. In Kirchner's work in the city
(1911–14),[157] there is an anonymity in his figures, which stems from

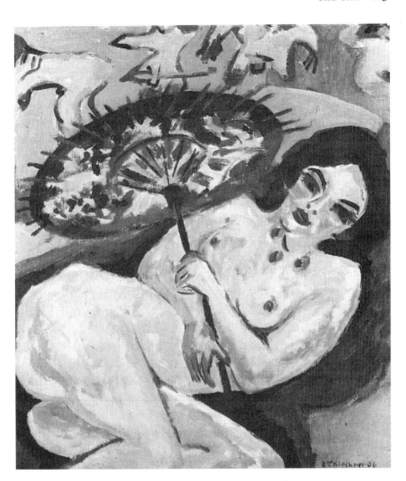

37. Ernst Ludwig Kirchner,
*Girl under a Japanese
Umbrella*, 1901.

primitivist simplification, but also derives from the passivity, anxiety, and alienation to be found in the street scenes of Munch. His attitudes derive largely from the literary culture of the time,[158] and in particular from a debate between those proposing a Nietzschean, instinctive approach to the life of the city (as in Heym), and those, influenced by Simmel, who like Kurt Hiller looked for 'a new urban intellectualism, a *Gehirnlyrik* (intellectual lyric poetry). This was to be based on irony and dissonance, benefiting from the abstract rationalising spirit of city life that Georg Simmel had described', as in Lichteinstein and Ernst Blass.[159] The primitivism he carries over to the new context is located as it is in Benn's poetry—in women. In the early painting of Kirchner and his associates, women (and children) are thought of as primitive. In the context of the studio and of nature this could be seen as positive and lib-

erating, but in the city these qualities become threatening, for Kirchner at least.[160] He may be responding to Macke's demand in his essay on Masks in the *Blaue Reiter Almanack*, that the primitive be redefined in terms of the modern—mentioning the cinema, military marches, and cabaret as modern equivalents for tribal ceremonies.[161]

38 In his *Die Straße (Berlin)* (*Street, Berlin*) of 1913, for example, the menace it emanates is difficult to locate at all precisely, despite many attempts to find a psychological narrative within it. Its elongated angular bodies lack any soft organic forms—and are almost literally reified, by seeming carved into the surface of the painting. Such work is 'crystalline'—very possibly in Simmel's sense, transferred from buildings to people. Above all, we sense a paradoxical claustrophobia, given the painting's implied context of the broad avenues and boulevards of Berlin. The unstable Futurist diagonals here are beginning to convey those effects of psychological disorientation which we are to find in the sets of Expressionist films. Here and in other of Kirchner's street scenes it is possible to feel that the geometrization has another explanation deriving from Worringer, in 'proposing that the psychology of fear and alienation, such as "primitive" man experienced in the face of a hostile, unknown environment, was expressed through abstract, geometrical pictorial form, which attempted to freeze and control the unknowable.'[162] Russell sees this as 'a scene of predation', in which human beings are stalked by other human beings and a hard bargain may soon be struck.[163] Maybe the painting follows Baudelaire's idea that the prostitute is a 'perfect image of the savagery that lurks in the midst of civilisation' with her 'barbaric sort of elegance'.[164] Kirchner tends to focus in his city paintings on the prostitute, whose smart appearance, while flirting with 'respectability', is a symbol of bourgeois hypocrisy and an affirmation of bourgeois consumption. This interpretative imagery arises for Gordon:

in the male figure to the right. In examining the store-window display, he is engaged in shopping; in measuring his wants against money-values, he is deciding his actions in a capitalist economy. The interaction of bourgeois male shopper and depersonalised female cocotte is thus inevitable: 'By choosing as his subjects prostitutes and their clients, Kirchner focusses on the objectification of human relationships inherent in economic exchange; the angular hardening of organic form . . . is a perfect visual analogue for the process of thingification'.[165]

This political allegory belongs to the critic rather than to Kirchner. His street scenes are more difficult to interpret than this, largely because

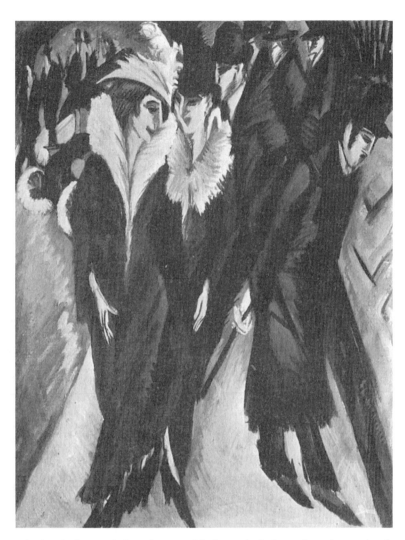

38. Ernst Ludwig Kirchner, *Street, Berlin*, 1913.

of what helps to define them as Modern: their formal, anti-anecdotal quality (which allows them to become less offensive objects of economic exchange). Indeed they differ from the much more documentary German painting of the city of a later period, in that they have no explicit sense of satire, no Hogarthian moral scene. The message has to be carried, if at all, by interpretation, which is clearly vulnerable in so far as it simply metaphorizes the Marxist concept of 'reification'. It is more likely that these paintings reflect Simmel's famous psychological insight into the nature of the 'lonely crowd', antithetical to that of the Unanimists:

The mutual reserve and indifference, the spiritual living conditions in large groups, are never more strongly felt to confirm the independence of the individual than in the thickest city crowd. It is here that bodily proximity and crowding first make spiritual distance truly visible; it is apparently only the reverse of this freedom, that one feels on occasion nowhere so lonely and deserted as in the big city crowd.[166]

Such pictures are nevertheless involved with another kind of dialectic, that between town and country which I mentioned earlier. They are antithetical to Kirchner's contemporary treatments of the nude in the landscape, for example in *Striding into the Sea* (1912), and entail an 'estrangement' quite different from the country ideal of 'die Einheit im Natürlichen' ('unity with nature'). The body and its sexuality *seems* freer and more natural in the country, whereas in the city

Er gestaltete als einziger das hilflose Getriebensein, die Verlassenheit des sich selbst entfremdeten Menschen, der er selber ist. Die Triebkräfte dieser Welt sind platter Materialismus und schamloser Egoismus.[167]

He depicted in a unique manner the helpless drivenness, the desolation of human beings who are estranged from themselves, as he himself is. The driving forces of this world are empty materialism and shameless egoism.

Kirchner's own (retrospective) account of his city work is not so much moral as rigidly concerned to establish his avant-gardist credentials:

Kirchner fand, daß das Gefühl, was über einer Stadt liegt, sich darstellt in der Art von Kraftlinien. In der Art, wie sich die Menschen im Gedränge komponieren, ja in den Bahnen, wie sie liefen, fand er die Mittel, jeweils das Erlebte zu fassen. Es gibt Bilder und Graphiker von ihm, wo ein reines Liniengerüst mit fast schematischen Figuren doch aufs lebendigste Straßenleben darstell(t).[168]

Kirchner found that the feeling that envelops a town is to be represented through lines of force. In the manner in which people compose themselves into the crush, and even in the way in which they run along, he found the means on occasion to fashion something alive. There are pictures and graphics by him in which a pure scaffolding of lines, with almost schematic figures, shows the life of the streets at its most vital.

He thought of himself as the 'Führer der neuesten Richtung' ('leader of the latest tendency')[169] who had forged a German style to compete with those of the French. He does indeed develop a Futurist interest in the rhythm of group movement, for, as Roters notes, Kirchner's six main street scenes develop an increasingly rhythmic style of composition. It is static in *Funf Frauen auf die Straße* (Five Women on the Street)

(1913)—where the women's faces are like those of the African primitive carvings Kirchner had made earlier and yet the arrangement of the figures echoes contemporary fashion plates.[170] The form is as we have seen dictated by diagonal movement in *Die Straße* (1913), but by the time of the *Friedrichstraße* (1914) it has rather fallen into a 'choreographic decline'.[171] In this latter work the men come goose stepping after the women in a kind of balletic parody of photodynamic repetition, and the image could almost come from the musical comedy stage. The same kind of pirouetting seems to be going on in the much larger *Potsdamer*

39

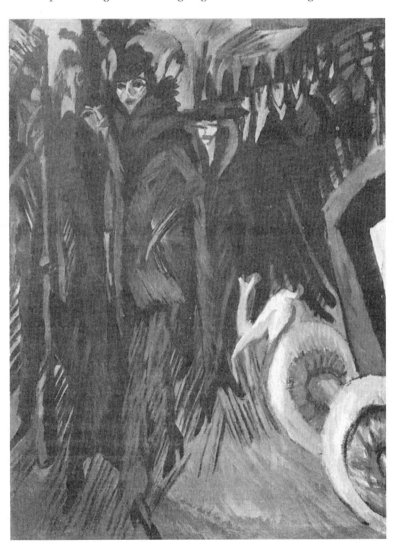

39. Ernst Ludwig Kirchner, *Friedrichstrasse, Berlin,* 1914.

Platz, where there are distortions of scale and constructions on V-forms which are like a synthesis of Boccioni's street scenes. (But Kirchner was not interested in movement as an abstract subject.)[172] There may be a kind of cross-fertilization here, since the dance is a central motif elsewhere in Kirchner's painting, and its association with the sexual is obvious. But a further (incongruous) *rapprochement* with the Nietzschean-Dionysian for these city scenes seems very doubtful.[173]

For a more overtly literary treatment of these themes we have to look to George Grosz, whose early street scenes are like Kirchner's: for example the angles of perspective in *The Street* (1915). This has a diagonal organization, oppressive atmosphere, and claustrophobic distortion, in which the predatory relationship between men and women is made much more explicit, and the curvilinear ground plan and leaning buildings are very like those of his contemporary. But a far greater degree of psychological tension and grotesquerie here, reminiscent of Benn, is already apparent, as in work like the drawing of a *Café Scene* of 1914. The converging diagonals in much of his work of this period may show a Futurist influence, but they energize a dynamic in the crowd which is given a far more sinister, dramatic, and interactive interpretation, whose political implications are reinforced by the cartoon-like simplification of the human figure. In Grosz's city, militarism, sex, violence, and the irrational all too obviously interact; as in images like the pen and ink drawing *Riot of the Insane* (1915) where the figures may be escapees from an asylum, or indeed ordinary citizens following their real desires, as in the *Pandemonium* of 1914.

The greatest and most summational of Grosz's early images is *The Big City* (1916–17) which obviously looks to work like Boccioni's *Forces of a Street*, (as in the street car at right centre). It realizes Meidner's demand reported earlier for 'whizzing rows of windows . . . screeching lights, scraps of human beings and advertising signs'. As a work made in wartime, it turns from Futurist celebration towards the dystopian political violence which was at the same time meeting up with Dada. Grosz here begins to make common cause with artists like Picabia, Tatlin, Heartfield, and others, who were later to be interested in 'projecting violent, ironic, and cinematic images of that great condensation of moral chaos, the city'.[174] But he also looks back to the poets we discussed earlier, and evokes their themes in a letter of 1917:

Oh sacred simultaneity: streets rushing on to the paper; the starry sky circles above the red head; the train bursts into the picture; the telephones ring; women scream in childbirth, whilst knuckledusters and still knife rest peacefully in the

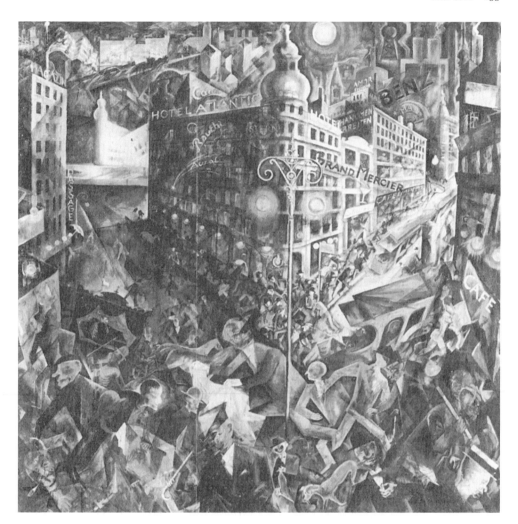

40. Georg Grosz, *The Big City*, 1916–17.

hot trouser pocket of the pimp; the labyrinth of mirrors; the magic street gardens where Circe transforms men into swine.[175]

His interest in crime arises out of political circumstance—but the Circean myth predicts a fearful metamorphosis (of a kind which Joyce was later to have the tact to restrict to the private space of the brothel). In this monumentally organized picture:

The city becomes man's destiny. Living beings become automata. Man is trapped in his own construction. The use of letters is not only part of the realism of the scene, it gives added dimension to the reading of the picture. The alphabet too, has invaded the street; the word itself has been abused.[176]

Grosz thus looks back to the apocalyptic beginnings of the Modernist evocation of the city—as in Meidner's 'Our city world! . . . The roaring colours of buses and express locomotives, the rushing telephone wires (aren't they like music?) the harlequinade of advertising pillars . . . and then night . . . big city night'.[177] (Grosz was indeed an associate of Meidner.) Heym's Baal comes to earth as Nietzsche's Dionysian forces go to work within the riotous politics of the city. Work like this prepares the way for a post-war painting far less abstract than that which we have so far discussed—a painting that is there to be read, in what Grosz called

the song of the signs: the dance of the letters and the pork-red kidney-destroying nights where the moon is next to the infection and angry cab-drivers, and in coal cellars people are strangled; emotion of the big cities.[178]

Bibliographical note

For the *flâneur* in painting in Baudelaire's time and after, see Robert L. Herbert, *Impressionism* (New Haven, Conn., 1988), esp. the 'Artist as Investigator' (43 ff.) which suggests a strong parallel between Edmond de Goncourt and Degas, whose *Women on a Cafe Terrace, Evening* he analyses as if it were material for a novel about prostitution. See also T. J. Clark, *The Painting of Modern Life: Paris in the Art of Manet and his Followers* (London, 1984). Cf. Andrew Lees, 'The Metropolis and the Intellectual', in Anthony Sutcliffe (ed.), *Metropolis 1890–1940* (London, 1984), 67–94; Simmel is only one writer among many who see the city as a problem from the late nineteenth century on—in London, Booth, Gissing, and Masterman, in Paris, Zola, Émile Levasseur, and Paul Meuriot, and so on. On the novelist and the city, cf. Volker Klotz, *Die erzählte Stadt* (Munich, 1969). And for the transition from the nineteenth to twentieth centuries, see Walter Benjamin, *Illuminations* (1955), ed. Hannah Arendt (London, 1973); *Charles Baudelaire: A Lyric Poet in the Era of High Capitalism* (London, 1983); and *One Way Street and Other Writings* (London, 1979). On the 'Literaturen Cafés' such as the Café des Westens in Berlin and the Café Stephanie in Munich, see Helmut Kreuzer, *Die Boheme. Analyse und Dokumentation der intellektuellen Subkultur vom 19 Jhdt bis zur Gegenwart* (Stuttgart, 1971), and Patrick Bridgwater (ed.), *The Poets of the Café des Westens* (Leicester, 1984). For a fuller specification of the context in which Eliot began, see Louis Menand, *Discovering Modernism: T. S. Eliot and his Context* (Oxford, 1987), 3–74. For, *inter alia*, the typographical rearrangement in Symbolist and later poetry, see W. Bohn, *The Aesthetics of Visual Poetry, 1914–1928* (Cambridge, 1986).

Notes

1 Between 1800 and 1910, the number of European townsmen tripled—by migration, rather than by an increase in the birth-rate. London grew from 4,770,000 to 7,256,000; Paris from 2,269,000 to 2,888,000; Berlin from 1,122,000 to 2,071,000, according to Andrew Lees, *Cities Perceived* (Manchester, 1985), 5.

2 Charles Baudelaire, in his *Salon de 1846*, in *Œuvres complètes*, ed. Y.-G. Le Dantec and Claude Pichois (Paris,1961), 949–52.

3 Charles Baudelaire, *Le Peintre de la vie moderne*, in *Œuvres complètes*, 1163.

4 Georg Simmel, repr. in K. H. Wolff (ed. and trans.), *The Sociology of George Simmel* (New York, 1950), 409–24. His essay led to a celebrated book, *Die Großstadt und das Geistesleben*, in 1903.

5 Simmel, *Sociology*, 410. His contrast here echoes that elaborated in Ferdinand Tonnies's *Gemeinschaft und Gesellschaft* (*Community and Society*) of 1887.

6 Rainer Maria Rilke, *The Notebooks of Malte Laurids Brigge* (1910), trans. John Linton (London, 1972), 4.

7 Simmel, *Sociology*, 410.

8 Ibid., 421–2. He goes on to refer to Nietzsche as a hater of the metropolis.

9 But see Patrick Bridgwater's excellent general study, *Poet of Expressionist Berlin: The Life and Work of Georg Heym* (London, 1991), which discusses Heym in relation to a wide range of contemporary influences from literature and painting.

10 Ernst Wilhelm Lötz, 'Die Nächte explodieren . . .'(1916), in Silvio Vietta (ed.), *Lyrik des Expressionismus* (Tübingen, 1985), 36. Henceforward referred to as *LE*. Attacks on the city were more common in German culture than in the French, most popularly in Julius Langbehn's *Rembrandt als Erzieher* (49 printings from 1890 to 1909) which saw Berlin as an 'abode of rationalism', and spiritually empty.

11 Ludwig Meidner, 'An Introduction to the Painting of Great Cities', repr. in V. H. Miesel (ed.), *Voices of German Expressionism* (New York, 1970), 111.

12 *In steinernen Meer*, ed. Otto Hüber and Johannes Moegelin (Berlin, 1910), pp. vii f.

13 Cited by Andrew Lees *Cities Perceived*, 206, from 'Einige Worte über städtische Cultur', *Socialistische Monatshefte* 7 (1903), 612.

14 Richard Le Gallienne, 'A Ballad of London' (1895). For other English examples, cf. R. K. R. Thornton (ed.), *Poetry of the Nineties* (Harmondsworth, 1970), 59 ff.

15 John McCormick, *American Literature, 1919–1932* (London, 1971), 130.

16 Cf. Alfred Lichtenstein's 'Der Ausflug' (*LE* 208 f) and 'Landschaft': 'Der Himmel ist ein graues Packpapier, | Auf dem die Sonne klebt—ein Butterfleck' (*LE* 209). Cf. also *LE*, sect. 8, 196 ff. esp. Klabund's 'Ironische Landschaft' (*LE* 208).

17 Oswald Spengler, *The Decline of the West* (1918–22; repr. London, 1980), ii. 94 and i. 32.

18 Eberhard Roters and Bernard Schulz (eds.), *Ich und die Stadt* (Berlin, 1987), 36.

[19] The poems are to be found in *LE* 54 f, 57, and 35.

[20] Umbro Apollonio (ed.), *Futurist Manifestos* (London, 1973), 26. Henceforward referred to as *FM*.

[21] Despite their theories concerning the 'art of noise' and so on as in Russolo's manifesto of 11 Mar. 1913 (*FM* 74 ff.), they seem to have had little success in producing enduring works of music—though echoes of their thinking are to be found later, in Varèse and Cage and Pierre Schaeffer for example.

[22] He alludes I think to the conclusion of Baudelaire's 'Le Voyage':

> Nous voulons tant ce feu nous brûle le cerveau
> Plonger au fond du gouffre, Enfer ou Ciel, qu'importe?
> Au fond de l'Inconnu trouver du *nouveau*!'

> Our brains are so consumed by this fire that we wish
> To plunge into the depths of the gulf of Hell or Heaven,
> what matter?
> To find the *new* in the depths of the unknown.

[23] This misogynist aggression is in tune with that we have discussed earlier, and Marinetti attempts to come close to his ideal in his *Mafarka le futuriste: roman africain* (Paris, 1909). Its first section, entitled 'Rape of the Negresses' (28–35), led to a law suit on grounds of indecency. Its foreword proclaims it to be a glorification of war, but its main concern seems to be with the revenge of the victors after battle in a popularized version of the morality-free Nietzschean superman (according to John J. White, *Literary Futurism* (Oxford, 1990) 318). Cf. also his 'Il Cittadino eroico, l'abolizione delle polizie e le scuole di coraggio. Discorso sulla bellezza e necessità della Violenza', 'The heroic citizen, the abolition of the police, and the schools of courage. Discourse on the beauty and necessity of violence', Discourse at the Borso del Lavoro in Naples, 26 June 1910. His *Le Futurisme* (Paris, 1911) was published in its (extended) Italian trans. in 1915 as *Guerra—sola igiene del mondo.*

[24] Cited in Marjorie Perloff, *The Futurist Moment* (Chicago, 1986), 85, from Bonner Mitchell, *Les Manifestes littéraires de la Belle Époque, 1886–1914* (Paris, 1966), 83. In 1910 Romains had published just such a 'poème épique' on the not obviously promising subject of a schoolgirl excursion into the country ('Un Crocodile', in *Un être en marche—poème* (Paris, 1910)) which was noticed by Pound in an article in which he intended to summarize the French Modern movement, 'The Approach to Paris' (in the *New Age* in 1913, repr. in Cyrena N. Pondrom, *The Road from Paris: French Influence on English Poetry, 1900–1920* (Cambridge, 1974), 179 ff). His reaction shows how striking Unanimist ideas seemed at the time. He quotes:

> Les petites filles marchent en avant
> Pour attendrir l'espace;
> La pension caresse avec leurs pieds d'enfants

La rue où elle passe

and comments: 'M Romains makes us take an interest in his particular croco-
dile, in its collective emotions, in the emotions of its surroundings.' His final
judgement, however, has that amazing wrongness of which he was always
capable when his enthusiasm was aroused:'It is possibly the nearest approach
to the epic that we have had since the middle ages' (Pondrom, *Road*, 180).

[25] Jules Romains, 'Reflexion', at the end of *Puissances de Paris* (Paris, 1911; 1919,
143–53, repr. in Pondrom, *Road*, 318 f.

[26] Jules Romains, *La Vie unanime: poèmes,1904–1907* (Paris, 1926), 39.

[27] His central insight (derived from meditations on Zeno's paradox) is that time
is cumulative rather than linear, and that it is a mistake to think of time as if it
were a kind of measurable space. For a simple exposition, see Leszek
Kolakowski, *Bergson* (Oxford, 1985), 14 ff.

[28] Henri Bergson, *Time and Free Will: An Essay on the Immediate Data of Con-
sciousness*, trans. W. L. Pogson (London, 1910), 100.

[29] Henri Bergson, *Matter and Memory*, trans. N. M. Paul and W. S. Palmer from
the 5th edn. of 1908 (London, 1911, repr. 1978), 325. Cf. also 70–85, 170–5, 193–7.

[30] On duration and the rhythms of consciousness, see Bergson, *Matter and
Memory*, 272 ff.

[31] Ezra Pound, 'Prolegomena', *Poetry Review*, 2 (Feb. 1913), 73 ; repr. in his *Literary
Essays* (London, 1954), 9.

[32] Jean Metzinger in his 1910 'Notes sur la peinture', cited in Virginia Spate,
Orphism: The Evolution of Non-Figurative Painting in Paris, 1910–1914 (Oxford,
1979), 19.

[33] The earliest Futurist attempts to paint such 'states of mind' ('stati d'animo')
were largely anecdotal, and depended upon an implied narrative to suggest
the temporal dimension, as in Boccioni's *Lutto* (*Mourning*) of 1910, whose
lugubrious Munchian subject is deeply incompatible with the movement's
explicit principles. Bergson influenced the Futurists through an anthology of
his writings by Giovanni Papini, *Filosofia dell'Intuizione* (Florence, 1909), and
was frequently referred to in Futurist journals.

[34] Cf. also Russolo's *La Musica* (1911): Bergsonian durée has frequently been
compared to music, which depends on the persistence of memory for its com-
prehension, since our ability to structure its sequences seems to require a
direct awareness of duration through time.

[35] Umberto Boccioni, in a letter to Barbantini of May 1911, cited in Ester Coen,
Umberto Boccioni (New York, 1988), 96. The picture was bought by Ferruccio
Busoni.

[36] The pastel sketch for it (1910) is by comparison photographic—its metamor-
phosis into the final version shows the motivating power of the idea.

[37] And yet, as Barr points out, their rebelliousness still seems to be subordinated
to the organization of the image, by a principle of 'classic balance and the
counterthrusts of the fifteenth century battle pieces by Uccello which Carrà

loved'; see J. J. Soby and Alfred H. Barr Jr., *Twentieth Century Italian Art* (New York, 1949), 10.

[38] Romains, *La Vie unanime*, 123.

[39] Ibid., 124.

[40] Boccioni later (1914) asserted that 'The study and therefore the influence of the archaic art of antiquity, of the Negroes, of wood carvings, of Byzantine art, etc, has saturated the paintings of our young friends in France with the archaism which is another evil brought about by this obsession with the past, a cultural phenomenon related to the influence of the classical world [but] there is a *barbaric* element in modern life in which we find inspiration' (*FM* 176]

[41] Bragaglia in 1911 wrote a manifesto of *Futurist Photodynamism* (*FM* 38ff.), in which he points out that Marey 'still shatters the action' into instants, whereas photodynamism 'has the power to record the continuity of an action in space' (or the transformation of expression on a face).

[42] Cf. also Balla's *Studies of Motion* (1912), *Leash in motion* (1912), *Rhythms of a Bow*, and *Swifts: Paths of Movement and Dynamic Sequences* (both 1913).

[43] For which see Boccioni's *Train in Motion* (1911) or *Dynamism of a Cyclist* (1913) and his other works of this kind.

[44] Cf. Bergson, *Matter and Memory*, 259 ff.

[45] Umberto Boccioni, cited in Coen, *Boccioni*, 132.

[46] These titles are paralleled in a curious triptych by Charles Cottet, *Au pays de la mer* (1898) on the life of the fisherman—in which a communal supper (*Les Adieux*) is flanked by *Ceux qui partent* (the fishermen) on the left, and *Ceux qui restent* (their wives) on the right. It was bought for the Luxembourg on exhibition, and is now in the Musée d'Orsay.

[47] Marianne W. Martin, *Futurist Art and Theory* (Oxford, 1968; repr. New York, 1978), 94.

[48] Caroline Tisdall and Angelo Bozzola, *Futurism* (London, 1977), 44.

[49] Umberto Boccioni, cited in Coen, *Boccioni*, 121, from Boccioni's own commentary on the triptych as published in the catalogue for the London exhibition of 1912. It has also been suggested that there may be a debt to Beethoven's *Les Adieux* piano sonata, Op. 81a.

[50] Umberto Boccioni, cited in Coen, *Boccioni*, 121. The circular forms using the front lapels and backbelts to suggest rotation make these 'mathematically spiritualised silhouettes' rather simply tubular.

[51] *L'Intransigeant* (7 Feb. 1912). Cf. Le Roy C. Breunig, *Apollinaire on Art* (London, 1972), 199.

[52] Maurice Reynal, in Edward F. Fry, *Cubism* (London, 1966), 99. This important exhibition (not including Picasso and Braque) is described by Fry (100 f.) as a 'public consecration' of Cubism. It included work by Villon, Gleizes, Metzinger, Picabia, Lhote, Leger, Marcoussis, and Gris.

[53] 'While we repudiate impressionism, we emphatically condemn the present reaction which, in order to kill Impressionism, brings back painting to old

academic forms. It is only possible to react against Impressionism by compassing it' (*FM* 46f.).

54 According to Spate, *Orphism*, 182, 183.

55 Robert Delaunay, in Pierre Francastel (ed.), *Du cubisme a l'art abstrait* (Paris, 1957), 98, 108.

56 According to Spate, *Orphism*, 185.

57 Guillaume Apollinaire, in Breunig, *Apollinaire on Art*, 212. Cf. p. 219 for an extended description.

58 Blaise Cendrars, from 'La Tour Eiffel', a lecture of 1924 (*Œuvres complètes* (Paris, 1960), iv. 195–200), cited in Spate, *Orphism*, 185.

59 T. S. Eliot, 'What Dante Means to Me ' (1950), in his *To Criticise the Critic* (London, 1965), 126.

60 Lyndall Gordon, *Eliot's Early Years* (Oxford, 1977), 40. Eliot seems to have attended seven lectures by Bergson at the Collège de France in Jan. and Feb. 1911.

61 'The dissolution of ordering thought into an irrational, almost surrealistic collage of discontinuous mental impressions obeys the laws of instinctive consciousness according to Bergson', according to Grover Smith, *T. S. Eliot's Poetry and Plays* (Chicago, 1960), 24.

62 Filippo Tommaso Marinetti, *Le Futurisme* (Paris, 1919), 90, cited in Martin, *Futurist Art*, 91.

63 F.-J. Carmody, *The Evolution of Apollinaire's Poetic* (Berkeley, Calif., 1963), cites many parallels, 82–3; P. Renaud, *Lecture d'Apollinaire* (Lausanne, 1969), follows Delaunay's recollection in saying that Cendrars read it to Apollinaire in 1912, and cites a draft to show this, 91 f. Cf. also Par Bergmann, *Modernolatria e simutaneita* (Stockholm, 1962), 376 ff. who sees parallels between 'Zone' and Boccioni's 'The Forces of a Street', and Severini's 'Souvenirs de voyage'.

64 Garnet Rees (ed.), *Guillaume Apollinaire: Alcools* (London, 1975), 123.

65 Cf. ll. 42–70. The aeroplane here may be indebted to Marinetti's *Le Monoplan du pape* of Dec. 1911. Cf. Carmody, *Evolution*, 92 f.

66 Apollinaire seems to have claimed that he did not need such encouragement to seek out this kind of subject-matter and make it appropriate for poetry. André Billy's account in the *Soirées de Paris* (1 Oct. 1912), 276 ff., reports that Apollinaire told him that 'For sometime now I have been trying new themes far different from those around which you have seen me entwine my verses up to now. I believe that I have found a source of inspiration in prospectuses . . . catalogues, posters, advertisements of all sorts. Believe me, they contain the poetry of our epoch. I shall make it spring forth.' And see the discussion in Bergmann, *Modernolatria*, 372 f.

67 Henri Barzun, *L'Ère du drame* (Paris, 1912), 98.

68 Ibid. 35–6.

69 Published in Barzun's review, *Poème et drame*, in Autumn (Sept./Oct.) 1913.

70 Jean Cocteau, *Carte blanche* (Paris, 1920), 105.

[71] Blaise Cendrars in *Der Sturm* (Sept. 1913), cited in Perloff, *Futurist Moment*, 10, from Miriam Cendrars (ed.), *Inédits secrets* (Paris, 1969), 360 f.

[72] Perloff, *Futurist Moment*, 22.

[73] Blaise Cendrars, in his 'A.B.C. du cinéma' (1919), repr. in *Au'jourd'hui* (Paris, 1931), 254.

[74] Guillaume Apollinaire, *Soirées de Paris* (15 June 1914), 323–4, cited in Perloff, *Futurist Moment*, 9. Her discussion of the work as a whole, 13 f., is exceptionally illuminating.

[75] Perloff, *Futurist Moment*, 27, nevertheless locates imagery within it, seeing (*inter alia*) 'a kind of abstract Moscow with its bell towers' at the top, then 'a rainbow-coloured world of whirling suns, clouds and wheel . . . a kind of unfolding aerial map', and finally (and less controversially) 'a little red toy version of the Eiffel Tower penetrating an equally child like rendition of the Great Wheel'. This last seems to me to constitute the only clear parallel between poem and painting.

[76] Stéphane Mallarmé, trans Anthony Hartley (ed.), *Mallarmé* (Harmondsworth, 1965), 18.

[77] Spate, *Orphism*, 197

[78] Cf. ibid. 193.

[79] Ibid. Spate argues, 194 f., for the influence of Kandinsky here.

[80] Ibid. 199 f.

[81] *Diaries of Paul Klee*, ed. Felix Klee (Berkeley, Calif., 1964), 374. Cf. Andrew Kagan, *Paul Klee, Art and Music* (Ithaca, NY, 1983), 54–61, showing that Klee was greatly influenced by Delaunay up to 1921.

[82] As reported by Apollinaire. Cf. Breunig, *Apollinaire on Art*, 264.

[83] Trans. Francis Steegmuller, *Apollinaire* (Harmondsworth, 1973), 207. One could perhaps say, with Spate, that 'The self-generating fluidity of such imagery—the way in which each image opens out into, merges with, and creates the next image—is comparable to the way that Delaunay's colour planes generate one another' (*Orphism*, 79). She discusses the poem on pp. 78 f.

[84] As Renaud, *Lecture*, 354, points out.

[85] Guillaume Apollinaire, 'Simultanéisme—librettisme', *Œuvres complètes*, ed. Michel Décaudin (Paris, 1965), iii. 890.

[86] According to André Billy, *Apollinaire vivant* (Paris, 1923), 54 f., 'Les Fenêtres' includes a number of lines dictated to Apollinaire by him and by Dalize, in 'une étrange collaboration'—hence its extraordinary arbitrariness of reference.

[87] Guillaume Apollinaire, *Tendre comme le souvenir* (Paris, 1952), letter to Madeleine Pagès of 1 July 1915, 48.

[88] Trans. Steegmuller, *Apollinaire*, 225.

[89] Ibid. 224.

[90] Ibid. 227.

[91] Renaud, *Lecture*, 320.

[92] For an extended account of collage in this period, see Christine Poggi, *In Defiance of Painting: Cubism, Futurism and the Invention of Collage* (New Haven, Conn., 1992).

[93] Pablo Picasso, cited in F. Gilot and C. Lake, *Life with Picasso* (New York, 1964), 77.

[94] Cf. Poggi, *Defiance*. 54 f.

[95] As Robert Rosenblum has shown with many more examples than can be cited above, in his 'Picasso and the Typography of Cubism', in D.-H. Kahnweiler *et al.*, *Picasso, 1881–1973* (London, 1973), 49–76.

[96] John Russell, *The Meanings of Modern Art* (London, 1981), 118. Poggi, *Defiance*, 148ff., traces a similar sexual punning in Picasso's *Au Bon Marché* (1913) in which the words 'un trou ici' have a sexual meaning and also refer reflexively to the gaps brought about in the picture plane by collage technique.

[97] Guillaume Apollinaire, *Œuvres poétiques*, ed. Marcel Adéma and Michel Décaudin (Paris, 1965), 192. Cf. 'Coeur couronne et miroir', ibid. 197, or 'Il pleut', ibid. 203.

[98] Guillaume Apollinaire, cited Roger Shattuck, *The Banquet Years* (London, 1969) 310.

[99] They were very likely influenced by Marinetti's *Zang tumb tumb*, and perhaps also by work like that of the Futurist poet Cangiullo, for example, who uses the word for 'baggage' to make the image of a pile of it on a platform. See John White, *Literary Futurism* (Oxford, 1990), 15 and 17. I agree with Herman's judgement that 'With its limited semantic scope, its obvious tautologies and its crude mimeticising (the poem as picture is never more than a crude cliché) the [autoillustrative] technique ultimately appears to be a self-defeating over-simplification' (*The Structure of Modern Poetry* (London, 1982), 81 f.).

[100] Margaret Davies in M. Chefdor *et al* (eds.), *Modernism* (Urbana, Ill., 1986), 156.

[101] Renaud, *Lecture*, 371.

[102] *Lettre-Océan* resembles Futurist poems by Cangiullo and Jannelli published in *Lacerba* in Jan. 1914, and Apollinaire himself seems to recognize this at the same time as he claims descent from Mallarmé, in his 'Simultanisme-librettisme (*Œuvres Complètes*, iii. 890) which was published in the same issue of *Les Soirées de Paris* as *Lettre-Océan* (on 15 June 1914). His relations with the Futurists were then good, thanks to the *Antitradition futuriste* manifesto he had published in June 1913.

[103] Guillaume Apollinaire, cited in Renaud, *Lecture*, 245. Poggi, *Defiance*, 221 f. discusses the influence of *Lettre-Océan* on Carrà's circular 'spoke and wheel' compositions (of which the most famous is his *Festa pattriotica* (1914)).

[104] Of the kind raised by Timothy Mathews, *Reading Apollinaire* (Manchester, 1987), 165–76.

[105] He claims that the essential concepts here were 'invented' in his *Technical Manifesto of Futurist Literature* (11 May 1912). The first example of the method

is the 'Battaglia + peso + odore' ('Battle + weight + smell') of 1912, published as an appendix to the Manifesto. His 'Destruction of Syntax—Imagination without Strings—Words-in-Freedom' is dated 11 May 1913 (*FM* 95ff.) and appeared in *Lacerba*, 12 (15 June 1913), 121 ff., in French (*La Gallérie de la Boétie*) on 22 June 1913; and was translated in *Poetry and Drama* (3 Sept 1913).

[106] Filippo Tommaso Marinetti, 'Manifesto tecnico della litteratura', in *Teoria e invenzione futuristica*, ed. Luciano De Maria (Milan, 1968), 44. My trans. These ideas had a considerable influence on D. H. Lawrence, as his letter to David Garnett of 5 June 1914 shows. Cf. *The Collected Letters of D. H. Lawrence*, ed. Harry T. Moore (London, 1962).

[107] For the attack on Symbolism continues, as in Marinetti's *Down with the Tango and Parsifal* (Milan 1914). Cf. Perloff, *Futurist Moment*, 107–9.

[108] This notion of a 'kinetic' literature has a long life in the irrationalist tradition, through Dada to the surfiction and concrete poetry of the Postmoderns.

[109] By 1914 Sant'Elia had written a *Manifesto of Futurist Architecture*.

[110] In the earlier 1912 manifesto, Marinetti had adduced a Bergsonian, intuition-ist reason for the use of verbs in the infinitive, 'because they adapt themselves elastically to nouns and don't subordinate them to the writer's I that observes or imagines. Alone the infinitive can provide a sense of the continuity of life and the elasticity of the intuition that preserves it' (*Teoria e invenzione*, 40). Marinetti admits, however, that he needs conventional syntax and punctua-tion in this manifesto 'in order to make myself clear' (*FM* 96).

[111] Marinetti, from *Teoria*, 694 f. White has an excellent commentary on this passage in his *Literary Futurism*, 179–87, and, for an equally good general dis-cussion, cf. Poggi, *Defiance*, ch. 8, 'Futurist Collage and Parole in Libertà in the Service of the War', 228–51.

[112] Virginia Woolf, 'Modern Fiction' (1919), in *Collected Essays*, ii (London, 1966), 107.

[113] Ibid. 108.

[114] It was published in *Der Demokrat* (11 Jan. 1911), trans. Michael Hamburger.

[115] J. R. Becher, in Paul Raabe (ed.), *The Era of German Expressionism*, trans. J. M. Ritchie (London, 1974), 45.

[116] A battle lost in Hoddis's case to a growing schizophrenia from 1912 on.

[117] Cf. Hoddis's 'Kinematograph', in which the Reihungsstil parodies the mon-tage technique of the silent film, in Silvio Vietta (ed.), *Lyrik des Expressionis-mus* (Tübingen, 1985), 58. Henceforth cited in the text as *LE*. Cf. also Ferdinand Hardekopf's 'Wir Gespenster (Leichtes Extravagantenlied)' (*LE* 59 f.), which satirizes the cinema audience's appetite for horrors, and the loss of the world of Dostoevskyan despair and Toulouse-Lautrec.

[118] Published on 5 Mar. 1911 in *Der Sturm*, repr.*LE* 209. This poem is parodied in turn by Blass in 'Nehmen se jrotesk—det bebt Ihnen': see Patrick Bridgwater (ed.), *The Poets of the Café des Westens* (Leicester, 1984), 31.

[119] Michael Hamburger, *Reason and Energy* (London, 1957), 222.

[120] See C. Eykman, *Die Funktion des Hasslichen* (Bonn, 1965), a study of Heym, Trakl, and Benn.

[121] In *LE* 35.

[122] Silvio Vietta and H. G. Kemper, *Der Expressionismus* (Munich, 1983), 34.

[123] 'Introduction to the Painting of Big Cities', from 'Das Neue Program', *Kunst und Künstler*, 12 (Berlin, 1914), 299 ff., repr. and trans. Erwin Miesel (ed.), *Voices of German Expressionism* (New York, 1970), 111 ff.

[124] Ludwig Meidner, in Miesel, *Voices*, 114, 112 f.

[125] But for a good counter-example of such abstraction in Meidner, see 'Corner House (Villa Kochmann, Dresden)' (1913).

[126] It also owes a good deal to the Nietzschean anti-urban description of apocalypse (cf. *Also Sprach Zarathustra*, trans. W. Kauffmann (Harmondsworth, 1978), 176–8), to Heym's poem 'Der Krieg' of 1911, and his 'Umbra Vitae' in which

> The people on the streets draw up and stare,
> While overhead huge portents cross the sky;
> Round fanglike towers threatening comets flare,
> Death-bearing, fiery-snouted where they fly.

(Cited in Carol S. Eliel, *The Apocalyptic Landscapes of Ludwig Meidner* (Munich, 1989), and trans. and ed. Michael Hamburger and Christopher Middleton, *Modern German Poetry* (New York, 1964), 155.

[127] Discussed in Donald Gordon, *Expressionism: Art and Idea* (New Haven, Conn., 1987), 40 f., who gives an extraordinary explanation via the mad Daniel Schreber's fantasies.

[128] Eliel, *Meidner*, 31.

[129] Cf. ibid. 36 f. These Futurist forms are most obvious in urban scenes like his *Wannsee-Bahnhof* (1913).

[130] He is not alone. Cf. Wegner's 'Die Maske' (*LE* 48), and 'Die tote Stadt' (*LE* 38), or Blass's 'Der Nervenschwache' ('The Neurasthenic'), published in *Der Sturm*, 1 (1910/11), which begins:

> Mit einer Stirn, die Traum und Angst zerfraßen,
> Mit einem Körper, der verzweifelt hängt
> An einem Seile, das ein Teufel schwenkt,
> —So läuft er durch die langen Großstadtstraßen.

> With a brow which dreams and anguish eat away,
> With a body, which despairingly hangs on a rope,
> twitched by a devil,
> He runs through the long city streets

[131] Meidner, '... im Nacken das Sternemeer ...' (Leipzig, 1918), 26 f., cited in Eliel, *Meidner*, 45.

[132] 'Kein Meisterwerk ohne ein agressives Moment' ('No masterpiece without an

aggresive element'), Marinetti in *Der Sturm*, 3 (1913), 104. His poems were published in a German translation by A. R. Meyer in 1912.

[133] The cycle published in Mar. 1912 included (in a *flugblatt*) 'Kleine Aster', 'Schöne Jugend', 'Kreislauf', 'Negerbraut,' 'Requiem,' 'Saal der kriegenden Frauen', 'Blinddarm', 'Man und Frau gehen', and 'Nachtcafé'. I follow Bruno Hillebrand (ed), *Gottfried Benn: Gedichte: In der Fassung der Erstdrücke* (Frankfurt, 1982). Henceforth cited as GFE.

[134] Childbirth is given an equally detached view in 'Saal der kreißenden Frauen' (*GFE* 30). The attitudes of the doctor are further seen in 'Der Arzt' (1917) (*GFE* 87–90) and the sequence 'Der Psychiater' (1917) (*GFE* 99–115).

[135] R. Meyer, cited by Raabe, *Era*, 51. The accusation that Benn is a psychiatric case follows on from this: 'Wenn früher jemand verrückt war, so sah er nur weiße Mäuse tanzen. Jungberlin hat hierin entschieden einen Fortschritt gemacht, es sieht Ratten . . . Ich überlasse diesen interessanten Fallen den Psychiatern' ('Before when someone was mad, they just saw white mice dancing. The youth of Berlin have made a decided advance in this matter, they see rats . . . I leave these interesting cases to the psychiatrists'), cited in H. E. Holthusen, *Gottfried Benn 1886–1922* (Stuttgart, 1980), 109, from a pseudonymous review by one 'Janus' published in a Munich journal.

[136] Ernst Stadler, in Bruno Hillebrand (ed.), *Gottfried Benn: Kritische Stimmen* (Frankfurt, 1987), 13 f., from the *Cahiers alsaciens* (Nov. 1912). He goes on to insist on Benn's objectivity ('unbeteiligte Sachlichkeit') in terms which were to become very significant for post-war German culture.

[137] Holthusen, *Benn*, 252.

[138] Gottfried Benn, 'Nachtcafé' (1912, 1917) (*GFE* 94 f.), trans. Hamburger, *German Poetry*, 67.

[139] Holthusen, *Benn*, 104.

[140] Gottfried Benn, in *GFE* 95.

[141] Poem IV, *GFE* 97, cf. 98. For his attitude to women cf. also 'Englisches Café' (*GFE* 55) (1913) and the woman in 'Untergrundbahn' (*GFE* 57).

[142] Gottfried Benn, *Prosa und Autobiographie*, ed. Bruno Hillebrand (Frankfurt, 1984), 253. He also comments in a letter of 22.2.36 on these early poems: 'Was für ein Inferno! Dies ist immer wieder mein Hauptempfinden dabei. Was für ein Gemisch von Heidentum, christlicher innerlichkeit, Glauben u Haß, Zersprengen u Sammeln, eben *Inferno*' ('What an Inferno! This is still my main impression of it. What a mixture of heathendom, Christian inwardness, belief and hate, bursting apart and bringing together—indeed an Inferno').

[143] On man as a parody of Hamlet cf. 'Der Arzt II' (1917), (*GFE* 88).

[144] Edward Timms, in E. Timms and P. Collier (eds.), *Visions and Blueprints* (Manchester, 1988), 24.

[145] Gottfried Benn, 'Gesänge' (1913) (*GFE* 47), trans. Edward Timms.

[146] Timms, ibid. 25, who finds parallels here to Yeats and Pound.

[147] Gottfried Benn, *Ithaka*, trans. J. M. Ritchie, in *Gottfried Benn: Selected Writings* (Oxford, 1972), 73. Henceforth cited as *I*.

[148] I say begins, because this process is arguably at its most extreme and widespread after the war in the work of such as Dix, Heartfield, Schad, Beckmann, and others.

[149] Wilhelm Worringer, 'Zur Entwicklungsgeschichte der modernen Malerei, Die Antwort auf den Protest deutscher Kunstler', in *Der Sturm*, 2 (1911), 597–8. In the process he makes the first use in *Der Sturm* (and perhaps in Germany) of the term 'Expressionist'.

[150] Peter Selz, *German Expressionist Painting* (Berkeley, Calif., 1957), 257.

[151] Hermann Bahr, *Expressionismus* (Munich, 1916), repr. in F. Frascina and C. Harrison (eds.), *Modern Art and Modernism* (London, 1982), 166, 169.

[152] Gordon, *Expressionism*, 67 ff., shows how the challenge of Expressionism as 'first an overthrow of the sexual mores of the German middle class family, and second, an attack on the religious values of the German Christian tradition' is related to primitivism in the progressive attitudes of the *Blaue Reiter* group.

[153] For Kirchner's ethnographical material, see Jill Lloyd, *German Expressionism: Primitivism and Modernity* (New Haven, Conn., 1991) 21ff.

[154] Gordon, *Expressionism*, 74.

[155] LLoyd discusses the relationship of these figures to the wall hangings in Kirchner's studio in *Primitivism*, 31 ff., and cites parallels in the work of Kirchner's friend Heckel.

[156] Roger Cardinal, *Expressionism* (London, 1985), 1.

[157] After 1914 Kirchner abandoned the city (and expressed anti-urban sentiments in his Davos diary). German thinkers and artists had a far less appreciative view of the city than the French; very few painters opted to live in cities before the war.

[158] Notably from his association with the Neopathetische Kabarett; cf. Lloyd, *Primitivism*, 139.

[159] Ibid. Lloyd sees Kirchner as much influenced by Heym, and also by Döblin with whom he was in contact in 1912: ibid. 139f.

[160] Cf. ibid. 47, 85.

[161] Cf. August Macke in Klaus Lankheit (ed.), *Almanack* 83 ff., Including: 'In the vaudeville theatre the butterfly-coloured dancer enchants the most amorous couples as intensely as the solemn sound of the organ in a Gothic cathedral seizes both believer and unbeliever' (*Almanack*, 88). Furthermore, 'What we hang on the wall as a painting is basically similar to the carved and painted pillars in an African hut. The African considers his idol the comprehensible form for his incomprehensible idea, the personification of an abstract concept. For us the painting is the comprehensible form for the obscure, incomprehensible conception of a deceased person, of an animal, of a plant, of the whole magic of nature, of the rhythmical' (*Almanack*, 88).

[162] Lloyd, *Primitivism*, 147. The organic, southern, and classical, on the other

hand, demonstrates an earlier, empathic response (that is why northern Gothic is more abstract). Lloyd supports her judgement here by pointing to the more curved character of the more 'positive' circus paintings.

[163] Russell, *Meanings*, 86.

[164] Charles Baudelaire, 'Le Peintre de la vie moderne', in *Œuvres complètes*, ed. Y. G. Le Dantec and Claude Pichois (Paris, 1961), 1187.

[165] Gordon, *Expressionism*, 137, citing Rosalyn Deutsche's 'Alienation in Berlin: Kirchner's Street Scenes', *Art in America*, 71 (Jan. 1983), 69.

[166] Georg Simmel, *Die Großstadt und das Geistesleben* (1903), 199.

[167] Wolf-Dieter Dube, 'Kirchner's Bildmotive in Beziehung zum Umwelt', in Lucius Grisebach and Annette Meyer zu Eissen (eds.), *E. L. Kirchner 1880–1938*, exh. cat. (Berlin, 1980), 13, who refers also to Otto Flake's novel, *Die Stadt des Hirns*.

[168] Ernst Ludwig Kirchner, *Davoser Tagebuch* (written 1925), ed. Lothar Griesebach (Cologne, 1968), 86.

[169] On his pre-dating of his pictures, his invention of 'Louis de Marsalle', etc., see Frank Whitford in Grisebach and Meyer zu Eissen (eds.), *Kirchner*, 38 ff.

[170] Cf. Lloyd, *Primitivism*, 150 and fig. 190.

[171] Eberhard Roters, 'Die Straße', in id. and Bernhard Schulz (eds.), *Ich und die Stadt* exh. cat. (Berlin, 1987), 38.

[172] At the same time, according to Roters in *Ich und die Stadt*, 48, they project emotions of a theatrical kind whose secret is their frontality, their threatening movement towards the spectator.

[173] Roters, ibid., makes a parallel with Heym's 'Gott der Stadt', which contains the lines

> Wie Korybanten-Tanz dröhnt die Musik
> Der Millionen durch die Straßen laut.

> Wild as the dance of Corybantes, the music
> of the millions rumbles through the streets.

But the idea here seems to have a great deal of generality.

[174] Robert Hughes, *The Shock of the New* (London, 1980), 42.

[175] Cited in Hans Hess, *George Grosz* (New Haven, Conn., 1985), 70, (letter to Otto Schmalenhausen(6 Dec. 1917).

[176] Hess, *Grosz*, 71. The lettering is very likely influenced by Severini's *Nord Sud Metro* and *Autobus* shown in Berlin in the autumn of 1913.

[177] Meidner, 'Introduction' (1913), in Miesel, *Voices*, 111.

[178] Cited in Hess, *Grosz*, 71 f. (from a letter to Oscar Schmalenhausen of 30 June 1917). Hess calls the painting an 'Expressionist hymn to the unleashed powers of life' (72).

5 | LONDON AND THE RECEPTION OF MODERNIST IDEAS

1. From Hulme to Imagism

In this chapter I am going to discuss the reactions of some English artists to Modernist ideas, in a city without much avant-garde tradition and inhibited by a conservative opposition with a proven reputation for outrage. This will allow us to sample a very small number of the many reactions against Modernist activity. There is nevertheless an intense theoretical debate in England, which echoes European concerns, concerning the significance of Post-Impressionist painting, which is followed by a rather bemused reaction to Futurist dogma and the speculative thinking of Kandinsky. This led to an alliance between the visual arts and literature in the Vorticist movement, of which Pound declared Picasso to be the classic 'father' and Kandinsky the romantic 'mother'.[1]

Throughout this pre-war period, the influence of *vers libre* and of the new philosophy of Bergson is quite strongly felt, and so there is some echo in England of the often rather feeble Post-Symbolist aesthetics of minor contemporary French poetry (neo-Mallarméanist, neo-paganist, paroxyst, fantaisist, and so on).[2] But for genuinely innovative work, rather than stylistic imitation, some kind of new intellectual perspective was clearly needed, and it began to be provided by the theories of T. E. Hulme, whom T. S. Eliot later saw as 'the forerunner of a new attitude of mind, which should be the twentieth century mind, if the twentieth century is to have a mind of its own'.[3] This 'new attitude' was to say the least eclectic, as Hulme's enthusiasms for Bergson, Nietzsche, Sorel, and then for Husserl, G. E. Moore, and Maurras, show.[4] His openness to such ideas typically enough arose from an early twentieth-century sceptical pragmatism (which can sound a bit like Post-structuralism): 'I am a pluralist . . . There is no Unity, no Truth, but forces which have different aims, and whose whole reality consists in those differences.'[5]

Hulme's earliest allegiance was to Bergson, about whom he wrote over twelve essays between 1909 and 1912, and from whom he takes the notion of mental experience as process, so that 'only the flux is real'.

This is quite incompatible with the 'mechanistic nightmare' of the rigid systems of the past (*FS* 58), and so the approach to experience of nineteenth-century scientific positivism has to be 'given up' in favour of a subjective, time-dominated psychological fluidity, within which 'the purpose and the will constitute the only reality' (*FS* 42). This view (expressed in 1909) gives Bergson a very Nietzschean twist, as does Hulme's remark above about forces with different aims. Only intuition and instinct, what is more, can suffice to grasp the nature of things (*FS* 6). The new psychology of mind thus demands an emancipation from nineteenth-century materialist assumptions, and Hulme attempts to show how this can be, by taking it for a walk, as we have seen the poets doing, and very much as Virginia Woolf will later do in her 'Modern Fiction'.

Sometimes walking down an empty street at night one suddenly becomes conscious of oneself as a kind of eternal subject facing an eternal object. One gets a vague sentiment of being, as it were, balanced against the outside world and co-eternal with it. (*FS* 44)

This is part of a general tendency towards intuitionism and subjectivity in early Modernism, and it leads Hulme directly to a theory about the way poetry should be written. As early as 1909 he sees the poetic image as corresponding to mental intuition, in writing about the 'visual concrete language' of poetry, which may function as a 'compromise for a language of intuition that would hand over sensations bodily'. Such a language can, what is more, 'arrest' the reader, make him 'continuously see a physical thing', and prevent him from 'gliding through an abstract process' away from it (*FS* 10, 12). His thoughts here are remarkably close to those of Hofmannsthal reported earlier.

Such assumptions, as Pound rather later discovered, could inspire a supposedly particularizing style, which Hulme himself exemplified in 'Autumn':

> A touch of cold in the Autumn night—
> I walked abroad,
> And saw the ruddy moon lean over a hedge
> Like a red faced farmer.
> I did not stop to speak, but nodded,
> And round about were the wistful stars
> With white faces like town children.

(It is nice to know that he was not so far taken in by Romantic or Wordsworthian impulses as to attempt to converse with the moon.)[6]

Hulme believed indeed that the 'standpoint of extreme modernism' could be demonstrated if the poet selects 'images which, put into juxta-position in separate lines, serve to suggest and evoke the state he feels'. He has almost arrived at the disjunctions of the German *Reihungsstil*. But as 'Autumn' shows, his mood is still far more wistfully Symbolist, and it is not surprising to see him claiming to 'find a fanciful analogy' for the process he desires in music, when 'Two images form what one may call a visual chord' and 'unite to suggest an image which is different to both' (*FS* 73).

This fundamental Modernist technique of elliptical apposition de-mands brevity, and is usefully incompatible with the discursive philos-ophizing and moralizing which was thought to be the bane of Victorian poetry. (The English Modernists seem to have been freer than the French and the Germans from the influence of Whitman.) It is also con-sistent with Hulme's opposition to the nineteenth-century 'elaboration and universal application of the principle of *continuity*', by which I assume him to mean *inter alia* the mechanistic processes of science. 'The destruction of this conception is, on the contrary, an urgent neces-sity of the present' (then 1916).[7] Free verse, with its peculiar flexibility, is suitable for a modern poetry which 'has become definitely and finally introspective and deals with expression and communication of momentary phases in the poet's mind' as in 'The vision of a London street at midnight, with its long rows of light' (*FS* 72).

Hulme had enunciated by 1909 principles of poetic expression (and an example for it), which are very similar to those implicit in Eliot's poetry of these years. He could be writing a prospectus for the 'Rhapsody on a Windy Night'. These principles will by 1911 inspire the Imagists. But until Pound and others gave them a more explicitly avant-gardist context, Hulme's views remain indebted to the Paterian view of art, as providing an intensification of immediate experience, which also underlies Joyce's *Portrait*. They link Modernist particularization and juxtaposition to a concentration on the epiphanic moment:

Life as a rule tedious, but certain things give us sudden lifts. Poetry comes with jumps, of love, fighting, dancing. The moments of ecstasy.

 Literature, like memory, selects only the vivid patches of life. The art of abstraction. If literature (realistic) did really resemble life, it would be inter-minable, dreary commonplace, eating and dressing, buttoning with here and there a patch of vividness. (*FS* 99)

Hulme had evolved a theory poised between late Symbolism and an

advocacy of those discontinuous features which were distinctly Modernist. F. S. Flint, who was well acquainted with Hulme's views, also saw Bergsonism as a potentially innovating extension of Symbolism. In his article on 'Contemporary French Poetry' (1912) he argued that Symbolism was 'in process of evolution into other, different, forms' as 'an attempt to evoke the subconscious element of life, to set vibrating the infinity within us, by the exquisite juxtaposition of images', whose philosophy of 'intuitiveness' had been formulated by Bergson.[8] It was thus well on the way towards specifying an experience akin to the epiphany we find in Joyce and Woolf (who also thought that such matters as dressing and buttoning could be left out of the novel).

However, neither critic had anything particularly experimental in mind, and Hulme's ideas did not immediately have much of an innovating effect when they were communicated to the Secession Club, at its first meeting on 25 March 1909. Flint, Storer, Rhys, and others were present, and weekly meetings continued (with Pound from the beginning of April) through the spring and summer. The Club was dissolved after a brief resumption in the autumn, and this is the 'forgotten school' to which Pound later refers.

He seems to have forgotten many of its doctrines, including that of the 'image', until he came upon verse by H.D. (Hilda Dolittle), which he labelled 'Imagiste', and so fitted some poetry to a theory that could not possibly have inspired it. He felt that the result was a kind of poetry which 'had as much right to a group name as a number of French "Schools" proclaimed by Mr Flint'.[9] The latter indeed obliged by elaborating three principles for a school of Imagism, all impressively avant-gardist in their dogmatism:

1. Direct treatment of the 'thing' whether subjective or objective.
2. To use absolutely no word that did not contribute to the presentation.
3. As regarding rhythm: to compose in the sequence of the musical phrase not in sequence of a metronome.[10]

Pound's following supplementary definition of the 'Image' as presenting 'an intellectual and emotional complex in an instant of time' gave it a suitably up to date (but inexplicit) significance, by his claiming to use the term 'complex', 'rather in the technical sense employed by the newer psychologists, such as Hart'.[11]

When Pound sent H.D.'s *Hermes of the Ways* to the magazine *Poetry* in 1912,[12] he claimed it for his movement as 'modern, for it is in the laconic speech of the Imagistes, even if the subject is classic'. The virtues

he finds in it paraphrase Flint—it is 'objective—no slither; direct—no excessive use of adjectives, no metaphors that won't permit examination'.[13] The poem begins:

> The hard sand breaks,
> And the grains of it
> Are clear as wine.
> Far off over the leagues of it,
> The wind,
> Playing on the wide shore,
> Piles little ridges,
> And the great waves
> Break over it.

Although the circumstances of the publication of these rather trivial and inaccurate observations may give it a claim to be considered the 'first Imagist poem' it is hardly typical. To find a poem on Modernist themes to which we can attach Imagist principles, we have to look at a poem by Pound, 'In a Station of the Metro', which is again retrospectively interpreted by him as satisfying the theory:

> The apparition of these faces in the crowd;
> Petals on a wet, black bough.

Its 'complex' was explained by Pound as arising from its recording 'the precise moment when a thing outward and objective transforms itself, or darts into a thing inward and subjective'.[14] In the original publication,[15] the lines are spaced

> The apparition of these faces in the crowd
> Petals on a wet, black bough

Pound's highly circumstantial account of the occasion of the poem, and of his attempts to write it, make clear its allegiance to Hulmean juxtapository principles, in a 'form of super-position, that is to say, it is one idea set on top of another'. It is the product of a reduction and simplification which achieves the stylistic metamorphosis we have discussed elsewhere, for Pound 'wrote a thirty line poem, and destroyed it because it was what we called work "of second intensity". Six months later I made a poem of half that length: a year later I made the following hokku-like sentence.'[16]

Hugh Kenner makes a good deal more of 'In a Station of the Metro'. Its 'vegetal contrast with the world of machines' makes it for him a little allusive *Waste Land*, with its 'crowd seen underground, as Odysseus and

Orpheus saw crowds in Hades'.[17] Once this train of association is set going his 'mind is touched, it may be' by the story of Persephone, so that

this tiny poem, drawing on Gauguin and Japan, on ghosts and on Persephone, on the Underworld and the Underground, the Metro of Mallarmé's capital and a phrase that names a station of the Metro as it might a station of the Cross, concentrates far more than it need ever specify, and indicates the means of delivering post-Symbolist poetry from its pictorialist impasse. [18]

But there is good reason to believe that Pound wanted the poem to have a much more immediate, pictorial, and chordal effect. For by this time Pound was inspired by abstraction in painting, and saw his poem as parallel to it:

there came an equation . . . not in speech, but in little splotches of colour. It was just that, a 'pattern', or hardly a pattern, if by 'pattern' you mean something with a 'repeat' in it. But it was a word, the beginning, for me, of a language in colour . . . I realised quite vividly that if I were a painter, or if I had, often, *that kind* of emotion . . . I might found a new school of painting, of 'noninterpretative' painting, a painting that would speak only by arrangements in colour.[19]

Pound's analysis, which not surprisingly leads into an endorsement of Kandinsky's theories, also derives from Hulme, for both of them see verbal analogy (the compressed observational metaphor without copula of Imagism) *and* the painter's vision, as part of the poetic process. Hulme tells us that 'Poetry is always the advance guard of language', and that 'the progress of language is the absorption of new analogies'. The example he gives is typically urban and pictorial: 'Two tarts walking along Piccadilly, on tiptoe, going home, with hat on back of head. Worry if he could find exact model analogy that will reproduce the extraordinary effect they produce. Could be done at once by an artist in a blur' (*FS* 81, 82).

Graham Hough may have been too harsh in saying that Imagism projected 'A world composed of atomic notations, each separate from the others [which] neither lead into each other nor into apprehension on any other level'.[20] This atomic notation was also designed to accommodate two specific types of the scepticism I have emphasized. First, it tried to show that it was still possible to get close to experience, by tying the poem to a specifically intuitive type of mental process, and what is more one which could underlie *all* the arts. And secondly, it excluded the outmoded, explicitly discursive moralizing of Victorian and Georgian verse.

2. Post-Impressionism versus Futurism

Pound sustained this affinity between poetry and painting in his 'Note' to the poems of Hulme:

as for the 'School of Images', which may or may not have existed, its principles were not as interesting as those of the 'inherent dynamists' or of *Les Unanimistes*, yet they were probably sounder than those of a certain French school, which attempted to dispense with verbs altogether [i.e. the Futurists]; or of the Impressionists who brought forth

'Pink pigs blossoming on the hillside'

or of the Post-Impressionists who beseech the ladies to let down slate blue hair over their raspberry coloured flanks.[21]

In describing Post-Impressionist painting so crudely, Pound failed to take just account of an aesthetic debate which, once it became involved with Cubism and Futurism, was nevertheless going to affect him (and Hulme) profoundly. For the ideas involved in the transition from Post-Impressionism to Matisse had a long life, and their story is largely that of a battle around the critical perceptions of Roger Fry and his allies (who in the end were thought by Pound and others to occupy a reactionary rather than progressive position). The first element in this conflict to emerge, though perhaps the least important, is the conservative opposition to the 'new' art shown by Fry in 1910.[22] His exhibition of 'Manet and the Post-Impressionists' laid its main emphasis on Cézanne (21 works), Van Gogh (22), and Gauguin (37). For Fry the most important painter beside Cézanne was Matisse, who had been greeted, when previously exhibited in 1908 at the New Gallery, as a painter 'with whom impressionism reaches its second childhood' and whose 'motive and treatment alike are infantile'.[23] By the exhibition of 1910 Fry had a counter-attack ready, which cleverly used the terms of earlier criticisms, but reversed their implied values by bringing to bear the new ideas about the relationship between the conceptual and the primitive:

this search for an abstract harmony of line, for rhythm, has been carried to lengths which often deprive the figure of all appearance of nature. The general effect of his [Matisse's] pictures is that of a return to primitive, even perhaps of a return of barbaric, art . . . Primitive art, like the art of children, consists not so much in an attempt to represent what the eye perceives, as to put a line round a mental conception of the object.[24]

But *The Times* reviewer of 7 November 1910 (C. J. Weld-Blundell) judged that the work shown had gained 'simplicity' by being merely regressive,

and throwing away 'all that the long developed skill of past artists had acquired and bequeathed'. It may reconstruct the past, but actually 'stops where a child would stop'.

Really primitive art is attractive because it is unconscious; but this is deliberate—it is the abandonment of what Goethe called the 'culture conquests' of the past. Like anarchism in politics it is the rejection of all that civilisation has done, the good with the bad.[25]

And Robert Ross thought that 'the emotions of these painters (one of whom, van Gogh, was a lunatic) are of no interest except to the student of pathology, and the specialist in abnormality'.[26] Sickert, having seen Picasso's *Nude Girl with Basket of Flowers* (?1908), wondered 'why a nude child is carrying a bunch of flowers in front of a grey vacancy', but conceded that that might be 'an old fashioned question to ask. I understand the tip has gone round that pictures need have no sense.'[27] It is the lack of a significant social context that seems most to disturb him, and so Realism is once more at issue, between 'those like Fry and Bell who saw progress in art as involving the assertion of the autonomy of aesthetic experience, and those like Sickert who felt that art needed to be underwritten by the security of its reference to a world of "gross material facts" '.[28]

As we have already seen, painting after Cézanne had been forced to question its own premises, and its answers were made to turn on our understanding of the varying relationships between abstraction and the object of representation, and between the expressive distortion of a particular subject-matter and the abstracting appreciation of its design. As Fry had overstated it in his 'An Essay in Aesthetics' of 1909:

We may then dispose once for all with the idea of likeness to Nature, of correctness and incorrectness as a test, and consider only whether the emotional elements inherent in natural form are adequately discovered.[29]

'Natural form' here smuggles back what has just been rejected. But Fry does not think that 'emotional elements' need to inhere in a subject-matter; they can be carried towards an aesthetic effect by the 'rhythm of the lines', 'gesture', mass, and the use of space, which are all part of a 'design'.[30] An emotional effect may therefore derive from a (unified) design distinct from, and opposed to, that to be derived from representation. This point is emphasized by Desmond MacCarthy in the catalogue to the 1910 Post-Impressionist exhibition: 'There comes a point

when the accumulations of an increasing skill in mere representation begin to destroy the expressiveness of the design.'[31]

This much publicized and controversial argument is the groundwork for the move towards abstraction in England, and has inspired much subsequent aesthetic argument. Expression (as we have seen it in Matisse) involves a subjective distortion, and hence the 'simplification' and 'synthesis in design' which the preface goes on to demand. Painting on these principles achieves something more than the 'passivity' of the Impressionists, who were thought to have rendered mere appearances, rather than penetrating the essence of the object, as Cézanne was supposed to have done.[32]

Fry found an inspiration for these virtues in the work of primitives who were thought to have taken a conceptual approach to representation, independent of the attempt to be true to visual experience: 'The artist of today', says Fry, 'has to some extent a choice before him of whether he will *think* form like the early artists of European races or merely *see* it.'[33] He thus thinks of 'modern' or 'progressive' formal thinking as a challenge to the natural, the easily read, and the morally controlled representation of the world, which had received its chief support in England from Ruskin.[34]

The second Post-Impressionist exhibition of 1912 thus took place in a context in which, not only for painting, but also for the notion of Modernist progress in general, lines of battle had been drawn. Bell's essay in the catalogue reaffirmed the demise of representation and asserted that artistic form, achieved by 'simplification' and 'plastic design' was 'an end in itself . . . a significant form related on terms of equality with other significant forms'.[35] And Fry urged his followers to accept that the 'new and definite reality' sought by art depended upon its 'cutting off the practical responses to sensations of everyday life'.[36] The exhibition included five comparatively late oils by Cézanne (including a version of *Le Chateau noir*) and six water-colours; and the 'followers' assigned to him (10 pictures by Herbin, 8 by L'Hôte, 6 by Marchand, and 4 by Derain) were there in substantial numbers. But the work now essential to the Bloomsbury point of view was that of Matisse, who had twenty-two paintings on show including *Le Luxe II*, the *Red Studio*, and *La Danse I*, which was largely praised, even D. G. Konody noting 'all the significant movement, the broad simplification, the swinging rhythm, but passionately intensified, that are to be found in the figures painted on Greek vases'.[37]

Fry and his allies, as well as the public, were to find Cubist work far

less amenable than this, as the undergraduate reviewer in *Isis* amusingly made clear in echoing the affected remarks of the Aesthetes:

We are threatened with a new system of aesthetic values. Instead of How Beautiful! and How Fine! we are going to have How Roguishly Rhomboidal! How Tantalisingly Triangular![38]

Fry had recognized that 'the logical extension of such a method [as Picasso's] would undoubtedly be to give up all resemblance to natural forms, and to create a purely abstract language of form—a visual music'.[39]

By now Fry had the converted to preach to, for, as the terms of the debate concerning the second exhibition became more public, it was obvious that since 1910 much of the argument about the new art had been won, despite a certain amount of grumbling about ugliness and moral degeneracy. Those willing to be influenced by Fry and Bell would by now have realized that the French were supposed to be dictating the standards of the debate concerning art, and that the Bloomsbury notion of abstraction as 'significant form' (even if it managed to squeeze out the Camden Town Group and others) was designed to preserve an essentially classicizing and French tradition, from Poussin via Ingres and Puvis to Cézanne, the Post-Impressionists, and Matisse (whom Fry preferred to Picasso). Bell could congratulate himself: 'The battle is won. We all agree now, that any form in which an artist can express himself is legitimate . . . we have ceased to ask "What does this picture represent?" and ask instead "What does it make us feel?"' And he goes on to appeal to the central inter-art analogy of his time: 'We expect a work of plastic art to have more in common with a piece of music than a coloured photograph.'[40]

His book on *Art* (1914), for all its confident simplification, is an excellent summary of a formalist approach to Modernist painting which was to remain dominant for decades. For Bell, the relationship between the beholder's emotion (*A* 7) and significant form (*A* 8), is brought about by 'unknown and mysterious laws' (*A* 11) and has to be intuitively apprehended (perhaps à la G. E. Moore),[41] although one might also follow Bergson, in saying that the relationship between the parts in 'significant form' may be due to an intuition of 'rhythm' (*A* 16). This leads to a kind of 'aesthetic rapture' which could never be derived from Frith's *Paddington Station* (*A* 17 f.) but is well intimated by Sumerian, Archaic Greek, and T'ang primitives. This appeal to the primitive had two advantages: it ruled out progress based on mimesis—'Giotto did not

creep, a grub, that Titian might flaunt, a butterfly' (A 102)—and so also showed that significant form sometimes had to be more important than an accuracy of representation (A 22). Cézanne, by replacing 'about 1880' the 'bad science' of Monet (A 208) had brought a new movement to birth whose 'simplification' (A 220) got rid of the 'detail' which is the 'heart of realism, and the fatty degeneration of art' (A 222). The 'Contemporary movement' is thus 'passionate and austere' (A 244) and is 'the one religion that is always shaping its form to fit the spirit, the one religion that will never for long be fettered in dogmas' (A 278). (Bell says too that it does not have priests, but then he could hardly have anticipated the absurd growth in the importance of critics like himself.)[42]

The argument that painting may require a specific type of *Gestalt*, which can be particularly emotionally satisfying, worked for Blooms-bury best when Cézanne, Matisse, and the Post-Impressionists were in question; it was hardly ever explicitly applied to the more abstract work of analytical Cubism or to Kandinsky. For 'significant form' actually derives much of its import from the mimetic context, of which it is seen to be a simplification. Bell comes close to conceding this:

Post-Impressionists, by employing forms sufficiently distorted to disconcert and baffle human interest and curiosity, yet sufficiently representative to call imme-diate attention to the nature of the design, have found a short way to our aes-thetic emotions. (A 227)

The Bloomsbury axis, despite its apparent theoretical sophistication, thus led to compromise and stopped short of accepting Cubism and the Futurists. The latter, Fry thought, posed less of a problem. Their exhibi-tion had taken place in the Sackville Galleries six months before his own, and he simply dismissed them (wrongly) for misunderstanding Cubism, and so failing to appreciate the tradition (his) deriving from Cézanne. And for Bell, as for Apollinaire, Futurism was too much tied to subject, producing a 'descriptive painting' to convey 'information and ideas' rather than an aesthetic emotion. And as mere social theorists they had 'nothing whatever to do with art' (A 20). Fry and Bell were also unwilling to connect Cézanne with Cubism, whereas Gleizes and Metzinger (whose *Cubism* was translated into English in 1913), very clearly did. These failures to appreciate non-Fauvist work probably prevented them from coming to terms with the early work of Wyndham Lewis, and so they ceased to be in the vanguard at the very point at which they had produced a potentially powerful and accommodating theory for its art. For the interest of Lewis and others in Futurism and Cubism left Fry and

Bell in a very uncomfortable relation indeed to the alliance which promoted Vorticism.

3. Futurism

As we know, the Futurists presented a far less austere view of appropriate responses to the modern than Fry and his circle; and they attracted at least as much attention, as when Marinetti visited England in March 1912 with Boccioni, Carrà, and Russolo, to issue manifestos, to put on an exhibition seen by 40,000 people, and to offer opinions on almost anything. Marinetti congratulated the British on their 'brutality and arrogance', berated them as 'a nation of sycophants and snobs, enslaved by old worm-eaten traditions, social conventions, and romanticism', and then performed some of his poems.[43] He liked London's Underground, its motor buses, and posters; and he accused English painters of living far removed from such things in a pastoral age.[44]

The absurdity of all this did not seem to favour a strong Futurist influence on avant-garde painting in England. Fry's followers in any case tended to produce pale imitations of Matisse. Their most serious competitor by this time was Wyndham Lewis. The public had been invited to admire his *Mother and Child* at the second Post-Impressionist exhibition, when the reviewer in the *Connoisseur* said that it represented maternity 'by what appears to be a complicated architectural diagram'.[45] Lewis had also shown a primitivist *Creation* (1912), depicting a male and female couple engaged in a fertility dance, and some of his *Timon of Athens* drawings. The *Smiling Woman Ascending a Stair* (1911–12) also belongs in this period; and is the earliest large work of Lewis that survives. It is described by Cork as a caricatural 'leering Harpy', and has the 'strong cubist bias' apparent in all these works with their restriction of colour tone.[46] But it also looks Futurist, as a study of motion, its lines implying directional forces, rather as does Duchamp's *Woman Descending a Staircase* of the same year. But it is difficult (in either case) to make exact comparisons or pin down influences, for Lewis had by 1912 assimilated the main lessons of Cubism and adapted it to his *own* form of dynamism. Far from being a humanist Bergsonian, he aimed at a cruelly mechanistic depiction of human beings, as in his study (renamed) *The Vorticist* (1912) whose disturbingly ambiguous forms can be read as anatomy and as robotic machine—a confusion to be most radically exploited by Jacob Epstein in his *Rock Drill*.

Lewis's work from here on seems to assimilate both Cubist and

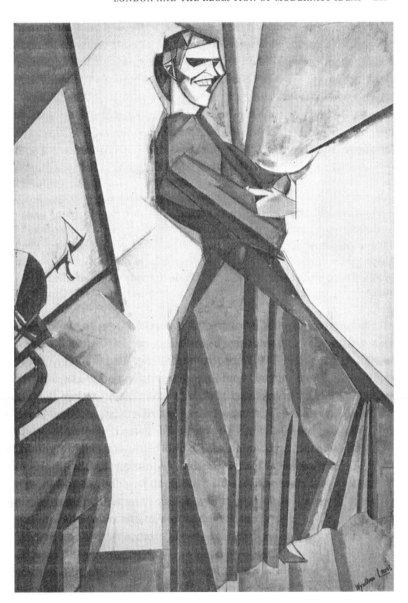

41. Wyndham Lewis,
*Smiling Woman ascending
a Stair*, 1911–12.

Futurist influences, and with a result far more individual than deriva-
tive. However, one of his most important paintings of this period,
the nine foot square *Kermesse* (1912), is known only by description and
inference, since it has disappeared. It may well have been made for
Madame Strindberg's Cave of the Golden Calf, or 'Cabaret Theatre
Club', described by Osbert Sitwell as 'a super-heated Vorticist garden of

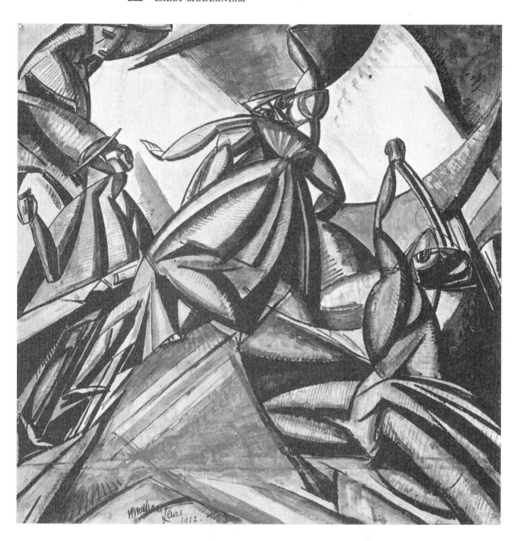

42. Wyndham Lewis, *Kermesse*, 1912.

gesticulatory figures, dancing and talking, while the rhythm of primitive forms of ragtime throbbed through the wide room'.[47] Even Sickert thought it 'magnificent' when it was exhibited at the Allied Artists' Summer Salon, and Bell approved of it as a 'pure design' to be judged as 'music'.[48] The popular press nevertheless saw it as a 'delirious octopus', 'a rather disunited family of Mr Wells' Martians', 'The Battle of the Angles', 'crabs in anguish', and so on.[49] We can only surmise the appearance of the work from a *Design for a Programme-cover—Kermesse* (1912) and a wash drawing, *Kermesse* (1912). Their subject is a primitive Breughelian peasant dance (looking back perhaps to the Brittany which

42

Lewis subjected to a Nietzschean analysis in his early stories), and Cork notes their Dionysiac lines of force combined with rock solid Cubist planes, as these would have been rather contradictory elements in the final large-scale picture.[50]

In the water-colour and drawing *Timon of Athens* series of 1912–13 (an unknown six of which were also shown at the second Post-Impressionist exhibition), Lewis recast the pyramid typical of Cubism as a military phalanx. His mechanistic figures, often armed, all war-like, are caught up in an impressively co-ordinated abstraction full of anger and aggression more Futurist than Shakespearian in character. The masterpiece of

43

VII

this series is the *Alcibiades* which, although it shows the influence of Uccello and of Carrà's *Funeral of the Anarchist Galli* (also shown in the Sackville exhibition), makes it clear that Lewis was as 'advanced' a painter as anyone of the period, given that no one could quite follow, let alone exceed, the analytical skills of Picasso and Braque, even had significant amounts of their work been available for study in England.[51]

Despite an aggression and dynamism here, of which Marinetti would surely have approved, the Futurist subject emerges much more obviously in the work of Nevinson, Etchells, and Wadsworth. The latter's *L'Omnibus* (1913) is very like Severini's *The Motorbus* and Carrà's *What I was Told by the Tramcar*, both shown in London. Once more 'the motor bus rushes into the houses which it passes, and in their turn the houses throw themselves on the motor bus and are blended with it'.[52]

The Futurists inspired a full issue of *Poetry and Drama* (September 1913), in which Flint wrote an account of them as sympathetic as that he had provided two years earlier, when he had then pointed out that 'by writing in French . . . M Marinetti has made of futurism a European problem (which must be remembered by those who talk of the conflict of languages: the European intellect speaks in French)'.[53] By 1913 he was even more impressed, and gives a pretty faithful account of 'Wireless Imagination', citing a passage in French from 'Bataille + Poids + Odeur'. He thinks that the reader should question 'the use of logical syntax in poetry' and wonders 'Whether poetry will not finally develop into a series of ejaculations, cunningly modulated, and coloured by a swift play of subtle and far-reaching analogies?'[54]

The dominance of Marinetti's ideas in the public mind made Futurism a threat to those English painters who wished to establish a distinct avant-garde grouping. Hence the scandal of the defection of Nevinson, who had allied himself with Marinetti by signing a manifesto with him in the *Observer* on 7 June 1914. His paintings such as *The Strand* (c.1914,

43. Wyndham Lewis,
Alcibiades, now known as
*The Thebaid from the
Timon of Athens Portfolio*,
1912–13.

now lost) and *At the Dance Hall* (1913–14) are no doubt best seen as examples of 'English Futurism', though *The Strand* is also mildly Cubist. His huge *Tum-Tiddy-Um-Pom-Pom* (1914, now lost) contains a gigantic smiling face lifted from Boccioni's *The Laugh* (shown in 1912), and, like his other paintings, has many debts to Severini's *Le Bal tabarin* (1912). Lewis reacted to the threat of this June manifesto by organizing an anti-

Futurist demonstration, and his views on the Futurist claim to have discovered a modern technological subject-matter remained uncompromisingly contemptuous:

It has its points. But you Wops insist too much on the Machine. You're always on about those driving-belts, you are always exploding about internal combustion. We've had machines here in England for donkey's years. They're no novelty to us.[55]

He nevertheless laid his followers open to the charge that Vorticism was largely provoked by Futurism, even if he himself had developed techniques for abstraction in art which were quite distinct from those of the Futurists.

4. Abstraction, Classicism, and Vorticism

As we have seen, this question of abstraction partly arises from the Bloomsbury promotion of a line from Cézanne to Matisse—and a not very direct confrontation with Cubism. Thus we find Fry lecturing at the Slade in 1913–14 on such subjects as 'The Problem of Representation and Abstract Form', and on 'Elements of Abstract Design'. But he failed once more to go far enough for the more self-consciously avant-garde party. T. E. Hulme denounced him for having accomplished 'the quite extraordinary feat of adapting the austere Cézanne into something quite fitted for chocolate boxes' (FS 115). His view of Cézanne could afford to be far less domesticating than Fry's or Bell's, because by 1914 he saw him as the pioneer of geometrical solidity in painting; and in saying this, he is very probably indebted to Gleizes's and Metzinger's connection of Cézanne to Cubism.[56] But he looked beyond Post-Impressionism and analytic Cubism to 'a new constructive geometrical art', which would be 'the only one containing possibilities of development' (FS 118). (He is thinking of the Cubist room of English art at the Brighton exhibition at the end of 1913.) In advocating 'machine forms' and 'hard mechanical shapes' he also demands a painting based on geometric abstraction, which will be dialectically opposed to the intuitive, Romantic, organic, Expressionist abstraction of Kandinsky. He thinks that Picasso is 'hard, structural' whereas Kandinsky makes a 'more scattered use of abstractions' and so is 'only a more or less amusing byproduct' of Picasso, and his movement 'a kind of romantic heresy' (FS 130). Hulme's approach to art is not so much formalist then as ideological. His judgement on Kandinsky may be wonderfully ahistorical, but it puts him firmly on the

side of an increasingly dominant Modernist geometric formalism for anti-romantic reasons. [57]

Hulme demanded an abstract art for reasons which not only stem from his anti-Romantic stance, but also echo the philosophical concerns of Worringer. For him abstraction implies a world-view that could eliminate the individualist psychology of Kandinsky, and also the demand for empathy attacked by Worringer. He had heard Worringer lecture in Berlin in the winter of 1911, and this helped him to see the work of Epstein, Gaudier Brzeska, and Bomberg as exemplary of a tendency away from the messy psychology of Bergsonian flux towards the 'geometric' attitude.[58] He says that:

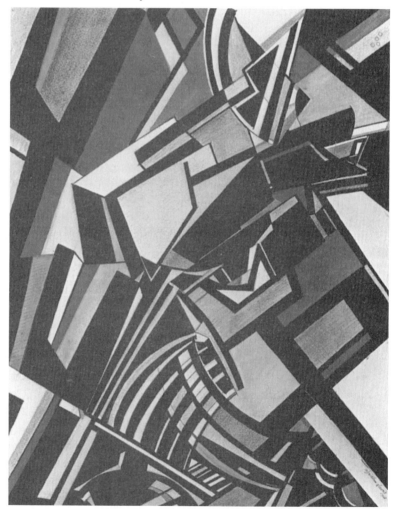

44. Wyndham Lewis, *Composition*, 1913–14.

the re-emergence of geometrical art may be the precursor of the re-emergence of the corresponding attitude towards the world, and so, of the break up of the Renaissance humanistic attitude.[59]

He is on the move from a Bergsonian subjectivism towards the classical defence of an anti-humanist geometrical art against ego-centred Romanticism. His attack on the ego here is nevertheless close to that of Marinetti. For Lewis's work had shown him how you can 'Put man into some geometrical shape, which lifts him out of the transience of the organic'.[60]

Lewis's work by 1914 was indeed abstract and hostile to humanism in something like the sense that Hulme favoured. (He may have been influenced by Hulme's conversation; but it is almost impossible to determine the extent of this influence.) Work like the water-colour

44 *Composition* of 1913–14 has an architectural design, breaks with figurative references, and uses mechanistic forms. Cork thinks it is as extreme in its technique as any other in Europe, and points out that the total abstraction of similar works (including the *Planners* (*Happy Days*) of 1913) anticipates the constructivism of El Lissitzky, Eggeling, and Richter. (Hulme actually uses the word 'construction' in relation to the abstract work he favours.)

Hulme's critical position was also closely oriented to the defence of an artist he much admired, David Bomberg, whose sixty-four square grid for *Ju Jitsu* (*c.*1913), although it echoes Severini's *Boulevard* (1910, shown in London in 1912), has its own extraordinary polyphony, as its disguised bodies intermittently 'fight to establish a figurative identity' against the triangular geometric analysis which surrounds them.[61] But it

45 was Bomberg's *In the Hold* which most specifically interested Hulme— who thought that as 'the eye travels through its 64 squares, noting "pattern", we are reduced to a purely intellectual interest in shape' (*FS* 133). However, it is no more plausible to ignore the human figures hidden here than it is in *Ju Jitsu*, for *In the Hold* transforms Bomberg's urban and Futurist theme of men at work into a series of geometrized fragments of the human figure, constrained within a space which is also the frame of the picture.[62] Bomberg claimed to wish 'to translate the life of a great city, its machinery, into an art that shall not be photographic, but expressive'.[63] The image develops Bomberg's theme of the tangle of limbs (as in *Ju Jitsu*); and, as the final chalk study in particular reveals, he may be celebrating the physical (and perhaps the potential political) strength of dockers. However, as the figures are seen to be lifting people,

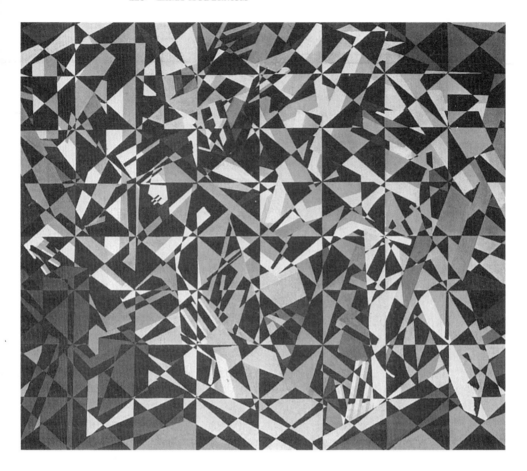

45. David Bomberg, *In the Hold*, 1913–14.

it is possible that the picture represents the arrival of immigrants in London.[64] In an interview with the *Jewish Chronicle*, Bomberg explained that his 'methods' were:

to concentrate upon form which may be contemplated from innumerable aspects. Take my picture 'In the Hold' which is being shown at the Goupil Gallery. It depicts some men emerging from one trap door and entering another in the hold of a ship. Over this subject I have superimposed a scheme of sixty-four squares, whereby the subject itself is resolved into its constituent forms which henceforth are all that matter. Art has too long suffered from what I may call a literary romanticism, from which I desire to emancipate it.[65]

Hulme may well be following Bomberg in praising the painting for making no concessions to 'general emotions' and in asserting that we

are confined by it 'to the appearance of form itself *tout pur*' as we appreciate it square by square (*FS* 132 f.).

Bomberg's declared aim by July 1914 was indeed to achieve 'Pure Form' and in aiming at this he may well have been aware of Bell's 'significant form' (his *Art* had been published in February). But the introduction he wrote for the catalogue of his one-man show at the Chenil Gallery in July 1914 is a much less stable mixture of ideas:

I APPEAL to a *Sense of Form*. In some of the work . . . I completely abandon *Naturalism* and Tradition. I am *searching for an Intenser* expression. In other work . . . where I use Naturalistic Form, I have *stripped it of all* irrelevant matter.

I look upon *Nature*, while I live in a *steel city*. Where decoration happens, it is accidental. My object is the *construction of Pure Form*. I reject everything in painting that is not Pure Form . . .[66]

By mid-1914 then, thanks to Bomberg and Lewis, English painting could claim a distinctive form of abstraction, which had some theory behind it, and, within this theory, a division between the Post-Impressionist line and its allies, and the line of Futurism and Cubism, which was fairly clear.

This state of play was much enlivened by the grandiose claims of 'Vorticism' and *Blast*, after Pound had re-entered the fray in late 1913, once more by adapting Lewis's already existing work to his own purposes in the defence of an avant-garde élite. He attacked the philistine 'rabble' who 'have built a god in their own image and that god is Mediocrity', through an interpretation of the *Timon* drawings of 1912. For him they express 'the sullen fury of intelligence baffled, shut in by the entrenched forces of stupidity'.[67]

We have been looking so far at the way in which painting established itself in the English public mind as the most radically avant-garde form of art (and also at the claim, despite references to Kandinsky, that its main home was rightfully and by tradition to be found in Paris). Thinking in other arts tended to follow painting's lead at that time, and the reasons for this are worth considering. Painting affronted well-entrenched academic conventions most directly, as painters are trained in relation to previous styles in a way that poets are not. It also demanded a new critical vocabulary which painters were often themselves not able to provide, hence their reliance on literary men, like Pound and Apollinaire and Marinetti, at least for publicity. They encouraged the spectator in the gallery to change in attitude, from an

often ingenious narrative 'reading' of painting, towards our present vigorous confrontation with the theory which purports to justify it. Since the new art converted its adherents through the dominant talk of the avant-garde, it at the same time helped to marginalize the 'mainstream' of more comfortable works, which did not attract an exciting critical vocabulary. The literary avant-garde could similarly gain credibility by allying itself to painting. Hence Pound's rather confused involvement in Vorticism, which was very largely a battle of definitions, as its followers attempted to distinguish themselves from European competitor movements. So he says that 'Vorticism is not Futurism, most emphatically NOT. We like Cubism and some Expressionism, but the[se?] schools are not our school.'[68]

This new school raised great hopes for co-operative enterprise between the arts, and indeed, in the minds of its promoters, for the status of London as a Modernist centre.[69] Pound claimed that 'New masses of unexplored arts and facts are pouring into the vortex of London' which could not help but bring about 'changes as great as the Renaissance changes'.[70] This image parallels his most simple, most well-known, and yet astoundingly vague definition of Vorticism, as 'a radiant node or cluster . . . through which, and into which, ideas are constantly rushing'.[71]

But the first thing to do was to curse your predecessors, as the Futurists had:

BLAST
years 1837 to 1900
Curse abysmal inexcusable middle class . . .
BLAST their weeping whiskers-hirsute
 RHETORIC of EUNUCH and STYLIST—
 SENTIMENTAL HYGIENICS
 ROUSSEAUISMS (wild Nature cranks)
 FRATERNIZING WITH MONKEYS . . .
 WE WHISPER IN YOUR EAR A GREAT SECRET
 LONDON IS NOT A PROVINCIAL TOWN.[72]

The Vortex and the Modernist city are seen as one and the same, because it is the metropolitan élite which attacks a philistine bourgeoisie, and for Pound, once 'the aristocracy of entail and of title has decayed, [and] the aristocracy of commerce is decaying, the aristocracy of the arts is ready again for its service'. These 'aristocrats' are nevertheless persons with primitivist powers: they are 'the heirs of the witch-

doctor and the voodoo'. Even in their more generally accepted role as 'despised' artists, they 'are about to take over control'.[73] This mixture of primitivism and aggression demanded the rejection of passive forms of art: and so, for Lewis, the Cubism of Picasso is less inspiring than the dynamic Futurism of Balla, whom he saw as a 'violent and geometric sort of expressionist'.[74]

These new allegiances left Pound in an awkward relationship to his own past, and so he attempted to rewrite Imagism into his latest artistic commitments (for his lectures at Lewis's Rebel Arts Centre), even going so far as to claim that H.D.'s 'Oread' was now Vorticist.[75] He felt himself throughout 1914 to be performing for England a function like that of Marinetti and Apollinaire elsewhere, and so approved of Apollinaire's Futurist sentiment, that 'on ne peut pas porter partout avec soi le cadavre de son père' ('you can't carry your father's corpse along with you wherever you go').[76] He had like them to find a place for literature in relation to painting, hence his assertion that 'the image is the poet's pigment' and his confident recipe for a 'transposition d'art': 'with that in mind you can go ahead and apply Kandinsky, you can transpose his chapter on the language of form and colour and apply it to the writing of verse.'[77] He attempts to put everyone else in their place, and in doing so he takes over a number of the key words of avant-gardist thought. He attacks Futurism on Hulmean grounds as 'a sort of accelerated impressionism'[78] which had ignored the problems of an abstracting formal organization, which is 'a much more analytic and creative action than the copying or imitating of light on a haystack'. Such Impressionist techniques involve 'merely reflecting and observing', as opposed to 'conceiving'.[79] Fry and Bell would agree, but Pound prefers 'another artistic descent', 'via cubism and expressionism'. He thinks that an apprenticeship to the Modernist tradition would involve a lot of 'fumbling about, looking at Matisse and Cézanne and Picasso, and Gauguin and Kandinski, and spoiling sheet after sheet of paper in learning just how difficult it is to bring forth a new unit of design'.[80]

When he comes to praise Lewis on the evidence of *Timon* as 'a very great master of design' he says that 'certain works of Picasso and certain works of Lewis have in them something which is to painting what certain qualities of Bach are to music', and continues with an astounding annexation of the history of classical music to Vorticism—'Music was vorticist in the Bach–Mozart period, before it went off into romance and sentiment and description'. His idea here is really just the abstractionist one, that 'A new vorticist music would come from a new compu-

tation of the mathematics of harmony' and be as distinct as possible from the 'dead cats in a foghorn, alias noise-tuners' of the Futurists.[81] His idea is not far from Bell's, that the two arts can convey emotion independent of mimesis:

It is no more ridiculous that one should receive or convey an emotion by an arrangement of planes, or by an arrangement of lines and colours than that one should convey or receive such an emotion by an arrangement of musical notes.[82]

Definitions of Vorticism were not of course a Poundian monopoly. Lewis had plenty more to say in *Blast*, in which his verbal expression was meant to be an equivalent of 'the stark radicalism of the *visuals*'.[83] His Expressionist individualism actually belongs far more to that Romantic and intuitive line of Modernism which we have had so much cause to emphasize as running through German culture, alongside the detachment and intellectual clarity of the French tradition, than it does to Hulme's idealized classicism, which fits Bomberg rather well. *Blast I* thus appropriately includes Wadsworth on Kandinsky's notions of 'Inner Necessity' (with copious quotations from *On the Spiritual in Art*), and a Nietzschean play by Lewis, *Enemy of the Stars* (which is truly Expressionist) and was designed 'to show [the Imagists] the way'.[84]

The opening manifesto of *Blast*, largely written by Lewis (and also signed by Aldington, Gaudier-Brzeska, Ezra Pound, Roberts, and Wadsworth) is a pretty loose compendium of many of the beliefs we have come across in other contexts: it looks to the unconscious, with its 'stupidity, animalism and dreams', it attacks the Futurists while appropriating their typography pretty well throughout, it sees art as 'revolutionary' and 'violent' (*B* 8), and appeals like Nietzsche (and Stirner) 'TO THE INDIVIDUAL' with the support of the Nietzschean–Dostoevskyan sentiment that, 'There is one truth, ourselves, and everything is permitted' (*B* 148). There is not much here that would not have appealed to the Futurists of 1910, despite an attack on the Marinettian cult of the motor car (*B* 9).

The (British) sense of humour may be derided, as a 'Quack English drug for stupidity and sleepiness', but is nevertheless a distinguishing feature of the manifesto—deployed against the Gulf Stream which 'make[s] us mild', 'The Gaiety Chorus Girl', 'Tonks', and Bridge's drizzling poems (*B* 11f.). Though, rather surprisingly, the ('stupidly rapacious') French with their 'poodle temper', aperitifs, and 'Bouillon Kub' (*B* 13), are only marginally better than the Brittanic Aesthete, a lymphatic vegetable who is a 'God-prig of simian vanity' and a sportsman to boot

(*B* 15, 17). These caricatures hardly amount to an Arnoldian analysis of Hebrew and Hellene; and avant-gardism here does not amount to much more than a shake of the fist at the sorts of targets just as easily to be found in *Punch*. It is the opposition of intellectual and aesthetic traditions, as cited in these blastings and blessings, which give some substance to Vorticist avant-garde politics. And so, amongst a number of targets whose humour or appositeness is lost in time, they blast Elgar, Dean Inge, Bergson, Croce, Marie Corelli, Weniger [*sic*], William Archer (as the translator of Ibsen), Beecham (surprisingly in view of the scandal surrounding his performances of Strauss's *Elektra*), and, less surprisingly, two of the Benson brothers. The opposing team is all the same not very strong, and contains more than one or two defensively humorous contestants, like the Pope and Henry Newbolt. Given Madame Strindberg, Charlotte Corday, James Joyce (the only name in this list of *any* consequence for Modernist art), and George Robey on the side of virtue, we may not expect the following manifesto to tell us much of the principles that may rationalize such preferences. The reader's final impression of the intellectual content of *Blast* is of violence, stridency, and confusion. Much of it is so hardly interpretable, as to come close to Dada, and although it is backed up by a number of machine-like, uncompromising, resolutely abstract designs,[85] one doubts that Lewis's contributors really had much common ground or would be willing to support each other's work.

We learn in fact far more from these pages about the Modernist self-image of its signatories, as 'Primitive Mercenaries' (*B* 30); for 'the artist of the modern movement is a savage' at large in the 'enormous, jangling, journalistic fairy desert of modern life' (*B* 33).[86] As Englishmen, who can claim to be the main providers of the 'machinery, trains and steamships' that characterize the 'Modern World', they will pursue a 'great Northern Art', which will partake of 'insidious and volcanic chaos', and 'never be French' (*B* 38 f.)—all this despite the concession that 'The nearest thing to a great traditional French artist, is a great revolutionary English one' (*B* 42).[87]

As this last remark admits, Modernist artistic achievements in England prior to 1914 were less impressive than those in other countries. London had a short-lived poetic movement (few of whose works have survived as of any great importance), and a style of abstraction in painting which, although original, had remarkably little influence, and was in any case soon abandoned under the pressures of the First World War by many of its practitioners. Nevertheless, a great deal of energy

had been spent in producing a critical awareness of Europe, and of new ideas, and this is the basis upon which Pound and Eliot and Joyce were soon to capitalize, so that the distinctive and enduring English-language contribution to European Modernism comes after the war, with major work from Lawrence (though *The Rainbow* and *Women in Love* were largely conceived before, and published during and after, the war), Joyce's *Ulysses* (from France), Virginia Woolf's novels, Pound's *Mauberley* (which is a farewell to London) and the early *Cantos*, and Eliot's *Gerontion* and *The Waste Land*. London's greatest contribution to the European movement therefore comes at a 'moment' which closely reflects England's rather conservative underlying social structure, in the classicizing and tradition-conscious work of the post-war years.[88]

Bibliographical Note

For further studies of Modernism in London and nearby in this period, see Sanford Schwarz, *The Matrix of Modernism: Pound, Eliot and Early Twentieth-Century Thought* (Princeton, NJ, 1985); James Longenbach, *Stone Cottage: Pound, Yeats and Modernism* (Oxford, 1988); Reed Way Dasenbrock, *The Literary Vorticism of Ezra Pound and Wyndham Lewis* (Baltimore, 1985); and Susan Compton (ed.), *British Art in the 20th Century: The Modern Movement*, exh. cat. (London, 1986).

Notes

[1] Ezra Pound, in Wyndham Lewis (ed.), *Blast*, 1 (1914), (repr. Santa Barbara, Calif., 1981), 154. Music is unfortunately not much at issue here, since the main story of its development (till the 1920s, when Walton and Lambert come on the scene) lies in its relationship to a predominantly post-Wagnerian and Impressionist aesthetic of Strauss and Debussy, as we can see in the cases of Elgar, Delius, and their followers. This despite the quaint notion of the Futurists that 'In England, Edward Elgar is co-operating with our efforts to destroy the past by pitting his will to amplify classical symphonic forms' (*FM* 32).

[2] As surveyed in F. S. Flint's 'Contemporary French Poetry' (1912), repr. in Cyrena N. Pondrom, *The Road from Paris* (Cambridge, 1974), 86 ff.

[3] T. S. Eliot, 'A Commentary', *Criterion* (Apr. 1924), 231.

[4] A good account of Hulme's development is to be found in Michael Levenson, *A Genealogy of Modernism* (Cambridge, 1984), 37 ff.

[5] T. E. Hulme, *Further Speculations*, ed. Sam Hynes (Minneapolis, 1955), 26.

Henceforth referred to as *FS*. Cf. 'We no longer believe in perfection, either in verse or in thought, we frankly acknowledge the relative' (*FS* 71).

[6] Levenson, *Genealogy*, 46, surely exaggerates the poem's avant-gardist claims in suggesting 'the absence of *any* narrative, *any* development of ideas, *any* articulation of character' here (emphasis added).

[7] T. E. Hulme, *Speculations*, ed. Herbert Read (London, 1924), 3.

[8] F. S. Flint, in Pondrom, *Road*, 86.

[9] Ezra Pound, 'A Stray Document', in *Make it New* (London, 1934), 335.

[10] 'Imagisme', in *Poetry* (Mar. 1913), repr. in Peter Jones (ed.), *Imagist Poetry* (Harmondsworth, 1972), 129.

[11] Ezra Pound, 'A Few Don'ts by an Imagiste', in Jones, *Imagist Poetry*, 130.

[12] Published in *Des imagistes* (Feb. 1914). In Jones, *Imagist Poetry*, 64.

[13] Ezra Pound, *Letters, 1907–41*, ed. D. D. Paige (New York, 1950), 11.

[14] Ezra Pound, on 'Vorticism' in the *Fortnightly Review* (1 Sept. 1914), 467, repr. by Harriet Zinnes (ed.), *Ezra Pound and the Visual Arts* (New York, 1980), 205.

[15] In *Poetry* (1 Apr. 1913), and repr. in the *New Freewoman* (Aug. 1913).

[16] Zinnes, *Ezra Pound*, 205.

[17] Hugh Kenner, *The Pound Era* (London, 1972), 184.

[18] Ibid. 185. For the calculated use of the gap in the text and an implied narrative behind it which really does depend upon a complex of allusion, we had better look to the Eastern rather than the Parisian influences upon Pound, as in the 'Fan Piece, for her Imperial Lord':

> O fan of white silk,
>> clear as frost on the grass-blade,
> You also are laid aside.

This is also a shortening of Giles's translation:

> Of all white silk, fresh from the weaver's loom,
> Clear as the frost, bright as the winter's show—
> See! friendship fashions out of thee a fan,
> Round as the round moon shines in heaven above,
> At home, abroad, a close companion thou,
> Stirring in every move the grateful gale.
> And yet I fear, ah me! that autumn chills,
> Cooling the dying summer's torrid rage,
> Will see thee laid neglected on the shelf,
> All thoughts of bygone days, like them bygone.

Herbert A. Giles, *A History of Chinese Literature* (New York, 1901), 101.

[19] Ezra Pound in Zinnes, *Ezra Pound*, 203.

[20] Graham Hough, *Image and Experience* (London, 1960), 12 f.

[21] This comment was published at the end of his collection, *Ripostes*, in Oct. 1912.

[22] There is a good account of the whole period in Stella K. Tillyard, *The Impact of Modernism* (London, 1988), which also emphasizes the indebtedness of the

Moderns to the arts and crafts movement. She also (92 ff.) gives an account of journalistic reactions to both the Post-Impressionist exhibitions. For a very full documentation and an acute commentary, see J. B. Bullen (ed.), *Post-Impressionists in England: The Critical Reception* (London, 1988).

23 By the *Burlington Magazine* in its Feb. 1908 issue, in Bullen, *Post-Impressionists*, 43.

24 Desmond MacCarthy, preface to the catalogue of the 1910 exhibition, in Bullen, *Post-Impressionists*, 98. Despite this kind of explanation, even Gauguin and Van Gogh were then 'too much' for E.M. Forster, and Wilfred Scawen Blunt thought he had seen 'works of idleness and impotent stupidity, a pornographic show', cited in Samuel Hynes, *The Edwardian Turn of Mind* (Oxford, 1969), 328 f.

25 C. J. Weld-Blundell, cited in Hynes, *Edwardian*, 329.

26 Robert Ross, in the *Morning Post* (7 Nov. 1910), in Bullen, *Post-Impressionists*, 101. This attack on modern art as degenerate was sustained by Weld-Blundell, T. B. Hyslop, and E. Wake Cook; see Tillyard, *Impact*, 104 ff.

27 Walter Sickert, in the *Fortnightly Review* (May 1911), in Bullen, *Post-Impressionists*, 158.

28 Charles Harrison, *English Art and Modernism, 1900–1939* (London, 1981), 48.

29 Roger Fry, *Vision and Design*, ed. J. B. Bullen (Oxford, 1981), 27.

30 Ibid. 23 f.

31 Desmond MacCarthy in Bullen, *Post-Impressionists*, 99.

32 Clive Bell amazingly describes later Monet as 'polychromatic charts of desolating dullness' in his *Art* (1914); ed. J. B. Bullen (Oxford, 1987), 187. Henceforth referred to as *A*.

33 Roger Fry, 'Bushman Paintings' (1910), in *Vision*, 69, and anticipating the 'conception' argument concerning Cubism.

34 This is, as we already know, a central theme in debates concerning Modernist innovation, and extends far beyond 1910, to the use of Post-structuralist theories as applied to painting.

35 Clive Bell, in Bullen, *Post-Impressionists*, 350. Tillyard, *Impact*, 183, estimates that there may have been as many as 20,000 copies of this essay in circulation (i.e. one for every four visitors).

36 Roger Fry, in Bullen, *Post-Impressionists*, 353, 355.

37 D. G. Konody in the *Observer* (6 Oct. 1912), in Bullen, *Post-Impressionists*, 371. Cf. 'The Comic Cubists', *Daily Mail* (5 Oct. 1912), 6, cited in Tillyard, *Impact*, 202.

38 *Isis* (19 Oct. 1912), 7; cited in Tillyard, *Impact*, 205.

39 Roger Fry in Bullen, *Post-Impressionists*, 353.

40 Clive Bell, note on 'The English Group' for the catalogue to the second exhibition, in Bullen, *Post-Impressionists*, 349.

41 Cf. J. B. Bullen in his Introduction to *Art*, p. xxxii, and *A* 87 f. and 113.

42 Tillyard, *Impact*, 54 f., emphasizes such claims for art as a substitute for religion—reporting Bell's remark that 'Art . . . may satisfy the religious needs

of an age too acute for dogmatic religion' (A 282). Lawrence, she notes, saw the apologists of Post-Impressionism as 'primitive Methodists'.

43 In a lecture at the Bechstein Hall (19 Mar. 1912), cited in Richard Cork, *Vorticism and Abstract Art in the First Machine Age* (London, 1976), i. 28. He follows the *Daily Chronicle* (20 Mar. 1912).

44 Cork, *Vorticism*, i. 28, citing *Evening News* (4 Mar. 1912).

45 *Connoisseur* (Nov. 1912), 191.

46 It was possibly painted 'against' Augustus John's *Smiling Woman* of 1909; cf. Cork, *Vorticism*, i. 19 f.

47 Osbert Sitwell, cited in Jeffrey Meyers, *The Enemy: A Biography of Wyndham Lewis* (London, 1980), 36, from his *Great Morning* (vol. iii of his autobiography) (London, 1948), 208.

48 Cited in Cork, *Vorticism*, i. 42, from the *Athenaeum* (27 July 1912).

49 Cork, *Vorticism*, i. 37 f.

50 Ibid. 39.

51 Cf. ibid. 46 f.

52 'Wadsworth seems to have aimed at nothing less than a literal illustration of this passage' (ibid. 106).

53 F. S. Flint, repr. in Pondrom, *Road*, 142.

54 Ibid. 226. He continues: 'Are we really not spellbound by the past, and is the *Georgian Anthology* really an expression of this age? I doubt it.'

55 Wyndham Lewis, *Blasting and Bombadiering* (1937; London, 1967), 34–5.

56 Gleizes's and Metzinger's work was published by Fisher and Unwin in London in 1913. On Cézanne, cf. 'Modern Art', in Hulme, *Speculations*, 100 f.

57 Fry's response to this dilemma was very different. He evades the religious and mystical claims for Kandinsky's painting by relying on the all-pervading (and Matissean) musical analogy. Having seen *Improvisation No. 30 (Cannons)* in London in 1913, he says that: 'one finds that after a time the improvisations become more definite, more logical and closely knit in structure, more surprisingly beautiful in their colour oppositions, more exact in their equilibrium. *They are pure visual music*, but I cannot any longer doubt the possibility of emotional expression by such abstract visual signs' (*Nation* (2 Aug. 1913), 677).

58 On the influence in England of Worringer's *Abstraktion und Einfühlung*, see Levenson, *A Genealogy*, 94 ff.

59 Hulme, *Speculations*, 78, cf. 81. He has thus turned against his 1908–9 views on the desirability of the 'maximum of individual and personal expression' (cf. FS 72).

60 Hulme, *Speculations*, 107.

61 Cork, *Vorticism*, i. 80. The triangulated grid is often superimposed over realist drawings and paintings in order to facilitate copying. The bodies here are really not discernible except with the help of a preliminary *Study* in the collection of the University of East Anglia.

62 The studies for the painting in Richard Cork, *David Bomberg* (New Haven,

Conn., 1987), 62–73, show how this geometric abstraction progresses, with an extraordinary return to representation in the last, which reveals to us the underlying plan of the finished painting.

[63] David Bomberg, in an interview with the *Jewish Chronicle* (8 May 1914), cited in Cork, *Bomberg*, 67.

[64] Cf. Cork, *Bomberg*, 64 f. and 66 f.

[65] David Bomberg, Ibid. 67.

[66] Ibid. 78.

[67] Ezra Pound, in Zinnes, *Ezra Pound*, 187, 188.

[68] Pound, *Letters*, 57.

[69] Hence such semi-successful enterprises as the Rebel Art Centre founded by Lewis in Mar. 1914 as a rival to Fry's Omega Workshops.

[70] Ezra Pound, *Gaudier-Brzeska* (1916; repr. New York, 1970), 117.

[71] Ezra Pound (on 'Vorticism'), in Zinnes, *Pound*, 207.

[72] Wyndham Lewis, *Blast*, repr. as *Blast I* (Santa Barbara, Calif., 1981), 18 f. Henceforth cited as *B*. The ellipses are mine.

[73] Ezra Pound, 'The New Sculpture', *Egoist*, 1 (16 Feb. 1914), in Zinnes, *Ezra Pound*, 182.

[74] Lewis, in *B* 144. On 139 f. he attacks Picasso. Balla had painted a number of canvases entitled 'Vortex' (not shown in London).

[75] The substance of this early lecture later appears in the essay on 'Vorticism' in the *Fortnightly Review* of Sept. 1914. In this month he also first meets Eliot. H.D.'s 'Oread' is cited by Pound, *B* 154, as an example of Vorticism.

[76] Ezra Pound, in Zinnes, *Ezra Pound*, 195.

[77] Ibid. 203.

[78] Ibid. 199. Cf. Hulme on Futurism in *Speculations*, 94, as 'the deification of the flux, the last efflorescence of impressionism'.

[79] Ezra Pound in Zinnes, *Ezra Pound*, 208, 206.

[80] Ibid. 199, 187.

[81] Ibid. 208.

[82] Ezra Pound, 'Edward Wadsworth, Vorticist', *Egoist* (15 Aug. 1914), in Zinnes, *Ezra Pound*, 190.

[83] Wyndham Lewis, letter to *Partisan Review* (*c.* Apr. 1949), cited in Cork, *Vorticism*, i. 260.

[84] Wyndham Lewis, *Rude Assignment* (London, 1950), 129, cited in Cork, *Vorticism*, i. 260.

[85] Including work by Roberts, Wadsworth, Epstein, and Hamilton.

[86] These are phrases that Eliot will take up in reviewing Lewis's novel *Tarr*.

[87] Pound keeps up the aggression in his *Salutation the Third* against the reviewers of *The Times* and others, as 'slut-bellied obstructionists', 'fungus', and 'continuous gangrene':

> HERE is the taste of my BOOT,
> CARESS it, lick off the BLACKING

He also continues, 'Let us be done with Jews and Jobbery, | Let us SPIT upon those who fawn on the JEWS for their money' (B 45). His reflections here are at least as jejune as those he offers later on the 'curious habits of dogs' (B 49), (censored) on 'ganglia' (B 48), or an alley cat which dies of migraine when a girl, whom he finds attractive, laughs (B 50).

88 London had to wait for some time for a major painter (though in sculpture there were Epstein and Moore), and had no major Modernist composer till Walton (though Frank Bridge became to say the least a distinguished contemporary follower of Berg).

6 | ASPECTS OF THE AVANT-GARDE

1. Diffusion and Adaptation

My central theme has been the relationship between changes in artistic technique and the ideas which inspired them, such as Schoenberg's belief in an unfolding law of musical progress and his reliance upon the 'unconscious' to help him discover it, or the Nietzschean and primitivist assumptions about the personality which gave artists the courage to explore divisions in consciousness, or the defence of collagist and Simultaneist methods of presentation as symptomatic of the confusingly multiple narratives of modern life. As ideas like these spread, they brought about profound stylistic changes in the arts all over Europe, as artists became aware of the new conventions, and adapted them in their own experiments.[1] In the process, new ideas were adapted to 'native' cultural traditions and to the individual artistic temperament, in a process which often enough involved a successfully creative *mis*translation. Three further examples of this process in artists working in the German tradition will lead towards some more general thoughts, about the nature of innovation, and of the avant-garde in the period up to the First World War.

The painter August Macke kept apart from the central Expressionist aesthetic in Germany, which involved a confrontation with Impressionism.[2] He accepted a relationship to French painting which sustained a commitment to these earlier values, as he adapted a wide range of Modernist technical innovations to a temperament which had little need for anguish or confrontation.[3] He seems indeed to have disapproved of the revolutionary (*Umwalzung*) aims of Kandinsky and his *Blaue Reiter* colleagues ('sie *ringen* glaub ich, zu sehr nach Form'—'they struggle, I think too much, to find the right form'), and his approval of Kandinskyan abstraction depended on little more than the Matissean musical analogy: 'Es ist wie das Summen von Millionen Bienen oder das Schwirren von Geigen mit einem unendlich sanften, lammartigen Paukenschlag' ('it is like the buzzing of millions of bees, or the twang of

violins, along with an unendingly soft lamb-like drum stroke').[4] His wariness stemmed from an abiding loyalty to the representation of the object, and a calm in the face of the metaphysical questions which preoccupied Kandinsky (and their mutual friend Franz Marc). For Macke, Fauvist simplification was to be valued for its harmonizing potential,[5] and the geometric analysis of Cubism adapted to less austerely formal ends. The colour range of Delaunay and the methods of Boccioni can probably also be discerned in his *Großes helles Schaufenster* (*Large Bright Shopwindow*) of 1912, and in other paintings which seem to be affected by an interest in the simultaneous contrast of colours.[6] Macke was therefore well aware of the 'new elements' in modern painting, and indeed of the urban environment which encouraged them: 'cars, express trains, aeroplanes, films and machines simply must give birth to a new artist, impart impressions to him that Böcklin and Lenbach never knew. Machine conquers man.' His basic stance was a mixture of enlightened tolerance and conservatism: 'The artist must adapt to this invasion while at the same time never sacrificing Maria in the Capitol or the Madonna with the Flower. This synthesis must be our aim.'[7] This eclecticism, manifest in his own works, shows how a major artist could adapt innovative techniques to a conservative sensibility, to magnificent and wholly individual effect.

In literature the receptivity of the artist to the idea may seem to be more immediate. It is already expressed in the medium of words, but it undergoes metamorphosis, in the most obvious way, in its literal translation from one language and cultural context to another, as it is adapted by the artist to a differing conceptual framework. One of the most dramatic examples of such influence is to be found in the work of August Stramm, who, having destroyed his earlier poems, wrote henceforth by adapting Futurist principles. He eliminated articles, adjectives, conjunctions, and punctuation from his work, and reduced his sentences so far as was possible to nouns and verbs, very much as required by Marinetti's Technical Manifesto published in May 1912 in *Der Sturm* (and then by a lecture of 1913 to which Walden drew his attention in the autumn of 1913).[8] But the result is not in the least *like* the expansively simultaneist literary work of Marinetti. This is because an aphoristic approach to experience and far wider philosophical preoccupations conditioned Stramm's translation of Futurist ideas into his own idiom. He was very likely already disposed towards a radical re-examination of language by Vaihinger and Mauthner, who tended to confirm the Nietzschean view, that philosophical frameworks are no more than

46

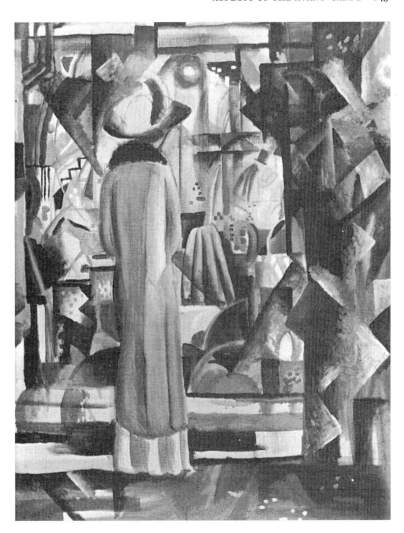

46. August Macke, *Large Bright Shop Window* (*Grosses helles Shaufenster*), 1912.

powerful fictions.[9] Marinetti's emphasis on analogy presumably helped Stramm to see *how* such a philosophical position might be expressed, in an abstract, but 'universally dynamic', style, reduced to its basic (primitive) elements. This style would have the particularly philosophical virtue of enacting our experience of the world, as built up from sensations (*Empfindungen*), an epistemological position much emphasized at the time by Ernst Mach. These sensations were to be thought of as constituting the as yet unappreciated fundamental identity of the self, so that in Mach's view (following Hume), 'Nicht das Ich ist das Primäre, sondern die Elemente (Empfindungen) . . . Die Elemente *bilden* das Ich'

('It is not the ego that is primary, rather its elements (sensations) . . . These elements make up the ego').[10]

They are also thought of as image-pictures, so that Stramm follows Marinetti and the Imagists in attempting to adapt the language of poetry to beliefs about the essentially fragmentary nature of experience. In doing so he constructs another version of the Modernist self. His hostility to the shackles of conventional everyday logic thus came to be expressed in his poetry by devices for syntactic ambiguity which, following Mallarmé and Marinetti, forced the reader to make associations between the component parts of his verse, which were based on immediate, and exclamatory, perception. For Stramm basic thought processes are expressed through Marinetti's 'uninterrupted sequence of new images', as in his *Freudenhaus* (*Brothel*); the poem constructs a kind of definitional essence of feeling and sensation (akin to Webern's songs) which repels the specification of any particular narrative occasion.

> Lichte dirnen aus den Fenstern
> Die Seuche
> Spreitet an der Tür
> Und bietet Weiberstöhnen aus!
> Frauenseelen schämen grelle Lache!
> Mutterschöße gähnen Kindestod!
> Ungeborenes
> Geistet
> Dünstelnd
> Durch die Räume!
> Scheu
> Im Winkel
> Schamzerpört
> Verkriecht sich
> Das Geschlecht!

> Lights wench out of window[11]
> contagion
> straddles at the door
> and offers moaning whores for sale!
> Women's souls shame shrill laughter!
> Mother's wombs yawn child-death!
> Unborn things
> spook
> mustily
> through the rooms!

Aghast
in a corner
shame-morrified[12]
cowers
sex!

The composer Anton Webern was like Stramm in reducing the elaborated style of a master to a state of apparent simplicity. And as Stramm seems to have seen his poetry as a necessary consequence of his understanding of language in relation to mind, so Webern was guided by Schoenberg's philosophical awareness of the evolution in our understanding of harmony, culminating in the Modern.[13] And yet his early atonal music 'is related to Debussy's revolution no less directly than to Schoenberg's',[14] because of his fastidious love of sound produced by the least possible means. Against the passionate complexity and striving of his teacher's *Second String Quartet* one can put the minimalist fourth movement of his *Five Pieces for String Quartet* of 1909 in which 'Melody is a broken sigh, haloed by pedal notes and ostinato harmonies'. The listening experience may seem far less driven and continuous than in Schoenberg, and 'it already induces a characteristically Webernian calm'.[15] Such profound technical and temperamental differences were, if Webern is to be believed, welcome to Schoenberg, who 'teaches no style at all . . . [the pupil] has to create, even from the most primitive beginnings of shaping a musical syntax'.[16] They thus shared a belief in the reconstruction of musical language, and in the intuitive processes of the unconscious, as a means towards the inevitable dissolution of tonality. By 30 August 1909 Webern had completed five of the orchestral Pieces which became his *Six Pieces for Orchestra*, Op. 6, dedicated to his teacher. They have a close relationship to Schoenberg's *Five Orchestral Pieces*, Op. 16, completed earlier in the same year, and his subsequent explanation of them depends on the same Expressionist notion of mood:

The first [movement] expresses the expectation of a catastrophe; the second the certainty of its fulfilment; the third the most tender contrast; it is, so to speak, the introduction to the fourth, a funeral march; five and six are an epilogue: remembrance and resignation.[17]

These momentous emotions are expressed through tiny, subtly expressive, and far from merely reticent melodic phrases in Webern's work in this period. This ensures that we pay an extraordinary attention to each element of his work, in which we can concentrate on the timbre of the

individual sound, without considering its logical relationships to those surrounding it; and yet Pierre Boulez rightly finds an extraordinary charm in Webern's procedures: 'the individual lines are exceptionally supple, with a curve, an unpredictability, a grace and a total absence of heaviness which are quite captivating.'[18] Webern still places the main emphasis upon melody, and on chords in close chromatic relation to it, with a Debussyan feeling for ellipsis, and the sheer beauty of clear, almost transparent instrumental colour.

The period 1908–10 was therefore just as crucial for Webern as it was for Schoenberg; he too worked a revolution in the concept of the musical work at the same time as his master. He came indeed to be just as influential, if not more so, upon later music, particularly that of the post-Second World War avant-garde. His aesthetic, like Stramm's, aimed at the aphoristic, in a sense very well defined by Schoenberg:

Every glance can be expanded into a poem, every sigh into a novel. But to express a novel in a single gesture, joy in a single breath—such concentration can only be present in proportion to the absence of self-indulgence.[19]

Webern's belief in the necessity of his practice arose out of an analysis as unrelentingly foundational and eliminative as that applied by Kandinsky to abstract painting or by Stramm to poetry, and he shared their extraordinary confidence in the psychological processes behind a purely emotional expression.

The role of a quite abstract general idea in the artist's adaptation is the key to all three of these sketches. It may derive from depth of historical analysis (Webern), from broad philosophical sweep (Stramm), or from the perception that an enduring subject-matter can be stylistically transformed (Macke), and of course all three of these preoccupations are in themselves deeply traditional ones. But they help to make new art when the artist, in these (and many other such) cases, begins to see in someone else's technique, of atonality, of syntactic disruption, of colouristic abstraction, a means towards an innovative realization of the idea, as part of a contribution to an ongoing debate. A great deal depends here upon the moral or emotional appeal of the 'teacher' to the 'receiver'—it may inspire courage, or the desire to represent the modern world, or a sense of historical mission, all of which inspire a confrontation with the audience. The demonstration at the première of Schoenberg's *Second String Quartet* on 21 December 1908 was for Webern an 'unspeakable, horrible experience': nevertheless, he thought, 'Nothing is more important than showing those pigs that we do not allow our-

selves to be intimidated.'[20] This avant-gardist solidarity is of prime importance; and yet when we consider the relationships of Delaunay to Macke, Marinetti to Stramm, and Schoenberg to Webern, the degree of *re*interpretation the latter managed to make of the former is quite remarkable. Macke's extraordinarily generous reaction to Delaunay helps him in the adaptation of Fauvist and Futurist simplifications to his own subject-matter. Stramm makes a radical change of technical direction which arises from a conversion which convinced him of the lack of truth to experience of conventional modes of expression. Webern's poised brevity is temperamentally antithetical to Schoenberg's desperate striving. Although atonality, abstraction, and syntactic compression are at one and the same time the governing aesthetic ideas and the basic techniques for these three artists, and link them to others in the avant-garde, it is furthermore the emotional worlds they create which are most distinctive of their work. This literal individualism is an obviously unpredictable factor, but it is essential to any proper understanding of the nature of influence in periods of artistic innovation. The family resemblances between the artists discussed above may be an extraordinarily useful guide to comprehension, as they establish genres and conventions for interpretation, but the progress of the artist in experimental work, and ours, ultimately depends upon an emotional and intellectual commitment to the individual, to the particular discovery, and to temperament.

This is because in the case of the artist and the innovatory work of art, generalized and institutionalized forms of explanation will always, by definition, lag behind the particularity involved in the artist's learning how to do something for the first time, and manifesting that within a work of art. These larger significances are indeed to be found in the activities of the group, and the history of the reception of the work. But even art which is produced within a well-established institutional context (of church decoration, the group show, or the concert, for example) remains the result of an activity which is more or less rational and purposive.[21] The reasons and purposes of the individual will be primary in the production of the work, and help to account for its differences from other work which it resembles.

Our adaptability as readers or viewers or hearers to differing stylistic conventions, or indeed to differing ideological commitments made in the same historical period (so that we are not tempted to offer a general judgement about what was institutionally possible, or realizable, at any particular time) presupposes some such reconstruction of the purposes

of the individual artist. We conjoin (or disjoin) our interests to those of the artist in a personal relationship to the work of art. 'We become interested in Picasso's project because that's *Picasso's* project.'[22] Accounts of 'influence' (like those above) therefore lead straight into questions about individual artist's intentions in the solving of particular problems, and in our cases unprecedented ones. It is within the framework of such intentions—as expressed in the language of the time—that I have tried to construct my account of the early Modernists.

I therefore have a good deal of sympathy for the type of approach recommended by Baxandall, who gives an account of Cubism (via Picasso's *Portrait of Kahnweiler*) which sees its basic concern as centring round a central technical 'problem'—the creation of an illusion of depth on a plane surface.[23] (He extends this analysis to include other features which we have already noted, such as the distinction between figure and ground, relief modelling and the light source, and local textures such as stippling.) We can then see Macke as influenced by the new paradigms for this type of representation as introduced by Picasso, in so far as he concentrates upon similar concerns; but in the light of a very different response to past painting, as I have tried to show. Such technical problems are indeed to be solved with a view to institutions beyond the painting, such as the market—not just of art-dealing, but also of the contexts in which the artist's discourse can be correlated to that of others' critical appreciation. This is a 'barter of mental goods'[24] which, as I argued above, is strongly encouraged by the pluralistic competition of metropolitan culture. And so the public salon, the increasingly more specialized dealer (like Vollard, dealing in Cézanne and early Picasso), and the responses of writers like Vauxcelles and Apollinaire, extend the reception of an artist's language—by inventing discourses which approximate to the particularity of his or her technique. There is therefore a gap between the interestingly common innovatory intentionality of Braque and Picasso in 1910–11 and the extrapolating interpretations of their work, which helped to create the notion of a Cubist avant-garde, for example in the work of Gleizes and Metzinger and in propaganda for the *Section d'Or* exhibition. Other painters were more willing than Picasso to belong to, or initiate, such movements (as in, for example, Delaunay's curious relationship to the 'Orphism' invented by Apollinaire).[25] But, in every case, the institutional context of a production must be relied upon by the artist to pass on a generalized message that something innovatory and worth while is going on.

This vital intentionality lends a paradoxical flavour to the types of

interpretation I have sketched above—concerned as they are with the diffusion of the idea (hence a certain similarity) which is modified by the sensibility of the individual artist (making a difference). It makes the notion of influence, essential for the artist's sense of a relationship to the past, and hence for the coherence of the kind of narrative I am offering, a very odd one. For as Baxandall points out, the very word 'influence' falsely passivizes the artist, at the very point at which he is most active in response, and likely to make a difference—for he may (to borrow just a few of Baxandall's long list of verbs) appropriate from, engage with, quote, copy, paraphrase, parody, or transform his stimulus.[26] I have argued that Modernist art in this early period is predominantly metamorphic or transforming—and one could argue that, by the Postmodernist era, it is primarily parodic, periphrastic, and intertextual.[27] But it is the intentionality of artists which such verbs record, and they are essential to our understanding of Modernist innovation.

The innovatory work can also exert, once it is appreciated, a retrospective influence. It can recast our understanding of the past so that we see it as anticipating innovation—for example, when we see the geometry of late Cézanne in the light of Cubism, or Schoenberg's aphoristic works in the light of Webern, or Mahler as approaching the dissonance of Berg, Wilde as a self-referential writer, or Dickens as a Symbolic one, tribal art as 'modern', and so on. This type of dialectical interaction between the individual artist and tradition[28] takes place, as I have argued, within a broadly philosophical matrix of ideas, which is fundamental to the enabling of the innovatory impulse. Once Macke has accepted an essentially Modern notion of the harmony of non-representational colours, Stramm an explicitly philosophical view of the mind and of language, and Webern the presupposition of the immanent evolution of musical language towards a greater complexity, they are all three willing to be guided in producing the work by unconscious impulses (which are destined to become one of the chief concerns of the post-war period). Some call this complex of ideas working in the artist the *Weltanschauung* of a period, Baxandall calls it its 'conceptual resources', and others may call it the 'twentieth century mind'. It is essential to grasp (along with Nietzsche) that such conceptual changes centre on ideas that have been around since Plato, but are also part of a history of adaptive learning. They make it possible to do something in 1910 that you literally could not think of doing before, any more than you could 'do' quantum mechanics before a certain date.

But this matter of chronology raises questions about the relationship

between innovation and 'progress'—should this enabling process be thought of as making for advance or improvement? For all the arts in Europe, after the advent of the Impressionists, and the naming and institutionalization of the 'avant-garde', tended to take over from the political and technological spheres the rhetoric of a demand for innovation, which could be thought of at the same time as progressive.

2. Progress and the Avant-Garde

Avant-gardes have most plausibly made this sort of claim when the cultures in which they are situated are perceived to be in crisis, and they think they have seen the necessary next step. In such conditions the motivation of the individual artist depends on a commitment to some form of critical position, a philosophical or political or social antagonism, of the kind that we have seen Ibsen, Nietzsche, Marinetti, and others inspire. The result may be a critical alienation (Eliot, Benn, Kirchner) or a prophetic utopianism (Romains, Marinetti, Kandinsky). Although these two postures are hardly complementary to one another, they do have in common the Modernist faith, that art can significantly change the state of consciousness of performer and audience, in ways which are antagonistic to the *status quo*.

But to convey historical conviction, that is, any sense of his or her own critical contemporaneity as making a difference, the avant-garde artist needs to be supported by evidence for the diffusion of the idea, as inspiring an unsettling analysis of conceptual paradigm and stylistic convention. In so far as the development of new paradigms for art is seen (as above by Macke, Stramm, and Webern) to derive from innovative technical breakthroughs, they are by definition 'progressive', because if you can imitate the technique, you can do something that you could not do before. So we need to be able to distinguish here between technical advances of this quasi-scientific kind, and an emancipation from previous conventions which is more obviously driven by ideological concerns.

This interdependence of the philosophical and the technical was put into acute tension by rising notions of the avant-garde. I have emphasized throughout the traditionalist conservatism of the major innovators of early Modernism, who assimilated the past, and generally justified their work as the logical next step. But once enough of these steps had been taken, in devising the new languages for the arts which I have analysed, the epoch began to be seen as one of exceptional inno-

vation, and the need to be perceived as avant-garde grew. Even when artistic change was thought to derive from the 'necessary' evolution of the language internal to an art form (as in Adorno's view of atonality, and many interpretations of Cubism), the artist's critical address to an audience remained an essential part of his or her institutional experience. And in periods in which technical experiment is a favoured aim, the notion of individual discovery becomes of political importance, along with the date on which the discovery is made. Hence the arguments reported above about Simultaneism, and Kirchner's pre-dating of some of his pictures. His *Self Portrait with Model*, for example, was brought back from 1909 to 1907, so that it might appear to have antedated much Fauvist work, and was then overpainted in 1926 to strengthen even further its claim to the innovatory features of lack of spatial perspective, and flatness. The artist can become dependent upon being written into a progressive art history, which is so influenced by notions of Modernity, that it looks for the dismantling of previous paradigms. Schoenberg himself shows an acute awareness of this kind of history when he attacks the past 'law' or 'code' which he sees (with some exaggeration) as having 'legislated' for German music. However, the actual relationships of the artist to innovation in this period, even of great ones, can be far less self-consciously progressivist than this, as for example in the case of Bartok, who began a series of sustained experiments with the string quartet at the same time as Schoenberg, and, without anything like his relationship to the idea of progress, established distinctively new harmonic conventions.[29]

Matisse, after 1911, has a similarly oblique relationship to avant-garde developments, and one which it is very difficult to interpret. A number of his paintings seem to experiment with some of the style characteristics of the avant-garde movements which succeeded Fauvism, but the nearest we seem to come to obvious allusion to other contemporary modes is in the portrait of *Yvonne Landsberg* (1914), which has 'lines of force' surrounding the figure. This is a fairly contrived bit of experimentation, and did not seem to lead anywhere for Matisse; but should we see work like his *Conversation* (begun in 1908 as a companion to the *Harmonie rouge* and completed in c.1910/12) as more 'advanced' than other of his works of the period, because it has an exceptional degree of flatness and geometrical simplification?[30]

What gives us trouble is not so much the (undoubted) extent to which Matisse could paint in an 'abstract' manner; he produced extremely

47, 48 abstract forms, as in his views of *Notre-Dame* of 1914 (one of these is an

47. Henri Matisse, *View of Notre Dame*, 1914.

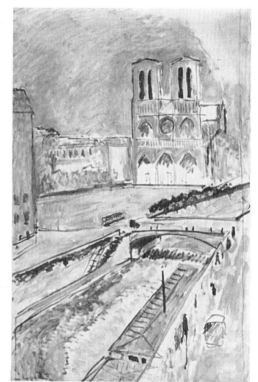

48. Henri Matisse, *View of Notre Dame*, 1914.

oil which looks like a water-colour sketch, and the other is a geometrical abstraction, which is easier to place in relation to Postmodernist minimalism than any likely contemporary influence).[31] It is rather the suspicion that an Expressionist aesthetic of decorative harmony ought to be antithetical to that of a more puritanically abstractionist avant-garde, which might claim to have 'superseded' the Fauvist search for decorative harmony. The conflict here seems to me to turn, not just on the political notion of avant-garde progress (just because such abstractions come 'after' Fauvism) but on a conflict of values, which are independent of the historical order in which formal paradigms succeed one another in any particular period. A great deal of abstraction, from Kandinsky through Mondrian to Barnett Newman and Rothko, was supposed to have had an air of purity and even of philosophical profundity (which was often aided and abetted by the pretentiously poetic interpretations which abstract painting tended to attract).[32] For example, in the work of Mondrian, who was in Paris from December 1911 until 1914. From 1913 he

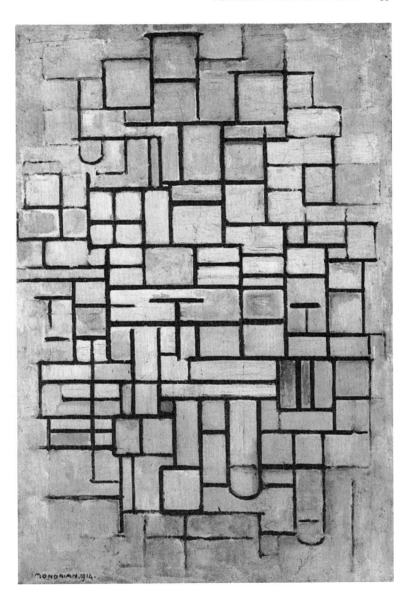

49. Piet Mondrian,
Composition VI, 1914.

concentrated on a sequence of paintings based on the façades of build-
ings which are almost entirely made up of a multitude of small rectan-
gular planes enclosed by lines. In this kind of work, direct observation is
no longer of any importance. John Milner believes that Mondrian's
main concern in these sorts of paintings was rhythmic structure, and
that in his horizontal canvases of this period he was 'isolating the

rhythms of the city and its dynamic restlessness'.[33] By 1914, Mondrian had evolved a distinct style of painting which no longer shows objects, but is made up of rhythmically interrelated flat coloured planes within

49 interlocked rectangles, as in *Composition No. 6* of 1914, where the colours are similar to those of Matisse's abstract painting of Notre Dame. On his return to Holland he produced a sequence of increasingly abstract studies in which vertical and horizontal lines intersect without ever forming closed rectangles. These depict the sea, another rhythmic subject, with a pier sticking out into it, and attempt to reconcile the male (vertical) and the female (horizontal) elements within the theosophical thought of Blavatsky. Their oval format may be meant to signify the cosmic egg, with the sea symbolizing the female principle.[34]

The Matissean 'decorative' tradition in art could be made to seem trivial beside this, because the pleasure it gives seems to be more contaminated by hedonist and 'bourgeois' habits of perception of the real world than is this kind of 'pure' abstraction. But Matisse challenges such claims to profundity by demanding an attention to figurative content, as well as to an abstracting simplification, in complex and astounding images such as his *Piano Lesson, Moroccans,* and *Bathers* of 1916. I believe that this summatory aim is made explicit in Jack Flam's fine

50 interpretation of the *Piano Lesson,* as an allegory for Matisse's own experience as an artist. In it, his son Pierre is seated between two contrasted images of women (the one erotic, and based on Matisse's own *Decorative Figure* of 1908 and the other the austerely reproduced *Woman on a High Stool* of 1914). He is also surrounded by signs of the artist's calling; an apparent teacher (actually a painting) demanding rigour and discipline, a nude signifying abandon and sensuality, a metronome as symbol of measure, geometry, and logic, and just by it a brass candlestick, standing for inspiration.[35] The abstract window reinforces a recurrent theme, of painting itself as a form of symbolic abstraction, and the structure of the image as a whole aspires to the condition of music through a mathematical harmony and proportion which echoes early Renaissance painting.[36] The picture thus dramatizes oppositions of the kind which have concerned us, between 'instinct and intellect, illusion and reality, sensuality and discipline'.[37] This is all brought to a level of abstraction whose deeply considered quality is confirmed by a very arabesque study for the painting with the same configuration of objects (which reveals the clutter in the room at Issy, with its papers on the piano, radiator under the window, patterned cloth on the piano, and garden urn through the window, covered in

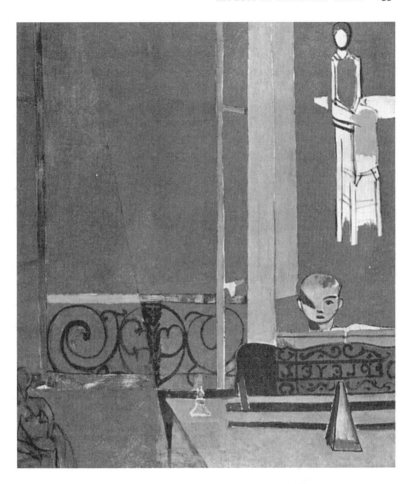

50. Henri Matisse, *The Piano Lesson*, 1916.

flowers). The design of the *Piano Lesson* is often supposed to derive from Cubism, and in particular from Matisse's recent admiration for Gris, and, as Schneider points out, 'The geometrical bias of Cubism made it easier to express analogies, if not to produce them systematically, [in a] . . . reductive schematisation which enables Matisse to play subtle variations—in this case on the triangle',[38] as in the repetition of the metronome shape for Pierre's right eye. The *Piano Lesson* may even be seen as anticipating the Abstract Expressionism of a much later period (notably Barnett Newman) with its use of large monochrome areas cut by lines. It clearly exploits flatness, but its greatness surely consists, not in its contribution to trivial critical debates, but in the way in which it brings about an extraordinarily poignant combination of emotional effects, suggested by the subdued elegiac interrelationship

between the figures, and the calm dignity of its abstract design. Such effects derive from assumptions which are very different indeed from those of the Cubist tradition, not least because Matisse aims at an emotionally significant, unifying vision of real-life situations, whereas the Cubists tend to fragment the human subject into a still life without drama (which abstracts from the human situation and plays with the signs for its representation).

In any case it is only a delusory belief in some kind of universal collective evolution (of the kind to be found in Hegelian Marxism) which could tempt us to believe that particular features of anyone's work are inherently more 'Modern' than others. Such theories, in defending holistic versions of what counts as progress, are inherently hostile to the adaptive tolerance and pluralism which the later work of Matisse exemplifies. His work also reminds us that progress, for the individual artist, lies in the pursuit of a vision, and this vision need not be at all constant in its relationship to the idea of a single historical evolution for art. Of course the critic, and indeed the artist as critic, can attempt to stand outside (or at least after) a historical epoch, and measure it by any 'progressive' yardstick he or she likes; but it is quite mistaken to believe that innovative change by artists can plausibly be seen as part of a unilinear historical process (and in this respect the arts contrast drastically with science).

This is because the relationship of the innovative artist to the past is often one of *re*discovery, so that progress may depend on breaking line and hopping over one's immediate predecessors (as Pound and Eliot so notably did). Robert Hughes therefore notes that 'Picasso, painting the *Demoiselles*, is the exact contemporary of Monet, painting his waterlilies at Giverny, and who can say which of them was the more "modern" artist?'[39] His question makes sense because the innovation-inspiring status of a work of art—its 'progressive' qualities—are so often reperceived in later narratives. Given the amazing pervasiveness of Cubist paradigms up to the Second World War, much significant *Post*-modernist art was forced to look back past Cubism, and new paradigms for it were indeed to be found in late Monet, who helped to inspire the 'allover' Abstract Expressionist characteristics of Jackson Pollock. Monet thus helped him to move beyond the caricatural Cubism of late Picasso, which Pollock abandoned. (Even so devoted an avant-gardist as Gertrude Stein had to wait some time for her (re)discovery as a Postmodernist writer of combinatorial prose.) The moral of this is that subversive technical innovation is never entirely self-justifying, and is

always subject in its turn to later adaptation and revision, guided by an individually conceived problematic (and may even lead off in seemingly 'non-progressive' directions).

The long-term acceptability of *all* technical paradigms for art will depend upon their social (and economic) utility for survival (which includes their acceptability within the eclectic and yet canonic atmosphere of the museum, the concert hall, the public library, and the educational process).[40] Even artistic revolutions can go to conceptual extremes, and then adapt themselves to the more popular understanding of particular audiences. This adaptation can even be a symbol of success—between 1912 and 1915 Picasso and Braque put back into their work 'an equivalent to every one of the traditional cues for the reading of a painting that they had broken with or eliminated during the preceding phase'.[41] Works like Picasso's *Harlequin* (1915) and Braque's *Man with a Guitar* (1915) allow for recognizable forms, a sense of mass, clearly contoured planes, and a more obviously pleasurable brighter colouring, textured surface, and decorative patterning, much of which is recognizably Matissean. This generic reorientation towards more accessible styles is of crucial importance for the post-war development of Modernism.

The work of Schoenberg and Stravinsky, immediately after the phases discussed in earlier chapters, makes a similar type of adaptation and revision. Indeed, Schoenberg's *Pierrot Lunaire* of 1912 was immediately seen as being progressive and regressive at the same time. The twenty-one poems of its text depended on a Symbolism which was hardly 'modern', and sat rather awkwardly with the agonized Expressionist gestures of an atonal vocal line.[42] Of course this mixture conveys the effect of just that kind of split in identity which I have emphasized (reinforced by the conflict between song and speech involved in Schoenberg's demand for *Sprechstimme*). But the style of the musical accompaniment returns to a classical contrapuntalism, which very strikingly divides the associative and dream-like language of *Pierrot* from its underlying architecture. ('Mondfleck', for example, in which Pierrot sees a spot of moonlight on his back, is in double retrograde canon, which reverses itself just at the moment of perception of the spot ('rightig | einen weissen Fleck'), and 'Parodie' appropriately contains a canon in inversion accompanied by an imitation.)[43]

Stravinsky's music immediately after the *Rite* also brings aggressively progressive elements together with reassuringly familiar ones. *Les Noces* (1917–23) retains the dominating idea of the *Rite* in its return to the

instinctual and 'universal viewpoint of a primitive, popular under-standing of the world, an archetypal event in a national, Russian form'.[44] As a collectivist work, it is close to the Unanimist and Simultaneist aims of the French avant-garde; and like the *Rite* it is a fertility rite which prepares a young girl to be sacrificed. But its final, four piano plus percussion version emerged when Stravinsky was thinking about an anti-Expressionist neo-classicism, and wanted an instrumental en-semble which was to be 'perfectly homogeneous, perfectly impersonal and perfectly mechanical'.[45] Its central technical advance lies perhaps in the way in which the music is rendered statuesque by repetition, engendered by little shifts of 'position' (which anticipate the minimalist procedures of Glass and others). Like the *Rite*, it lacks any underlying harmonic progression.[46] Stravinsky thus 'progressed' and simplified and anticipated the Postmodern, as he moved from the wild Expres-sionism of the *Rite* towards a far more severe objectivity.

There seem then to be two phases of innovation: that of radical change to the language of an art (with which I have been primarily con-cerned), followed by a more pragmatic, audience-orientated adaptation of new techniques, which often demands a highly allusive compromise with the past. Berg's *Three Orchestral Pieces*, Op. 6, of 1914/1915 (which are formally poised between the traditional genres of suite and sym-phony) is typical of this in having many such links to earlier music, which run in particular through Mahler, as the rondo pays homage to his stylized waltzes and ländler, and the hammer blows of his *Sixth Symphony* are re-imagined within the fateful march rhythms of the third movement. The *Three Orchestral Pieces* thus mediate between the parodic re-creation of nineteenth-century modes, and the exploration of atonality. The listener can be orientated by a generic framework from the past, at the same time as an atonal revision of its gestures produces dramatically Expressionist effects. These moves by Berg, Matisse, Picasso, Braque, Schoenberg, and Stravinsky towards a greater accessibility subsume a further strategy, which is essential to the later development of Modernist work. For the stylistic eclecticism sketched above is in itself innovatory; it uncompromisingly exploits a relativistic historical awareness through strategies of allusion (and it opens the way to the self-consciously intertextual, parodic eclecticism of much Post-modern art).

My account so far has indeed been broadly progressive, in that I have assumed that the major developers of the technical paradigms dis-cussed above had an exceptionally strong influence on the Modernist

thinking of others. But this assumption can marginalize the 'lesser' followers of major figures, in so far as Fauvists like Derain, Vlaminck, Van Dongen, or Dufy, and Cubists like Gleizes and Metzinger, are seen as less experimental within the paradigm than their superiors, and therefore less 'advanced'. It is nevertheless far from obvious that an artist like Gris is a 'lesser' painter, because (like Macke) his standards remained more conservative and his technique was also more legible than that of early Picasso or Braque. He was described by Waldemar George in 1921 as 'one of the most orthodox grammarians of the Cubist school',[47] a judgement of him frequently confirmed by references to him in the literature as 'logical' and by his use of grids, geometrical armatures, and

51 the Golden Section in his work. A painting like his *Still Life Before an Open Window, Place Ravignan* (June 1915), depends upon a very traditionally conceived contrast between nature and art, as it brings the window and the view through it into the same plane (in an otherworldly Symbolist atmosphere of blue), and great work like this demands a constant respect for mimesis, which derives from his retention of the still-life standards of the old masters. Although we partly understand it through the paradigms developed (first) by others (indeed

IX it too descends from Boccioni's *The Street Enters the House*), its value hardly depends upon the date of its production.

Successful artistic innovation nearly always demands reinforcement from artists whose activities tend to confirm the importance of the ideas which I have emphasized as essential to the success of artistic movements. The works which result may not prove to be worth remembering for much more than the purposes of this kind of historical explanation, but such minor movements all contribute to the general conviction that change is necessary, as they take up otherwise dominant ideas in less viable forms.[48] Gossez's Dynamism, for example, preceded Futurism,[49] but lacked any Marinettian flair for publicity, or staying power, and did not attract any adherents of genius. Nor did Beaudouin's 'Paroxysme'—which saw man as the 'demiurge' of Nietzsche,[50] and appealed to the subconscious as a source of poetry. In their openness to innovatory ideas and contemporaneity of outlook, such movements provided vital support for inevitably stressful changes in artistic convention. They were involved with their time, by being restless, self-critical, and self-determining, and *ipso facto* part of the competition between stylistic paradigms. Such new paradigms would never even become available if *some* artists did not value their practice 'in terms of its power to generate the sense of a need for progress, which progress is measured by the

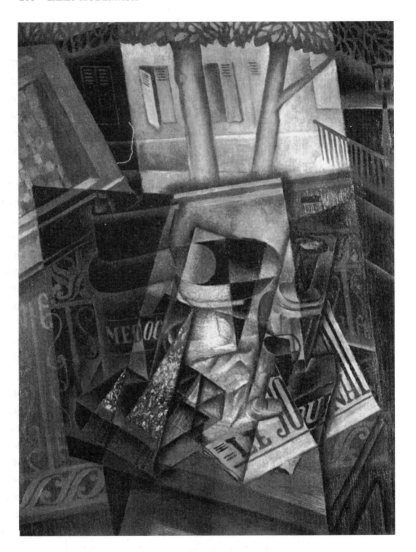

51. Juan Gris, *Still Life before an Open Window, Place Ravignan*, 1915.

victory of one "paradigm" of practice, one "hypothesis", one "concept of art" one manner over another less novel'.[51]

Such arguments hardly appealed to the true conservatives of this period, who, like Elgar, Vaughan Williams, Puccini, Suk, and Rachmaninov, developed earlier styles, and thought of themselves as sustaining enduring values. A poem like Valéry's *Le Cimetière marin* (*The Graveyard by the Sea*) may be technically conservative for its date (1920), and hark back to Symbolism, but its philosophical concerns alone make it a far more profound poem than any of Apollinaire's. Some of the

greatest works of the period from 1900–1918, like Valéry's poem, bring previously developed techniques to their highest point (as in Ravel's *Daphnis and Chloe*, Rachmaninov's *Third Piano Concerto*, or the later work of Fauré, Bonnard and Monet). The worth of such work to us is in the end quite independent of any relationship to the avant-garde progress of their time. And yet, it is always going to be dependent upon some such progress having been made in the past (as, for example, in the relationship of the conservative Elgar to the once-revolutionary Strauss).

This variability in the predisposition of artists towards innovation reminds us once more that the primary focus for the avant-garde is the artist's mind; as I have argued throughout, innovatory artistic conventions and changing notions of the person are correlative to one another. I now turn therefore to some strange developments of the idea of the artist's identity in the early Dada movement in Zurich. This was intimately related to the reactions of an internationalist Modernist movement to world war. In the process, a hugely influential model for avant-gardist activity in the post-war period was established.

3. Irrationalism and the Social

We have seen the intimate connection between changing conceptions of the self and innovation in art move, in the late nineteenth century, away from the description of social reality towards a focus upon associative processes within the individual (and often dissenting) consciousness. Aschenbach, Stephen Dedalus, and Freud himself, are justificatory figures in the transition from logical deduction to juxtaposition in art. The disruption of harmonic development in Schoenberg's *Erwartung*, Cubist collage, Apollinaire's 'Lundi rue Christine', and Prufrock, all expressed radically new conceptions of the nature of consciousness. The liberating openness to image-association and juxtaposition in such work also had its external constraints and causes, notably as a reaction to 'the simultaneousness of the ambient' thought typical of modern life in the city. In the process it constructed worlds which seemed to be less and less susceptible of explanation and description through the causal processes of historical narrative. The world seen as simultaneist (as in a newspaper, or through the artist's intertextual memory of tradition), or as subject to the intuitive leaps of the unconscious, could be full of estranging displacements from the history that Joyce's Stephen was later to describe as a 'nightmare' and Eliot as an

'immense panorama of anarchy and futility'. Indeed, as Eliot moved from a Bergsonian stream of consciousness towards collage, the world became for him a place of multifarious and competing voices and historical contexts.

The way was thus made open for a radically allusive juxtaposition, by considerations which Derrida and others have since tried to make central to the philosophic tradition, by arguing (with Nietzsche and the Symbolists) that language is constituted, not by the literality demanded by history, but by the hidden armies of metaphor and image.[52] It is such inherently unreliable analogical devices which come into ironic or absurdist conflict in the Modernist writing of Marinetti, Lichtenstein, Hoddis, and many others.

The positive, unalienated interpretation of such conflicts was that they provoked the emancipation of the subject, out of bourgeois conformity.[53] The multiple consciousness aimed at by 'parole in libertà', and the visual logic of the 'synthetico-ideographic' poem, both challenged the subordinating effects of an analytic and discursive logic. The negative dystopian interpretation of such states of mind sees the subject as falling through dissociation into alienation or neurosis. In early Modernism we find a number of attempts to redeem such states, by representing the artist who experiences them as a witness, martyred by his internalization of the contradictions of society (as in Kafka).[54] Both Kandinsky and Schoenberg wrote plays centring on these themes—the former's drama, *Die Gelbe Klang* (*The Yellow Sound*) (1909; publ. 1912), and the latter's opera, *Die Gluckliche Hand* (1913). Hence also Aschenbach's feeling that he is an affront to the bourgeoisie, and Prufrock's narcissistic imagery of martyrdom, accompanied by (absurd) claims to an insight into the nature of the universe.

The confrontation of these tensions seemed to demand a conception of the person as driven by a highly subjective, largely unconscious, 'inner necessity', which may diversely express itself—in the search for a relaxing harmony of design in Matisse, the raw feelings of *Erwartung*, or the cosmic vibrations of Kandinskyan abstraction. The nature of the feelings thus evoked demanded investigation in the light of radically new ideas, for example in solving the problem of our responses to abstraction, or in explaining 'cosmic' feelings through Jung's archetypes of the collective unconscious. Such emotions could arise from Bergsonian intuition, or from the release of primitive instinct, or from the internal conflicts and contradictions caused by the family and social institutions (a conflict which the later conjunction of Surrealism and

psychoanalysis, and of Marx and Freud in the Frankfurt school, was to attempt to elucidate).[55] All of these developments in early Modernism tended to encourage the artistic expression of the irrational, most particularly as the symptom of contradictions and tensions which society at large denied and repressed. A growing number of avant-gardist groups in the Modern period claimed that the new art was intended to be irrational, as part of a battle against authority for the liberation of subconscious processes, and the transformation of human consciousness.

These tendencies were most obvious in German-speaking cultures, in which the conflictual context in which the Modernist worked was often explicitly perceived as familial. The battle between youth and traditional authority was literally dramatized in the German theatre, with the father figure as metaphor for the repressive society surrounding the artist. The poet hero of Reinhard Sorge's *Der Bettler* (*The Beggar*) (1912) has to contend with a father who is madly obsessed by his fantasies concerning the canals on Mars (as a means to the technological redemption of the earth),[56] and Walter Hasenclever's *Der Sohn* (*The Son*) (1914) is rescued from an oppressive father by his Mephistophelian friend to the strains of Beethoven's Ninth Symphony. He abandons his work (for a mathematics exam) to join a revolutionary organization of young men who, amongst much other Nietzschean talk, demand the death of fathers, and (like Benn's students in *Ithaka*) a Dionysian frenzy, as they aim at the 'Brutalisierung unserer Ichs in der Welt!' ('the brutalizing of our egos in the world'). They attack the Christian 'Gott der Schwachen und Verlassenen' ('God of the weak and dependent') and their general judgement, after an inflammatory speech from the Son, is that 'die Vater . . . sollen *vor Gericht!* ('Fathers . . . shall come to judgement!'). In the final scene the Son meets his father's accusations by asking for his freedom and proudly claiming

Ja, ich habe die Revolution begonnen, inmitten der Foltenkammer, wo ich stehe—und bald wird mein Name über Leitantikem stehn.[57]

Yes, I have started the revolution, right inside the torture chamber in which I am confined—and soon my name will outlive those of the leaders of antiquity.

The Father (conveniently) dies of heart failure when his Son threatens him with a revolver. Such conflicts may indeed arise from an Oedipal psychopathology, but the Son's Nietzschean Messianic verse fantasies are also fed by reminiscences of Goethe's *Faust*, the poetry of Stefan

George, and right-wing anarchism. In plays like this, as in Benn's *Ithaka*, it is difficult to see how far the aim at a revolutionary turn in conscious-ness towards the 'new man' is not in fact wholly disabled by the obvi-ously hysterical psychopathology it so proudly displays. The Son is not the first or the last in a long line of German irrationalist prophets. His kind of anti-bourgeois revolt is well defined by Ferdinand Hardekopf, in launching Franz Pfemfert's 'AktionsBücher der aeternisten' in 1916:

Unsere Psychologie wird euch skandalisieren. Unsere Syntax wird euch asphyxi-ieren. Wir werden eure großen Konfusionen belächeln, abstrakt und augurisch. Erhabene Konjunktive werden zerstaüben, Futura exacta narkotisch ver-dampfen, und je-m'enfichistisch zergehen schaumige Duftbälle von Quintes-senz.[58]

Our psychology will scandalise you. Our syntax will asphyxiate you. We will laugh at your gross confusions, in abstraction and augury. Solemn conjunctives will spray about, the demands of the future (tense) evaporate in narcotics, and the frothy perfumed balls of the Quintessence dissolve in je m'en foutisme.

Just such ideas inspired the Dada movement, which began in Zurich in the same year. As its ideas spread throughout Europe after the war, it provided a model for those avant-gardes which exploited irrationalist states of mind to aim at social transformation. It also sustained the Futurist belief, that 'advanced' art needs to be protected by confronta-tional activity, and must aim at a constant metamorphosis, in providing what will seem 'new', and therefore 'surprising'. This led in the high Modernist and Postmodernist periods to some of the most tediously pointless of conceptual art, which attached an 'idea' new to the artist to a boring and technically unchallenging object. Early Dada was usually more sophisticated than this, and it redeems itself *inter alia* by its comedy, as the laughter of the audience secretly transcends the threat of wilful irrationalism in the performance. The Dada Night at the Salle Waag in Zurich on 14 July 1916 was an absurd cabaret, with an air of menace:

Boxing resumed: Cubist dance, costumes by Janco, each man his own big drum on his head, noise, Negro music/trabatgea bonoooooo oo ooooo/5 literary experiments: Tzara in tails stands before the curtain, stone sober for the animals, and explains the new aesthetic: gymnastic poem, concert of vowels, bruitist poem, static poem chemical arrangement of ideas[59]

These 'bruitist' Dada poems married the operatic Simultaneism of Barzun to the aggressive lyrical intoxication of Marinetti. 'L'Amiral

cherche une maison à louer', for example, was recited (in March 1916) by its authors Hulsenbeck, Janko, and Tzara in three languages—or more precisely, in three phonetic approximations to them.[60] Janco in English refers to the 'honny suckle' and the 'weopour will arround the hill', and claims to 'love the ladies', one of whom (his 'sweetheart'), jazzily says 'yes yes yes oh yes oh yes oh yes oh yes oh yes yes yes oh yes sir'. But (as all three reciters conclude in unison) 'l'amiral n'a rien trouvé'. Tzara's Frenchman meanwhile puts 'le cheval dans l'âme du serpent . . . tandis que les archanges chient et les oiseaux tombent' ('puts the horse into the soul of the serpent . . . while archangels shit and birds fall'). And for Hulsenbeck's German, 'der Conciergenbäuche Klappenschlangergrün sind milde ach verzerrt in der Natur' ('the rattle-snake green concierges' bellies are gently alas contorted into nature'), while Janco's girl gets on with her 'oh yes's. There is an 'intermède rhythmique' half-way through the poem (with dynamic markings from p to fff), in which Hulsenbeck's 'hi hi Yabou', and Tzara's 'rouge bleu' are accompanied by 'sifflet, cliquette and grosse caisse' ('whistle, castanet, and big drum').

Tzara's 'Note pour les bourgeois' which was appended to the published version of this poem claimed that it emerged from a grand synthesis of the Modernist movement, in following the same simultaneist principles in poetry as did the Cubists (including Picabia, Duchamp-Villon, and Delaunay) in painting. He also invokes Mallarmé, Marinetti, Cendrars, and Romains and Apollinaire as his precursors, along with Barzun, who had 'l'idée première' of the poem's 'essence'. For Tzara the experience of hearing 'l'amiral' was an inherently liberating activity, depending upon 'la possibilité que je donne à chaque écoutant de lier des associations convénables' ('the opportunity I offer the hearer to attach suitable associations') to the poem. This was supposed to be in itself anti-bourgeois, since it made impossible the naturalist 'psychological penetration of the motives of the bourgeois'. Such a need for psychological explanation (and sympathy) was to be distrusted, since, 'despite all efforts at resistance', it would bring about 'an identification with the various precepts of bourgeois morality'.[61] (This belief in an intrinsically anti-bourgeois freedom of association, emancipated from a humanist individualism, persists pretty well unchanged through to the work of Roland Barthes and others.) Even a basic intelligibility might lead to compromise—and so an instinctual response, far removed from our usual understanding, has to be aimed at:

the subjective folly of the arteries the dance of the heart on burning buildings and acrobatics in the audience. More outcries, the big drum, piano and impotent

cannon, cardboard costumes torn off the audience hurls itself into puerperal fever interrupt.[62]

Performances like this took their place within what were in effect avant-garde magazines in theatrical form, featuring poetry by Cendrars and Hoddis, Hardekopf and Aristide Bruant, a balalaika orchestra, pictures by Delaunay, poems by Mühsam, Rubinstein playing Saint-Saëns, readings of Kandinsky and Lasker-Schuller, of Jacob and Salmon. They attempted to keep alive in wartime the reconciliatory internationalist tendencies of what was now clearly seen as the Modernist Movement. The first part alone of the (final, climactic) Dada soirée in the Saal zur Kaufleuten in Zurich on 9 April 1919 included a speech by Eggeling on elementary *Gestaltung* in abstract art, Suzanne Perrotet wearing a negro mask by Janco and dancing to compositions by Schoenberg, Satie, and others, and poems by Hulsenbeck and Kandinsky, leading up to another 'poème simultané' by Tristan Tzara ('La Fièvre du mâle') to be read by twenty voices.[63]

Dada in Zurich thus mixed irrationalist liberation and anarchist incongruity with a generally welcoming attitude to other types of avant-gardist activity. It took the techniques of Modernism seriously enough to see what happened to them when taken to extremes, as in the attack on the semantic functions of language by phonetic poetry such as Hugo Ball's 'sound poem' *Karawane* of 1917,[64] in which he thought he had managed 'to discard language as painting has discarded the object'.[65] Such work is meant to appeal directly to the unconscious, and avoided any psychologically plausible interpretation, by (as Ball put it) subjecting the artistic process 'to the same unforeseeable laws of chance' as he thought affected life in general.[66]

These irrational norms for experiment oscillated between the cosmic pretensions of Kandinsky, the attempts at a revolutionary psychic transformation of Sorge and Hasenclever, and a countervailing awareness of Dada's comic potential, as 'a clownery out of the void . . . a gladiator's gesture, a play with shabby remnants, a death-sentence on posturing morality and fulsomeness. The Dadaist loves the absurd . . .' [67] Such mockery is obvious in work like Hulsenbeck's 'End of the World' (1916), beginning

> This is what things have come to in the world
> The crows sit on the telegraph poles and play chess
> The cockatoo under the skirts of the Spanish dancer
> Sings as sadly as a head waiter's bugler and the cannon lament all day[68]

This is a song of innocence rather than of experience, and it is hardly surprising to find Arp making the Blakean assertion that 'We were seeking an art based on fundamentals, to cure the madness of the age, and a new order of things that would restore the balance between heaven and hell'.[69]

The divergent attitudes described so far make it difficult to see Dada as an art movement, precisely because its centre of interest so often lay in the psychology of those who participated in its activities. Art itself was 'a stratagem whereby the artist can impart to the citizen something of the inner unrest which prevents the artist himself from being lulled to sleep by custom and routine'.[70] In avoiding conventional forms of expression to convey its alienation from established order, it exalts the individual's irrational responses above *any* contextual position in language or in culture. It is a kind of proto-existentialist search for an asocial personal authenticity. As Tzara puts it:

I call *je m'en foutisme* the kind of life in which everyone retains his own conditions, though respecting other individualisms, except when the need arises to defend oneself, in which the two-step becomes national anthem, curiosity shop, a radio transmitting Bach fugues, electric signs and posters for the whorehouses, an organ broadcasting carnations for God . . .[71]

His Dada Manifesto of 1918 from which I quote above, is a very significant (and typical) document, in that it summarizes the underlying assumptions of many artists who were inspired to affirm an extreme subjectivism opposed to all ideological systems.

If I cry out:

> *Ideal, ideal, ideal,*
> *Knowledge, knowledge,knowledge*
> *Boomboom, boomboom, boomboom*

I have given a pretty faithful version of progress, law, morality, and all other fine qualities that various highly intelligent men have discussed in so many books, only to conclude that after all everyone dances to his own personal boomboom.[72]

For Tzara, Dada 'expresses the knowledge of a supreme egoism, in which laws wither away',[73] and attempts to get through to the underlying, unconscious human nature which has the merit of being primitive and spontaneous. This primitive self was not, for Tzara, to be explained away by psychoanalysis, which he thought was 'a dangerous disease' which 'puts to sleep the antiobjective of man and systematises the bourgeoisie'.[74] He was a good deal less certain than many of his German

colleagues were to be, that a 'new man' could emerge from this anti-ideological process, freed from the restrictions of a bourgeois identity. For although Dada thought of itself as a new ethic, it failed to make the kinds of ethical and artistic agreements which later seemed to be possible for the Surrealists. These were hardly likely for artists who professed themselves uninterested in rational negotiation: 'We recognise no theory. We have enough cubist and futurist academies: laboratories of formal ideas.'[75] Dada only achieved a moderately coherent oppositional role in situations torn by quite specific political conflicts, as for example in Berlin after the war.[76]

4. A Political Conclusion?

Dada had a more than strategic importance. It sustained the critical strain in Modernism by putting new conceptions of the self to a severe test. Most importantly, perhaps, its questioning of the very institutions under which it operated has made Dada for many the model of a radical avant-garde. It has been influentially interpreted as a 'revolt against art' which attacked 'the uncritical assumption that art embodies and legitimises a culture's vision'.[77] In doing so it was thought to have challenged a liberal-bourgeois tradition which was willing to identify the best of a culture with the best of its art, as did Clive Bell, for example. Peter Bürger goes so far as to demand that Dada stand for the whole of Modernism in arguing that 'European avant garde movements can be defined as an attack on the status of art in bourgeois society.' This is because 'the avant gardists' think that 'art in bourgeois society' is mere aesthetic appearance with no real critical function, dissociated 'from the praxis of life'. For him, the Dada avant-garde attempted 'to organise a new life praxis from a basis in art'.[78] But the best that he can then do, to support his position with respect to the early Modern period, is to interpret Dada artworks as signifying the political attitude he favours, so that Duchamp's signing of the mass-produced *Urinal* (a work actually produced in the United States, in 1917) is about the procedures of art in that it 'negates the category of individual production'.[79] This, to say the least, plays down the anti-ideological individualism of most of the Dada work we have looked at; and in any case, as Terry Eagleton and others have pointed out, the critical position of such anti-art is far from obvious. It seems to wish to be

an art which is not appropriable by the ruling order because—the final

cunning—it isn't art at all. The problem with this however, is that what cannot be appropriated and institutionalised because it refuses to distance itself from social practice in the first place may by the same token abolish all critical point of purchase upon social life.[80]

The Dada belief in irrationalism as a means to self-liberation stretches back past Marinetti's affirmation of madness and absurdity to Rimbaud's 'dérèglement de tous les sens'—while it extends its influence forward to William Burroughs and beyond. Its confrontation with social orthodoxy has remained a central theme in avant-gardist activity; and it is perhaps the most significant legacy of Modernism to the Postmodern. But the chief disadvantage of its strategy remains: it is an activity which has to be defined by the known history of the very aesthetic it controverts. It is condemned to a second-order intertextual role, and its parasitism no doubt accounts for the ease with which all sorts of anti-institutional works have been assimilated by the museum as 'valuable objects', and by the academy as political examples. The strength of a 'bourgeois' culture is that it can be fatally adaptable to the art of its enemies, since it has the advantage of believing in a pluralist debate.

Bürger's political interpretation of Dada is typical of an approach to Modernism broadly antithetical to my own, which has concentrated upon the adaptive responses of the individual to historical influence. Such interpretations see the artist's techniques as symptomatic of larger, all-embracing cultural forces, which it tends to hypostatize as 'discourses', which are curiously independent of the individuals using them. So Bürger speaks of Duchamp's work as 'negating the category' of individual production. This strategy can produce a form of criticism which sharpens our political concerns, within the academy and elsewhere. But in exploiting the larger contexts of politics as discourse, it all too often takes on the burden of historical generalizations which are not only very difficult to verify, but in fact extraordinarily conservative, and ill-adapted to an understanding of the nature of learning and change.

The most successful political interpretations of the visual arts in the context of Modernism have so far concentrated on the Impressionist and Post-Impressionist periods, and have tended to see the works they discuss as depending upon the realism which Modernism contests.[81] Linda Nochlin's interpretation of Seurat's *Sunday Afternoon on the Island of La Grande Jatte* (1886), as 'an anti-utopian allegory' is a by now well-known case in point. It derives from a dystopian interpretation

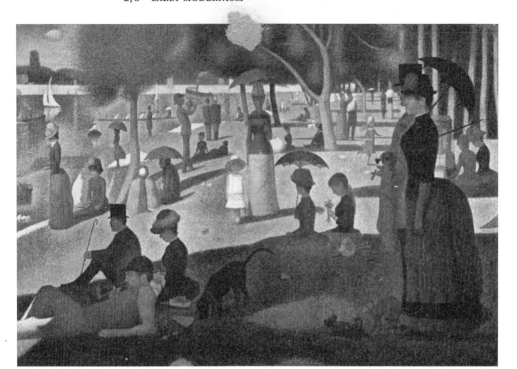

52. Georges Seurat,
*Sunday on The Island of La
Grande Jatte*, 1884–6.

of urban experience significantly different from that offered above, because Nochlin sees Seurat's work as symptomatic of 'the alienation associated with capitalism's radical revision of urban spatial divisions and social hierarchies'.[82] But this 'association' (commonly made by Marxist critics) involves a commitment to some very unlikely empirical generalizations, as when Nochlin follows Bloch and others in suggesting that leisure in the city was not *really* enjoyed, and in so doing fails to allow for the diversity of Modernist responses to the city which I have emphasized.[83] (The desperate expedient of the Freudian assertion, that it subconsciously was not enjoyed, is of course still open to her.) This lack of concern for diversity occurs because this kind of criticism is hostile to a liberal pluralism, and is most interested in psychological descriptions which are supposed to apply to whole classes, and most notably to an implausibly homogenized 'bourgeoisie'. (We saw this before in looking at some interpretations of Kirchner's street scenes.)[84] Such ideological certainties allow Nochlin to assert that in *La Grande Jatte* Seurat 'invents visual codes for *the* modern experience of the city' whose universally alienated aspect is shown by the fact that there is 'no interaction among the figures'.[85] (It is amusing then to note the wit and

plausibility with which Stephen Sondheim and James Lapine invented some for their musical, *Sunday in the Park with George*.) Kirk Varnedoe notes that 'the frozen architectural rhythms' of the painting are meant, in interpretations like Nochlin's, 'to critique the starchy rigidity of the middle class strollers', so that Seurat's 'stylisation' may be 'deciphered as disguised Realism'. But he feels that 'critiques that require a century to decipher' have 'failed in some basic sense'.[86] I agree.

There are in any case more plausibly historical alternative interpretations of the bearing of the figures in the painting. Seurat's biographer Gustave Coquiot thought that the painting was 'prim and level headed' because Seurat did not much like vulgar activities—he was 'too sedate' for rowdiness and bawdry, and so produced 'a sacred grove with neither nymphs nor Priapus'.[87] The painting might rather look back to the dignity of Benozzo Gozzoli, or the pan-Athenaic procession of the Parthenon (with its monkey as a revived medieval symbol of profligacy).[88] To suggest that evidence like this, concerning Seurat's temperament, moral attitudes, and allusions to other paintings, might cast doubt upon the judgement that such features are merely epiphenomenal to a class experience, is of course to privilege the vision of the individual artist as a starting-point for the explanation of his work.

I believe that such considerations offer a far more plausibly detailed explanation of features internal to this particular painting, and in particular of the connection between its technique, of the modern frieze, and the idea of an almost parodic dignity to be gained by a statuesque treatment (an effect recently captured in a contemporary context by Bill Jacklin's paintings of the Sheep Meadow in New York). But Nochlin makes the technique of this image responsible for making 'references' which are not at all clearly related to our knowledge of any one painter. She asserts that:

in these machine-turned profiles, in these regularised dots we may discover coded references to modern science and to modern industry with its mass production; to the department store with its cheap and multiple copies; to the mass press with its endless pictorial reproductions; in short, a critical sense of modernity.[89]

If we doubt that Seurat intended such 'references', we have to conclude that Nochlin is not so much 'discovering' them as (reasonably enough) making them for us, so that the 'critical sense' she finds in the picture is her own. In interpreting the dots of a fairly common pointillist technique as an implicit critique of the 'mass press', Nochlin believes that

Seurat 'resolutely and consciously removed himself as a unique being projected into the work by means of a personal handwriting'.[90] And yet it is surely very easy to appreciate Seurat's unique stylistic modification of pointillism; one has only to look at other work, which is similar in method, but obviously different in sensibility.[91] It seems to me just as obvious that an artist capable of using such a technique to produce so breathtakingly beautiful a balance of colour and geometry cannot be primarily concerned that his painting carry so trivial and commonplace a judgement on undesirable social conditions and practices, particularly as they were so often, and so much more explicitly, made by persons not involved in the activity of painting masterpieces.

The reduplication of such judgements by the art critic seems to me to be a work of supererogation, as for example in James Herbert's judgement that all Fauvist nudes involve the 'politics of gender' in that they attempt to disguise the power of the male gaze behind 'supposedly higher, disinterested aesthetic values'.[92] Matisse's *Blue Nude* is furthermore colonialist; like all his 'pictures of African objects', it 'played a part in authorising, in the name of knowledge, further colonial incursions into the massive continent to the south'.[93] Even Fauvist landscapes, at Collioure and elsewhere, however classicizing, function in the same way, to distract us from the real nature of the power from which they derive: for 'Just as aesthetic disinterestedness dissimulated the masculine subject's social and sexual interest in the female subject, it hid the tourist's interest in exerting control over the sites they visited.'[94]

The attempt to see more formalist types of Modernist art as an (implicitly Post-Structuralist) critique of their own language seems to me to suffer from similar defects. As we have already seen, Cubist collage often depends upon a highly appreciative allusive interplay, between fragments from popular media, directly reproduced in the image, and the formal sophistication of the artist's hand, as, for example, in Picasso's *Guitar, Sheet Music, and Glass* (after November 1912) which contains a wallpaper pattern (which may well be a parodic reply to Matisse's 'overall' decoration based on the same motif), a guitar which has a punning Cubist table-top shape for its bottom curve, a fragment of newspaper showing LE JOU | LA BATAILLE S'EST ENGAGÉ, and a Cubist drawing in charcoal of a glass. Work like this does not so much criticize as dignify its commonplace objects. However, Cubist collage may also be extracted from the intentionalist matrix of the culture of its time and seen as revealing to us, in the light of Post-Structuralist theory, the 'liberating' effects of the sign recognized as artificial (and therefore

as implicitly opposed to the illusory ideological hegemony promoted by a 'bourgeois' and hence reactionary belief in mimesis). Bryson similarly sees Gris's *Breakfast* (1914) as an example of 'semiotics on vacation' in its use of newspaper, wallpaper, and a manufacturer's label,[95] and Rosalind Krauss sees Cubist painting in general as exemplifying the Saussurean arbitrariness of the sign. This kind of criticism adapts early Modernist notions of the relationship between conception and vision (largely inspired by the study of primitive art), to current theoretical preoccupations, so that 'if African art had inaugurated collage this was because it opened not only onto the arbitrariness of the sign but also onto its negative character, its quality of being only a marker within a system of differences'.[96] Krauss, like Nochlin, seems to overgeneralize wildly in suggesting that 'collage operates in direct opposition to modernism's search for plenitude and unimpeachable self presence', by 'setting up discourse in place of presence' and so treading 'on the threshold of postmodernist art'.[97]

This dependence on theoretical (and sociological) generalization, which is unlikely to fit all the evidence, cripples all such high-level definitions of Modernism and its products. Terry Eagleton, for example, prescriptively defines *the* nature of *the* Modernist work of art in terms very reminiscent of Bürger. Since he agrees with Jameson that high Modernism was 'born at a stroke with mass commodity culture' he wishes to suggest that the Modernists all attempted to disguise this fact in 'a strategy whereby the work of art resists commodification, holds out by the skin of its teeth against those social forces which would degrade it to an exchangeable object'. In order to 'fend off' this 'reduction',

the modernist work brackets off the referent or real historical world, thickens its textures and deranges its forms to forestall instant consumability, and draws its own language protectively around it to become a mysteriously autotelic object, free of all contaminating truck with the real. Brooding self-reflexively on its own being, it distances itself though irony from the shame of being no more than a brute, self-identical thing.[98]

This comic picture of the wretched Modernist work of art is grotesquely exaggerated. It is as if the transition from Symbolism to Modernism had not taken place. In any case, there are so many counter-examples— nearly all the artists we have discussed thought of themselves as realist in one or another sense, for example in attempting a new psychological realism concerned with the unconscious, or in presenting the nature of the modern metropolis, and so on. Most of the Modernist art we have

discussed above asks us to be aware of the relationship *between* technique and idea, medium and message, and reflexivity and mimetic commitment. But Eagleton wants to interpret such facts in a completely one-sided manner, so that he can see works of art as anxiously alienated from the external world and themselves (as Seurat's pedestrians were for Nochlin). They can then, by a 'devastating irony', get into the right kind of deconstructive self-contradiction, by becoming 'fetish' objects, so that

> the modernist work escapes from one form of commodification only to fall prey to another. If it avoids the humiliation of becoming an abstract, serialised, instantly exchangeable thing, it does so only by virtue of reproducing that other side of the commodity which is its fetishism. The autonomous, self-regarding, impenetrable modernist artifact in all its isolated splendour, is the commodity as fetish resisting the commodity as exchange, its solution to reification part of that very problem.

The power of the work of art is no more than its function in the marketplace. The long-term political aim of this kind of interpretation is made clear: 'It is on the rock of such contradictions that the whole modernist project will finally founder', because its self-regard puts it at far too great a distance (further than Brecht, anyway) from transforming 'political forces'.[99] The 'modernist project', as an implausibly Hegelianized whole, somehow fails to align itself on the right side of Eagleton's historical dialectic.

This is persuasive interpretation, which reads theoretical concerns into the art of the past, and uses it for contemporary political purposes. There is nothing inherently illogical in this, as we have seen—T. S. Eliot is far from alone in confirming that the 'really new' artwork can recast our appreciation of the old, and so also can a new theory of interpretation. We *can* see Seurat in the light of Roy Lichtenstein, and Cubism in the light of Derrida, and not a few works of art as involving us in 'aesthetic' concerns in order to avoid political ones. But such interpretation needs a narrower, less implausibly generalized focus for its descriptions. Theoretical concerns seem to me to be better justified by working on criteria for the application of the most basic categories for interpretation. (In the case of Seurat, upon the typology of the human interrelationships the work of art projects, and in that of Cubism, upon the nature of artistic language in relation to mimetic commitments.) I believe (following the position I share above with Baxandall) that political interpretation in this field is at best complementary to the historical

reconstruction of artistic intentions, most particularly in the case of innovative work (and the same might well be said of science, which is even more obviously dependent upon socio-economic factors).[100] The difference between my approach and the politicizing one turns, in the end, on the scope of the relevant context (and upon empiricist scruple in specifying it). I have taken a liberal philosophical view of the relationship of individuals to their time (and class), whereas a Marxist interpretation might say that artists can 'objectively' express alienation, or reveal the arbitrariness of representation as a means of challenging dominant ideologies, or fetishize the art object, and so on, even when as individuals they may have been wholly unaware of the power and scope of such concepts (by virtue of their unemancipated positions within 'bourgeois' or 'capitalist' society).[101]

This for me is too broad; the context needs to be more closely defined (to the point at which, as I suggested at the outset, contradiction and inconsistency are allowed to emerge). This is because, as I hope I have shown, artists and their works of art are at least as good as their critical interpreters at redefining for us the boundaries between our concepts. My narrower contextual constraint has not, in any case, prevented me from interpreting early Modernist art as responding to the tensions and contradictions brought about by larger cultural forces—such as the city, the growth in the media, the repressions of family life, and so on. These larger social formations and their historical relationship to the avant-garde indeed merit a closer and more extensive attention than I have been able to give them here. Modernist art is indeed the site of a struggle in matching technique to idea which can include the relationship of the work to political and religious ideologies, as we have seen throughout, and obviously so in the case of Kandinsky, Joyce, and the Futurists. The innovative artist responds to basic and recurrent problems of a philosophical character—most notably, as I have shown, those centred on representation, personal identity, our relationship to the biographical past, the growth in secularization, the ways in which works of art may be related to general conceptions of language, logical versus irrational processes, and emotions which may work at a subconscious level. None of these are simply 'aesthetic' problems. They are of general philosophical, epistemological, ethical, and hence political concern, and the art they provoked thereby earns a particular standing in our awareness of the past. I agree with Charles Altieri that:

Given our need for memory and the manifest power of various canonical works

to transcend any single structure of social interest . . . it is possible to recover some of the force of classical ideals of a canon. Through that effort, we recover modes of thought about value and human agency sorely lacking in the dominant critical attitudes, fostered by the hermeneutics of suspicion.[102]

A more overtly political approach to the interpretation of work of this kind seems to me to be by contrast far *less* problematic than those concerned with value and human agency, since the political interests of the interpreter can so often be read off the interpretation offered, and with a depressingly shallow and repetitive obviousness. Such interpretation all too often leads, particularly when it is trumpeted as being 'against the grain' of the likely historical intentions of the artist, to crudely pragmatic judgements of the past through the political inclinations of an 'enlightened' present. From the point of view of the history of ideas, as I have tried to present it, the answers to the questions which artists pose themselves are not nearly so obvious as the political approach pretends, if only because their ideas become problematic within highly specific historical contexts (as Nietzsche and others argued), and in art (as opposed to science) they remain allied to the unsolved problems of philosophy. The efforts of the Modernists to confront such dilemmas have a special interest, because they indeed thought of themselves as confronting inherited tradition, in this philosophical sense, as their many theoretical reflections cited in this book will show. This gives the work of many of them depth.

In this perspective, the Dadaist notion of the avant-garde has been a disaster—it is parasitic upon the institutions it attacks, its thought is shallow, and its failure to develop its own artistic tradition condemns it to the purely *ad hoc* gesture. Duchamp's *Urinal* is not a profound, or even a continuously interesting, work of art—it is a politico-historical example, and the type of avant-garde to which it belongs is condemned to have no more than an interesting political history. Under such conditions the notion of the work of art as a complex and permanently interpretable locus of deep problems, implicit in Tzara's manifesto, is sacrificed—as Bürger blithely urges—in favour of the praxis of an ongoing life, which is all too often that of ideological competition between artistic groups.[103]

All the major artists we have discussed had explicitly critical beliefs about the values dominant in their society (as their attitudes to sexual relations alone would show). These early critical positions led to a postwar divide, between classicizing Modernists (such as Pound, Eliot,

Woolf, Joyce, and Gide), who were preoccupied by the threat of social decline, and were to that extent the conscious upholders of 'good' past tradition, and an iconoclastic avant-garde, of Dadaists, Surrealists, and others, who looked to the release of repression in art as encouraging a utopian social progress which would reject or suppress past traditions. This suggests that an answer to the question, whether early Modernist art can be seen as 'progressive' in some political sense, would need to pursue its historical analysis some way beyond the chronological limitations I have set myself, in particular towards the reactions to Modernism which were part of the political and aesthetic debates which took place in the 1930s, and which continue in the many attempted contrasts between Modernism in general and Postmodernism. I have tried to make it clear that most early Modernists were part of a sceptical intellectual tradition, but the wish to supersede the art of the past by a reconsideration of its languages seems to have engaged artists of the political right (such as Kandinsky, Eliot, Lewis, Pound, and Benn) just as much as it did those of the political left (such as Picasso, Joyce, many German Expressionists, and much of the Dada movement). Much of the German Expressionist work discussed in this book, for instance, is explicitly sexist—produced in the belief that only superior men can produce a revival of humanity, and that women are inherently inferior, if not primitive. As Douglas Kellner remarks, 'The Expressionists on the whole were reactionary on the question of women's liberation, and were far behind Ibsen and the Naturalists on this issue'.[104] Although the notion that intellectual and political progress depends upon an enlightened eighteenth-century secularizing and equality-advocating model is immensely attractive, the narrative I have offered seems to suggest that the idea of innovation in an avant-gardist context can liberate artists for whom neither a leftwards nor a secular temperament seems to be necessary. Indeed, the claim of many early Modernists to progressive attitudes is often far *less* strong than that of the technically conservative, whiggish, and bourgeois, liberal realists who preceded and surrounded them, and upon whom they so often depended for a critical defence.[105]

It is therefore vital, at least for the interpretation of early Modernism, to distinguish between its evolution at the hands of men who, like Matisse, Kandinsky, Schoenberg, Stravinsky, Pound, and Eliot, were, as the conservative Hilton Kramer points out, 'tradition haunted' and 'mindful, above all, of the continuity of culture and thus committed to the creative renewal of its deepest impulses',[106] and a Futurist and Dada avant-gardism which attempted to destroy the past, and, by doing so, to

lead to very different kinds of political liberation—often Fascist in the Futurist case, and socialist anarchist in the Dada one. For these destroyers, as Barthes put it, 'The new is not a fashion but a value . . . to escape from the alienation of present society, there is only one way: *escape forward*.'[107] From such a perspective the avant-garde may seem to espouse the values of freedom *from* alienation, oppression, the bourgeoisie, and so to aim at goals whose justifications are indeed social rather than aesthetic. But both the conservative and the radical avant-gardes needed a basic guarantee of liberal freedoms *to*, for a critical innovatory art to be at all possible, as the conflicts with the censor of Baudelaire, Flaubert, Zola, Wedekind, Wilde, Ibsen, Schiele, Marinetti, and Joyce, and the wholesale condemnation of Modernism by Nazis and Soviets alike show.

The early Modernists of left and right were indeed 'the combative conscience of bourgeois civilisation',[108] and to that extent their allies were all those who fought against authoritarian rigidity (such as Heinrich Mann, Arthur Schnitzler, or the anti-Victorians Shaw, Wells, Strachey, and others). As I have tried to show, this movement of liberalizing ideas (drawing at the turn of the century upon Wedekind, Nietzsche, Ibsen, Shaw, and others) is an essential part of the turn *towards* Modernism. But it depended upon the advocacy of tolerance made by the Naturalists of the nineteenth century, in such matters as sexual expression, secular as opposed to religious views, and the rights of minorities, particularly women.[109] Most early Modernists (misogynistic Futurists dissenting) seem to have taken the principles involved in that kind of battle for granted, so that what then becomes 'Modern' is not so much a realist explicitness about the world outside art, as the (increasingly post-Freudian) interpretation that it is given. For the early Modernist attack on nineteenth-century consensual realism did not cover a retreat to the aesthetic—on the contrary, it led to an experimental search for new kinds of realism, most particularly concerning the subjective realm (as Virginia Woolf and Joyce were to make clear after the war). Most importantly, it led to an exploration, within Modernist experimental art, of the differences between male and female experience of the world. The aim then was not to provide reliable descriptions of external reality, but to produce forms of art which modified these in such a way as to provoke psychological responses of a kind to reveal the new (and competing) ideas of the nature and value of subjective experience, such as we find in Bergson, Freud, and others. Lawrence, inspired by Marinetti and Freud, realized this as well on the right as did the

Dadas and Surrealists on the left. Such work tests our conception of the very nature of the self. Hence my emphasis throughout on the expressionist nature of early Modernism. I have tried to show that it was concerned, not just with the limits of a permissible description of experience, or questions about the nature of abstraction from it, but with understanding the close interdependence between changes in artistic convention and changes in beliefs about 'the nature of human nature'. These preoccupations helped it to ask questions to which its later critics and interpreters still need to find satisfactory answers.

Bibliographical Note

On Mauthner, cf. Gershon Weiler, *Mauthner's Critique of Language* (Cambridge, 1970). For a general study of the experimentalism of the German Expressionist play, see M. Patterson, *The Revolution in German Theatre, 1900–1933* (London, 1981). For the politics of the arts in Germany after the war, see Helen Lewis, *Dada Turns Red: The Politics of Surrealism* (Edinburgh, 1990), and Joan Weinstein, *The End of Expressionism: Art and the November Revolution in Germany, 1918–1919* (Chicago, 1990). For the reactions of artists in France to the First World War, see Kenneth E. Silver, *Esprit de Corps: The Parisian Avant Garde and the First War, 1914–1925* (London, 1989). On the contrast of Modernism with Postmodernism, with references, see further Astradur Eysteinsson, *The Concept of Modernism* (Ithaca, NY, 1990), 128 ff. On Soviet and Fascist reactions to Modernism cf. e.g. Igor Golomstok, *Totalitarian Art* (London, 1990). For a study of the marginalized and often promotional role of women in the Modernist movement, see e.g. Shari Benstock, *Women of the Left Bank: Paris, 1900–1940* (Austin, Tex., 1986). The issue of women's freedom is central to the non-experimental work of this early period. Before the advent of Richardson, Woolf, Compton-Burnett, Mansfield, Rhys, and others, the most important experimenters seem to have been H.D. and Gertrude Stein, with, perhaps, May Sinclair. For a polemical feminist study of the Modernist period, see Sandra Gilbert and Susan Gubar, *No Mans Land: The Place of the Woman Writer in the Twentieth Century* (New Haven, Conn., 1988)—the first volume of a trilogy. For the vexed issue of Wedekind's attitudes to women see Elizabeth Boa, *The Sexual Circus: Wedekind's Theatre of Subversion* (Oxford, 1987). For a good anthology of German debates on the left concerning the significance of Modernism, see the anthology *Aesthetics and Politics: Debates between Bloch, Lukacs, Brecht, Benjamin, Adorno* (London, 1977).

Notes

[1] e.g. the spread of Expressionist techniques in painting to Scandinavian countries, as described in Marit Werensjiold's *The Concept of Expressionism* (Oslo,

1984), 95–164; the spread of the Futurist style to Belgium, Czechoslovakia, Poland, and Hungary, as exemplified in Pontus Hulten (ed.), *Futurismo e futurismi* (Milan, 1986); and, perhaps most interesting of all, the reception of a whole range of Modernist ideas in Russia, documented in John Bowlt (ed. and trans.), *Russian Art of the Avant Garde: Theory and Criticism, 1902–1934* (rev. and enl. edn., London, 1988). And the spread of atonality, as Jim Samson argues in his *Music in Transition* (London, 1977), runs through Scriabin and Szymanowski as well as through Schoenberg and his associates. For the painter the art exhibition and the studio visit were obvious modes of migration, and so we want to know who actually saw the *Demoiselles* in the studio, and how Kirchner adapted Matisse after seeing him in Paris. The exhibition could also establish the national and international importance of available styles, as for example at the Sonderbund exhibition in Cologne from 25 May to 30 Sept 1912 (which was the model for the Armory show in New York in 1913) and the Autumn Salon at Berlin in 1913. On these exhibitions see Peter Selz, *German Expressionist Painting* (Berkeley, Calif., 1957), 241 ff. and 265 ff.

[2] In Kirchner and others 'Strident colours were the mark of a refusal of Impressionist shimmer; ugly nudes a declaration of war on the aesthetic standards of the salon tradition'; Roger Cardinal, *Expressionism* (London, 1985), 113.

[3] Even his late paintings (such as the *Spaziergang auf der Brücke* (*Walking across the Bridge*) of 1912 and the *Große Promenade* (*Large Promenade*) of 1914) still owe much to Renoir.

[4] August Macke, cited in Rosel Grolleck, 'Indianen Sturm und Masken: August Macke's Beitrag zum Blauen Reiter', in Ernst-Gerhard Güse (ed.), *August Macke* (Munich, 1986), 40, 43.

[5] He had seen Matisse's work in Munich in Feb. 1910 and made sketches from him: in particular of the *Open Window, Collioure* and of *Luxe calme et volupté*; see Güse, *Macke*, 34. This influence continued in his still lives of 1910–12, in the Matissean transcription of fruit, table cloth, jugs and so on (ibid. 82).

[6] Johannes Langner in Güse, *Macke*, 82, compares the *Großes helles Schaufenster* with *Forces of the Street* and also Delaunay's *Simultaneous Windows*. When Macke saw Delaunay's solo exhibition in Cologne in Mar. 1913 he wrote to Bernhard Koehle: 'bin ich ganz begeistert . . . diese Bilder vor allen anderen imstande sind, einen mit einer geradezu himmlischen Freude an der Sonne und am Leben zu uberschüttern—sie sind gar nicht abstrakt, sondern größte Wirklichkeit, ich sehe es ganz genau' (I'm really enthusiastic . . . these pictures are above all others capable of showering you with an absolutely heavenly delight, in the sun and in life. They are not abstract, but extremely truthful, I can see that quite clearly') (cited by Langner, in Güse, *Macke*, 85). His *Badenden Madchen* (1913) clearly owes something to Delaunay's *Ville de Paris* (and very likely something also to Le Fauconnier).

[7] August Macke, cited by Karl Otten in W. Raabe, *The Era of German Expressionism* (London, 1974), 140.

8 Cf. Patrick Bridgwater, 'The Sources of Stramm's Originality', in J. D. Adler and
 J. J. White (eds.), *August Stramm: Kritische Essays* (Berlin, 1979), to which I am
 indebted in much of what follows.

9 He was also influenced by Worringer and Kandinsky, cf. Bridgwater, 'Sources',
 37 ff.

10 Ernst Mach, 'Antimetaphysische Bemerkungen' (1885), repr. from *Die Analyse
 der Empfindungen und das Verhältnis des Physischen zum Psychischen* (Jena,
 1903), in *Die Wiener Moderne* (Stuttgart, 1981), 141. Cf. Hermann Bahr's 'Das
 unrettbare Ich' in the same volume, 147 f.

11 'Freudenhaus', trans. Bridgwater, from *August Stramm, 22 Poems* (Wymond-
 ham, 1969), n.p. *'Lichte dirnen* aus den Fenstern' here can be adjective and
 noun, or adverb and verb, or noun and verb.

12 Here 'Schamzerpört', a portmanteau word combining 'shame/de[stroy]/
 [indig]nation' which the original printer simplified to 'schamzerstört'
 ('destroyed by shame'). See Stramm's letter cited by J. J. White, *Literary
 Futurism* (Oxford, 1990), 238.

13 He puts Schoenberg in the company of Strindberg, Plato, Kant, Kokoschka,
 Mahler, Kraus, and Weininger in a letter to him of 23 June 1909, cited in Hans
 Moldenhauer, *Anton Webern: A Chronicle of His Life and Work* (London, 1978),
 113.

14 Wilfred Mellers, *Caliban Reborn: Renewal in Twentieth-Century Music*
 (London, 1968), 53.

15 Ibid. 54.

16 From a testimonial of 1912, cited in Moldenhauer, *Webern*, 77.

17 In a note for a performance of the work in 1933 cited ibid. 128.

18 Pierre Boulez, *Stocktakings from an Apprenticeship*, trans. Stephen Walsh
 (Oxford, 1991), 294.

19 Foreword (1924) for the printed score of Webern's *Six Bagatelles for String Quartet*,
 Op. 9 of 1911. Webern thought in retrospect (1932) that these bagatelles were so
 short because 'I had the feeling that when the twelve notes had all been
 played the piece was over. Much later I realised that this was part of
 a necessary development' (sc. of dodecaphonic composition); see Anton
 Webern, *The Path to the New Music* (Philadelphia, 1963), 51. This retrospective the-
 oretical adjustment is like Pound's reading back of Imagism into his earlier poetry.

20 Anton Webern, letter to Schoenberg of 27 Dec. 1908.

21 According to Michael Baxandall, *Patterns of Intention: On the Historical Expla-
 nation of Pictures* (New Haven, Conn., 1985), 41.

22 Flint Schier, in Norman Bryson *et al.* (eds.), *Visual Theory* (Cambridge, 1991), 155.

23 Baxandall, *Patterns*, 45—and also the surface and depth of the individual
 brush stroke.

24 Ibid. 48.

25 On which see Virginia Spate, *Orphism* (Oxford, 1979).

26 Baxandall, *Patterns*, 58 ff.

[27] Cf. Linda Hutcheon, *A Poetics of Postmodernism* (London, 1988), esp. chs. 2 and 8.

[28] Cf. Astradur Eysteinsson on T. S. Eliot and Tradition, in *The Concept of Modernism* (Ithaca, NY, 1990), 59–62.

[29] Cf. Janos Karpati, *Bartok's String Quartets* (London, 1975).

[30] And maybe its apparent theme of non-communication, turning on the 'NON' of the grill. But this is the kind of anticipatory, double-focused, towards Pinter, thematic treatment of Modernism that I have tried to avoid.

[31] A Symbolist motive for this kind of geometric abstraction is offered by Flam, who compares these images with the *Open Window, Collioure* (1914) which is for him a despairing image of 'Mallarméan absence', a look into nothingness (Jack Flam, *Matisse, the Man and his Art, 1869–1918* (London, 1986), 394). This painting was not exhibited until 1966 and then, appropriately enough, as part of a show centring on US Abstract Expressionism (in Ad Reinhardt).

[32] For an account of some of the philosophical pretensions of abstraction, see Mark Cheetham, *The Rhetoric of Purity: Essentialist Theory and the Advent of Abstract Painting* (Cambridge, 1991). Apollinaire's *Méditations esthétiques* (1913) are, as Francis Steegmuller points out (*Apollinaire: Poet among the Painters* (Harmondsworth, 1973), 129), 'written in the turgid, metaphysical style that he seems to have been the first to consider essential to the discussion of *avant garde* art, but which has become all too familiar to readers of prefaces to art books'.

[33] John Milner, *Mondrian* (London, 1992), 109. Cf. the *Composition in Blue Grey and Pink* of 1913.

[34] Cf. *Pier and Ocean* (Composition No. 10) (1915) analysed by Milner, *Mondrian*, 125.

[35] Flam, *Matisse*, 427.

[36] Flam, ibid. 428, sees many golden sections here.

[37] Ibid. 428.

[38] Pierre Schneider, *Matisse* (London, 1984), 404.

[39] Robert Hughes, *The Shock of the New* (London, 1980), 385.

[40] Throughout this period the conservative teaching of historical and biblical narrative painting in art schools continued. Cf. the hilarious account given by George Grosz of the Royal Academy in Dresden in his *A Small Yes and a Big No* (London, 1982), 39–54.

[41] Mark Roskill, *The Interpretation of Cubism* (Philadelphia, 1985), 55.

[42] Its text was originally published in 1892 and translated from Guiraud's French into German by Eric Hartleben. The realization of *Sprechstimme* in this work is still a matter of much dispute. Cf. Pierre Boulez, *Stocktakings: From an Apprenticeship*, trans. Stephen Walsh (Oxford, 1991), 206 ff. For a general study which places the work in the pierrot tradition, see Jonathan Dunsby, *Schoenberg: Pierrot Lunaire* (Cambridge, 1992).

[43] Constant Lambert also felt that its relationship to past and present was not fully

resolved. For him a 'typical Schoenberg phrase' drew from *Tristan* and *Parsifal*, so that *Pierrot* was an example of Schumann and Wagner 'gone wrong': 'there is a slight touch of a Lieder recital that has taken a wrong turning' (in his *Music Ho!* (1934; repr. London, 1966), 248, 249). This 'wrong turning' was fully exploited in one of *Pierrot*'s successor works—Berio's *Recital I*.

44 M. Druskin, *Igor Stravinsky, his Personality, Works and Views* (Cambridge, 1983), 41.

45 Igor Stravinsky and Robert Craft, *Expositions and Developments* (London, 1962), 118.

46 Cf. Stephen Walsh, *Stravinsky* (London, 1988), 77.

47 Waldemar George, 'Juan Gris', in *L'Amour de l'art* (Paris, Nov. 1921), 35, cited in Christopher Green, *Juan Gris* (London, 1992), 21.

48 Cf. e.g. L. Somville, *Les Devanciers du surréalisme* (Geneva, 1971), and K. Cornell, *The Post Symbolist Period* (New Haven, Conn., 1958), for accounts of the many literary movements in Paris alone from 1909–1916.

49 Gossez delivered a lecture on 16 Jan. 1910 on 'Le Dynamisme poetique'; cf. Somville, *Devanciers*, 86 f.

50 A theme of his work *L'Homme cosmogonique* (edn. of 1922), cited in Somville, *Devanciers*, 107.

51 Charles Harrison, *English Art and Modernism* (London, 1981), 18.

52 Cf. Eysteinsson, *Concept*, 47–9, for an argument that it is only with Post-Structuralism that literary theory catches up with Modernist practice—in its crises of language and representation and of the subject.

53 Though it should be noted that a rational non-associationist critique of bourgeois thought was sustained in this period by Sternheim and Kaiser amongst others. See M. Helena Gonçalves da Silva, *Character, Ideology and Symbolism in the plays of Wedekind, Sternheim, Kaiser, Toller and Brecht* (London, 1985).

54 A tradition which continued via the Freudian interpretation of Marxist false consciousness in the Frankfurt school, to the work of R. D. Laing and others in the 1960s and beyond. Gablik says that 'the overarching principle of modernism has been autonomy. Its touchstone is individual freedom, not social authority. Liberation from rules and restraints, however, has proven itself to mean alienation from the social dimension itself' (Suzi Gablik, *Has Modernism Failed?* (London, 1984), 24.

55 Cf. e.g. Raymond Geuss, *The Idea of a Critical Theory* (Cambridge, 1981), and Martin Jay, *The Dialectical Imagination* (Boston, 1973).

56 Reinhard Sorge, *Der Bettler* (Berlin, 1918). The son wishes to provide the 'Grundlage und Anfang eines erneuerte Dramas' ('the foundation and beginning of a renewed drama') (44), to test all its limits ('grenzen', 46), and 'Bilder | Der Zukünfte erzählen' ('make narrative pictures of the future') (47). He is to be the prophet of the 'Massen der Arbeiten', women, and cripples who are waiting for a sense of the higher life from him (48).

[57] Walter Hasenclever, *Der Sohn*, in *Gedichte, Dramen, Prosa*, ed. Kurt Pinthus (Hamburg, 1963), 129, 137, 154.

[58] Cited in Raymond Furness, *German Literature in the Twentieth Century* (London, 1978), 169 f.

[59] Tristan Tzara, 'Zurich Chronicle', in the *Dada Almanach* (Berlin, 1920), 14, from Robert Motherwell (ed.), *Dada Painters and Poets* (2nd edn., Cambridge, Mass., 1989), 236.

[60] The poem is reprinted in Motherwell, *Dada*, 241; it was published in the June 1916 issue of the *Cabaret Voltaire* magazine.

[61] As Hulsenbeck pointed out in 1920, cf. Motherwell, *Dada*, 24.

[62] Tzara ,'Zurich Chronicle', ibid. 236.

[63] See Hans Richter, *Dada: Art and Anti-Art* (London, 1965,) 77 ff., whom I follow.

[64] Printed in its various typography, ibid. 8. Cf. Ball's own account of the poem in Motherwell, *Dada*, p. xxxv.

[65] Hugo Ball, Diary, 5 Mar. 1917 (cited in Richter, *Dada*, 41).

[66] And the same is true for poems by Hulsenbeck (cited ibid. 20 ff.) and Arp (cited in ibid. 52 ff.).

[67] Hugo Ball, 'Dada Fragments', in Motherwell, *Dada*, 51 f., who goes on to say that 'The Dadaist is fighting against the agony of the times and against inebriation with death' (in his Diary, 'Flucht aus der Zeit', 18 June 1916).

[68] In Richter, *Dada*, 53 f.

[69] Jean Arp, 'Dadaland', cited in ibid. 25. Cf. Richard Hulsenbeck, 'The German dichter is the typical dope, who carries around with him an academic concept of 'spirit', writes poems about communism, Zionism, Socialism as the need arises and is positively amazed at the powers the Muse has given him' ('En avant Dada', in Motherwell, *Dada*, 28).

[70] Aldo Rukser, 'Dada Almanach' (Berlin, 1920), cited in Richter, *Dada*, 101.

[71] Tristan Tzara, 'The Dada Manifesto' (1918), in Lucy Lippard (ed.), *Dadas on Art* (Englewood Cliffs, NJ, 1971), 18. It was read out in the Meise Hall, Zurich, on 23 Mar. 1919.

[72] Ibid. 17. Note the appeal once more to an internal rhythm.

[73] Ibid. 16.

[74] Ibid. 17. The Freudian system is of course a general explanation of anything, including Dada, but I am stressing here that it did not provide early Dada with the 'idea' which inspires its techniques.

[75] Ibid. 15.

[76] On the political aims of Dada in Germany according to Hulsenbeck's manifesto, see Lippard, *Dadas*, 48 ff. and 50–1.

[77] Charles Russell, *Poets, Prophets and Revolutionaries* (Oxford, 1985), 113.

[78] Peter Bürger, *The Theory of the Avant Garde*, trans. Michael Shaw (Manchester, 1984), 49.

[79] Ibid. 51. Cf. 56 f. for his further analysis of Duchamp.

80 Terry Eagleton, *The Theory of the Aesthetic* (Oxford, 1990), 371. The choice between Dada and the distancing political criticism of a Brecht, for example, surely lies with the latter, so far as political effectiveness (and a respect for individual assent) is concerned.

81 For an excellent overall view, see Francis Frascina *et al.*, *Modernity and Modernism: French Painting in the Nineteenth Century* (New Haven, Conn., 1993).

82 Linda Nochlin, 'Seurat's *La Grande Jatte*: An Anti-Utopian Allegory', repr. in her *The Politics of Vision* (London, 1991), 171.

83 Cf. ibid. 170. Only a complex theory of false consciousness can attempt to persuade one that people are not 'really' enjoying something they say they enjoy; i.e. they are deceived or would see that they were, if only they could be got to adopt the Marxist interpretation of their experience. But the same goes for any other kind of conversion experience, e.g. the Freudian.

84 Cf. Peter Gay's amusing essay on the differences within the bourgeoisie, in his Introduction to his *The Bourgeois Experience*, i. *The Education of the Senses* (Oxford, 1984), 1–45.

85 Nochlin, 'Seurat', 171, 173.

86 Kirk Varnedoe, *A Fine Disregard: What Makes Modern Art Modern?* (London, 1990), 15–17.

87 Gustave Coquiot, cited in John Russell, *Seurat* (London, 1965), 146.

88 Ibid. 154 f.

89 Nochlin, 'Seurat', 173.

90 Ibid. 174. He is supposed to be different from Cézanne, Gauguin, and Van Gogh in this respect.

91 Nochlin thus adapts Seurat's picture to a political interpretation without being at all convincing about the circumstances of its production. It is, she says, 'possible to read' it as anti-Fourierist—it 'may be considered' a parody of Puvis's *The Sacred Grove*, and so on. Some of the contemporary responses to the picture may justify her emphasis on 'the monotony, the dehumanising rigidity of modern urban existence' (ibid. 180) in which 'gender difference' is 'objectified and systematised', and even the wet nurse is 'dehumanised' as a 'critical index of social malaise' (ibid. 185). The types in the picture are no longer 'picturesquely irregular' as in earlier caricatural tradition, but are 'reduced to laconic visual emblems of their social and economic roles, [in] a process akin to the workings of capitalism itself' (ibid.).

92 James D. Herbert, *Fauve Painting: The Making of a Cultural Politics* (New Haven, Conn., 1992), 65.

93 Ibid. 11. Marianna Torgovnick, *Gone Primitive* (Chicago, 1990), *passim*, is equally keen on this kind of guilt by association.

94 Herbert, *Fauve Painting*, 108.

95 Norman Bryson, *Looking at the Overlooked* (London, 1990), 83.

96 Rosalind Krauss, 'Using Language to do Business as Usual', in Norman Bryson *et al.* (eds.), *Visual Theory* (Cambridge, 1991), 84. Bryson sensibly

objects to this that there is a 'sliding scale' between arbitrariness and illusionism (97) and that the matter should not be discussed 'ahistorically' (99). Christine Poggi, *In Defiance of Art* (New Haven, Conn., 1992), 48 ff., also endorses a Saussurean approach to collage, but allows for 'resemblance' and 'iconicity'.

97 Rosalind Krauss, *The Originality of the Avant-Garde* (Cambridge, Mass., 1986). 38. As Christopher Green points out, in *Juan Gris*, 34, this goes beyond intention and process on to a 'metaperceptual plane' in which the distinctions made at the time between analytic and synthetic Cubism no longer matter. And cf. his discussion of Gris and Cubism in relation to theories of language, ibid. 83–7. He points out that paintings should in any case be treated as 'parole' rather than as 'langue' (thus making the artist present once again).

98 Terry Eagleton, 'Capitalism, Modernism and Postmodernism', in his *Against the Grain: Selected Essays* (London, 1986), 139, 140.

99 Ibid. 140.

100 Which in the case of Cubism might well come to political conclusions closer to those of Patricia Leighten, *Reordering the Universe: Picasso and Anarchism, 1897–1914* (Princeton, NJ, 1989), 111 ff., than to those of Krauss.

101 Cf. Adorno's rejection of an intentionalist approach as reported in Eysteinsson, *Concept*, 44.

102 Charles Altieri, in Robert Hallberg (ed.), *Canons* (Chicago, 1984), 42.

103 In any case, the ultimate political direction of art, even in the Dadaist tradition, is not all that obvious. It is far too easily assumed, for example, that Dada tended to the left, partly because of its post-war history, and partly because of its encouragement of a reflexivity which seems to be compatible with a later Brechtian distancing and estranging critique. But Dada and the other irrationalist movements which so much inspired Postmodernist art are open to the accusation that they are no more than a playful deconstruction of dominant modes of thought, and hence ultimately neo-conservative in tendency.

104 Douglas Kellner, in Stephen E. Bronner and Douglas Kellner (eds.), *Passion and Rebellion: The Expressionist Heritage* (London ,1983), 191.

105 Cf. e.g. Peter Keating, *The Haunted Study* (London, 1989). It is hardly surprising that there was a (broadly socialist) Realism which would have liked to have superseded formalist Modernism in the 1930s. The most critical texts often depend upon a synthesis of Modernist formal innovation and the Realist tradition. Eysteinsson, *Concept*, 118, cites *Heart of Darkness, The Ambassadors, The Good Soldier, Der Zauberberg, La Condition humaine*, and *La Nausée*. Joyce's *Portrait of the Artist* would be another.

106 Hilton Kramer, *The Age of the Avant Garde* (London 1974), 7.

107 Roland Barthes, *The Pleasure of the Text* (New York, 1977), 40.

108 Kramer, *Age*, 6.

109 For an account of the latter see Eysteinsson, *Concept*, 89 ff.

BIOGRAPHICAL NOTES

Guillaume Apollinaire (Wilhelm Apollinaris Kostrowitsky) (1880–1918) French poet, art critic, and journalist. His poetic work appeared as *Les Alcools* (1913) and *Calligrammes* (1918). He was a supporter of the Cubist and other schools in painting. Also wrote pornography, short stories, and *Les Mamelles de Tirésias* (1918), a play which helped to give rise to the term 'surrealist'.

Jean (Hans) Arp (1888–1966) French sculptor and painter. Exhibited with the Blaue Reiter (Blue Rider) group in Munich, 1911. Helped found Dada movement 1916–19 and was later associated with the Surrealist movement. Second only to Brancusi in his influence on organic abstract sculpture.

Hugo Ball (1886–1927) German poet and polemicist. Studied philosophy as a student, later associated with Wedekind. Founded Dada Cabaret Voltaire in Zürich in 1916.

Henri-Martin Barzun (1881–) French poet, founder of Simultanéiste movement; author of 'La Trilogie des Forces' (1908–14).

Charles Baudelaire (1821–67) French Symbolist poet and critic. Author of *Les Fleurs du mal* (1857), was prosecuted for offences to public morals. Also wrote a number of poems in prose, as well as art criticism.

Clive Bell (1881–1964) English art and literary critic. Influenced at Cambridge by G. E. Moore. Married Vanessa Stephen in 1907, in 1910 met Roger Fry, and was closely associated with the Bloomsbury Group. Author of *Art* (1914) and of *Civilisation* (1928).

Gottfried Benn (1886–1956) German poet. Collected early poems published in 1927. Embraced philosophy of Nihilism as a young man, and in 1933 associated himself with National Socialism. In army during war, after which he achieved a European reputation for his later poems, collected in 1956.

Alban Berg (1885–1935) Austrian composer. Disciple of Schoenberg, his work was characterized by free harmonic language tempered with romantic tonal elements. Among his principal works are the operas *Wozzeck* (1925) and *Lulu* (of which the first two acts were performed in 1937), and the posthumous Violin Concerto of 1936.

Henri Bergson (1859–1941) French philosopher. From 1900 a professor at the Collège de France and in 1927 won Nobel prize for literature. His most important works include *Time and Freewill* (1889), *Matter and Memory* (1896), and *Creative*

Evolution (1907). His anti-rationalist philosophy deeply influenced the Italian Futurists.

Umberto Boccioni (1882–1916) Italian artist and sculptor. After working with Balla, Severini, and Marinetti from 1898 to 1914, wrote comprehensive survey of the movement, *Pittura, scultura futuriste* (1914).

David Bomberg (1890–1957) English painter, founder member of the London Group (1913). In Paris, met avant-garde artists including Modigliani, Derain, and Picasso. His large compositions, *The Mud Bath* and *In the Hold* (1913–14), combine abstract and Vorticist elements.

Georges Braque (1882–1963) French painter. One of the founders of classical Cubism, worked with Picasso 1908–14. After World War I developed a non-geometric, semi-abstract style. In 1924 and 1925, designed scenes for Diaghilev ballets *Les Facheux* and *Zéphyr et Flore*.

Carlo Carrà (1881–1966) Italian painter. Initially (1909–14) aligned himself with the Futurists and was one of the original signatories of the Futurist Manifesto at the Paris Exhibition, 1911. In 1915 met Giorgio di Chirico and was influenced by his 'metaphysical painting' movement. Thereafter aimed to synthesize past and present, seeking a bridge between Giotto and Cézanne.

Blaise Cendrars (Frédéric Louis Sauser) (1887–1961) Swiss novelist, poet, and traveller. In 1910 met Apollinaire, by whom he was greatly influenced. Wrote his first long poem in America, *Les Paques à New York* (1912), which, with his *Prose du Transsibérien* and his third and longest poem, *Le Panama ou Les Aventures des mes sept oncles* (written 1918, published 1931), had an important shaping influence on modern poetry.

Paul Cézanne (1839–1906) French artist. Exhibited at the first and third Impressionist exhibitions in Paris in 1874 and 1877. In his later period (after 1886) he emphasized the underlying forms of nature—'the cylinder, the sphere, the cone'—and thus became the forerunner of Cubism.

Joseph Conrad (Jozef Teodor Konrad Nalecz Korzeniowski) (1857–1924) Polish-born British novelist. In 1878 joined an English merchant ship and sailed between Singapore and Borneo. His stay in the Belgian Congo provided background and incident for his famous short story, *Heart of Darkness* (1899). Settled in Kent, where he wrote short stories and novels, including *Lord Jim* (1900), *Nostromo* (1904), and *The Secret Agent* (1907).

Robert Delaunay (1885–1941) French painter. First works painted in a colourful Divisionist technique, but subdued under the influence of Cézanne. Later returned to high-key colour in series of paintings of Saint-Severin and the Eiffel Tower, by which he is best known. Then began isolating areas of pure colour in his pictures, a technique he called Orphism, which eventually led to almost pure

abstraction. Visited in 1912 by members of the Blaue Reiter (Blue Rider) group, who were greatly influenced by him.

Marcel Duchamp (1887–1968) French-born American painter. Associated with several modern movements including Cubism and Futurism, he shocked his generation with such works as *Coffee-Mill* (1911) and *Nude descending a staircase* (1912). One of the pioneers of the Dada movement.

T. S. Eliot (Thomas Stearns) (1888–1965) American-born British poet, critic, and dramatist. Lived in England from 1911. An associate of Ezra Pound, whose enthusiastic support led to the publication of Eliot's first volume of poetry, *Prufrock and Other Observations* (1917). Introduced into the Bloomsbury Circle, where his influential volume *The Waste Land* (1922) was published by Leonard and Virginia Woolf at the Hogarth Press. Edited the quarterly review *The Criterion* from 1923 to 1939. In 1948, awarded the Nobel prize for literature.

Sigmund Freud (1856–1939) Austrian neurologist and founder of psychoanalysis, which he refined into a method of treatment. In 1900 published his seminal work *Die Traumdeutung* (*The Interpretation of Dreams*) and in 1902 was appointed extraordinary professor of neuropathology at the University of Vienna, where he established the Vienna Psychoanalytical Society (later the International Psychoanalytical Association) with Alfred Adler and Carl Jung.

Roger Fry (1866–1934) English artist and art critic, became a champion of modern artists, especially Cézanne, and organized the first London Exhibition of Post-Impressionists in 1910. Founded the Omega Workshops in London (1913–21), in association with Vanessa Bell, Duncan Grant, and others of the Bloomsbury Group, to design textiles, pottery, and furniture. Writings include *Vision and Design* (1920), *French Art* (1932), and *Reflections on British Painting* (1934).

Albert Gleizes (1881–1953) French painter. With Jean Metzinger, founded *Section d'Or* Gallery in Paris, 1912 and wrote *Du Cubisme* (1912), both of which gave impetus to the development of Cubism as an international style.

Juan Gris (José Victoriano González) (1887–1927) Spanish painter. Associated with Picasso and Matisse in Paris and became a consistent exponent of synthetic Cubism. Exhibited with the Cubists in the *Section d'Or* exhibition in Paris, 1912, and at the Salon des Indépendants, 1920. Settled in Boulogne and in 1923 designed the décor for three Diaghilev productions.

Georg Grosz (1893–1959) German-born American artist. Associated with the Berlin Dadaists in 1917 and 1918. Produced a series of bitter, ironical drawings attacking German militarism and the middle classes. Fled to USA in 1932 and subsequently produced many oil-paintings of a symbolic nature.

Walter Hasenclever (1890–1940) German dramatist and poet. Wrote the lyrical poems *Der Jüngling* (1913) and *Tod Auferstehung* (1916) and pioneered German

Expressionism with his father–son drama *Der Sohn* (1914). A pacifist, he committed suicide in a French internment camp.

Georg Heym (1887–1912) German poet. Member of *Der Sturm* group (*The Storm*, weekly Berlin review, *fl.* 1910). Wrote Expressionist poetry, including *Der ewige Tag* (1911), and *Umbra vitae* (1912).

Hugo von Hofmannsthal (1874–1929) Austrian poet and dramatist. Devoted himself to drama, one of his major works being the comedy *Der Schwierige* (1921). Wrote the libretti for Richard Strauss's *Der Rosenkavalier* (1911), *Ariadne auf Naxos* (1912), *Die Frau ohne Schatten* (1919) and others. With Strauss and Max Reinhardt, helped found the Salzburg Festival after World War I.

T. E. Hulme (Thomas Ernest) (1883–1917) English critic, poet, and philosopher. Joined Pound, Wyndham Lewis, and Epstein as a champion of modern abstract art, of the poetic movement known as 'Imagism', and of the anti-liberal political writings of Georges Sorel. Killed in action in France, he left a massive collection of notes, published as *Speculations* (1924) and *More Speculations* (1956).

Richard Hülsenbeck (1892–1974) German poet and artist. One of the founders of the Zürich group of Dada artists at Hugo Ball's Cabaret Voltaire in 1916. In 1917 transmitted Dada movement to Berlin, where it took on a more political character.

James Joyce (1882–1941) Irish writer, born in Dublin, left for Paris in 1902. Wrote *Dubliners* (1914) and was championed by Pound, who published the auto-biographical *Portrait of the Artist as a Young Man* in instalments in *The Egoist* (1914–15). His seminal novel, *Ulysses*, was published in Paris in 1922; and in the United Kingdom in 1936.

Carl Jung (1875–1961) Swiss psychiatrist. Met Freud in Vienna in 1907, became his leading collaborator, and was elected president of the International Psychoanalytical Association (1910). Increasingly critical of Freud's insistence on the psychosexual origins of the neuroses, he eventually broke with him and published his own research in *The Psychology of the Unconscious* (1911–12).

Wassily Kandinsky (1866–1944) Russian-born French painter, an originator of abstract painting and an influential theoretician. Published *On the Spiritual in Art* in 1912, the year in which he established the Blaue Reiter (Blue Rider) Group with Franz Marc and Paul Klee. Later worked at the Bauhaus in Germany (1921–33).

Ernst Ludwig Kirchner (1880–1938) German artist. Became the leading spirit in the formation of 'Die Brücke' ('The Bridge') (1905–13), the first group of German Expressionists. Many of his works were confiscated as degenerate by the Nazis in 1937, and he committed suicide in 1938.

Jules Laforgue (1860–87) Uruguay-born French poet and prose writer. His verse, including *L'Imitation de Notre-Dame la Lune* and *Le Concile féerique* (1886), had a great influence on T. S. Eliot and others.

D. H. Lawrence (David Herbert) (1885–1930) English novelist, poet, and essayist. Encouraged by Ford Madox Ford and Edward Garnett, established his reputation with the semi-autobiographical *Sons and Lovers* (1913). Prosecuted for obscenity after publication of *The Rainbow* (1915) and left England for Italy, where he wrote *Women in Love* (1921) and where he eventually died of tuberculosis. Was again prosecuted for obscenity over his private publication in Florence of *Lady Chatterley's Lover* in 1928 and over an exhibition of his paintings in London in 1929. Other major works include *Aaron's Rod* (1922), *Kangaroo* (1923), and *The Plumed Serpent* (1926). Collected poems published in 1928.

Wyndham Lewis (1882–1957) English novelist, painter, and critic, born in Nova Scotia. Instituted the Vorticist movement with Erza Pound, and established *Blast* (1914–15), the magazine which expounded their theories. Served on the Western Front from 1916 to 1918 as a bombardier and as a war artist. His novels, *Tarr* (1918), *The Childermass* (1928), and *The Apes of God* (1930), are vivid satires of intellectual and Bohemian life.

Alfred Lichtenstein (1889-1914) German poet. Early Expressionist writer, whose speciality was the grotesque. His poem *Die Dämmerung* was published in a journal in 1911. His collected works, *Gedichte und Geschichten*, were published posthumously in 1919.

Ernst Mach (1838–1916) Austrian physicist and philosopher. His writings, *Mechanik in ihrer Entwickelung* (1883) and *Beiträge zur Analyse der Empfindungen* (*Contributions to the Analysis of Sensations*, 1897), greatly influenced Albert Einstein and laid the foundations of logical positivism.

August Macke (1887–1914) German painter. Influenced by Matisse, was a sensitive colourist, focusing on the kind of subject-matter favoured by the Impressionists. In 1912 founded the Blaue Reiter (Blue Rider) Group with Franz Marc, and Wassily Kandinsky. Killed in action at Champagne, France.

Stéphane Mallarmé (1842–98) French poet, leader of Symbolist School. The wilful obscurity of his style was made famous by his poem, *L'Après-midi d'un faune* (1876), later illustrated by Manet. Other works admired by the 'decadents' were *Les Dieux antiques* (1880), *Poésies* (1899), and *Vers et prose* (1893).

Thomas Mann (1875–1955) German novelist, moved to Italy and established his reputation with *Buddenbrooks* (1901) at the age of 25. *The Magic Mountain* (1924) won him the Nobel prize for literature in 1929. Exposed Italian fascism in *Mario and the Magician* (1930) and settled in the USA in 1936, from where he made anti-Hitler broadcasts to Germany. In 1947 returned to Switzerland, and in the same

year published his masterpiece, *Doktor Faustus* (1947). Earlier works include the novella *Death in Venice* (1912).

Marinetti (Emilio Filippo Tommaso) (1876–1944) Italian writer, one of the founders of Futurism. Studied in Paris and Genoa and published the original Futurist manifesto in *Figaro* in 1909. Writings include *Le Futurisme* (1911), *Teatro sintetico futurista* (1916), and *Manifesti del Futurismo* (1920), which celebrate war, the machine age, speed, and 'dynamism'. Became a Fascist in 1919.

Henri Matisse (1869–1954) French painter. Studied in Paris and became influenced in 1890s by Impressionism, Neo-Impressionism, and the Divisionism developed by Seurat and Signac. Also admired Cézanne. Painting in St Tropez in 1904, began using high-pitched colour and so started a movement dubbed Les Fauves (Wild Beasts), which included Derain, Vlaminck, Dufy, and Rouault. In later years began working with large paper cut-outs and abstract designs.

Ludwig Meidner (1884–1966) German painter and lithographer. In 1906 visited Paris, where he was greatly impressed by the work of Van Gogh. Belonged to no major artistic movement, but his work's style and subject-matter show Expressionist influences. Shortly before World War I, produced a series of apocalyptic visions which prefigured the disaster and chaos to come.

Jean Metzinger (1883–1957) French painter. With Albert Gleizes, wrote *Du Cubisme* (1912) and founded the *Section d'Or* gallery in Paris in 1912, around which Cubist artists gathered.

Piet Mondrian (Pieter Cornelis Mondriaan) (1872–1944) Dutch artist, helped found the De Stijl movement in architecture and painting. Discarded the traditional sombre Dutch manner in 1909, when he moved to Paris and came under the influence of Matisse and Cubism. During World War I began constructing grids of black lines filled in with primary colours. A great theoretician, he published a pamphlet called *Neo-Plasticism* (1920) which inspired the Dutch philosopher Schoenmakers, and his work has been a major influence on all purely abstract painters.

Claude Monet (1840–1926) French Impressionist painter, exhibited with Renoir, Pissarro, and Sisley at the first Impressionist Exhibition in Paris in 1874. There, one of his paintings, *Impression: soleil levant*, gave the movement its name.

C. R. W. Nevinson (Christopher Richard Wynne) (1889–1946) English artist. Became a leader of the pre-1914 avant-garde and co-signed the Futurist Manifesto with Marinetti. His most famous works reflect his experience at the front as a Red Cross volunteer and as an artist attached to the Bureau of Information. In 1937 published the autobiographical *Paint and Prejudice*.

Friedrich Nietzsche (1844–1900) German philosopher, scholar, and writer. First book, *The Birth of Tragedy* (1872), was dedicated to Richard Wagner, from whom

he broke violently in 1876. Before physical and mental breakdown in 1889, produced a stream of brilliant and unconventional works, including *Untimely Meditations* (1873–6), *The Joyous Science* (1882), *Thus Spake Zarathustra* (1883–92), *Beyond Good and Evil* (1886), *On the Genealogy of Morals* (1887), and *Ecce Homo* (his autobiography, completed in 1888 but withheld from publication by his sister until 1908).

Pablo Picasso (1881–1973) Spanish painter and sculptor. The dominating figure of early 20th-century French art and, with Braque, a pioneer of Cubism. One of the chief inventors of Collage. Made a number of set designs for a series of Diaghilev ballets (1917–24) and was later associated with the Surrealist movement. In the South of France from 1946, he experimented in sculpture, ceramics, and lithography.

Ezra Pound (1885–1972) American poet and critic. Major exponent of the poetic movement 'Imagism'. In London met Ford Madox Ford, T. S. Eliot, and Wyndham Lewis, with whom he edited *Blast* (1914–15), the magazine of the 'Vorticist' movement. Was the London editor of the Chicago *Little Review* (1917–19), and in 1920 became Paris correspondent for *The Dial*. From 1924 lived in Italy and became involved with Fascist ideas. Regarded by T. S. Eliot as the motivating force behind 'modern' poetry. Poetic works include *Personae* (1909), *Homage to Sextus Propertius* (1919), *Hugh Selwyn Mauberley* (1920), and his series of *Cantos* (1917, 1948, 1959).

Rainer Maria Rilke (1875–1926) Austrian lyric poet. His early work expressed spiritual melancholy and the search for the deity, as in *Geschichten vom lieben Gott* (1900) and *Das Stundenbuch* (1905). He became Rodin's secretary and published *Das Rodin-Buch* in 1907, whereupon he abandoned mysticism for the aesthetic ideal in *Gedichte* (1907, 1908). *Die Aufzeichnungen des Malte Laurids Brigg* (1910) portrays the anxiety and loneliness of an imaginary poet, while in his masterpieces, *Die Sonnette an Orpheus* and *Duineser Elegien* (1923), the poet is exalted as mediator between crude nature and pure form.

Jules Romains (Louis Farigoule) (1885–1972) French writer, established his name and the Unanimist school with his poems *La Vie Unanime* (1908) and *Manuel de déification* (1910). Remained prominent in French literature and was president of the International PEN club from 1936 to 1941. Works include poetry, *Odes et prières* (1913), *Chants des dix années 1914–1924* (1928), *L'Homme blanc* (1937); drama, *L'Armée dans la ville* (1911) and *Knock, ou Le Triomphe de la médecine* (1923), and the novels, *Mort de quelqu'un* (1910), *Les Copains* (1913); and the 27-volume *Les Hommes de bonne volonté* (1932–46).

Luigi Russolo (1885–1957) Italian artist. Original signatory of Futurist manifesto composed by Marinetti. With Boccioni, Carrà, Balla, and Severini, one of the founders of the Futurist movement.

Arnold Schoenberg (1874–1951) Austro-Hungarian Jewish composer, conductor, and teacher. His *Chamber Symphony* (1907) and the second *String Quartet* (1908) caused uproar at their first performances in Vienna because of their free use of dissonance. To harness his free chromatic style he developed the 'twelve-note method', dodecaphony, or serialism, first used in Piano Suite Op. 25 (1921–3).

Artur Schopenhauer (1788–1860) German philosopher, reacted against the post-Kantian idealist tradition represented by Hegel, Fichte, and Schelling. Greatest work was *The World as Will and Idea* (1819), which emphasized the active role of Will as the creative force in human nature, and which was greatly to influence Nietzsche and Freud. His diverse essays and aphoristic writings were collected as *Parerga und Paralimpomena* (1851) and he subsequently influenced not only philosophical movements like existentialism but a wide range of figures including Wagner, Tolstoy, Proust, and Mann.

Georges Seurat (1859–91) French artist, founder of Neo-Impressionism. Developed the system known as Pointillisme, founded on the colour theories of Delacroix and the 'chroma' theory of the chemist Chevreul. Main achievement was to combine an Impressionistic palette with classical composition, but his colour theories influenced Signac, Pissarro, Degas, and Renoir.

Gino Severini (1883–1966) Italian artist, moved in 1906 to Paris, where he worked as a Pointillist. In 1910 he signed the first Futurist manifesto, and exhibited with Balla and Boccioni in Paris and London. After 1914 he evolved a personal brand of Cubism and Futurism in his nightclub scene paintings. From 1940 adopted a decorative Cubist manner. His publications include *Du Cubisme au classicisme* (1921).

Georg Simmel (1858–1918) German sociologist and philosopher. Major representative of German sociological formalism, emphasizing the form of a phenomenon rather than its content. Also wrote extensively on philosophy and his books include *Philosophy of Money* (1900, trans. 1978), and a collection of essays published as *Georg Simmel: On Women, Sexuality and Love* (1984).

Reinhard Johannes Sorge (1892–1916) German dramatist. Wrote first full-length Expressionist play, *Der Bettler* (*The Beggar*, 1910) at the age of 18. Killed in war, 1916, at the age of 24.

Gertrude Stein (1874–1946) American writer. Settled in Paris with Alice B. Toklas and became influential in its world of experimental arts and letters. Was associated with Picasso and attempted to apply the theories of abstract painting to her own writing. Her main works include *Three Lives* (1908), *Tender Buttons* (1914), *The Making of Americans* (1925), *The Autobiography of Alice B. Toklas* (1933), *Four Saints in Three Acts* (opera, 1934), and *Everybody's Autobiography* (1937).

August Stramm (1874–1915) German writer. Impressed by Marinetti's Futurist polemic, evolved a condensed poetry, and wrote plays in a hectic Expressionist manner. Two of these were later set as operas by Hindemith.

Richard Strauss (1864–1949) German composer whose symphonic poems include *Don Juan* (1889), *Till Eulenspiegel* (1894–5), *Also Sprach Zarathustra* (1895–6), *Tod und Verklärung, Don Quixote,* and *Ein Heldenblen* (1898). In 1905 he produced an opera based on Oscar Wilde's play *Salome* and began a collaboration with the dramatic poet Hugo von Hofmannsthal in 1909, with *Elektra.* This collaboration produced much of his best work for the theatre, including *Der Rosenkavalier* (1911) and *Ariadne auf Naxos* (1912).

Igor Stravinsky (1882–1971) Russian composer. Leapt to fame with the Diaghilev ballet, composing music for *The Firebird* (1910) and *Petrushka* (1911). His international reputation was consolidated by these and the sensational première of *The Rite of Spring* in 1912. Later turned to neo-classicism, in such ballets as *Pulcinella* (1920), *Apollo Musagetes* (1928), *The Card Game* (1937), *Orpheus* (1948), and *Agon* (1957). His later work, such as *In Memoriam Dylan Thomas* (1954), *The Flood* (1962), and *Elegy for J. F. K.* (1964), was influenced by the 12-tone system of Schoenberg and Webern.

August Strindberg (1849–1912) Swedish dramatist and novelist, considered the greatest writer of modern Sweden. His satirical novel about the art circles of Stockholm, *Röda rummet* (*The Red Room*, 1879), caused great outrage and is regarded as marking the arrival both of the modern realistic novel in Sweden and of the naturalist movement. His efforts to express inner reality through dramatic means make him a forerunner of expressionism and a major influence on modern theatre.

Tristan Tzara (Sami Rosenstock) (1896–1963) Romanian poet. Surrealist writer, one of the founders of the Dada movement at Hugo Ball's Cabaret Voltaire in 1916.

Anton von Webern (1883–1945) Austrian composer, studied under Schoenberg and mastered his 12-tone technique. His fragmentation of melody and extreme economy of expression made his early performances controversial. The Nazis banned his work and he spent most of his later life in retirement at Mödling.

Virginia Woolf (1882–1941) English novelist, critic, and essayist. An associate of Keynes, E. M. Forster, Roger Fry, Duncan Grant, Lytton Strachey, and others in the 'Bloomsbury Group'. In 1917 founded the Hogarth Press with her husband, Leonard Woolf. Her third novel, *Jacob's Room* (1922), marked her experiments with narrative and language and made her a celebrity. Her reputation was then consolidated by *Mrs Dalloway* (1925), *To the Lighthouse* (1927), and *The Waves* (1931). With James Joyce, she is regarded as one of the great modern innovators of the novel in English.

Wilhelm Worringer (1881–1965) German aesthetician. In 1911 coined term 'Expressionist', with reference to Cézanne and Van Gogh. Saw abstraction as an island of stability in a Bergsonian world of flux. Wrote *Abstraction and Empathy* (1908) and *Form in Gothic* (1912), two key documents in the history of modern art.

INDEX

Note: Page references to illustrations are in bold type. Titles of works under the names of various authors are alphabetized without reference to the definite or indefinite article.

Index compiled by Frank Pert